RODIN
SCULPTURE & DRAWINGS

Catherine Lampert

ARTS COUNCIL OF GREAT BRITAIN · 1986

RODIN Sculpture and Drawings Hayward Gallery, South Bank, London SE1
1 November 1986 to 25 January 1987

Organized by the Arts Council of Great Britain

Advisory Committee

Jean Chatelain; Monique Laurent; Alan Bowness; Sir Roy Strong

The exhibition has been generously supported by Pearson plc.

Copyright © 1986 by The Arts Council and the authors

All rights reserved.

Designed by Gillian Malpass
Set in Linotron Bembo by
Tradespools Ltd, Frome
Printed in Italy by
Amilcare Pizzi, S.p.A., Milan

Produced and distributed by
Yale University Press on behalf of
The Arts Council of Great Britain

Library of Congress Catalog Card No.: 86–50765
ISBN 0–300–03807–0 (Yale cloth)
 0–300–03832–1 (Yale pbk)
 0–7287–0504–4 (Arts Council pbk)

Selected and organized by
Catherine Lampert
Assisted by Rosalie Cass

All photographs of works in the collection of the Musée
 Rodin by Bruno Jarret
© Musée Rodin and SPADEM and Bruno Jarret

Translations from the French by David Macey unless
 otherwise noted

Special photography of the *Gates of Hell* at Stanford
 University by Jean-Louis Maserati

Frontispiece: Detail of Pl.189 showing Rodin with nude
 figure of Andrieu d'Andres and Jessie Lipscomb.

Contents

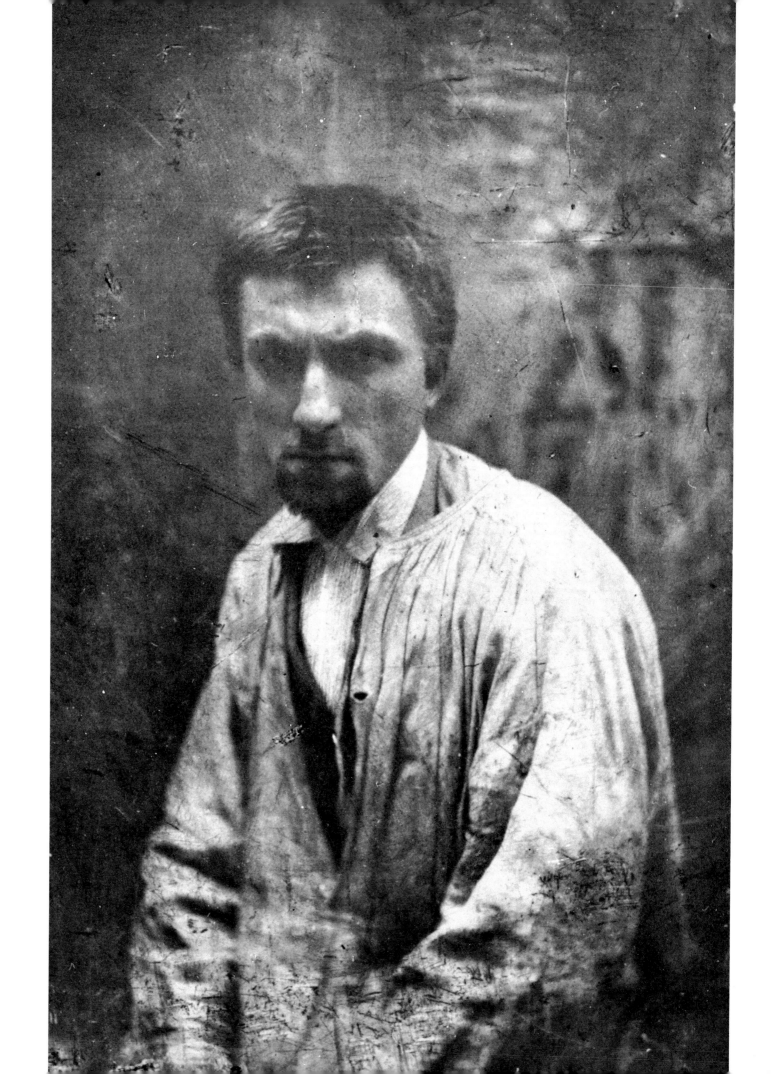

Foreword

THERE HAS BEEN a general revival of interest in Rodin since 1960, founded partly on public exhibition of previously unseen plasters and partly on enthusiasm for the partial figures. During the last decade the activities of the Musée Rodin in Paris and the 1981 exhibition, *Rodin Rediscovered*, at the National Gallery in Washington have encouraged an appreciation of Rodin's working methods while these and other comprehensive treatments of nineteenth-century sculpture have reminded us of the traditional aspect of Rodin's taste, especially as seen in his portraits and marbles. The purpose of this exhibition, explained in the preface, is not to recast Rodin's reputation but to consider the correspondence between the ideas and techniques he pursued in private and his masterpieces. The drawings and sculptures have been chosen to trace particular themes and configurations and to expose unfamiliar areas of Rodin's creativity.

The Arts Council is extremely grateful to the Musée Rodin and to other public and private collectors for their generous collaboration. The exhibition has been selected by Catherine Lampert of the Arts Council. Henry Moore took a keen interest in the last Rodin exhibition at the Hayward in 1970 and agreed to be the patron of this one. We had hoped that he would be able to visit it. We should like to express our indebtedness to the members of the Advisory Committee, M. Jean Chatelain of the Musée Rodin and Mme Monique Laurent, Chief Curator, Mr Alan Bowness, Director of the Tate Gallery and advisor on the 1970 exhibition, and Sir Roy Strong, Director of the Victoria and Albert Museum. Mlle Claudie Judrin, Curator of Drawings at the Musée Rodin, offered invaluable help from the beginning and has written the entries for the drawings from the Museum's collection. Likewise the advice of Mlle Nicole Barbier, Curator of Sculpture, who contributed the sculpture entries, and of Mme Hélène Pinet and M. Alain Beausire in the Archives has been essential to the research and documentation.

The freedom to borrow from geographically dispersed collections and to realise the exhibition on an ambitious scale has been made possible thanks to generous financial support from Pearson plc.

Joanna Drew
Director of Art

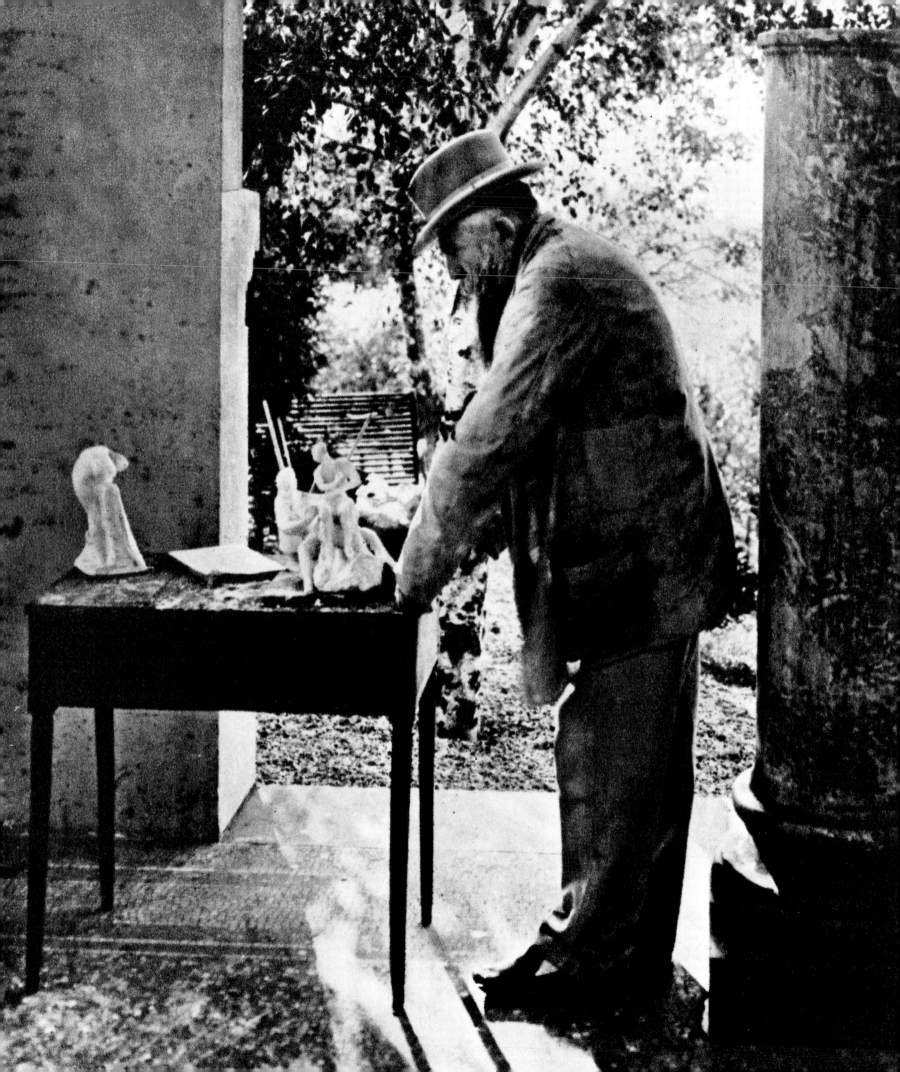

Preface

THIS PROJECT, first conceived as a book and then an exhibition, seeks to contrast the primarily historical view of Rodin's portraits, commissions, studies, etc. with one which concentrates on the cross-fertilization between his drawing and sculpture. Moreover, in my view, particular gouaches and line drawings of all periods deserve to be classed with the finest and most quintessentially sculptural works on paper ever made. A consideration of Rodin's early sketchbooks gives weight to the theory, argued by close contemporary observers like Rilke and Camille Mauclair, that Rodin's powers of invention and the subjects which arrested his attention were established by 1880 and remained persistent, but not static, for the rest of his life. Undertaking wide visual comparisons, for example between the agitated use of ink during all periods or between under-appreciated masterpieces like the *Crouching Woman* and the *Tragic Muse*, comes naturally within the bounds of such an overview. The importance of legendary figures, such as Balzac and Victor Hugo, to Rodin's concept of artistic inspiration, and his collaboration with female artists and models are sub-themes.

The choice of loans and reproductions is deliberately not an expression of connoisseurship. Works I think particularly remarkable such as *She who was the Helmet-maker's Once Beautiful Wife*, and *Naked Balzac* (with folded arms) and *Bellona* were left out of the selection and minor studies were included instead in order to offer a view of Rodin not available from museums' permanent installations. Only the Musée Rodin with its much loved, evocative rooms at the Hôtel Biron and the newly re-opened gallery of plasters at Meudon can regularly present an inclusive view of the range of Rodin's legacy (and furthermore display fragile large plasters like the *Monument to Victor Hugo*, which cannot travel).

The curators at the Musée Rodin have been consistently open-minded to alternative views and personally encouraging and helpful to me, as were the scholars in the United States with years of experience working on Rodin whose published material is a basis for exploration of Rodin's thinking and working methods. I am especially indebted to Albert Elsen, Kirk Varnedoe and John Tancock, and Claudie Judrin, Curator of Drawings at the Musée Rodin who very generously allowed me the privilege of seeing the entire collection over a period of years.

I would like to acknowledge the essential moral support and practical contribution of Rosalie Cass and Andrew Dempsey. Apart from the Advisory Committee I am grateful too in various ways to Frank Auerbach, Dore Ashton, Nicole Barbier, Andrew Best, Alain Beausire, Irène Bizot, Ruth Butler, John Cass, Melanie Clore, David Cripps, Penelope Curtis, Joanna Drew, Gerlinde Gabriel, Sir Lawrence Gowing, Daniele Gutmann, William Darby, Gustave Delbanco, Robert Elborne, Barry Flanagan, Lucian Freud, Tim Hilton, Samuel Josefowitz, David Macey, Michael Le Marchant, Gillian Malpass, Jean-Louis Maserati, Robert Mason, John Nicoll, Irena Oliver, Hélène Pinet, Jane Mayo Roos, Alan Stanton, Michel Strauss, William Tucker, Euan Uglow, Paul Williams and Baroness Willoughby de Eresby, as to many others.

Catherine Lampert

Photographic Acknowledgments

Bibliothèque Nationale, Paris
pls. 171, 194, 212, 230
Jean-Loup Charmet
pl. 184
© 1986 Rory Coonan
pl. 174
A. C. Cooper Ltd
pls. 159, 178, 274, 287, 301
Courtauld Institute of Art
pls. 31, 41, 162. 167a, 167b, 173, 195, 204, 210, 213
cat. no. 96
David Cripps
pls. 70, 92, 166, 167, 206, 207
cat. no. 80
Prudence Cuming Associates Ltd
pls. 108, 155, 156, 165, 263, 272, 285
Documentation photographique de la Réunion des musées nationaux
pls. 32, 45, 53, 77, 133, 134, 135, 163
Courtesy of The Harvard University Art Museums (The Fogg Art Museum), Bequest—Grenville L. Winthrop Cambridge
pl. 98
Leo Holub
cat. no. 77
© Bruno Jarret and Musée Rodin by SPADEM
pls. 5, 7, 11, 12, 13, 18, 20, 21, 22, 23, 24, 25, 26, 27, 36, 39, 40, 46, 47, 49, 50, 51, 55, 60a, 60b, 61, 64, 66, 72, 74, 78, 82, 83, 94, 95, 96, 97, 100, 104, 105, 106, 107, 113, 116, 125, 126, 127, 139, 141, 144, 148, 150, 154, 157, 158, 170, 177, 179, 181, 185, 186, 187, 188, 191, 193, 196, 209, 214, 216, 218, 225, 228, 229, 235, 236, 237, 239, 241, 242, 246, 247, 248, 249, 250, 251, 252, 253, 255, 259, 260, 264, 267, 269, 270, 271, 275, 276, 278, 279, 280, 282, 283, 290, 291, 294, 295, 296, 297, 298, 299, 300, 304, 305

cat. nos. 1, 10, 18, 19, 38, 41, 46, 48, 50, 51, 64, 68, 69, 93, 95, 97, 102, 108, 121, 127, 137, 143, 150, 152, 157, 160, 161, 163, 166, 171, 181, 189, 190, 197, 198, 199, 200, 201, 217, 222, 223, 224, 225, 228, 230, 232, 234, 235, p. 212
Kimbell Art Museum, Fort Worth
pls. 286, 288
Laboratoire et studio Gérondai, Lomme-Lille
pl. 137
Jean-Louis Maserati
pls. 79, 90, 121, 122, 123, 124, 131, 132, 136, 140, 143, 153
© Musée Rodin by SPADEM
pls. 1, 2, 3, 4, 8, 29, 30, 33, 84, 88, 91, 129, 138, 142, 145, 146, 147, 161, 164, 176, 180, 200, 201, 205, 211, 217, 223, 226, 227, 231, 232, 233, 234, 256, 257, 302 cat. nos. 242, 243, 251, 252, 253, 254, 255, 258, 261, 263, 265
The Nelson-Atkins Museum of Art, Kansas City, Missouri
pl. 34
Art Gallery of Ontario, Toronto
pls. 109, 110, 111
Hans Petersen
pls. 63, 101
© Rading Reklamefoto
cat. no. 188
Matti Ruotsalainen
pls. 81, 119, 120
Schopplein Studio, San Francisco
pls. 118, 172, 215, 221, 222, 265
cat. no. 120
John Webb
pls. 48a, 48b, 149, 219, 258, 303, 306
cat. nos. 23, 109, 141, 196
Murray Weiss
pl. 199
cat. no. 115

List of Lenders

DENMARK

Axel Martens
Ny Carlsberg Glyptotek, Copenhagen

FINLAND

Ateneumin Taidemuseo, Helsinki

FRANCE

Musée des Beaux-Arts et d'Archéologie,
 Besançon
Bibliothèque Nationale, Paris
Musée du Louvre, Departement des Arts
 Graphiques, Paris
Musée Rodin, Paris
Musée National de Céramique, Sèvres

GERMAN DEMOCRATIC REPUBLIC

Museum der bildenden Künste, Leipzig

HUNGARY

Szépmüvészeti Muzeum, Budapest

SWITZERLAND

Galerie Beyeler, Basel
Musée d'art et d'historie, Geneva
The Josefowitz Collection
Harry Spiro
Kunsthaus, Zürich

UNITED KINGDOM

Trustees of the British Museum
Browse and Darby
Bruton Gallery
The Syndics of the Fitzwilliam Museum,
 Cambridge
K. Delbanco Collection
Glasgow Art Gallery and Museum
The Burrell Collection, Glasgow Museums &
 Art Galleries
Hunterian Art Gallery, University of
 Glasgow, J. A. McCallum Collection
Herman Collection
Kodak Limited, Hemel Hempstead
Trustees of the National Museums and
 Galleries on Merseyside (Walker Art
 Gallery)
Manchester City Art Galleries
The Visitors of The Ashmolean Museum,
 Oxford
Reading Museum and Art Gallery
The Royal Photographic Society
The Trustees of the Victoria and Albert
 Museum

UNITED STATES OF AMERICA

Paul and Natalie Abrams
B. Gerald Cantor Collections
The Art Institute of Chicago
The Minneapolis Institute of Arts
The Metropolitan Museum of Art, New York
The Museum of Modern Art, New York
Rodin Museum, administered by the
 Philadelphia Museum of Art
The Fine Arts Museums of San Francisco
Stanford University Museum of Art
National Gallery of Art, Washington D.C.

and private collections

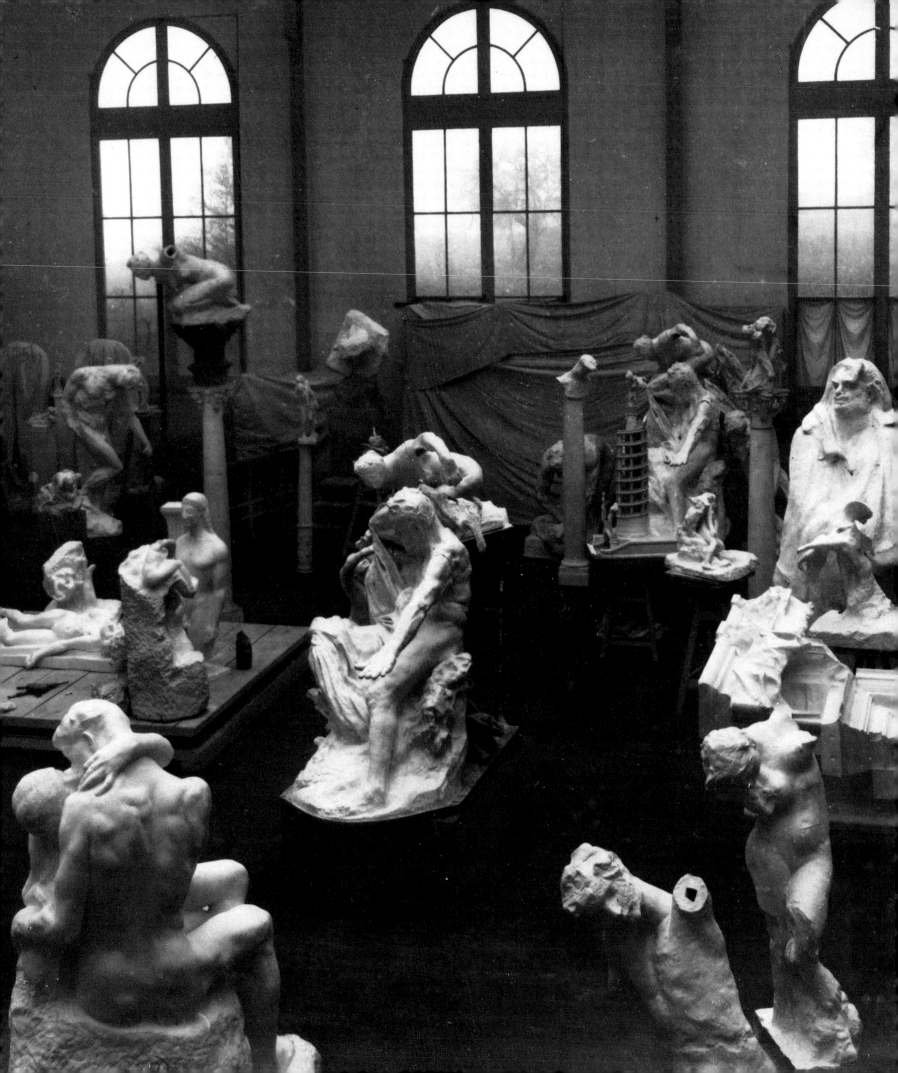

The Early Years and the Drawings from Dante

Rodin's art has universal appeal because the spectator knows that what it has to say about self-destruction and invincibility is true. The pulsating surfaces and graceful yet staggering sense of mass bring us nearer to the human fabric, while the aura, exaggeration and marvellous synthesis of body shapes crystallize the images in our mind. The sculptures can be taken away in the memory. It is a measure of Rodin's power that so many individual works have been understood by so many generations and nationalities with the utmost ease. The *Age of Bronze, St John the Baptist, Adam, The Thinker, The Kiss,* the *Gates of Hell,* the *Burghers of Calais* and even *Balzac* have all been well known outside a fine-art context. A century later their period style seems incidental beside their ability to transmit feelings.

In each the human body is treated in an unusually candid and vital way. Not surprisingly, they were first received with ferocious controversy. The extravagant praise and the denigration of critics and audiences as each was unveiled in the annual Salons and special exhibitions never came at the margins of public attention; in the late nineteenth century art was a matter of national identity, a mirror of the degree of decadence or promise present in society. Rodin participated in the idea of art being on a par with religion; he explained that beautiful works of art 'say everything that one can say about man and the world. Besides, they make us understand that there is something else that one cannot know.'[1] With a naivety and modesty hard to understand today Rodin thought his legacy might convince others to let nature be their sole inspiration. When in the early 1900s his artist/assistants such as Victor Peter and Emile Bourdelle were encouraged to use their own sensibilities and judgment to realise the enlargements and carved versions of Rodin's popular work (for the master's signature) it was his way of saying that the pieces themselves, *Eve, Danaïd, The Kiss* and so on, were living creations—not stylistic manifestations, but things in their own right, capable of evolution.[2] Embedded in this belief was Rodin's own experience of the nourishing powers of the physical presence of his drawing and sculpture and the art he collected. In a strange sense his methods, many unprecedented, were ingenious ways of keeping every single one of his offspring and adoptions by his side. Filled with plasters, marbles, bronzes and *objects d'art,* his grand rooms and gardens at Meudon and the Hôtel Biron were valued by Rodin as sanctuaries where man could commune with art and Nature.

When Rodin died in 1917 and his estate went to the French nation it contained over 400 distinct sculptures and some 7,000 drawings. Housed initially in various buildings at his home in Meudon, only a small proportion have ever been shown.[3] More experimental material has appeared in public in the last fifteen years than in the previous sixty and there are finally inventories being published. Our modern sense of propriety is shocked when faced with such an outpouring, uncensored and very explicit in its reference to the fetishistic power of the female form. However, the experience of seeing Rodin's œuvre unedited is riveting and the entire output of his lifetime presents an altered, more vivid picture of his audacity and singularity. Very little is one-off. Themes and techniques (many of

2 The portico at Meudon with the *Heroic bust of Victor Hugo* and *Woman seated with her foot in the air,* Musée Rodin.

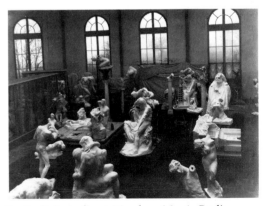

3 Rodin's studio at Meudon, Musée Rodin.

1 Rodin's studio at Meudon with plasters of *The Kiss, Monument to Victor Hugo, Balzac* and *Meditation,* Musée Rodin.

4 *Heroic head of Victor Hugo* with plaster studies of the *Inner Voice (Meditation)*, Musée Rodin.

which he invented) have their roots in the early period; most works could be aligned in family trees with intriguing cross-references. The off-shoots that Rodin derived within a single category, right to the end of his life, are astonishing. When Rodin's work is seen through his eyes, a playfulness comes across that is frequently lost within the solemn displays of bronzes and the preponderance of late marbles in most museum collections. Rodin treated objects, his own and others, rather like surrogate companions, sometimes placed them in pantomines with performances immortalized through deliberately contrived photographs.[4] Works made over different decades spoke to each other: thus a favourite female standing nude, *Meditation,* could be juxtaposed at one moment with the *Shade* and at another confront the bust of Victor Hugo. Naturally there was an element of fantasy, in the way of Pinocchio or Pygmalion and Galatea, but Rodin was not anxious for the creations to leave their solid state. For him, even if nominally in clay, plaster, marble or pencil on paper they were not artificial. Merely mute, faithful in spirit but capable of changing their messages when seen under different lights and in different contexts.

The artist that emerges from closer inspection of this self-made Rodin museum is a person deeply affected by the Romantic movement. Rodin's ideas about inspiration, passion and heroism were largely derived from the conventional views of the early nineteenth century. It is therefore hardly surprising that, for example, commissioned to make the vast bas-relief known as the *Gates of Hell,* he took Dante's *The Divine Comedy* as its theme and assembled something steeped in the melodramatic, colouristic spirit of Romantic painting. In addition, Rodin, born in Paris in 1840, the son of a minor police official and all his life a self-professed member of the working class, believed in a secular, republican society where there would be no hierarchy from well-born to common. He came to express this democratic ideal by allowing the natural, intuitive gestures and physiques of his models (generally humble) to be the source of his grand, timeless statements.

It is a fallacy to believe, as some have, that Rodin's 'genius' lay undiscovered until the age of thirty-seven when the *Age of Bronze* 'made a sensation among artists' in Brussels and then Paris in 1877.[5] For the sake of a dramatic story many biographers have claimed that the development of Rodin's artistic vision was hindered by his working-class origins and then blocked by the refusal of the Ecole des Beaux-Arts to admit him to the rank of fine artist as a young man of eighteen. There is much to suggest in the many drawings and few sculptures that survive of his twenties and thirties that Rodin was already chasing his own fantasies but was confused as how to turn the images of his imagination and observation into finished works. What he did meanwhile was to use the lumps of clay and pencils carried in his pockets to pin down these thoughts in a cryptic, original way. One of the marvels of Rodin's delayed coming of artistic age was his ability in the period 1878–82 to recognize the potential of the most primitive of these sketches and to find ways to develop the techniques and personal signs into substantial works, and then a decade later to enlarge diminutive figures made on modelling stands to a life-sized scale. On each occasion Rodin re-improvised the rough plasticity and awkwardness and, therefore, left the works with a look of newly born vulnerability. Never to be at ease in intellectual society, Rodin, when professing to his friend Hélène Wahl his inadequacies as a correspondent, described the hermetic nature and constancy of his inventiveness: 'You know that I am no scholar, and that having to write and speak embarrasses me; clay and pencils are my natural means of expression.'[6]

2

It is fitting that this particular study of Rodin which will concentrate on the genesis and survival of certain preoccupations, conceptual and formal, should begin in 1854. In that year, at his father's instigation, Rodin, only fourteen and previously considered a slow pupil at his uncle's school in Beauvais, entered the Petit Ecole. This free school, known officially as the Special Imperial School of Drawing and Mathematics, based its curriculum on lessons which would prepare students to realise other people's designs. The objective was to master a variety of styles and learn to copy accurately. Drawing was the principal activity and there are illustrations which show the students in the Salle d'étude with their drawing-boards, gazing at plaster casts of antique torsos, lion friezes, ornamental columns and large potted plants. Much time was spent copying Renaissance and Baroque art as well as Classical friezes from the originals and from engraved and plaster cast reproductions in the Louvre and the Bibliothèque Nationale. Fellow students included his future artist friends Alphonse Legros, Jean-Charles Cazin and Jules Dalou, but most students, like Rodin, who failed to move on to the Ecole des Beaux-Arts, simply entered the decorative trades.[7]

5 *Sheet of sketches*, Musée Rodin (cat. no. 2).

The energetic director of the Petite Ecole, Hilaire Belloc, employed serious artists as instructors, including E. Viollet le Duc, Jean-Baptiste Carpeaux and Horace Lecoq de Boisbaudran. The latter probably had the greatest influence on Rodin. When in 1913 Rodin wrote a preface for a re-issue of Lecoq's *Education de la mémoire pittoresque et la formation de l'artiste* he recalled then that 'despite the originality of his teaching he kept to tradition and his studio was, in effect, one could say a studio of the 18th century'.[8] In practice this meant an emphasis on terracotta sketches in the fluttery, animated style of Houdon and Clodion and the amorous subjects of Fragonard and Watteau. Lecoq, however, did not expect his pupils mechanically to imitate their sources. His goal was to teach each one to recognize the expression of his own temperament. Students were assigned special exercises designed to train them to depend on their memory. In some one section of the body was taken as a module for the whole. Lessons were devoted to fixing the fugitive effects of light, movement, skies, plants and children. Ultimately the pupils were asked to render complex subjects entirely without reference to direct observation or preliminary sketches. Imagination and memory were central to the making of art. What is more, the students not only were exposed to the set poses of jaded professional models but, exceptionally, were allowed the experience of drawing from each other, and Fantin-Latour remembered an occasion when the class set up their easels in a garden next to a cabaret in Montrouge.

Whether Rodin was included on any of the open-air sessions with the moving model we do not know. Undoubtedly he heard about them. Progressive artists elsewhere were rejecting the conventional repertory of poses. The young Monet (born in the same year) and his friend Bazille, for example, had peered over a wall to watch Delacroix painting a menagerie of naked people.[9] For Rodin's future explorations it is clear that his innate and obsessive fascination with the unadorned human body was not discouraged but reinforced by his experience in the life room at the Petite Ecole. In his second year he was allowed to model in clay and in 1857 earned the first prize for modelling ornaments. In the evenings he drew at life classes held at the Gobelins factory. Rodin's copies of the polychromatic re-creations of Roman costumes and Hellenic processions popular in the nineteenth century reveal his early fascination with the way pure line and transparent flat tone could unify a complicated subject, with the short-cut of tracing contours onto a fresh page in order to correct deficiencies and allow his

3

6 *Lovers*, Mastbaum Sketchbook (29v), Philadelphia Museum of Art.

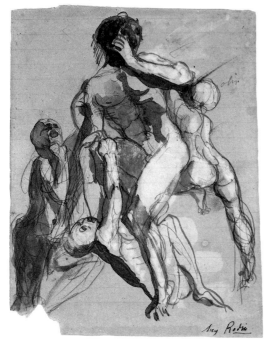

7 *Ugolino*, Musée Rodin (cat. no. 35).

mind to concentrate on rhythm, and with establishing a physical type with a particular psychological message.

We can witness the versatility engendered by the instruction at the Petite Ecole when we look through the Mastbaum sketchbook (now at the Philadelphia Museum of Art) dated to about 1856. The pages explore popular motifs—madonnas, cherubs, rustic cottages, mythological figures. Uniformly what Rodin concentrates on is silhouette. Where figures are grouped, as with a mother and two children, the verso of page 3, he looks for a way of interlocking the bodies so that the perimeter line is not random but firmly circumscribes a geometric unit, one person continguous with the other, like the lovers (p. 29v). Among the few pages with any indication of setting is a memorable one whose principal scene records bathers at an outdoor swimming bath moored on the Seine. The largest figure is shown in profile, thus establishing unequivocally his physique and its enduring place in Rodin's store of useable images. In the margin Rodin drew a struggling standing couple and below a reclining man obviously reworked.[10]

Lecoq was aware that many young people aspired to become artists without any knowledge of literature. He believed it was the professor's duty to bridge this gap which otherwise 'would inevitably prevent them from achieving the level they might otherwise have reached'.[11] Once at the Petite Ecole Rodin was made aware of his ignorance and took steps to make amends. He enrolled at the Collège de France to study history and according to his biographer and friend, Judith Cladel, began to read poetry, moving from Homer, Virgil and Dante to Victor Hugo, Musset and Lamartine.[12] The number of writers we know Rodin to have read in his lifetime is not enormous. It is his manner of reading and re-reading the same few people that stands out and is consistent with his faith in the artist's gift of being able to generalize human experience and transcend his age. The words, imagery and structure of Dante's *Divine Comedy*, read always in the same 1785 translation by Antoine Rivarol, were committed to his private store of imagery and, when silently recalled, had a powerful talismanic effect on his mind. Certain episodes, the story of Paolo and Francesca, or Ugolino, or the Centaurs, embodied the self-generated sufferings of mankind and the bestial origins of human beings removed from the squalid political circumstances.

Meanwhile, Rodin's failure three times in succession to gain admission to the Ecole des Beaux-Arts, perhaps because his sculpture was too obviously eighteenth century in style, meant that he could become only an apprentice *practicien*. The young Rodin was employed by a succession of restorers, jewellers, ornament-makers and masons and gradually become known as a worker with exceptional skills. During the Second Empire decorative and architectural commissions ranging from the grand schemes of Hausmann to the municipal monuments to honour the defenders of civic liberty and national independence were being undertaken on a vast scale. A few carvings most likely by Rodin survive today or are known through reproduction, such as the caryatids on the Théâtre des Gobelins (1864–65). Shadowy as this period 1858–71 is in terms of documentation, the anecdotes and visual evidence correspond to the better-known mature Rodin, consistently someone gifted with his hands, astonishingly serious in his ambition for his art and dependent for moral support on the women closest to him.

On one of his first assignments he met an older sculptor Constant Simon who explained to him the secret of modelling. The apprentice was trying to render a leaf in three dimensions and was told to focus exclusively on the contour lines,

going slowly around the projecting solid until from each angle the modelling corresponded precisely to the profile visible at that vantage point. Much later Rodin explained:

I place the model in such a way that it stands out against the background and so that the light falls on this profile. I execute it, and move both my turntable and that of the model, so that I can see another profile. Then I turn them again, and gradually work my way around the figure.[13]

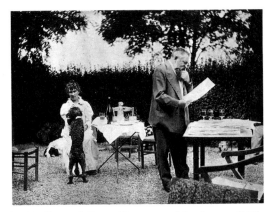

8 Rodin and Rose Beuret at Meudon, c.1910, Musée Rodin.

In 1863 Rodin joined the Union Centrale des Arts Décoratifs and tried, unsuccessfully, to become friends with a famous member, Carpeaux, whose terrifying sculpture of *Ugolino and Sons* of this date made a great impact on Rodin. Together with the son of the well-known modeller of animals, Antoine-Louis Bayre, in the next year Rodin organized a makeshift studio in the basement of the Museum of National History at the Jardin des Plantes and in addition attended anatomy classes at the Ecole de Médecine. In his words the students appropriated 'pieces of animals, lion's paws and other things from the lecture rooms . . . We worked furiously; we looked like savages.' This early contact with raw, fragmentary subject matter was unforgettable; certainly the presence of the eccentric, scholarly Bayre haunted the younger artist. Much later Rodin spoke of him: 'I have never known so melancholy a man, nor one with so much power . . . we boys, with the incomprehension of our age, looked upon him with a mixture of mistrust and fear.'[14]

Of all members of his immediate family, Rodin was closest to his sister Maria, three years his elder. Like his pious mother and his maternal aunt, Thérèse Cheffer, who kept house for a painter and raised three sons who all entered the fine-art trades, Maria was sympathetic to Rodin's desire to become an artist and became engaged herself to his friend, the painter Barnouvin. The surviving letters to Maria from the summer of 1860 when she had gone to stay with relatives in the country, express Rodin's loneliness and his nervousness at their imminent reunion: 'While we are apart I am obliged to dwell on my feelings in order to prove that I am still your Auguste, even though I cannot kiss you. When I write to you I can be more tender than I could be if I were at your side talking to you and that compensates for many things.'[15] In 1862 Maria died suddenly, after having been jilted by Barnouvin, and the grief-stricken Rodin entered the Order of the Fathers of the Holy Sacrament, but was encouraged by its remarkable head, Father Pierre-Julien Eymard, to devote himself instead to art.

Shortly afterwards, while working in the Gobelins district, Rodin met Rose Beuret, then a seamstress. In January 1866 Rose gave birth to a boy, Auguste-Eugène Beuret, who as a small boy suffered brain damage following a fall from a window. Rodin and Rose lived together for fifty-two years until her death in February 1917, a fortnight after their marriage and nine months before Rodin's own death. Unsophisticated and allegedly simple and jealous as she was, Rodin's letters even in old age reveal his tenderness for her and the importance of her steadfast devotion to his well-being. In the early years she was trusted to dampen the clay of his works in progress. The life-sized *Bacchante* for which she posed has disappeared, but Rodin's first distinguished bust records her high cheekbones and fiery close-set eyes. This allegorical work, *Mignon* (1867–68), depended on the Romantic interpretation of the heroine of Goethe's story. Mignon's passion is evident in her dishevelled hair, parted lips and wary look, like that of Delacroix's *Orphèline*, but is nevertheless faithful to Rose's unique beauty. The same passion enlivens the angry, helmeted *Bellona* (1879). When Rose was

9 *Bellona*, Victoria and Albert Museum (cat. no. 59).

5

seventy, in 1914, Rodin commissioned a photographer in England to record her marvellous profile.[16]

Although the sculptures Rodin made in his little spare time in his studio in a stable on the rue Le Brun, such as the *Man with the Broken Nose* (1864), failed to be accepted in the Salon, his demonstrably superior abilities earned him a permanent job within the boisterous, successful Albert-Ernest Carrier-Belleuse. It is customary to view Rodin's relationship with Carrier-Belleuse in the context of his future achievement. In many accounts Rodin's creativity has been said to have been repressed by the polished style of the workshop and by the knowledge that his conceptions would be altered and signed by someone else. In fact Rodin gained from being engaged on a wide variety of assignments, ranging from figurines, busts and ornaments for commercial sale to large-scale public monuments. Later on, what Rodin had learnt about the business side of a thriving sculptor's studio would be immensely valuable.

Carrier-Belleuse was said to 'paint' his faces, that is to use deep undercuts for features like the eyebrows and curls, in other words to advocate what was called 'couleur'. In his maturity he actively pursued in his portraits of actresses a lascivious tone which corresponded to his amorous suggestions to the sitters. The male subjects Rodin would have encountered in the studio were politicians, men of letters and other artists, all of whom appreciated the crisp characterizations which undermined the prevalent Neoclassical frigidity advocated by the Academy. Rodin responded to Carrier-Belleuse's taste for mythological seductions enlivened by strong diagonal movements, the *Abduction of Hippodamie* (*c.*1871) being a prime example and one possibly attributable in execution if not conception to Rodin.[17]

Their association was temporarily interrupted in 1870 by the Franco-Prussian War which brought an end to the building industry in Paris. Rodin enlisted in the army but was discharged several months later on account of his myopia, a life-long condition responsible for not only his poor academic performance as a boy unable to see the blackboard but his tendency to position himself as close as possible to the model. In the spring of 1871 Rodin decided to join Carrier-Belleuse in Brussels where the older man was engaged on the decorations for the Palais de la Bourse. The two quickly fell out over Rodin's right to market small bronzes like *Suzon* and *Dozia* under his own name. In 1873 he entered a partnership with the Belgian sculptor Antoine van Rasbourgh which also restricted Rodin's right to work independently. His frustration was already reflected in the letters Rodin wrote to Rose in 1871 who, at the time, was living with his parents and son in Paris. Mixed with tender messages and sympathy for the hardships which they were enduring during the Commune there are constant pleas to her to keep his clay works in progress properly moistened. Small sums of money were sacrificed to pay Bernard, the stone carver executing a marble version of the *Man with the Broken Nose*, and a caster called Demax and to meet the rent of the Paris studio.[18]

Rose joined Rodin in Brussels in mid-1872 and they both remembered the next five years as being the happiest time of their lives. Apart from the beer and the congenial company of the Belgians, they recalled their Sundays spent in the countryside. During long walks through the forest at Soignes with its seven monasteries, Rodin sketched while Rose held the umbrella. Rodin associated his whole Belgian experience with 'this vegetable cathedral which was for a long time the dwelling place of my thoughts'.[19] The revelations which seem to have remained in his mind were to do with the sublime power of Nature to induce in

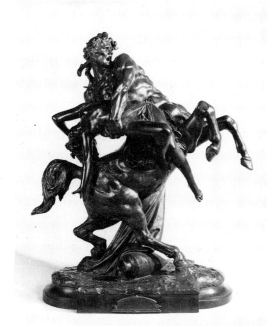

10 Albert-Erneste Carrier-Belleuse, *The Abduction of Hippodamie*, Bruton Gallery, Somerset.

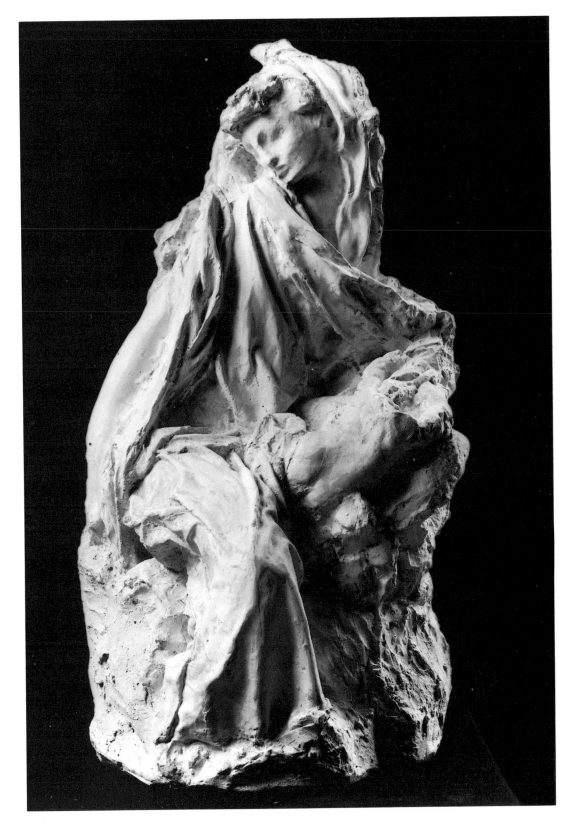

the artist a feeling of grandeur allied to the geometric structure of natural form, and specifically the effect of raking light on volume, thus the use of chiaroscuro to intensify contrasts and codify patterns of convex and concave form. Rodin applied his observations to charcoal and pastel sketches of the high, narrow trees of the forest. Equally beneficial to his discovery of his own visual inclinations

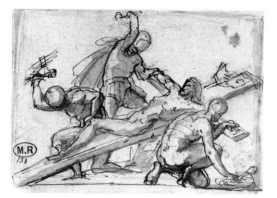

12 Drawing by Rodin after Rubens's *Descent from the Cross*, Musée Rodin, D133.

13 Copy of Rubens's *Portrait of Adrienne Perez* (Antwerp), Musée Rodin.

14 Four studies including a sketch for *La Ronde* and a skater, Goupil Album, pl.80.

was the time spent in the cast museum in Brussels, his first-hand contact with Flemish and Dutch painting in churches and palaces and his friendships with the artists Constantin Meunier, Paul de Vigne and the engraver Gustave Biot. In this period Rodin copied Rubens, making oil paintings of the Antwerp *Portrait of Adrienne Perez* and of the crucifixion called *Coup de Lance,* as well as a drawing after Rubens of Christ being nailed to the cross.[20]

We have only a patchy record of the sculpture Rodin made for his own benefit during the period of 1871–77. Two large works referred to as 'Joshua' and 'Bacchante', evidently made from living models, broke and had to be abandoned. A plaster known as *Medea* exists, a fragmentary *Ugolino* and a *Seated male nude*. There are several straightforward portraits, a number of rather saccharine figurines of women and children and busts of maidens, and free-standing and *in-situ* stone carvings, particularly several brawny caryatids, made as architectural decorations for buildings—mainly for facades and fireplaces. Most large pieces were accomplished in partnership with van Rasbourgh, and are not necessarily products of Rodin's taste. Given the number of missing works it is impossible to assess his sculptural development. What is clear is that he lacked confidence in his own experimental inclinations. He recalled with not untypical exaggeration and self-pity: 'the things I made in my studio were better than anything I have since executed, and had I been less negligent, some of them might have been preserved . . . then I did not know my work had any merit'.[22] And in retrospect he regretted the melodrama and Italianate trend of the times which infected the public commissions he and van Rasbourgh designed, such as the Loos monument of 1875 in which the huge figures of Industry, Commerce and the Sailor depended on a mixture of Rubens and Michelangelo.

We are lucky to have, because of Rodin's habit of hoarding his work, the notebook drawings which are so uninhibited that even today they seem like

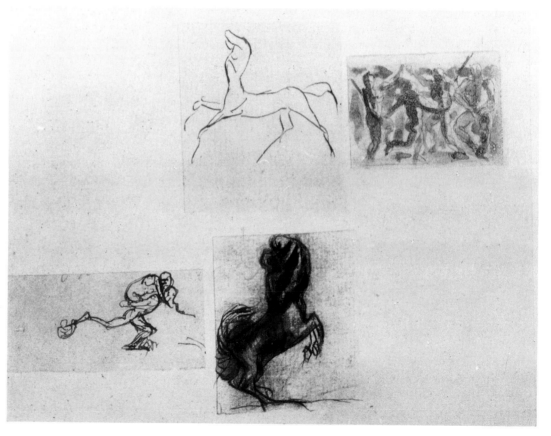

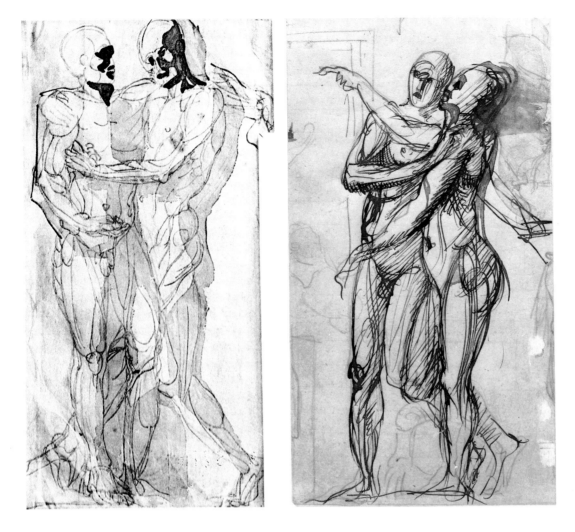

burning messages. Rodin's sketches of centaurs, tortured men, sprawling infants and lovers do not disclose a personality different to that manifested in the sculpture but are more often idiosyncratic, daring and confessional. Without them our appreciation of Rodin's early nonconformity would be impossible. Indeed we might wrongly assume his only channel to discovering his identity was through Michelangelo. Many figures are actually formed from several layers drawn directly over others, usually ink and wash over pencil, the additions sometimes imposed months (or years) after the first notation. Most drawings are small (15 × 10 cm at most), on poor quality scraps of paper and all are undated. They lack the rudimentary conventions for studies for sculpture, not even the hasty testing of motifs from various angles which Carpeaux used to help structure his future sculpture. Rarely do Rodin's drawings indicate a normal spatial location (even the ground) or include the delicate, fine line detail, tone or finish which he had mastered at the Petite Ecole. There is nothing calculated about the notebook and ledger-paper studies. Friends of this period remembered Rodin drawing obsessively, while he ate, walked and stayed awake at night.[23] If anything, the sketchbook studies are like a painter's ciphers. Speaking of Rembrandt, Seymour Slive has reminded his reader:

> the majority of his drawings can be compared to notes, ideas and aphorisms jotted down by a great writer. Sometimes they are worked over and polished. They may inspire or find a place in more ambitious works. It is not necessary, however to see their relation to larger projects in order to enjoy their quality or

9

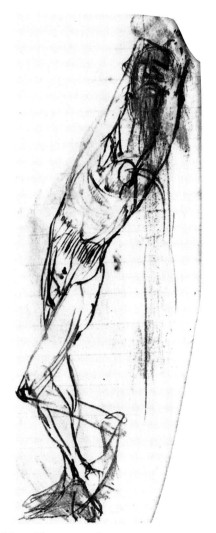

17 *Man with arms raised*, Szépmüvészeti Muzeum, Budapest (cat. no. 8).

grasp their importance. Indeed their spontaneity and freshness have a direct appeal sometimes missing from more elaborately executed pieces.[24]

Without attempting to burden Rodin's closeted development with over-tidy categories, it is still fairly clear that his early efforts were neither all of one sort nor random, but basically alternative pursuits. First there are drawings that are stressful, in means and feeling: Rodin tracked down in jerky lines images of constricted men engaged in tragic struggles. Second there are drawings allied to his training and to his work in the decorative trades: almost as a pastime he drew plump, light-hearted cherubs and maidens, using chalk and stump as well as overlaid ink lines. Surprisingly it is not obvious which category led to Rodin's discovery of his own subject. Nor did the two activities finally coalesce, although we begin to see this happening at a particular point in the early 1880s when, working furiously on the contents of what was becoming an interconnected field of writhing bodies, the *Gates of Hell*, Rodin turned in some gouaches to a kind of primal encounter. Previous distinctions between episodes and genders then become almost irrelevant to the overall lubricity and vacuum-like space.

The constricted, linear mode was initially stimulated by Rodin's practice of copying bas-relief in the Classical or Renaissance style. One sheet has been identified with Germain Pilon's sixteenth-century *Entombment* which was in the Louvre (and hence was probably drawn by Rodin before his departure for Brussels). Christ is surrounded by agitated spectators, Rodin ignores Pilon's elaborate linear treatment of the figures' draperies, strips them naked, and pulls the kneeling figure on the left into a plainly visible side-on view. Kirk Varnedoe, writing extensively on the early drawings, has pointed out how, in comparison with the original motif, 'Rodin's version is more square, his poses more stiffly

18 Copy of the *Entombment* by Germain Pilon (Louvre), Musée Rodin, D2036.

19 *The Cruel Repast (Ugolino devouring the head of Archbishop Ruggieri)*, c.1875–80, Philadelphia Museum of Art (cat. no. 56).

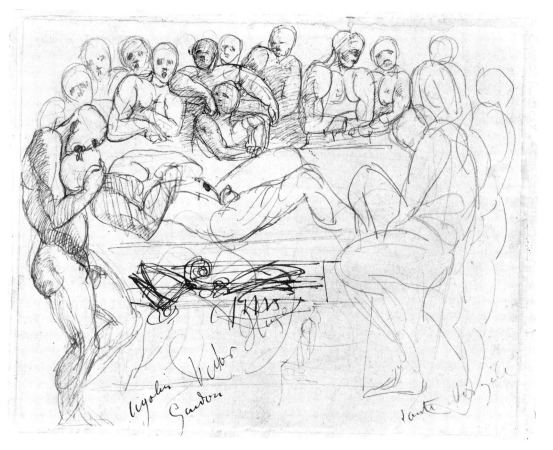

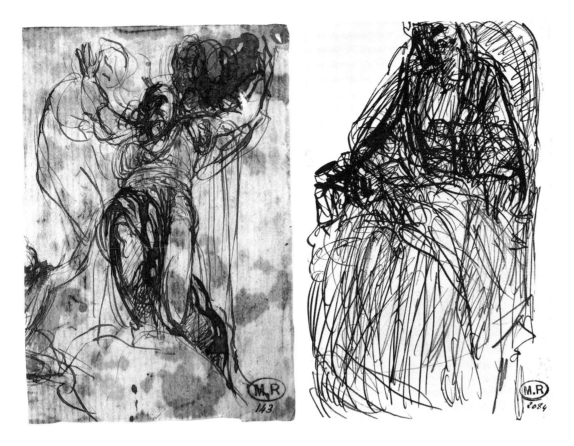

20 *Elevation of the Cross with three figures*, Musée Rodin, D143.

21 *Woman in armchair* (the Duchess of Choiseul), Musée Rodin, D2084.

profiled and his gestures more clutching and compressed. The feminine, swooning Pilon has become tensely masculine.'[25] As revealingly, I believe, the figures' identities are no longer obvious and, given their nakedness, each embrace hints at a sexual encounter hardly manifest in the original.

The motif of a crowd scene with a central horizontal figure and circle of onlookers is repeated in several sketches of the same period, one an *Entombment* (D404) and another a *Lamentation*, both derived from works in the Louvre. Eventually, about 1880, the composition was transferred to the *Cruel Repast* (or *Ugolino devouring the head of Archbishop Ruggieri*), a scene from *The Inferno*. Ugolino's bloodthirsty revenge is more disturbing because of the lack of redeeming graphic details. Each man, protagonists and spectators alike, is identically denatured—their physiques are cold, ideal specimens made of clipped lines, while the facial features are reduced to black holes for eyes and mouth, eliminating any sense of character or accountability.

A large number of the cramped pencil drawings in this linear category use the *écorché* method of defining the bodies as if composed entirely of muscular units, the flesh flayed away, strands knotted by the knees and elbows. Often the abbreviations are horrific and prickly, like the sharp, wedge-shaped feet and hands and the skulls joined by a straight line to the collar-bone. Rodin's pen nib works over the pencil outlines, adding evidence of the artist's changes of mind and indifference to the messy thickets left behind. In true Romantic spirit the more agitated his pen became the more able he was to stir up the aggression latent in the subject and in his mind. Curiously the pen remains for the duration of Rodin's life the tool that is associated with a conflict between liveliness and frenzy. The unforgettable drawing called *Elevation of the Cross with three figures* from the very early 'Album I' lets the pen run repeatedly in ellipses which suggest a mesmerizing loss of control. Forty years later a group of cursive ink drawings of Rodin's domineering mistress the Duchess of Choiseul in a high-

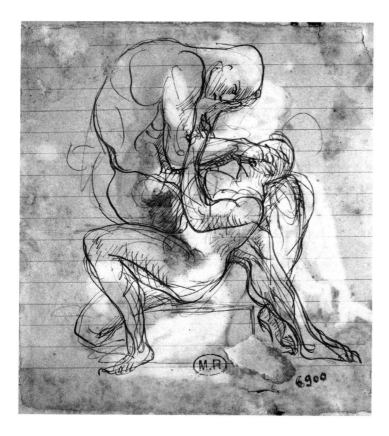

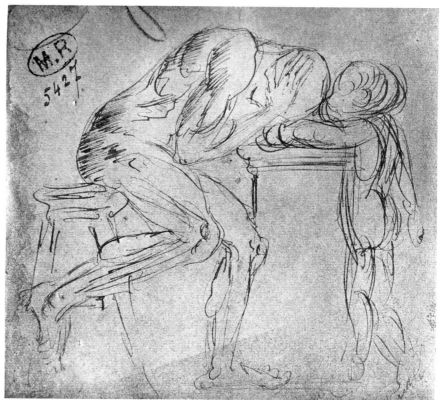

22 *Seated man with child*, Musée Rodin, D6900.

23 *Seated man slumped against a table, with child leaning on the table*, Musée Rodin (cat. no. 13).

backed chair (*c.*1912), shows how the broad nib and black ink can still engender such expressive, fervent thickets.[26]

As Rodin matured his line became more fluid and the figures more volumetric and naturalistic. The consistency of Rodin's art comes not in the modes used but at a conceptual and formal level. Specifically certain subjects which seem to be identified with deep-rooted emotions are identified by a constant body type and pose, defined by contour lines as rigidly and economically constructed as would be a sculptor's armature. One essential pose was the profile figure either seated or standing made of a sequence of bent head, rounded chest, pronounced buttocks and strongly muscled legs. He is sometimes developed into a seated figure with right arm propped on the left knee to support the head; he appears in the drawings such as the *Cruel Repast, Shade of a seated man,* and *Ugolino in his prison.* Ostensibly the meditating pose is inherited from Michelangelo (who borrowed from antiquity). Yet there is something modern about the way Rodin used the theme to convey someone dwelling on his own self-inflicted agonies. His subject is neither a person of status, like Lorenzo de' Medici or Moses, nor is he merely a bug-like, doomed, medieval creature damned by a higher order. If anything, the figure is autobiographical, an artist or poet who becomes alienated intellectually and emotionally from his family and colleagues; someone driven to pursue a dream at great cost. The sketch of the man at the table with an angel-like child looking on very nearly makes this connection explicit.

Several of the attempts to give three-dimensional life to this person probably date after Rodin's return from Italy in the spring of 1876. In late 1875, aware that the 400th anniversary of Michelangelo's birth was being celebrated by special exhibitions, Rodin, aged thirty-five, had set out on foot. His avowed intention was to discover the secret of movement in Michelangelo. What he brought back was not a full portfolio of sketches with useful 'secrets' or even motifs of the Renaissance masters but a highly personal, intoxicating memory of what it was

like to experience great art. He wrote to Rose from Rome after passing over the Mount Cenis pass, through Florence and then South:

> I have received three lasting impressions: Reims, the Walls of the Alps, and the Sacristry, which one does not analyse the first time one sees it. You will not be surprised to hear that I have been working on a study of Michelangelo ever since I arrived in Florence, and I believe that the great magician is letting me into some of his secrets.[27]

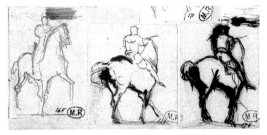

24 *Assemblage of drawings after Donatello's 'Gattamelata',* Musée Rodin, D165, 173, 174.

Afterwards the rest of Italy in comparison rather fell away, becoming a series of sensual impressions, including the 'terrestrial paradise' between Pisa and Florence with mountains coloured green, violet and blue, and the isolated works of the antique and Renaissance from Rome, Naples, Siena, Padua and Venice. Rodin found Donatello on a par with Michelangelo and made note too of Verrocchio, Vincenzo di Rossi and Raphael.

During his months in Italy one of the few sculptures Rodin drew repeatedly was Donatello's equestrian statue in Padua, *Gattamelata*.[28] His ink studies concentrate on the effect of the strong sun on the horse's mass, the swelling oblong balanced on spindly legs, the soldier's limbs and sword aligned to the stressed axes of the horse. The relationship of volume and line, light and inky shadow gives even the tiny sketches an hallucinatory power. Their magic belongs to the page and the medium, yet the message is so dematerialized that it also conveys Rodin's transposed feelings. The specific use of dark to underpin mass crops up again soon afterwards in Rodin's haunting studies of centaurs, particularly *Centaur with a woman on his back* and *Centaur abducting a young girl,* and the terracotta *Bacchanale* (cat. no. 44), and later in illustrations like those to Bergerat's *Enguerrande* which are charged with a similar optical dazzle and emotive magnetic pull.[29]

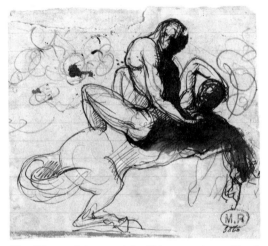

25 *Woman being carried off by a centaur,* Musée Rodin (cat. no. 40).

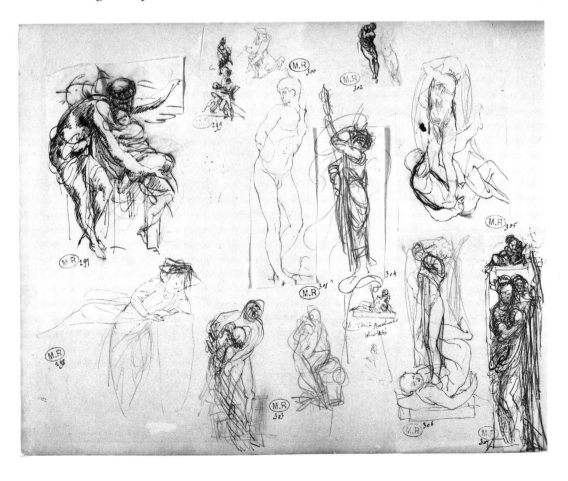

26 *Sheet of sketches,* Musée Rodin (cat. no. 3).

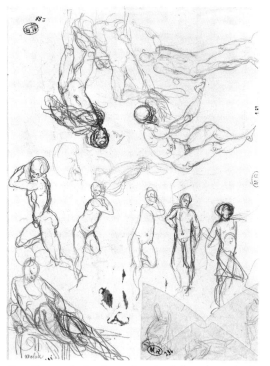

27 *Sheet of sketches after Michelangelo*, Musée Rodin (D285–288).

Returning to Brussels, his imagination 'inflamed', Rodin resumed work on his standing man with raised arm, first entitled *The Conquered One* and then *The Age of Bronze*.[30] Many years later Rodin was able to further articulate the prime formal consequence of his Italian visit. It was that antique art and Renaissance art used two opposing systems, both arbitrary but both derived from Nature. His thoughts were conveyed to Paul Gsell in one of their discussions (*c*.1910) while his hands fashioned little clay examples of both. The Greek metaphor for the human body relied on four directions: placing weight on one leg, balance was sustained by counterpoise, like the movement of an accordion—when compressed on one side the other stretched. 'Translate this system into spiritual language', he told his friend, and 'you will then realise that antique art signified joy of life: quietude, grace, balance, reason.' Beginning a Michelangelesque alternative, Rodin explained that the master arranged the body in the shape of a console, head bent, thorax incurved and knees as the lower bulge:

> this shape results in very deep shadows in the hollow of the chest and under the leg . . . We notice that his sculpture expresses the painful withdrawal of the being into himself, restless energy, the will to act without hope of success, and finally the martyrdom of the creature who is tormented by his unrealisable aspirations.[31]

The description is appropriate to his own pre-Italy, inward-looking figure, the *écorché*-rooted constricted man. The immediate consequence in 1876 of seeing the arbitrary structures of the two systems and their equal validity was to realise that they were not pure inventions, that Michelangelo was heir to the Gothic tradition which also used the console shape. Moreover, after the Italian experience, Rodin gained the confidence to believe he could continue the tradition of Michelangelo and indeed eliminate the need to challenge his immediate contemporaries. Within months he found his former heroes, sculptors, like Rude and Carpeaux, seemed to have 'fallen in the dust'; in his estimation only Puget was any longer to be compared to Donatello and Michelangelo.[32]

Rodin now treated his model for the *Age of Bronze,* the soldier Auguste Neyt, as an object, recording each 'facade' of the body, not only from the normal salient viewpoints but from an overhead shelf looking down and crouched below looking up.[33] The planes of the head, shoulders and haunches were registered as a sum of minor facets while the periphery was kept taut and succinct. Neyt's chest is thrust forward and balanced by his flexed hips with weight on the left leg, in indirect homage to Michelangelo's *Dying Slave*. In spite of the nominal, empirical neutrality of these efforts—or because of them—something about the final work seems awkward, especially the back view. Although the readings had been superimposed from an objective scrutiny, the man remained in a posture uncomfortably theatrical by modern standards, and by the conventions of 1877 puzzlingly obscure (all the more so for the lack of a spear in the raised arm). Seeing the completed statue of Neyt in the Paris Salon in 1877 Rodin admitted that it was not as good as he had previously imagined; perhaps he meant not as authentic as he had hoped.[34] A similar procedure had a much more liberating effect when applied to drawing. Sheets of quick notations like *Figure studies* (D285–288) were apparently drawn from life in quick succession, although the poses themselves echoed Michelangelo, especially his *David* and the *Genius of Victory* in the Bargello, as well as an antique figure of Apollo. The models pirouette on one leg, their heads twisted, some with a hermaphroditic quality

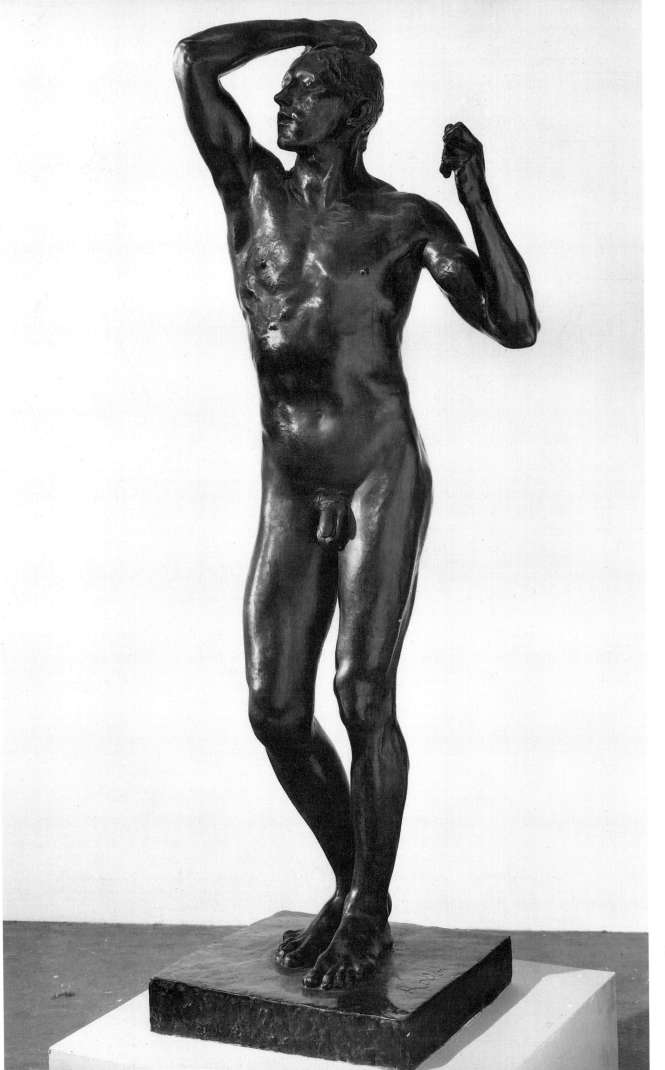

28 *Age of Bronze*, 1877,
Victoria and Albert Museum.

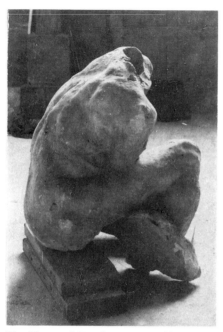

29 *Torso of Urgolino*, in profile, *c*.1877.
Photograph by È. Freuler, Musée Rodin
(cat. no. 246).

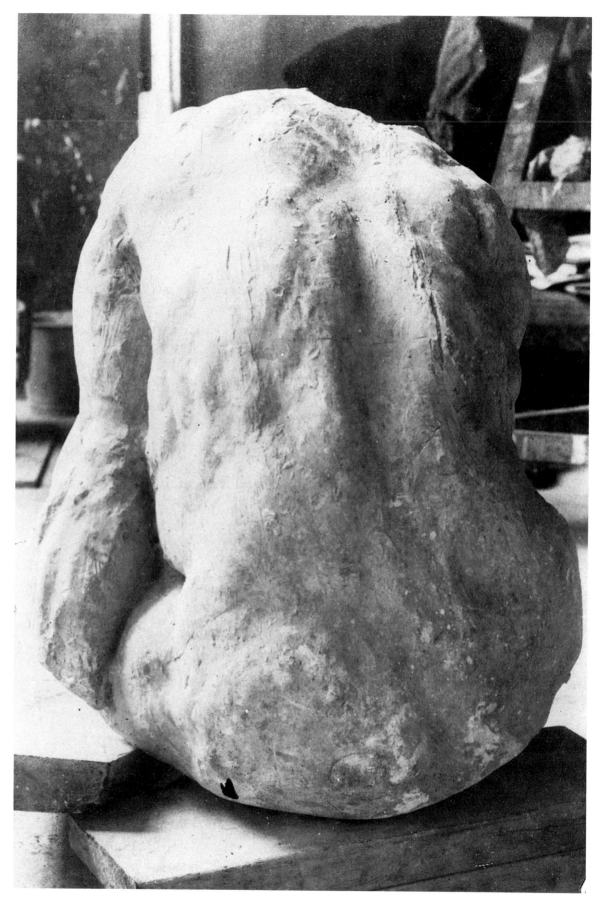

30 *Torso of Ugolino*, from the back,
c.1877. Photograph by E. Freuler, Musée
Rodin (cat. no. 245).

conveyed by swelling abdomens and others formidably male.[35] The freedom to put down what his eyes saw, and go on unselfconsciously to the next 'take', a feature of the previous drawings of infants, comes through in these sheets.

A one-metre high *Torso of Ugolino* is thought to have been made shortly after Rodin's return from Italy. The fact that the work survived as a fragment may have been accidental because the impoverished, unrecognized Rodin worked so long on the clay models the limbs tended to weaken and break. Rodin very likely began with an idea of a complete group similar to Carpeaux's famous pyramidal *Ugolino and his Sons,* shown at the Salon in 1863 and in the previous year as a craggy terracotta at the Ecole des Beaux-Arts (in 1911 Rodin acquired a bronze cast of the sculpture).[36] Obsessed with the Ugolino story (some thirty sketches survive) Rodin perhaps subconsciously reduced his seated *Ugolino* to a fragment, close in spirit to the *Belvedere Torso,* known to him from reproductions and from the original in the Vatican. He had already imitated the pose and brutality of the headless and broken-legged figure in his *Trophy of the Arts* made in 1874 for the Palais des Académies in Brussels. Whereas the Classical torso is a senuous spar, beautiful in its brevity and chance condition, the torsion of Rodin's work with its scissor-locked legs and hunched chest is painful. The flesh and musculature are no longer idealized and firm but distressed by the scored, pulverized surface that gives off unhealthy emanations much like the sinister chunk in the right half of Delacroix's *Barque of Dante* isolated from its surrounding by dark impasto.

31 Jean-Baptiste Carpeaux, *Ugolino and his children,* 1863.

The photographs Rodin had taken of *Ugolino* on the studio floor stress its monolithic quality so much that it seems rather more like a rock or an unearthed remain than a statue. When this *Ugolino* was finally shown in Rodin's own pavilion in the place de l'Alma exhibition of 1900 it was raised onto a mound, the height of a seated person. By then there was a context and an aesthetic for showing fragments; by then Rodin's standing allowed him to determine his own ambience by assembling a complete population of sculpture and drawings, eschewing altogether the stuffy idioms and containing frame of the Academy's hierarchial compositions. Rodin's lump of plaster could be seen for what it was: a sign for the torment brought on by hubris, free of gesture and narrative.

Numerous drawings of the late 1870s have truncated bodies, but Rodin was

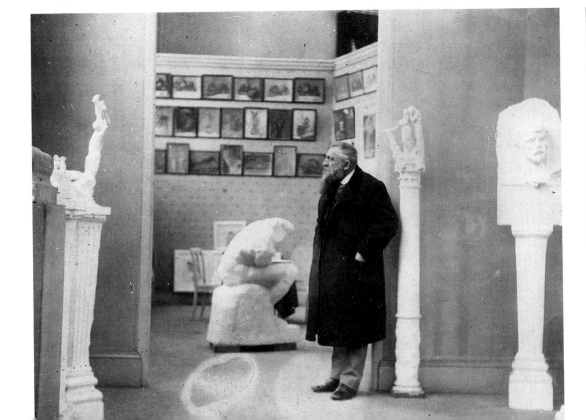

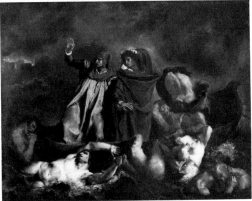

33 Rodin in the pavilion at the Place de l'Alma with the *Torso of Ugolino* and drawings, 1900, Musée Rodin.

32 Eugène Delacroix, *Barque de Dante,* Musée du Louvre.

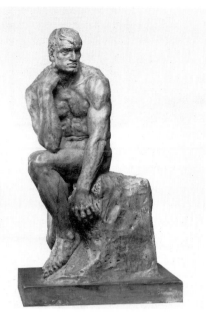

34 *Seated male nude* (study for The Thinker), *c.*1876, Nelson-Atkins Museum of Art.

36 (facing page top) *Nude infant with raised arms,* Musée Rodin, D244.

35a, b, c, d *Vase des Titans, c.*1878, Victoria and Albert Museum (cat. no. 21).

not so adventurous in three dimensions. A small, 37 cm wax, *Seated male nude* (now in Kansas City), that foreshadows *The Thinker,* depends upon Michelangelo's contrapuntal pose and emphatic musculature (as shown specifically in his *Dawn*). Rodin endeavoured to implant a modern sensibility into the work by means of the model's actual proletarian features, right down to the homely forelock and projecting chin. The result is dry. Shortly afterwards, around 1878, Rodin, by now back in Paris and working part-time for Carrier-Belleuse, blended these prototypes and his own inward-looking man more successfully in the *Vase des Titans.*[37] Perhaps following his employer's red-chalk drawing (Musée de Calais), Rodin made four seated Titans each measuring only 30 cm, their backs bent to support a *jardinière* bowl. The poses are taken in essence from the contrapuntal figures of Michelangelo's *Igundi* and his *Night* and *Day*. Rodin's *Titans* exist in several versions; in some, like the set in the Maryhill Museum of Fine Arts in Washington State where the figures are placed on roughly modelled mounds, the kneecaps and pectoral muscles are amplified by small lumps of clay and swags are improvised to represent the eventual drapery, both like the scribbled pencil lines and sweeps of dark wash on paper. A spontaneity and materiality, previously only risked in private on paper was allowed to animate this utilitarian object although in the final ceramic vase the muscles are somewhat muted by the glaze.

Rodin's parallel pursuit of the period 1860–80, the modelling and drawing of putti and nubile women, belonged to a commonplace genre. Rodin invariably interpreted his toddler as a neckless, ankleless, chubby figure with a cigar-shaped torso. This clumsy, constant thing was shown stretching and romping. On paper, and probably in crude clay models, foreshortening was attempted

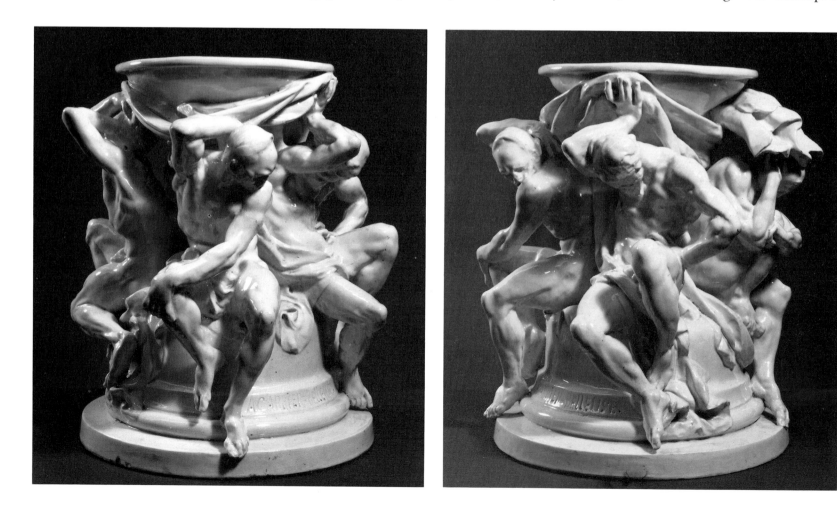

recklessly, the children shown from any angle as if to catch them in mid-air.[38] The use of conte crayon, wash and an ink line reinforced with a wide nib demonstrated Rodin's passion for giving these blimp-like forms a graspable identity, volumes with ballast and a determined distance from viewer. This manifestation of aplomb and immediacy came to Rodin naturally and creatively when drawing putti, whereas his serious adult encounters in the linear mode seem invariably tortured and painstaking. Rodin turns the children in space, literally and in his imagination, as unselfconsciously as he does twenty years later when he returns to drawing the figure divorced from an allegorical, literary or indeed sculptural purpose. It feels as though in the 1870s Rodin's disregard for and deprecation of his talents in this second-class sphere of activity, the decorator's trade, may not have been a bad thing. The routine, two-minute sketches of putti or mythological figures like Castor and Cupid with their arched backs, ovoid stomachs and writhing legs and arms fostered his exploration of the erotic, juicy sensibility which was to burst forth when transferred to the female body.

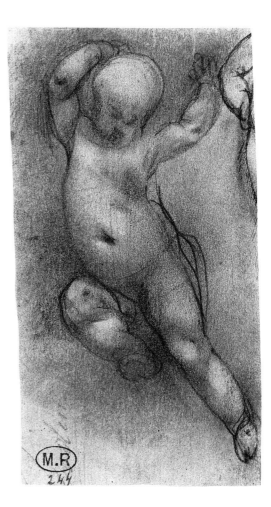

About 1878 Rodin, once again living in Paris and still obliged to work for Carrier-Belleuse and various commercial artists, transferred this sensuality to large, black-chalk drawings on the 'Golden Age' theme depicting a maiden or couple with infants. The technically accomplished drawing called *Springtime* (*c.*1878) shows a young woman in a diaphanous garment that scarcely hides the voluptuousness of her rounded abdomen.[39] The meeting of her legs is demurely obscured by one child, another held aloft provides an excuse for her provocatively flexed spine. The orchestration of convex and concave is so simple that it has the effect of intensifying the contact between woman and child. This

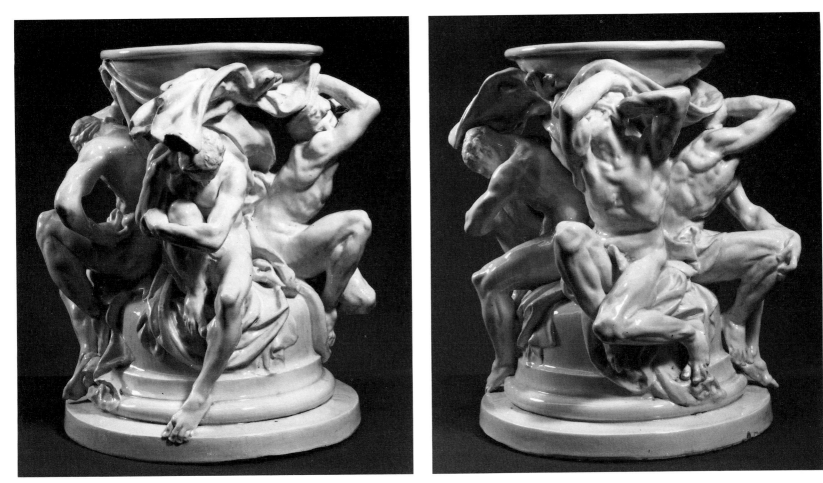

understatement happens also in the best of the early terracottas such as *Maternal Tenderness*.

Contained in Rodin's gravitation towards simplicity and spatial articulation was a quiet denial of the rococo frivolity of Clodion and Boucher, and of Carrier-Belleuse's attempt to be more suspenseful. A piece by the older master called *Angelica,* made in marble in 1866 and later editioned in terracotta (during the time Rodin was in his employment) had depended for effect on an element of threat and surprise. The foliage that inches towards Angelica's crotch, and her turned head and averted eyes refer to the imminent plunder of her body.[40] When Rodin repeated the pose and essentially the theme in his own work in the early eighties in studies for the *Gates* such as *Desinvolture* and *Kneeling Fauness,* his modelling of an absolutely unadorned body conveys far deeper eroticism.

The first large-scale sculptures by Rodin to use the arched-back pose of the cherubs were the twin Triton figures designed in collaboration with a sculptor, Charles Cordier, in the summer of 1879 for a villa in Nice. Framing the bedroom balcony the former cherubs became monstrous fleshy creatures. What is unexpected is the way in which Rodin counteracts the flaccidness of the lateral bands of these eunuch-like figures with the tension of the spiralling vertical axis. We sense Rodin for the first time able to reject the tight musculature and self-

37 (facing page top) *Couple with putto*, *c*.1880, Philadelphia Museum of Art (cat. no. 66).

38 (facing page bottom left) *Springtime*, Art Institute of Chicago (cat. no. 4).

39 (facing page bottom right) *Maternal tenderness*, Musée Rodin (cat. no. 14).

40 *Desinvolture*, Musée Rodin (cat. no. 85).

conscious perfection of the antique and of Michelangelo. Writing home to Rose, Rodin described the indolent air of the Mediterranean, the wine, his desire to bathe in the sea—if only he could swim—and 'the beautiful women of the Midi', as if in anticipation of his imminent conversion to sculpting female nudes for their own sake.[41]

There is a direct visual connection between this flexed Triton and Rodin's first piece of modelling with a feeling of shivering life.[42] It was a small terracotta study of the supple model Adèle who probably began coming to his Paris studio in the autumn of 1880. She was clearly not a girl so accustomed to the standard poses that she could no longer move about freely. In fact, the opposite. Even her repose was uninhibited. She lay back, the triangle of her raised left arm guarding her face and modesty, but her belly and pelvis stretched and tilted to increase the sense of exposure. Her lower half is lean, even adolescent, but her breasts are conceived as mounds obviously rendered in the stuff of plastic clay, not worked gingerly in a preconceived manner. A notion of sculptural arabesque married with the torsion of the pose perhaps inspired Rodin to sever her head and lower legs so that viewed horizontally she become a bridge, or vertically an arc, as economical as Brancusi's *Princess*. The rippling surface breaks light down into facets and translucent membranes. Strikingly innovative as an isolated fragment, the *Torso of Adèle* rapidly became Rodin's first personal module, available to be used in works as diverse as the lyrical *Eternal Springtime* (1881) and the altar-like, art-nouveau *Fallen Angel* of the 1890s.

Rodin's return from Brussels to France in March 1877 had coincided with the successful entry of the *Age of Bronze* in the Paris Salon. Writing to Rose in an impatient, energetic vein he asked her to send his large *Ugolino* and his entry card to the Bibliothèque Nationale (and reported that he had obtained a special pass for the Egyptian collection at the Louvre). He also asked after his statue of Joshua and the monument to Byron which were being cast.[43] With this feeling of determination and urgency, it is understandable that his optimism was crushed by the accusation of critics and the Salon jury that his standing man was a 'servile copy', most probably a mere assemblage from life casts. Rodin's Belgian friends Felix Bouré and Gustave Biot immediately wrote letters of support to Rodin and he himself defended his position to the president of the Salon jury in a letter which concluded: 'It causes me such pain to see my figure rejected because of a shameful suggestion; it causes me pain because it could have meant so much for my future. I am thirty-six and I have not much time.'[44]

Following this slight Rodin set to disproving his accusers and competing directly with the leading sculptors. Rilke's description—of course based on hindsight—does not exaggerate:

> Whoever fears to expose himself to a charge of exaggeration would have no means at all to depict Rodin's activity after his return from Belgium. His day began with the sun, but didn't end with it; a long stretch of lamplight was added to its many bright hours . . . In those days he laid the foundation for this entire immeasurable work. Almost every piece with which we are acquainted was then begun with a bewildering simultaneity, as though the beginning of their realisation was the only guarantee that it would be possible to carry through something so immense.[45]

Ostensibly the large figures of *St John the Baptist* (1878–80) and *Adam* (1879) were the continuation of Rodin's belief in the candid observation of uncontaminated natural man—Jean-Jacques Rousseau's theory, already given a voice in paintings

41 *Triton*, Villa Neptune, Nice, 1879. (Photo courtesy of Albert Elsen.)

22

42 *Torso of Adèle*, *c.*1881, Courtesy Browse and Darby (cat. no. 82).

by artists such as Millet and sculptors such as Rodin's contemporary Jules Dalou. Rodin's *Adam* had borrowed much from Puget's *Satyr* which was available first-hand when he travelled to Marseilles after working in Nice in 1879.[46] The striding *St John* was supposedly directly inspired by the living model. Thirty-five years after the event Rodin told Dujardin-Beaumetz in an interview of 1913 that his conversion to the unpremeditated poses of ordinary people had been instantaneous. He claimed it occurred when an Abruzzi peasant, César Pignatelli, knocked on the studio door in Paris, looking for work modelling: he 'undressed, mounted the revolving stand as if he had never posed; he planted himself, head up, torso straight, at the same time supported on his two legs, opened like a compass'. The movement was so arresting that Rodin resolved 'to make what I had seen'. According to the same account, thereafter he continued to reject the prevailing academic norms wherein the 'very thought of balancing a figure on both legs seemed like a lack of taste, an outrage to tradition, almost a heresy'.[47] Whether the pose was spontaneous or stage-managed, it is obvious Rodin genuinely responded to the particulars of Pignatelli: his pronounced curvature of the spine, rounded shoulders and firm buttocks—an authentic console type (and relative of the constricted man of the *écorché* drawings), revealed as slightly ill-bred by the pigeon toes and craggy peasant features and

23

therefore believable. Undeniably *St John* and *Adam* have a nineteenth-century rhetorical quality, their stoic isolation verging on pathos. By the next pair of sculptures—*Eve,* Rodin's interpretation of the Italian model Mme Abruzzesi (who posed also for his *Ariadne* and *Cybele*), and the ultimate seated man, *The Thinker*—there had been a shift: Rodin was attempting to work in the Realist corporeal tradition of Courbet and Manet. Introspection went with fidelity to the model's physique and with a rugged sense of touch. The result was neither patronizingly graphic nor overly metaphorical, but used the abstract aspects of form and surface to suggest strength and dignity.

Rodin might have have continued to build his career on modern anti-heroes. Ironically the reasons why he did not do so were largely the bridling sense of the injustice of the accusation that he used life casts and the limitations on his studio time because of economic problems. In fact these discouraging conditions saved Rodin from his impatience to become famous and to make important statements. His Salon output was painstakingly retarded during the period 1877–81 because for economic reasons he still worked for others, designing mascarons for André Laouste for the Palais du Trocadero and carving decorative sculptures in Nice and Marseilles, returning to Paris for good in February 1880.[48] The invitation of Carrier-Belleuse to join the small group of artists designing vase decorations for the Manufacture de Sèvres which came in June 1879 was probably extremely welcome; it was certainly fortuitous. Above all Sèvres was peaceful. Between June 1879 and December 1882 Rodin worked in the attic studios sketching and modelling in paste on the fired vases. As Roger Marx explained, at Sèvres

> Rodin forgets his resentments: he lets himself go and gives his all, without any afterthoughts. His mind is calm, his soul full of joy. This moral atmosphere is the key to the Elysean lands in which his imagination roams; and yet, as always, he is at once epic and informal, spontaneous and reflective, innovatory and traditional.[49]

The simple routine of going to Sèvres, on the outskirts of Paris, seems to have been healthy, as well as less arduous than carving. Rodin walked back to his home on the rue St Jacques, accompanied by Rose, through the landscaped park of St Cloud, filling his notebook with further sketches. At Sèvres he had an excuse to pursue motifs of 'charm and grace and light and dark' that continued the tradition of Correggio and Prud'hon and Watteau, pagan idylls calling for intertwined maidens and infants, and to work his way into sexually suggestive Bacchanalian themes under the guise of dreaming up cycles for the friezes of large urns. The documented total of 1,352 hours' work produced only 18 vases.[50] A fellow artist, Taxil Doat, observed Rodin's involuntary dropping away from reality:

> While he was working he was completely absorbed, impervious to everything around him, when the bell rang lunch, I would pass by his studio to let him know it had rung and go out together. With a distracted air he would very slowly detach his wide open eyes from the object he was working on as though reluctant to be awakened and wrenched from the dream that filled his head and vanished in the presence of others.[51]

Speaking of 'Sèvres' as a reflective experience is, of course, more meaningful when we consider it in tandem with Rodin's mounting excitement for a new, prestigious commission. That same spring of 1880 Rodin learned that he might

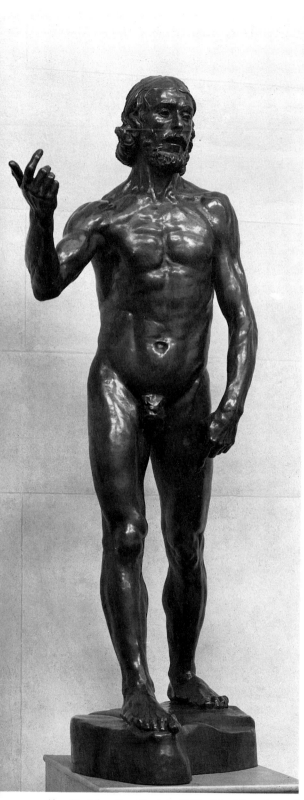

43 *St John the Baptist*, 1878–80, Victoria and Albert Museum.

44 *The Thinker*, 1880, Burrell Collection, Glasgow (cat. no. 74).

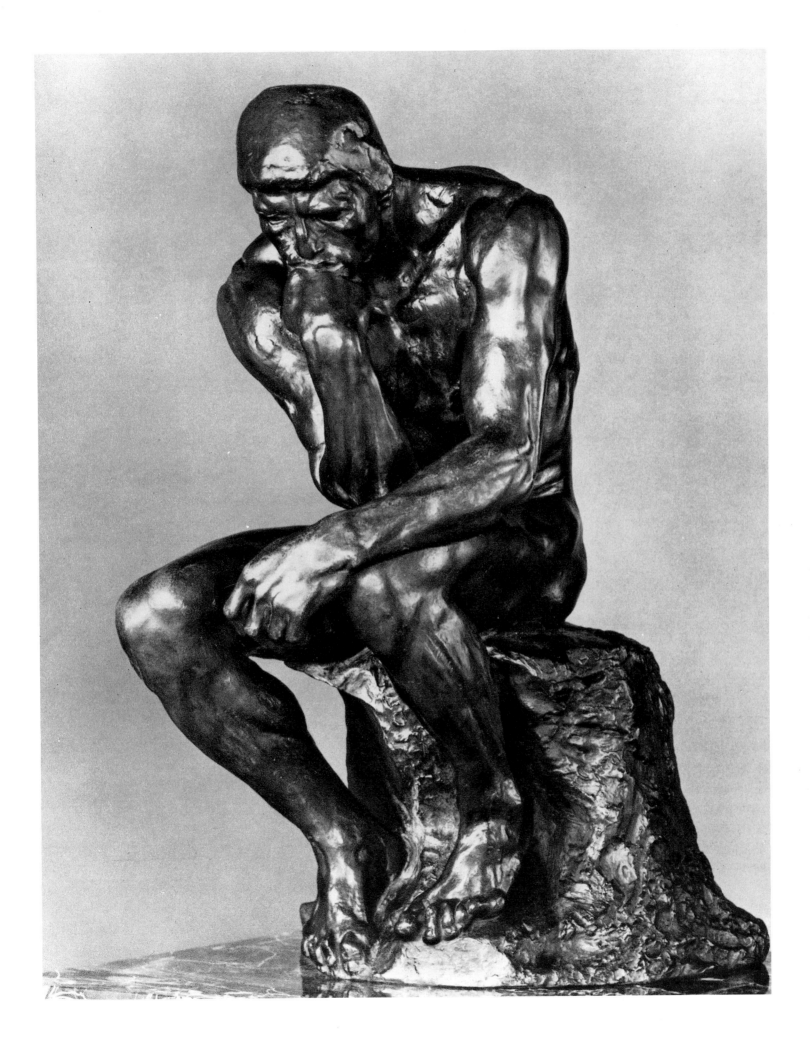

45 *Le Jour*, 1881–82, Musée national de Céramique, Sèvres (cat. no. 27).

47 (facing page) *La Nuit*, 1881–82, Musée Rodin (cat. no. 26).

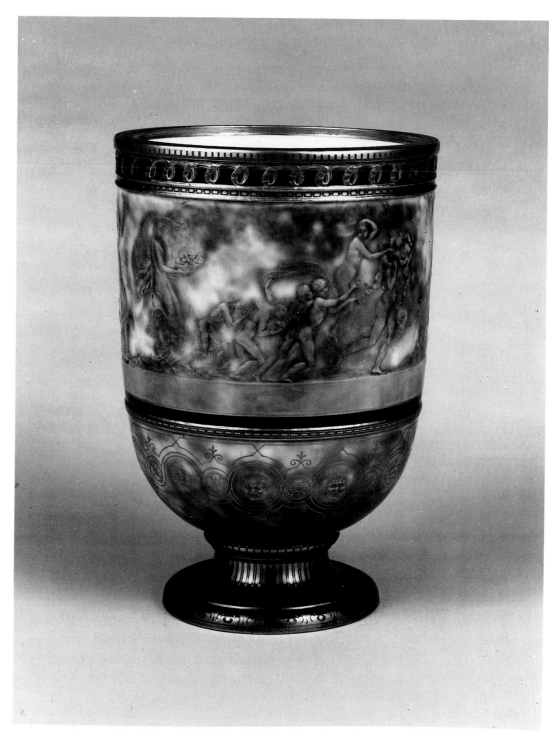

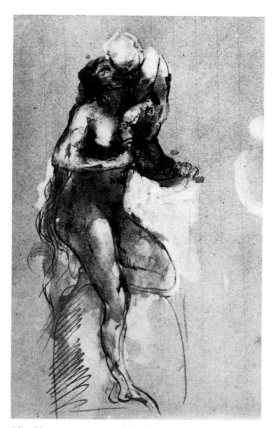

46 *Young woman and child*, 1880.

be asked to design a large entrance door for the future Museum of Decorative Arts. The proposal was Edmond Turquet's, the Under-Secretary in the Ministry of Fine Arts and brother-in-law of the painter Maurice Haquette, a colleague of Rodin's at Sèvres.[52] In a sense what went on for the next five years in the studio at the Dépôt des Marbres, assigned to Rodin because of this commission, was miraculous. An insecure artist who had hoped to win an honoured place in the Salon by executing statues of heroic figures like St John the Baptist became obsessed with making dozens of small figures. By 1885 Octave Mirbeau could report seeing '300 figures, each portraying a different attitude or feeling', the overall sensation being one of their 'twisted contortions' and 'tragic vibrations'.[53]

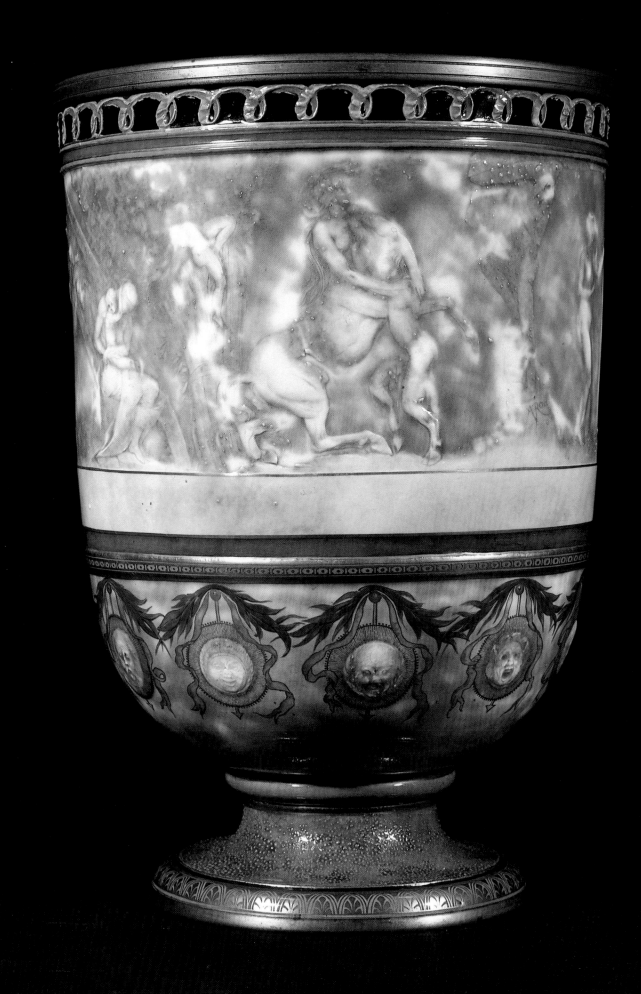

48a, b *Vase de Saigon*, 1880, The Josefowitz Collection (cat. no. 25).

Rodin's perceptive friend Gustave Geffroy explained: 'For him, the positions of the human body could not be reduced to a few types. Rather they seemed to be infinite, all giving rise to new ones through the decomposition and recomposition of movements, multiplying in fleeting aspects each time the body shifts.'[54] Eye-witnesses observed the transformation of a man still referred to in 1887 as 'Carrier-Belleuse's most able assistant'[55] into the foremost French sculptor, 'the maker of a gigantic work which will provide us a counterpart to the Baptistery portal in Florence, the work of Lorenzo Ghiberti that Michelangelo said deserved to be called the Gate of Paradise'.[56]

What took place between 1880 and 1885 was a process liberated and continuously fed by the activity of filling small sketchbooks and scraps of paper with heavily worked single and paired figures. These 'black' or Dante gouaches, as they are usually called, were the first locus of the gravity-less, time-less settings for amoral observations. Their influence on Rodin's sculpture is on the one hand proven by exact parallels between sketches and the maquettes and *études* for the *Gates* and on the other is a matter of sensibility. The breed of bloated, sexless figures engaged in erotic coupling of an undefined kind, like the *Man struggling with a woman,* appeared on paper several years before equivalent

sculptures of the mid-1880s to late 1890s, works such as *Earth* and the 'Iris' series.[57] Cryptic line drawings seem to have been removed from the sketchbooks and glued onto fresh paper in order to be reworked by layers of ink and wash applied and rubbed off so that the drawings became friable and crusty. Rodin was said to have worked with his fingers as well as the rag and brush. Using white gouache, he imagined light on these isolated, truncated forms, creating the opposite impressions of masses revealed by carving and solids dematerialized by a camouflage-like dappling. Hardly known outside specialist circles, these drawings are among the most beautiful works on paper of the nineteenth century. Unlike any painters' drawings, they seem forceably made, the tools and paper manipulated in a way which speaks of Rodin's desire to amplify the rudimentary human outlines until the beings seem equivalent to the suffering, voluptuous, graspable species immortalized by Ovid and Dante but revitalized by Baudelaire, Géricault, Delacroix and Courbet.

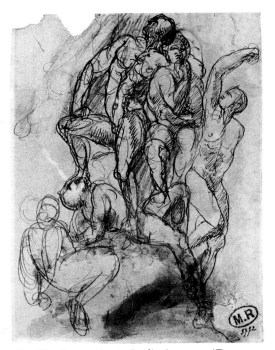

49 *Blasphemy*, Musée Rodin (cat. no. 47).

The contribution of Rodin's 'black' drawings to his sculpture is a neglected area for at least three reasons. First, these small fragile sheets, the majority in the Musée Rodin or in private collections, have rarely been shown. Second, they have never satisfied the art historical criteria for 'studies' for sculpture in that not only are they undated, but few appear to rehearse poses in an exact or practical way. Third, Rodin himself felt unsure about their worth in so much as they were associated with the imagination and with private obsessions. Very few were published, exhibited or sold in the 1880s and it was not until 140 were seen in facsimile in the 'Goupil' album published by Boussod, Manzi, Joyant & Cie in 1897 that they were known publicly.[57] By this time Rodin had constructed an explanation for the inspiration for his sculpture solely around the Romantic idea of responding directly to the observation of ordinary society, as represented by unprofessional models. Even in the early years when students made their way to the studio on the rue de Fourneaux to see the man who had made the *Age of Bronze* and the *Man with the Broken Nose* (finally shown in the Salon of 1878), they were 'amazed to find him working on the kind of thing Carrier-Belleuse did but he showed them Ugolino . . . He talked about art with an intelligence entirely new to us, and the only reference he made to himself was this, "I think only of outlines, to see that they are right and just".'[58] This statement is accurate in that it reflects Rodin's preoccupation with outline, the three-dimensional equivalent of a sculptural armature, and with the behaviour of people in extreme circumstances, such as the predicament of Ugolino. But it belies his preoccupation with expressive distortions and the plasticity of his material.

On 13 May 1883 Rodin wrote a letter to Léon Gauchez, the editor of the magazine *L'Art* which was to publish eight drawings with a review of the Salon that spring written by D'Argenty.[59] Three were captioned as sketches for work at the Manufacture de Sèvres, four were sketches for the 'monumental door for the Museum of Decorative Arts', and the last, like an entombment, was simply entitled 'the vision of the sculptor'. Actual drawings and plasters had alrady appeared in the exhibition of the Cercle des arts liberaux, on the rue Vivienne in February-March and had attracted the interest of Geffroy who had mentioned Rodin's memory of Delacroix's sketches as a likely source for these plasters and drawings of writhing figures. Rodin explained in his letter to Gauchez:

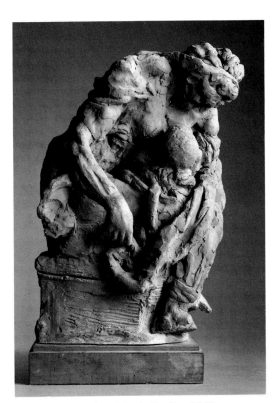

50 *Nursing mother*, Musée Rodin, S369.

those of the drawings which have no great character and which are rather pretty, like that of a woman holding a child by the feet and playing with it, are for the Manufacture de Sèvres. I am executing them in *pâté en pâté*. Most of the

29

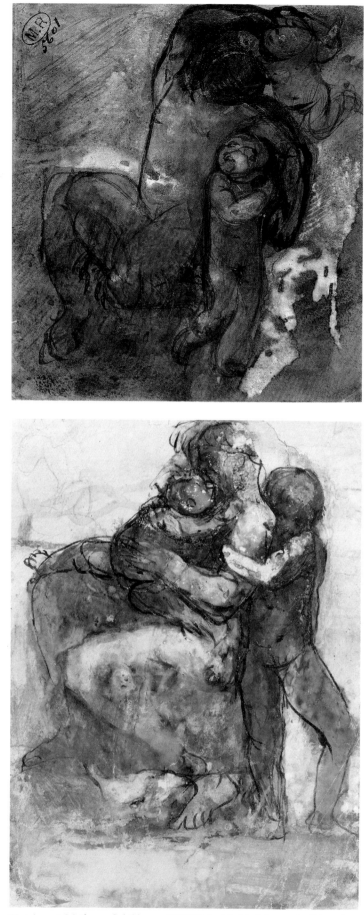

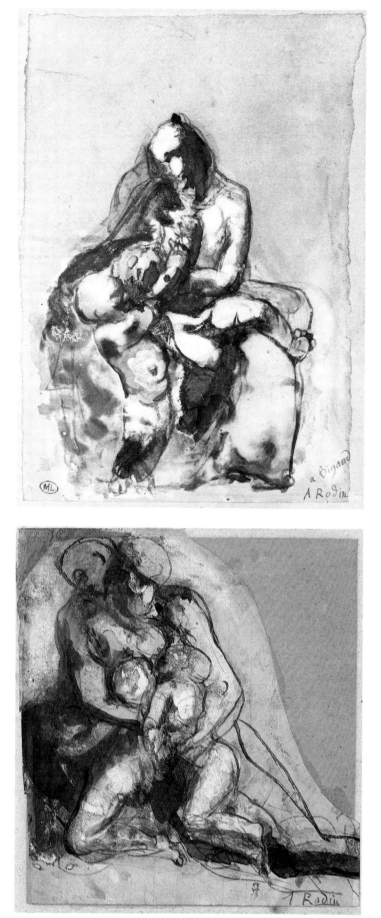

53 (above) *Mother and children*, *c*.1880 Philadelphia Museum of Art, (cat. no. 31).

54 (above) *Charity*, Fitzwilliam Museum, Cambridge (cat. no. 30).

51 (top) *Seated figure holding a child, with a second child on her shoulder*, Musée Rodin (cat. no. 32).

52 (top) *Seated woman with two children*, Musée du Louvre (cat. no. 28).

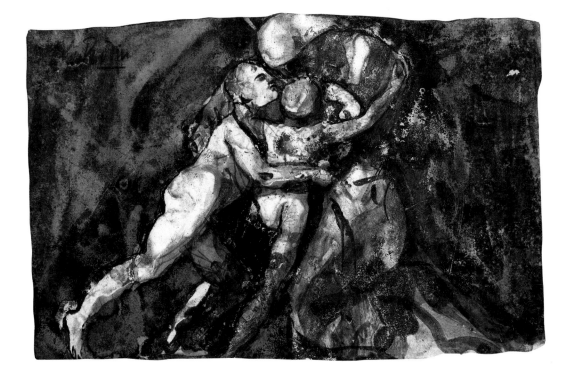

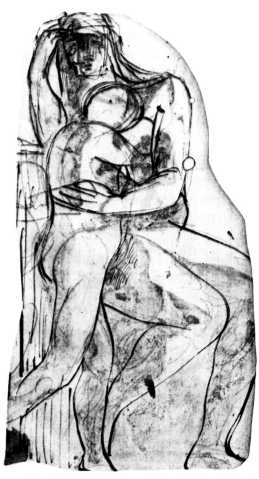

others are studies for Dante's work, which I am trying to translate into drawings. For before I could get down to the real work, I had to transform myself and to work in the same spirit as this tremendous poet; in the drawings, I am therefore working by trial and error, trying things out. In many of them, I am trying to come to grips with the thought of the master, and even if I do not use my drawings, or even if they do not all become part of the work, they will at least have helped in its presentation. I cannot imagine that all my drawing will be modelled, as sometimes the overall harmony requires something different to the work one has done from the point of view of pure expression.

For the moment, then, there are so many drawings that they are more like illustrations to Dante, seen from a sculptural point of view. It seems to me that the poet always expresses himself in primitive and sculptural terms.[60]

56 *Seated figure with child*, Szépmüvészeti Muzeum, Budapest (cat. no. 34).

55 (above left) *Woman kneeling and clasping two children to her*, Musée Rodin (cat. no. 33).

57 *Woman and child*, formerly collection of Roger Marx.

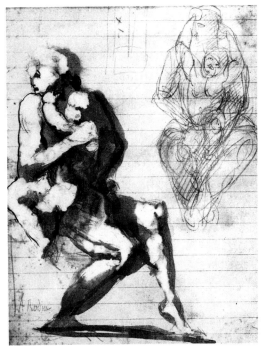

As Rodin tried to enter Dante's mind his pen came to dwell less on narrative incidents and more on primary encounters. The majority of the drawings appeared to be tender embraces between adults, either ones of the same sex like Dante and Virgil or the opposite, symbolized by Paolo and Francesca, or alternatively the union of parents and children. These two- or three-figure groups were shadowed by nearly identical-looking subjects used on the vases at Sèvres under the guise of the *enlèvement* theme: thus, pagan seductions in which the girl is held aloft or full-fledged Bacchanalian scripts with luscious women with long tresses, and sirens and centaurs acting out man's bestial desires. By mid-1881, despite what Rodin said, the distinction between the ideas for vases and the private, imaginary drawings was only nominal. Nowhere is this more obvious than in the development of the seated man or woman with head turned in profile of the *écorché* period, now visualized as an anxious being—father, madonna, Medea, Niobe or Ugolino—perhaps protecting, or perhaps threatening the smaller figure.

The subject of parent and child, of course, was familiar in Rodin's art in the 1870s and had begun along traditional lines with terracottas of young mothers

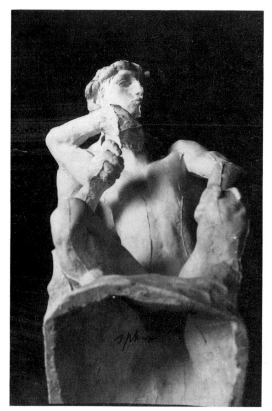

58 *Man and small figure*, Musée Rodin, Ph2764.

59 *The genius of sculpture* (or *Michelangelo modelling the slave*), Goupil Album, pl.119.

and robust offspring. Superficially similar to these is the little-known plaster, *Medea,* a work probably that referred to by Rodin as 'la femme drapée' in letters to Rose dated April 1877. The actual date of the piece is unknown, but it was very likely influenced by Delacroix's *Medea,* particularly the version now in Lille which had been shown in Paris at the Exposition Universelle in 1855.[61] A bare-breasted, anguished woman turns her head away from the struggling children she is about to murder. At first glance Rodin's unfinished study is more circumspect. Yet, the contrast between the silky throat of the woman, the smooth backsides of the children hidden in her garments and the slightly Gothic look of the drapery generate a sinister, erotic suggestiveness.

When Rodin became obsessed with drawing the Medea subject, the protagonists visualized nude, he was inclined to fix the pose of the adult but let the children change position: some are on the ground, moving between the larger figure's legs and others are held on the lap or even lifted into the air. The parents look away, distracted and stiff, while frequently the children become embryonic in form, with globular heads and a cigar-shaped bodies. The annotations 'madonna', 'Medea' and 'Ugolino' appear on nearly identical sheets.[62] Looking at the drawings as a group we have the feeling that Rodin began with this subject of the disturbed parent and child to work from deeply-felt personal experience. The implication is not the joyful association of procreation and fertility but a painful one; Rodin may have been infertile himself.[63] More importantly he seems to have envied those with a happy family life. In his letters to the wives of friends, such as Mariana Russell and Edith Tweed, there is the suggestion that, much as he approves of domesticity and paternity for others, he accepts that his own sense of fulfilment will come through art not fatherhood.[64] The gouaches have an archaic, mute, ponderous quality which fits the complexity of the emotion. Van Gogh's words express the artist's sense of otherness:

> Oh, my dear brother, sometimes I know so well what I want. I can very well do without God both in my life and in my painting, but I cannot, ill as I am, do without something which is greater than I, which is life—the power to create. And if, frustrated in the physical power, a man tries to create thoughts instead of children, he is still part of humanity.[65]

There are sculptures which place a stiff, upright child between the outstretched arms of the parent. One in particular, now missing, the *Sculptor's Soul,* suggests the innocent child is a muse, unable fully to understand the thought processes of the adult, but nevertheless there to listen and comfort. Several drawings reinforce this personal interpretation of the artist and muse: two sketches, the *Genius of Sculpture* and the lost *Sculptor's Dream,* depict the artist in front of his modelling stand concentrating on the clay surrogate person while receiving messages from an airborne, but wingless muse. The child appears in the drawing entitled *Les Limbes* which was reproduced in *L'Art,* and in the *Centaur* (Musée des Beaux-Arts, Lyons), astride the creature. The interesting aspects of this persistent theme are how far Rodin rebelled by translating the traditional idea into his own terms, stripped of allegorical attributes, and how consistently the form used is a cigar-shaped symbol, occasionally active with spritely kicking legs but nonetheless reconizably his own invention. Many gouaches loosely allied to the story of the centaurs in Dante, like the *Witch's Sabbath* now in Chicago, the beautiful *Centaur carrying away a young man* in Copenhagen and the child trapped under the centaur in *Achilles and Cheiron,* use an impish figure with flipper-like feet, strong, gripping thighs and a tail.

32

61 *Centaur*, Musée Rodin, D1894.

60a, b *Bacchanale*, Musée Rodin (cat. no. 44).

62 *Achilles and Cheiron*, Fitzwilliam Museum, Cambridge (cat. no. 39).

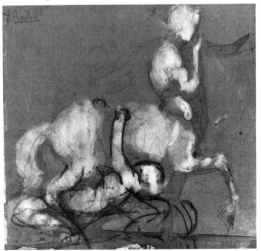

63 *Centaur carrying away a young man,* Ny Carls-
berg Glyptotek, Copenhagen (cat. no. 42).

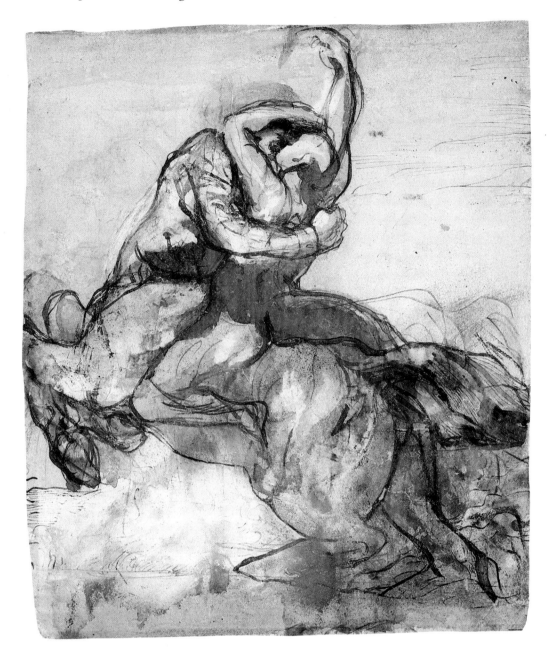

The rough *Bacchanale* with its twisting, swelling forms carries a similar
message of sensual intoxication. The point is not that any one drawing
foreshadowed or paralleled or even attempted to plot Rodin's explorations in
three dimensions but that collectively their indirect way of giving visual identity
to extremely private, sexual impulses in itself crystallized Rodin's vague notion
of other-worldliness and led him to attach his imaginary longings to particular
physical actions and thus to his subject which was without precedent. Rodin
began turning away from Classical proportions and the usual upright orientation
of man and revolving the small clay sketches or scraps of paper in his hands, so
that images were freed from gravity and logic; thus in a dream-like vacuum,
riders and horses are shown back to back, portions concealed by the murky
gouache and rounded shapes like buttocks and shoulders picked out by light.
These were the methods and aesthetic Rodin sought in the *Gates,* the first public

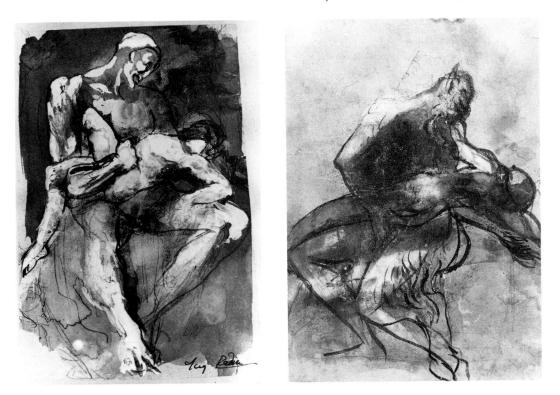

64 (above left) *Ugolino in his prison*, Musée Rodin (cat. no. 36).

65 (above centre) *Satyr and nymph*, *c*.1883, Philadelphia Museum of Art (cat. no. 37).

66 (above right) Detail of third architectural maquette for the *Gates of Hell* with *Ugolino*, Musée Rodin.

location for his new species of the human race. Rodin's rejection of both an illusionistic and a lyrical and symbolic codification of human behaviour anticipated in part the modern ideas of alienation and disorientating illogical occurrences. The late drawings follow this direction in their sensations of weightlessness and impermanence.

Inseparable from the themes and ambience of the 'black' gouaches are certain techniques and practices which were also pioneered on paper and employed for the rest of his lifetime. One was the transferral of a particular shape or juxtaposition of shapes to several contexts. The contracted figure holding another across his lap becomes such a fixture. *Ugolino in his prison* is uncannily similar formally to the drawing of *Satyr and woman* and is itself reproduced in clay in the right panel of the third maquette for the *Gates*. The child held tenderly in the gouache *Le Baiser* at the Fogg Art Museum when reversed becomes the victim in *Woman carried away by a centaur*. Joining figures at cross-axes was not original to Rodin: Bayre used it to electrify and clarify the groin-to-groin contact between the two protagonists in his *Theseus Combating the Minotaur* (*c*.1840) and Géricault intended it as a metaphor for sexual union in his linear study *Woman being carried off by a centaur* and the beautiful watercolour *Le Baiser* depicting a voluptuous woman and youth in bed. What Rodin did that was new was to allow the bodies to be completely contiguous, interlocked. This contact produces the shocking aspect of famous works such as *The Kiss* and *She who was the Helmet-maker's Once Beautiful Wife,* a union of old woman and young girl. It is the use of modules which begins in the drawings and dominates Rodin's thinking later on when playing with his plasters that was his own.[66]

The habit of tracing figures to improve a contour and adapt to a new context, a method which Rodin pursued as a student in his copies of antique costume and friezes, became common in the developed gouaches. Frottage and stencils also produced mirror-images or reversals. In the line drawing *The Shades approaching*

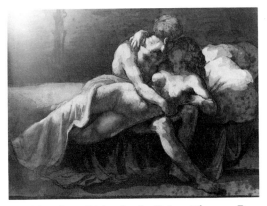

67 Théodore Géricault, *Le Baiser*, Thyssen-Bornemisza Collection.

68 *The Shades approaching Dante and Virgil*, Fitz-william Museum, Cambridge (cat. no. 52).

69 *The Shades of Three Warriors*, Goupil Album, pl.4.

70 *The Three Shades*, 1881, Private Collection (cat. no. 75).

Dante and Virgil the nearly identical, ramrod–like bodies of the two protagonists are rotated to a diagonal axis in order to convey their fear and imminent flight. The famous *Three Shades,* which was planned from an early date for the top of the *Gates,* is comprised of three almost identical casts of an adapted version of *Adam* that permit the earth-bound viewer an almost complete reading of their physiques while being more effective from a theatrical standpoint, more eye-catching, more haunting. The small sculpture *The Three Faunesses* joins the heads as if making a tripod appropriate to a witches' coven or pagan dance. Leo Steinberg was one of the first to comment on the analogy between this obsession with repeated forms and patterns and modern painting: 'By assembling three casts of her, Rodin wins for himself the painter's advantage. The margins become engaged intervals, so that the repeat of this one irregular body yields infinite rhythmic amplifications.'[67]

At the same time that Rodin was tracing images, he was cutting them out and pasting them onto clear backgrounds. Some were then integrated by dabs and washes of sepia and overlaid line, but others were not touched, emphasizing the

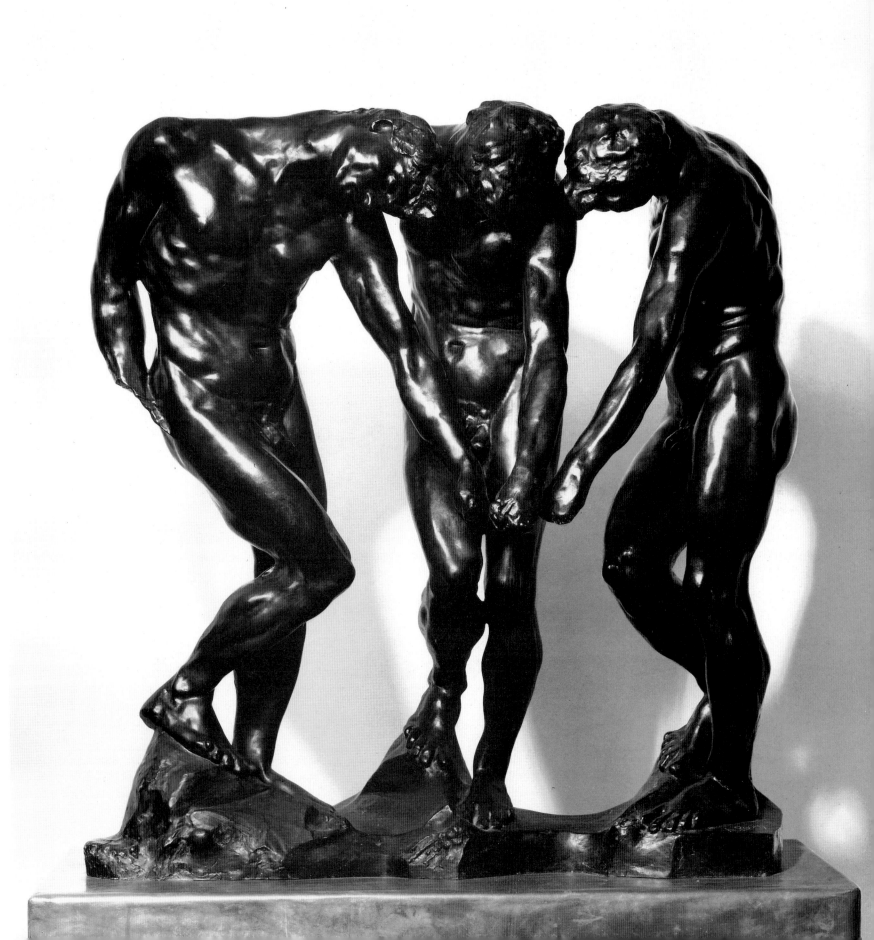

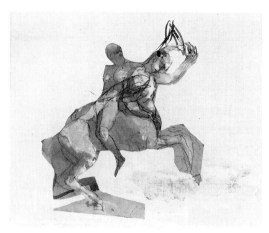

71 *Centaur carrying a woman*, Philadelphia Museum of Art (cat. no. 43).

contrasts of scarred, textured mass, crude, knife-rendered silhouette and the pure blankness of the surrounding area. Two-dimensional cut-outs by Rodin varied from the decal-like *Centaur* and the *Shades of Three Warriors* to the strange scene of father and sons annotated 'la chêne', presumably because the cutting line which caused the central head to be bowed gave the impression of an oak tree with bark-like weathered surface. Among the cut-outs are several heads, for example, the *Furies* and *St John the Baptist*. The truncated look of these fragments seems in keeping with Rodin's decorative work, for example the Trocadero mascarons and with his love of antique fragments; specifically the *Mask of Minos* may have been partly inspired by Schliemann's discovery, made known in 1877.[68] The handling of the heads within compositions, like a row of beads on the large Sèvres urns and a macabre string beneath the entablature of the *Gates,* seems partly medieval in origin.

Rodin added to the tracing and cut-out methods a mesmerizingly intense use of directional light, texture and colour. Introducing a strong directional beam to highlight broad planes and organize the rhythms between masses was a well-known device, perpetuated by followers of Poussin and by Géricault in his

74 *Spandrel*, Musée Rodin (cat. no. 53).

72 (facing page bottom left) *Mask of Minos*, Musée Rodin (cat. no. 54).

73 (facing page bottom right) *Masque tragique*, Szépmüvészeti Muzeum, Budapest (cat. no. 55).

75 *La luxure*, Goupil Album, pl.12.

76 *Study for a circle of lovers*, Goupil Album, pl.8.

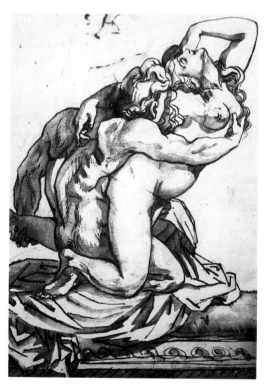

77 Théodore Géricault, *The Wounded Cuirasseur*, Musée du Louvre.

violent black and white drawings of *c*.1819, as well as by decorators skilled in the use of glazes and patinas to exaggerate volume. In many gouaches the bands of dark and light wash create a flickering look that effects movement from one drawing to another. Comparing now scattered drawings we recognize the same characters, for instance the girl with left leg kicked back who is carried away by an abductor on a Sèvres design and reappears in the arms of a man in *Study for a circle of lovers*. The dryness of Rodin's ochre, blue-grey and white-lead palette suggests weathered frescoes or stone, transparent and opaque coatings mixed, and moving forms under candlelight. The overlaid pen lines literally bite into the water-softened paper and increase the sensation of fervent attack appropriate to the nocturnal—crypt-like or celestial—settings and the themes of rape, murder and illicit couplings. These drawings take more from Dante than just the episodes tentatively suggested by scholars: they use the sensory immediacy of Dante's language. We can see the frozen waste surrounding the sinners where 'the grief which finds the ice blocking their eyes turns inwards to increase their anguish. For the first tears form a coagulation, and in the manner of a crystal mask, fill all the cavity beneath the eyebrows.'[69]

Individual works on paper from this period deserve to be better known for they equal in quality and originality Rodin's sculpture. For example, the study of one man supporting another, *Ugolino/Icarus* (D1993), reworked with gouache as *Ecoinçon* (*Spandrel*), comes out of the archetypal muscular profile, but now the struggling bodies are solidified by the luminous wash. The original drawing of *Ecoinçon* was glued onto a larger sheet, visually adhered by the trail of six quick strokes across the boundary. The intensity and abandon is unique. Another outstanding gouache, the *Centaur carrying away two women*, achieves a potent sensation of three dimensions within a tiny rectangle. The face of the centaur shows monstrous deformations but the conspiracy between him and his captives is perhaps loving. The clutch of drawings which formerly belonged to a friend of Rodin's from the period, Henri Liouville, and were acquired by the Musée

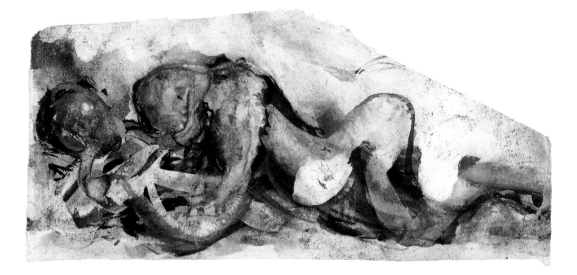

Rodin only in 1984, deals with the theme of embracing figures, themselves often slightly reptilian, equine or tumescent, and thus dehumanized but enacting in a slow-moving fashion encounters and death struggles painfully heart-wrenching.

Rodin's sculpture had quickly found a path of its own when he began modelling directly from unposed living models, especially lean young men and women whose thin layer of flesh over bones was an impetus in itself to risk more than the generalized, smoothed limbs and featureless heads of the gouaches. Making sculpture with the resources to cast instantly and work many pieces at a time deflected Rodin's need to draw and changed his two-dimensional aesthetic. Indeed on paper he became less surprising for a time. By November 1883, in order to 'frustrate the deformity and obnoxious operations of the photographic camera', he was prepared to oblige Louis Gonse, the editor of *La Gazette des Beaux-Arts,* who wanted to illustrate the *Age of Bronze* with an engraving-like, cold rendering, made from a photograph-inspired substitute. It consisted of hatched interior and tight perimeter line—fascinating in its own way, but conservative.[70] The freedom and other-worldliness of the previous beautiful India ink, sepia and gouache 'black' drawings had come to an end.

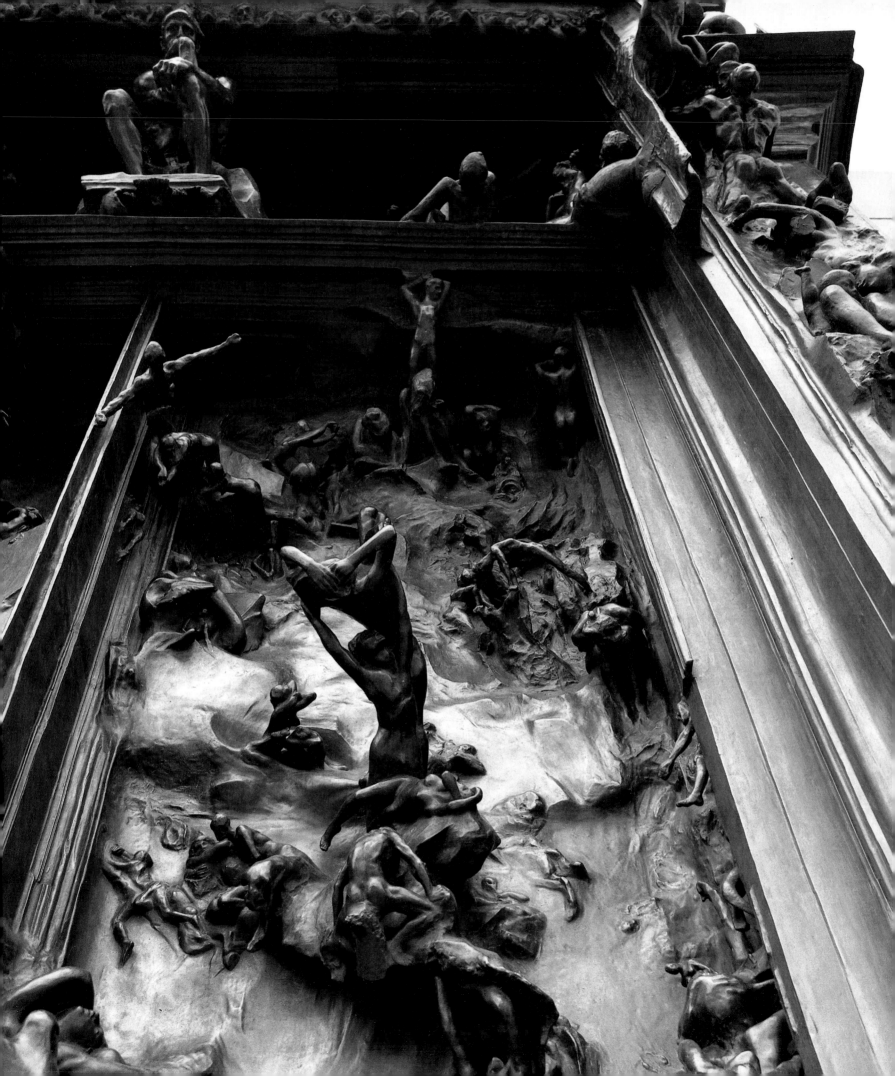

The *Gates of Hell*

SOON AFTER Rodin learned in the early spring of 1880 that he was being considered for a major commission for a monumental door for the planned Museum of Decorative Arts he made two decisions about what he would do if asked. The first, that he would 'accept' Dante's *Inferno* as the theme and the second, that the low relief would be comprised of dozens of small figures.[1] These choices were intended to guarantee that the portal would be a manageable project, one that would demonstrate Rodin's skills as a modeller and an interpreter of the afflictions of modern society and thus, an exemplary monument that would establish his deserved and overdue reputation as a creative sculptor of consequence. Ideas laden with divergent and innovative possibilities were linked in such a way that in a matter of months what was originally to be executed as a demonstration of his capabilities as a traditional sculptor became something just the opposite. The *Gates of Hell* ended up as a field of restless bodies whose narrative function and postures are nearly impossible to distinguish, much less read as an entirety. Seen from the ground the work, 7.5 metres high, is completely different from photographs of details or from the rectangle face-on.[2] The plaster that Rodin lived with for thirty-five years has a sensibility altogether more dream-like than the bronze versions cast posthumously. Furthermore the three-dimensional elements extracted from the agitated milieu of the relief frequently seem, when isolated, to be becalmed and exquisite.

It is not hard for modern viewers to gain a sense of the artist's absolutely helpless self-identification with its entire contents. Every group has its own poetic message, but exists also as an island worked intuitively and structurally into the material fabric of the whole. The spontaneity and confessional quality, as if a visual soliloquy, survive. The *Gates of Hell* could be called the greatest nineteenth-century public sculpture, but it was equally Rodin's private laboratory and library. Its disorienting structure, devoid of registers and thus of a readable hierarchy, let alone of naturalistic settings, manages to be true to the chaotic but uncontrollable course of human passion.

Of the many factors which led the then forty-year-old Rodin to invent his own standards and own territory, two especially concern this study. One is the influence of the compositional and tonal problems of painting. Many of these problems had already been pursued on scraps of paper in the years immediately before and after 1880; others were absorbed and carried in Rodin's head, specifically his fascination with Michelangelo's *Last Judgment* and with the recent historical paintings of David, Géricault and Delacroix. Accompanying his desire to rival painters was another experience which resulted in an even more unsettling drive. With resources from the commission Rodin was able to hire numerous models, particularly women, and scrutinize them at will. Poses that not only were descriptive of the models' uninhibited movements, but could be expanded upon as metaphors for the creative process were captured in clay. The equation between nudity and the pure, innocent primal state was a point which had been made by many artists during the nineteenth century, usually with relatively bland references to Eve or to the time-honoured mythological figures

80 *Eve and the serpent*, Szépmüvészeti Muzeum, Budapest (cat. no. 6).

79 Right panel, the *Gates of Hell*.

43

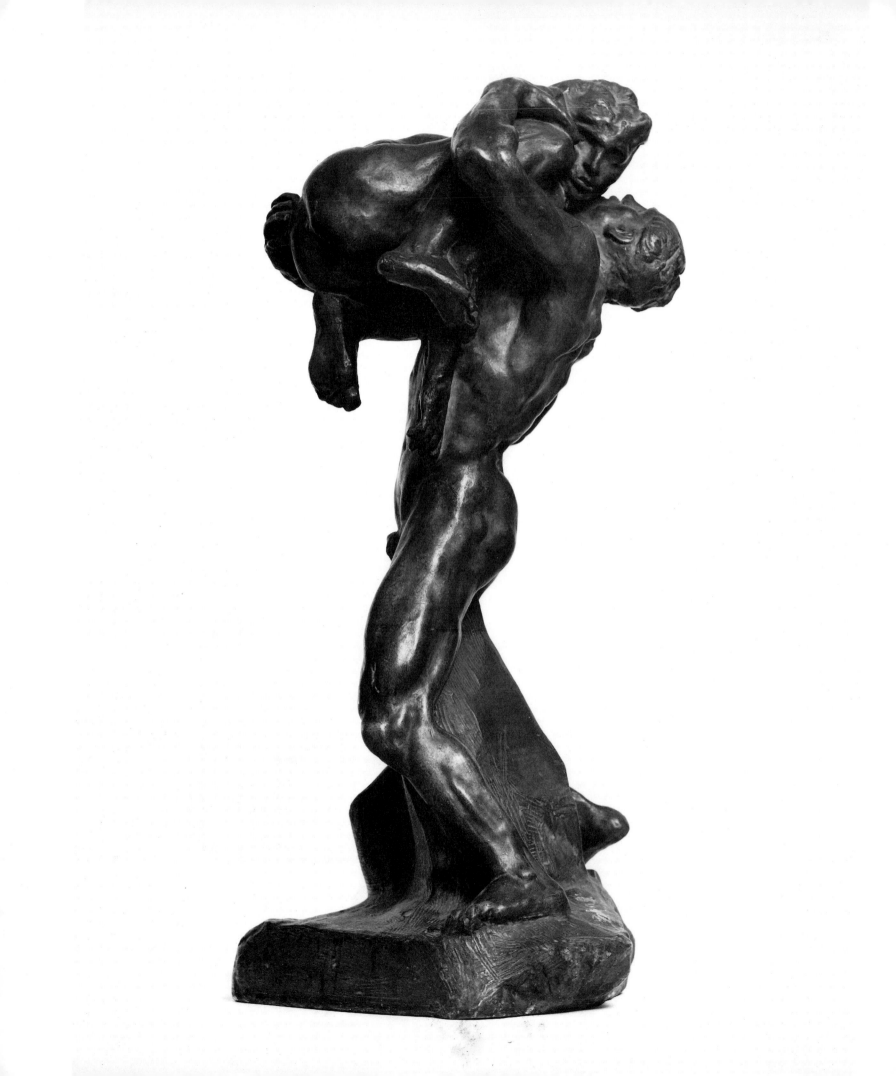

of Diana, Venus, etc.[3] Rodin, however, began not only to dispense with the conventional attributes but to seek to catch his model in positions normally not disclosed to strangers (nor indeed to marital partners). By concentrating on just those aspects which brought out the relationship between soft clay, sexual awareness and the artist's impulse to make something unprecedented, he initiated practices which developed into a quest pursued with almost scientific zeal for the rest of his life: that of looking at the human species and attempting to turn it inside out to expose its inner mechanisms and its reproductive urge without loosing a sense of the spirit and dignity of mankind.

The history of the *Gates* in the first period, 1880–83, though hardly pin-pointed with chronological exactitude, is well enough documented by the undated surviving sketches, maquettes and verbal descriptions to show that it was not long before Rodin's imagination overwhelmed his caution. It is perhaps revealing that in trying to describe the transition from traditional to radical means, the foremost expert on the *Gates,* Albert Elsen, has found it necessary to speak in turn about its various elements—the Dante drawings, the architectural genesis, the method and the work as seen through the eyes of the contemporary commentators. This breakdown is not surprising because the *Gates of Hell* as a work of art is so unwieldy, unfinished and profoundly autobiographical that it defies other people's attempts to provide a neat epilogue. Ironically, the most controversial aspect, the composition, began with Rodin's carefully respecting the time-honoured architectural and decorative format of a grid with picture-window inserts and decorative banding. Double doors were imagined, divided horizontally in four, producing eight panels, or, with the addition of side pilasters, as many as sixteen. The first drawings on ruled paper looked back to Ghiberti's fifteenth-century doors on the cathedral baptistry in Florence, borrowing the way the scenes of paradise were contained within a hierarchy of static zones. The thought of including a vine motif, which, running along the struts, would soften the grid and lift the eye upwards, was perhaps an idea remembered from the cathedral at Orvieto.[4] Interior sections might be compressed in the manner of friezes on antique sarcophagi or of niches within medieval facades.

Rodin knew his audience would be conversant with *The Divine Comedy* and able to comprehend from iconographic clues both episodes and their relevance to contemporary life. The problem was that when Rodin thought of the cantos he thought not of generalized lessons of sin and damnation but of the character of the individual protagonists and the grittiness and tenderness of Dante's imagery. He had read again and again the translation by Rivarol, and knew from memory the combinations of words which triggered flashing visions of the poignant exchanges between Dante and Virgil and the spectacle of what they witnessed.[5] Many plastic equivalents had already been sketched in a cryptic fashion in clay and on paper and Rodin had become accustomed to disjunctive thinking, to using evocative units which were more like poetry than like the coded synthesis of a Renaissance narrative language. Annotations had already entered his drawings as if they were incantations, many suggesting analogies or alternatives such as 'écoinçon' (spandrel) with its architectural connotation, and 'the tomb' for an adaptation of the abduction theme to a horizontal format.

At the first meeting between Rodin and Edmond Turquet, his enthusiastic and bold advocate at the Ministry of Fine Arts, in July 1880, just prior to the official decree charging him with the portal, Rodin explained his ideas for the *Gates*. Or rather, he confessed that he wanted to illustrate the 'moving details' of Dante's

81 *Je suis belle*, Ateneumin Taidemuseo, Helsinki (cat. no. 72).

82 Architectural sketch for the *Gates*, Musée Rodin.

poem and for that anticipated making and assembling 'hundreds' of statues.[6] This was a formidable ambition but not a fanciful one. Mention of hundreds of statues carried the implication of more complicated and numerous castings than the allocated fee would cover. Nevertheless, as Rodin recalled many years later, Turquet listened to what must have seemed the impractical dream of an inexperienced monument-maker and by his silence tacitly agreed to let Rodin proceed as he wished.[7] With the commission Rodin was allocated one of the State's studios at the Dépôt des Marbres (eventually he occupied two). These were high-ceilinged, purpose-built premises situated around a large courtyard located off the rue de l'Université at the end nearest the Eiffel Tower. Moving first to studio 'M' in July 1880, after twenty years' labouring in cramped premises, within months Rodin was working at an extravagant pace and on a monumental scale.[8]

After a year the portal had became what it remains today, two distinct entities: the upright and vertiginous bas-relief with sunken and projecting subjects, all of a miniature scale, and the detached, often highly finished statues. The rough wooden scaffolding which represented the intended bronze framework was constructed by a carpenter called Guichard, and, judging from his invoice, apparently in place as early as January 1881.[9] It was on the scale of the projected doors, probably the size of 4.5 by 3.5 metres mentioned by Rodin in a letter to the government of 20 October 1881.[10] The towering frame which stood in the studio, virtually unadorned, for the first years consisted of horizontal planks recessed in a box-like structure and crossed by a vertical beam representing the central opening. Three-quarters of the way up came another beam to indicate the lintel, above which was the box-like tympanum. Along the outer edges were planks to represent the side pilasters (or external bas-reliefs as they are sometimes called). It is possible that clay was applied directly to the planks and casts taken to initiate the background texture. Gradually, as the fragile sculptures in the round were completed, they were inserted into plaster backgrounds or, as the official inspector Roger Ballu put it, assimilated 'into an ensemble which he arranges in the groups laid out on the panels of the door'.[11] Rodin probably began with the rectangular stretches of the pilasters, then concentrated on the deep tympanum with figures in the round and lastly resolved the central panels.

By 1885 large areas existed in the form we know today but it was not until a continuous plaster with stepped mouldings was hastily prepared for Rodin's retrospective exhibition of 1900 that the general public could begin to estimate the doors as an architectural or decorative reality. Even then, important groups in high relief were missing, 'indicated only by numbers scrawled in pencil on the white surface'.[12] After 1900 Rodin made minor changes and in 1917, the year he died, the pieces standing around in Meudon were assembled under the supervision of the first director of the Musée Rodin, Léoncé Bénédite. Five bronze versions were cast posthumously, the first two in 1928 and the last in 1981; the original plaster was claimed by the State by right of the original commission and is now part of the collection of the Musée d'Orsay.[13]

While the small figures were being made they conformed to ordinary gravity-bound space; thus the up-ending, sawing-off of parts, tilting or submerging was improvised, rather than planned—a process which began in Rodin's hand and then, with finesse, was continued when he tried the works within their settings which, in turn, became appropriately elaborate and mysterious. Rodin shied away from groups that had to be cast in blocks and read from a ground line, preferring one- or two-figure units which could be reoriented in minutes.

83 *Buoso and snake*, Musée Rodin (cat. no. 49).

84 *Eternal Springtime* in clay in front of the scaffolding for the *Gates*, c.1881, Musée Rodin.

85 The *Gates of Hell*, *c*.1887, photograph from the collection of the grandson of Jessie Lipscomb.

86 The *Gates of Hell*, *c*.1887, photograph from the collection of the grandson of Jessie Lipscomb.

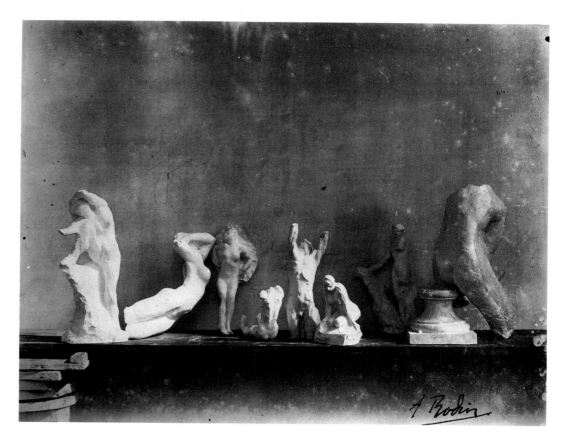

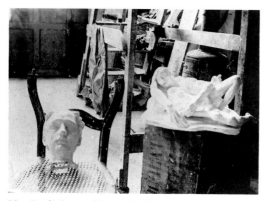

87 Shelf of plasters including *Torso of Adèle,* collection of Harry Spiro (cat. no. 270).

90 (facing page) Lower right panel of the *Gates* with *Avarice and Lust.*

88 *Avarice and Lust,* 1880–82, photograph by E. Druet, after 1896 (cat. no. 259).

89 Rodin's studio with *Avarice and Lust* and a *Head of Camille Claudel, c.*1887, collection of the grandson of Jessie Lipscomb.

Described in books and in museums as 'studies' for the *Gates,* many are not properly that. Often their scale and finish are actual. They range from the scarcely visible nymphs and masks tucked around the entablature to the 70 cm, free-standing *Thinker* conceived to sit at the centre of the tympanum. A number of groups intended for the *Gates,* the most famous being *The Kiss,* were not incorporated in the final version. Sometimes sculptures referred to as studies are actually enlargements of the original elements which were made for exhibition in the Salon or for clients or to incorporate in unrelated sculptures. For example, *Meditation* appears close to its original size on the *Gates.* The arms were raised in one version and in another amputated; it was enlarged to 106 cm and then 158 cm, and exhibited as a single figure, often called *The Inner Voice.* It took on an allegorical role as a literary muse in the *Monument to Victor Hugo* and appeared in composite groups conceived at the end of the 1880s such as the very private piece *Christ and Mary Magdalene,* or the female couple, idiosyncratically entitled *Constellation.*

Accompanying the clay figures in the studio were hundreds of negative and positive plaster casts. Some were the precious master *moulage à bon creux* (negative piece-moulds) from which a limited number of high quality bronze editions could be made. Many more were merely the results of either the routine castings of Rodin's work in progress or his own amputations and amalgams of limbs and bodies. Stacked on the shelves, on the floor or simply 'scattered pell-mell', they presented a 'vista as of some phantasmagoric cemetery, peopled by a mute yet eloquent crowd, each unit of which we feel impelled to examine'.[14] Visitors felt they had left the familiar realm of one-off allegorical statues and had come to a space where the terms of reference were of a new order. When Roger Ballu was sent in June 1882 to assess and report on Rodin's progress he had difficulty deciding from the panels, independent figures and sketches what was happening and ended up confessing in his perceptive report:

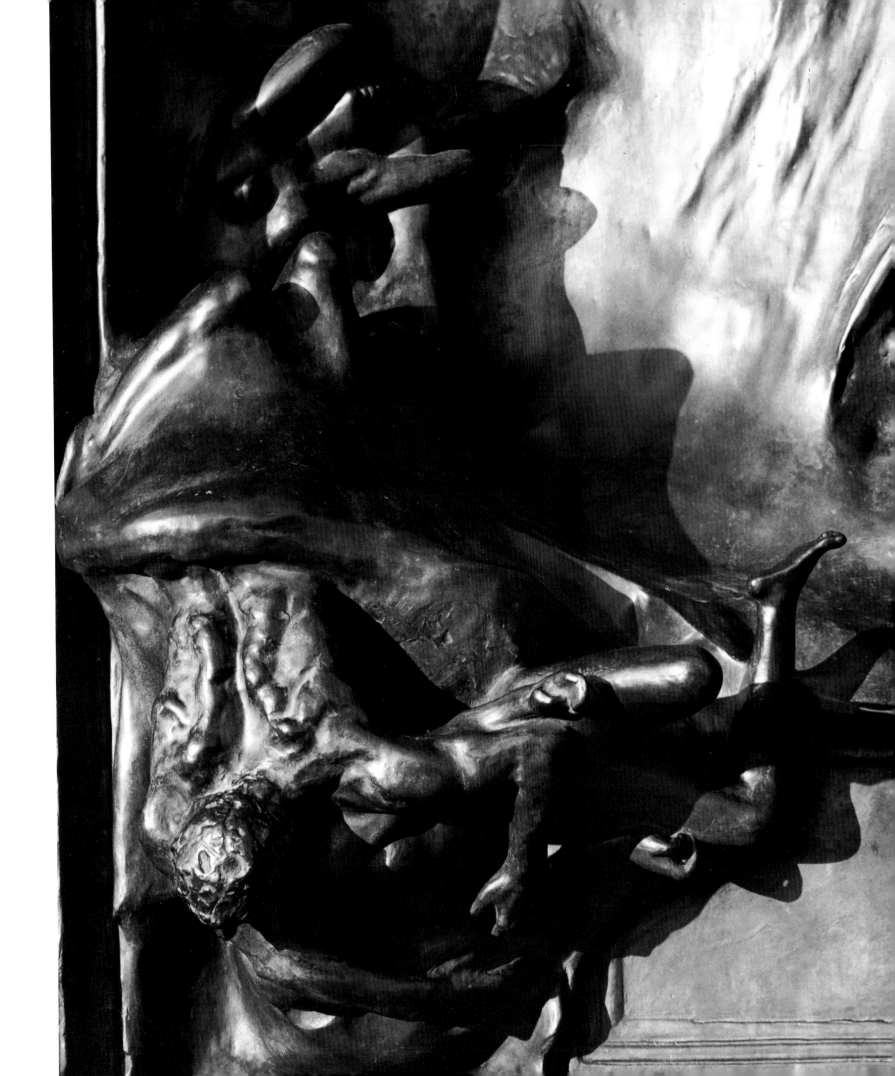

91 *The Thinker* in clay positioned on the scaffolding for the *Gates*, 1881, Musée Rodin.

I cannot anticipate the effect that these compositions, all done in high relief, will have on the great portal as a whole . . . this notwithstanding, Mr Rodin's work is extremely interesting. This young sculptor reveals a really astonishing originality and power of expression with overtones of anguish.[15]

Only *The Thinker* seems to have stayed for long in its commanding position, perched on the crude shelf above a blank expanse, his downcast distracted gaze curiously evokes both the 'cursed lovers who entwine forever' in the flux below and the nothingness of Purgatory with its never-ending torture and depravity.[16] This seated man is not only a descendant of the constricted seated figures of the *écorché* studies but an alter-ego presiding imaginatively and almost as a mascot over the construction of the *Gates*. Albert Elsen has argued convincingly that Rodin's identification with the seated, meditating figure was singular and obsessive, continuing until an enlargement was situated outside the Panthéon in 1906 and by his direction placed over Rose's grave (later their joint one) at Meudon.[17] In a sense *The Thinker*, probably in its present form by late 1880, epitomized Rodin's identification with the anonymous hero and the great epic histories of Western civilization, and thus with Dante, Ovid and the Bible. Mirbeau who knew Rodin well described its meaning: '*The Thinker* in his austere nudity, in his pensive force, is at the same time a wild Adam, implacable Dante, and merciful Virgil . . . but he is above all The Ancestor, the first man, naive and without conscience, bending over that which he will engender.'[18]

We gather from Rodin's correspondence and the accounts of journalists that, despite the confusing jumble of the studio with its modelling stands and heaps of plasters, visitors caught a sense of Rodin's intoxication with his own creation and soon spoke themselves of 'the doors' as a living entity and a masterpiece in progress. By the spring of 1882 Rodin's friend from the Petite Ecole, Alphonse Legros, now a professor and artist living in London, was telling his friends 'wonderful things about the door'.[19] William Henley, the editor of the English *Magazine of Art*, longed to see these drawings and in his letters, entreated Rodin to send photographs or sketches of his *chef d'œuvre* to publish in the June issue. In October he was still pressing Rodin for visual material: 'would you entrust me with the sketches of the door and of "the thinker" which you mentioned in your letter'.[20] Cosmo Monkhouse in 1884 began asking Rodin for photographs or a description of the door for *Portfolio* with the same persistence and the same negative results.[21] Rodin did not seem to mind verbal descriptions appearing, and memorable ones were written by Octave Mirbeau, Félicien Champsaur and Gustave Geffroy in 1885–86. Eventually, by 1887, lithographs of the central portion of the tympanum with *The Thinker* and the *Three Shades* were made, one published in *L'Art Français* in 1888 and another accompanying Truman Bartlett's articles in the *American Architect and Building News* in 1889. What we gather from Rodin's reluctance to have his work photographed or shown in plan, is not that he could not make up his mind about details, nor that his attention turned elsewhere after 1884 (though both contentions have some truth) but that the *Gates of Hell* was a metaphysical presence in the rue de l'Université. Rodin sensed, quite rightly, that it would be demeaned by the limiting, distorting vision of the camera lens as it would be by the neutral medium of a line drawing or depicted from any fixed vantage point.

Between late 1880 and early 1881 both the rudimentary drawings in pencil and ink of the portal in perspective and the more finicky studies in ink, wash and white gouache of the rectangle alone started to show Rodin's impatience with the

92 (facing page) *The Three Shades* (cat. no.75).

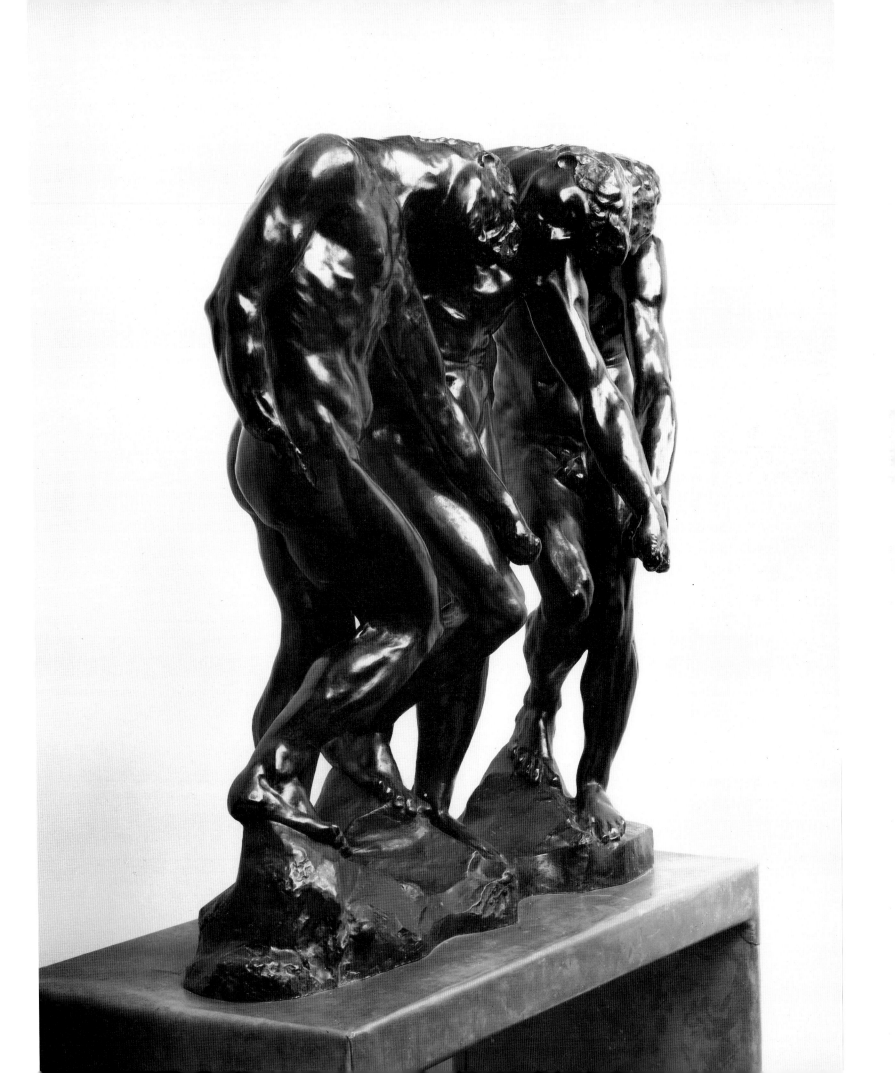

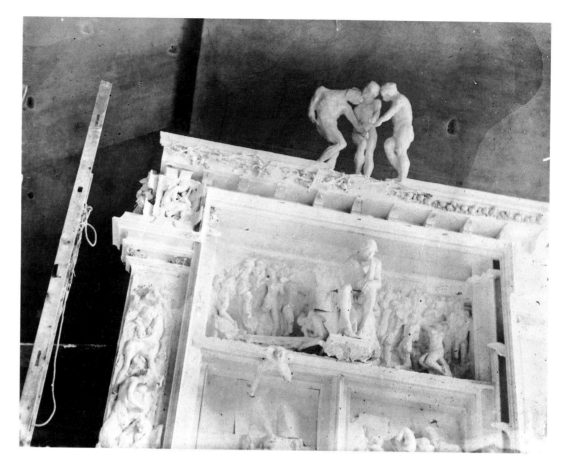

93 The *Gates of Hell*, *c*.1887 with the *Three Shades*, photograph from the collection of the grandson of Jessie Lipscomb.

94 Sketch for the *Gates* from notebook 48, p.50, 1880, Musée Rodin.

95 Sketch for the *Gates* from a notebook indicating *Adam* and *Eve* and *The Thinker*, 1880, Musée Rodin.

window-pane approach. He began augmenting the bulk of the central divide and the lintel by tonal modelling in the architectural sketches and allowing the quick ink notations to treat the intersection of the vertical and horizontal axes somewhat like that of a cross. In the next stage the frontality of the grid and the inert Renaissance-style banding was complicated. The notebook sketch with scrawls representing three statues introduced a pyramidal format: on the ground stood *Adam* and *Eve* (abandoned in later versions); lodged in the central panels were the principal subjects from Dante—Paolo and Francesca on the left and Ugolino on the right; and at the apex *The Thinker*.[22] Once the tympanum was crowned by the *Three Shades* standing clear of the block, there existed and remained, overall, an elaborate but scintillating *croix de Lorraine* effect.

Meanwhile Rodin pursued a parallel research process, the making of terracotta architectural maquettes. Crude in manual terms, indeed made by the thumb with pats of clay, they seem to have been useful in predicting the emotive consequences of different structural approaches. In the third and final terracotta model, itself just over one metre high, Rodin increased the depth of the pediment so that when translated to the actual dimensions the principal groups would sit just above eye-level. To shadow *The Thinker* he considered an overhanging porch punctuated by three blocks, perhaps appropriated from Renaissance keystones. The interior was to be further encompassed by robust side pilasters studded along their length with large twisting figures. The result would be to suck the visitor into the space. He would be confronted by a heavy portal with horizontal tiers: at the lowest level, embracing figures; higher up, crowd scenes with a medieval density; and along the sides, niches.

Although in the maquettes the figural inserts were obscurely fashioned, in their creator's mind's eye they exemplified the need for a wholehearted synthesis

of emotional fervour and spatial dynamics. Rodin seems to have begun secretly hoping to rival the experience of Gothic cathedrals where the pilgrim leaves behind earthly concerns and, by circumnavigating the structure and entering the portal, prepares to receive religious instruction and to meditate in solitude. Drawing in pencil on a photograph of his final maquette Rodin extended the porch, thus turning it into a ceiling and giving the whole such depth and majesty that even as a piece of architecture it was destined to be inappropriate in its intended place on the exterior of a secular, stylish, new Museum of Decorative Arts.[23] Moreover, the two principal representations of the consequences of unbridled passion, one innocent (Paolo and Francesca) and one dehumanized by another's evil (Ugolino and his sons), though thematically commonplace at the time as metaphors for the fate of those who transgressed society's norms, after being stripped naked and twisted together were far too erotically charged to pass the criteria of Third Republic taste. The Salon and the Ecole had been long satisfied with sanitized visions of romance and tragedy, and in relation to *The Divine Comedy* preferred an interpretation that provided a cautionary reminder of a more barbaric time. If anything, Rodin's approach was an anachronistic one, a medieval revival, where the viewer's nerves were stimulated to the point of vicarious participation in nightmarish scenes too unbridled and disorienting to ignore. The impulse which had made Rodin in 1860 remove the draperies from the protagonists in his pencil-and-ink copy of Pilon's *Entombment* and expose their agony was continuing in the face of the Realism prevalent in the late nineteenth century.

While the maquettes were in the forefront of Rodin's search for an appropriate geometry, structure and overall ambiance, it might have been expected that the more elaborate of the two kinds of sketches, the gouaches, would be used to advance his ideas for the contents of the individual recesses. This he attempted. Working in a notebook dated to 1881 by the sketches of Auxerre (where he very

96 The third architectural maquette for the *Gates*, 1880–81, Musée Rodin.

97 Sketch for the *Gates* with separate relief panels, 1880, Musée Rodin, D1969.

98 *Adoration* with sketch of the *Gates* in corner, Fogg Art Museum.

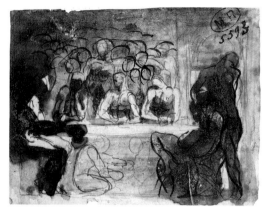

99 *Minos*, Musée Rodin, D5593.

likely went that summer), he concentrated on extracting eight scenes from *The Inferno*. Within the pockets of the tonal architectural drawings made on ruled paper and scribbled on individual sheets were indications of the heated dramas he thought of including. However, as we might imagine, by 1880 Rodin was unable to conform to the conventions of presentation drawings which valued legibility above feeling. In his excitement he reverted to the cursory style with loopy script and dark touches until each panel began looking much like another. The central protagonist and supporting players were surrounded by a ring of male spectators; in fact in organization the compositions mimicked the format of traditional 'judgments' or 'depositions', especially those known to Rodin from carvings and paintings in the Louvre and through his travels, while attempting to describe Minos' banishment and Ugolino's revenge on Archbishop Ruggieri.[24] When Rodin tried to transfer these scenes, of course only notionally, to clay for the maquettes, he realised that they were altogether too fussy, and would be for the spectator too remote. Faced with this 'dilemma' Rodin seems to have let the bias of his advanced 'imaginary' gouache-and-ink drawings take the lead. Narrative groups were abandoned, backgrounds cut away and replaced with simple figural units, icons that could be comprehended instinctively and universally.

Twenty years later, speaking to the journalist Serge Basset, Rodin recalled this period:

> I lived a whole year with Dante—living only with him, and drawing the eight circles of his Hell . . . At the end of the year, I saw that while my drawings rendered my vision of Dante, they were not close enough to reality. And I began all over again, after nature, working with my models . . . I had abandoned my drawings.[25]

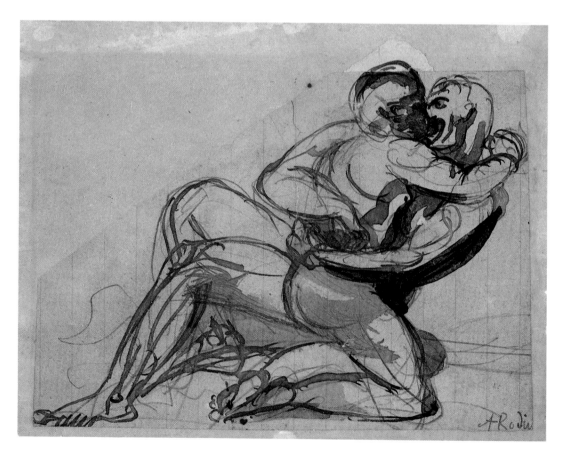

100 *Two figures wrestling back to back*, Musée Rodin (cat. no. 98).

101 *Man struggling with a woman*, Ny Carlsberg Glyptotek, Copenhagen (cat. no. 104).

102 *Love turning the world*, 1881, Victoria and Albert Museum (cat. no. 57).

103 *Figure studies*, 1881, Victoria and Albert Museum (cat. no. 58).

This statement, which accurately records Rodin's dissatisfaction with the very drawings of the eight circles mentioned above, has been mistakenly assumed to mean Rodin actually abandoned drawing wholesale after a year and thereafter devoted himself to working directly from the moving model. Both contentions are wrong, indeed illogical. The first, for example, made unlikely by Rodin's letter to Gauchez in 1883 and by the drawings in *L'Art,* the second contradicted by observers of the mid–1880s such as Gustave Natorp who recalled Rodin as always drawing.[26] He never considered the possibility of abandoning drawing; it was his primary means of recalling an image, an essential part of the process he endorsed of working 'by trial and error, trying things out'.[27] Moreover, the drawings were his companions and way of establishing his identity. For example, in the late summer of 1881 he went to London to visit Alphonse Legros, who was known for his etchings, and with his help Rodin made two prints (and subsequently, three more). In an early one, *Love turning the world,* cherubs rotate a large globe. They are thematically straight from the stock of putti sketches, but characteristically reveal Rodin's desire to examine movement free from ordinary gravity and logic. The drypoint *Figure studies* (1881) was obviously made to test the action of the needle on copper: only one proof was taken before the plate was cancelled. Distinguishable among the faint, overlapping contours are a fearsome Shade with open mouth and two standing figures— the male in profile and the female seen from the back—who have the pagan, sleep-walking manner of the sequences on vases such as *Le Jour* and *La Nuit,* and the arched back of the *Falling Man.* Two drypoints in the next set, *Bellona,* from the allegorical bust of 1879, and *Springtime,* from the black chalk drawings, were equally retrospective, giving the correct impression that Rodin travelled with his creations as companions.

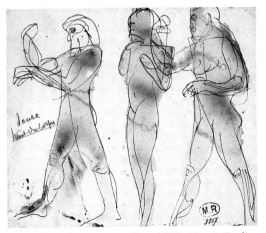

104 *Three dancers in profile, c.*1883, Musée Rodin, D3557 (possibly drawn in the British Museum).

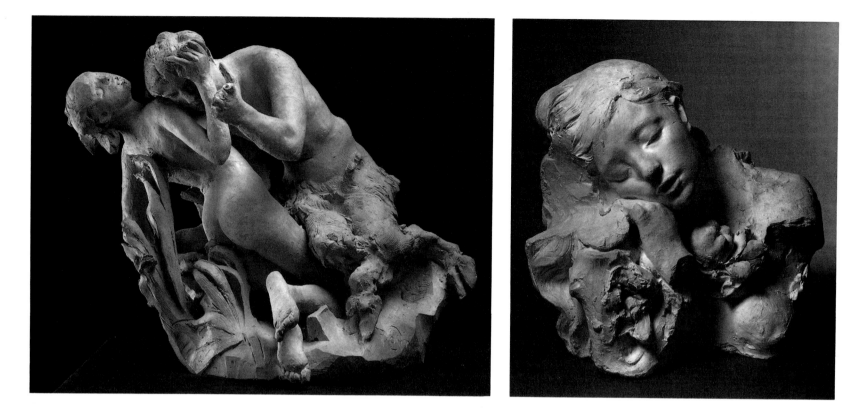

105 *Faun and Nymph*, Musée Rodin (cat. no. 16).

106 *Sleep*, Musée Rodin (cat. no. 15).

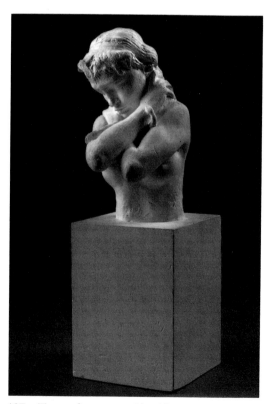

107 *Torso of a young girl with a serpent*, Musée Rodin (cat. no. 17).

The real issue was not the priority of drawing versus sculpture, nor of working from the imagination rather than from life; these were unavoidable conditions. The real issue was whether Rodin would continue to abide by the refined rococo niceties of the eighteenth-century revival. Or whether he would release the sensual potential of the undulating forms of Bacchanalian lovers perfected at Sèvres and the tense but riveting word-pictures of Dante and Baudelaire using them as the excuse for an investigation of sexuality *per se*. Typically he did not reject the light-hearted mode but started working on several levels. He continued to produce drawing-room sculptures—very beautiful ones in the period 1880–85, some surviving today as terracottas. In the charming *Faun and Nymph* he placed a fluttering covering over the lower halves of the couple and kept a respectable distance between their sinuous forms. On the tender, unfamiliar bust *Sleep* the girl's apple-like breasts are adorned by an approximation of flowers and fruit. A study for *Eve* called *Torso of young girl with a serpent* depends on the snake to interpret her shame and excuse our contemplation of the shy, nubile girl. The unremarkable combination of folded arms and half-glimpsed softness turns out to be an amazingly subtle idea of a structural cage and interior curves. *Eternal Springtime* takes Adèle's torso, adds the remainder, and combines her with an effeminate male figure hovering on one knee. In the bronze the latter's outreaching arm is supported by an ornate column, the overall impression definitely meant to be lyrical and engaging.

Rodin might have become a master of these slightly *risqué* terracottas in which grace and verisimilitude outweigh a sculptural idea. They might have been his alternative, saleable line, a contrast to the heroic statues of athletic men. The impulse to go outside this pattern came, paradoxically, when he pretended to submit to what was before his eyes. His natural instinct to move physically close to bodies to sense their mass and heat and compensate for his myopic focus began to influence what he chose to investigate and how he responded to the pliable clay. The change, which amounted to a conversion, is evident between

56

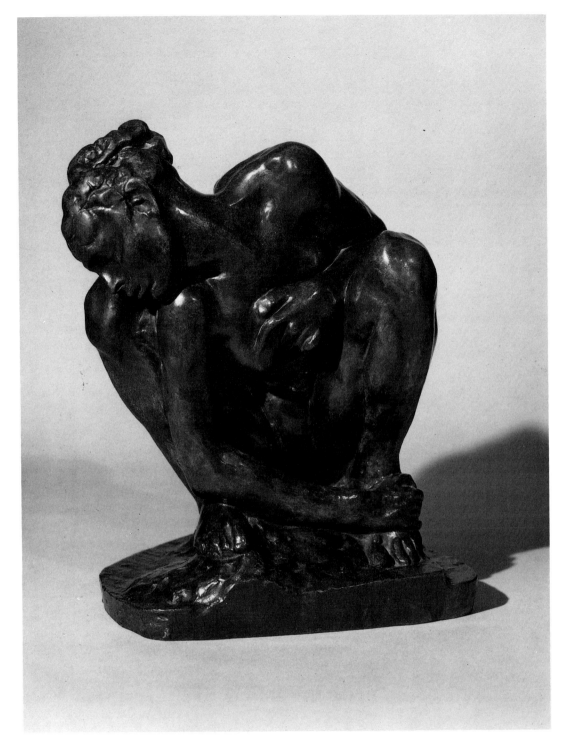

the *Fallen Caryatid with Stone,* exhibited in 1883 and probably made in 1880, and the *Crouching Woman* of 1880–82. Supple as the first girl is, Rodin's interest in a 'fallen caryatid' conforms to the general principles of Carpeaux, updated by Jules Dalou, Alfred Stevens and other contemporaries who imposed the metaphor for eternal suffering on the appealing vision of a woman on bended knee, helpless and fundamentally simple, and thus to be pitied.

The *Crouching Woman* has no parallel. Like Pignatelli stepping up to pose for *St John,* the girl Adèle was 'discovered' on her haunches as if a tribal woman, uncontaminated by a conventional sense of propriety but not necessarily virginal. Rodin may have been tempted for years to place a model in the pose of

109 and 110 (following pages) *Crouching Woman,* 1880–82, (enlargement), The Josefowitz Collection (cat. no. 105).

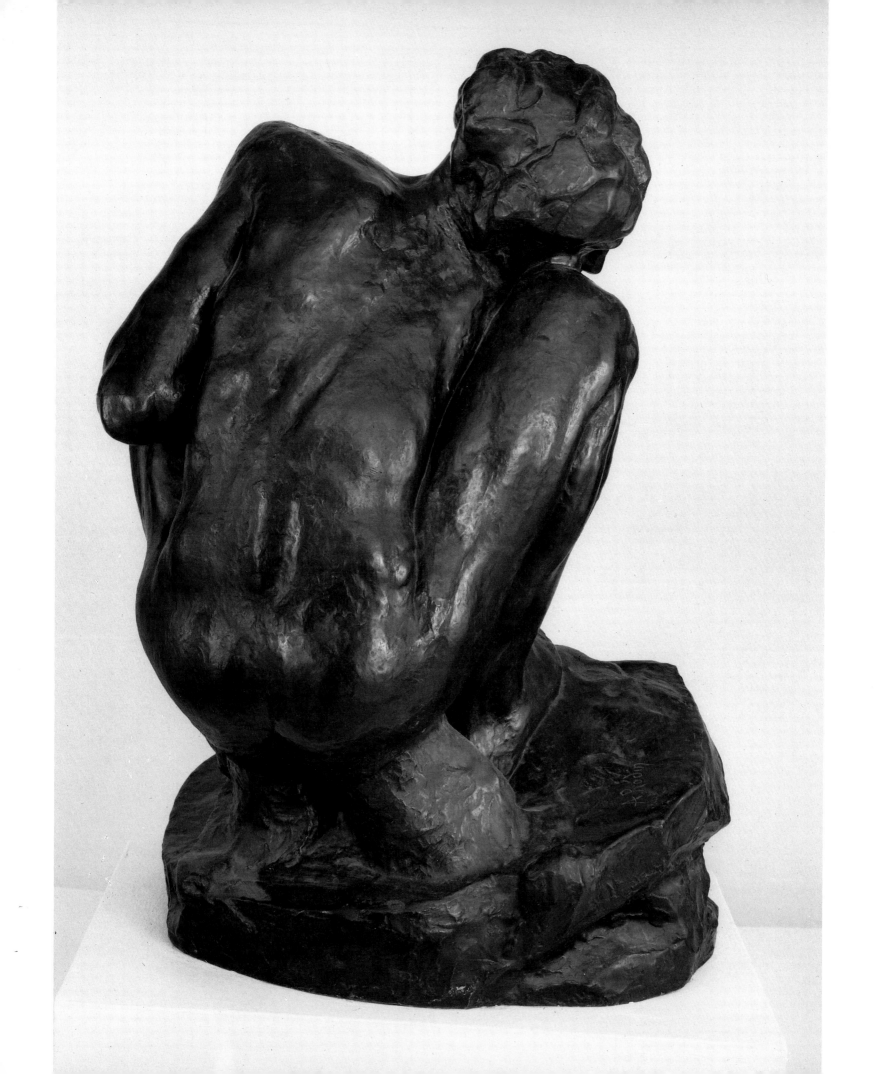

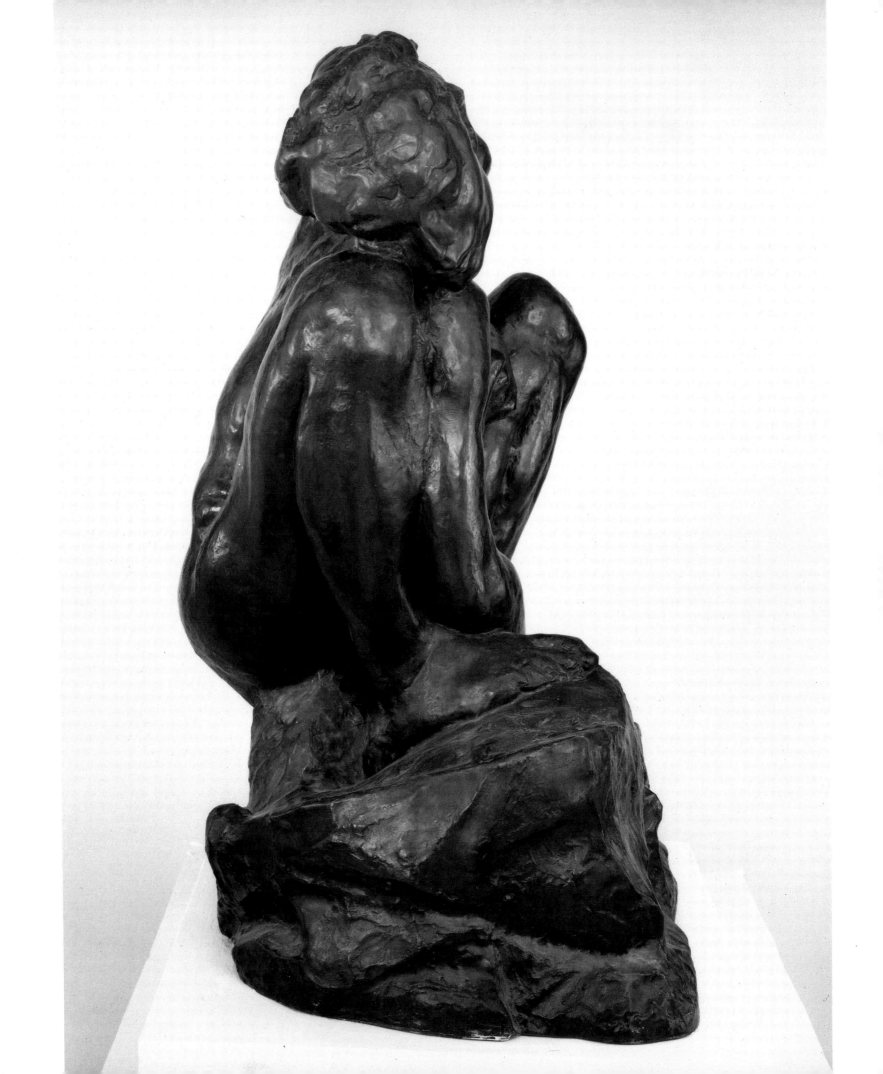

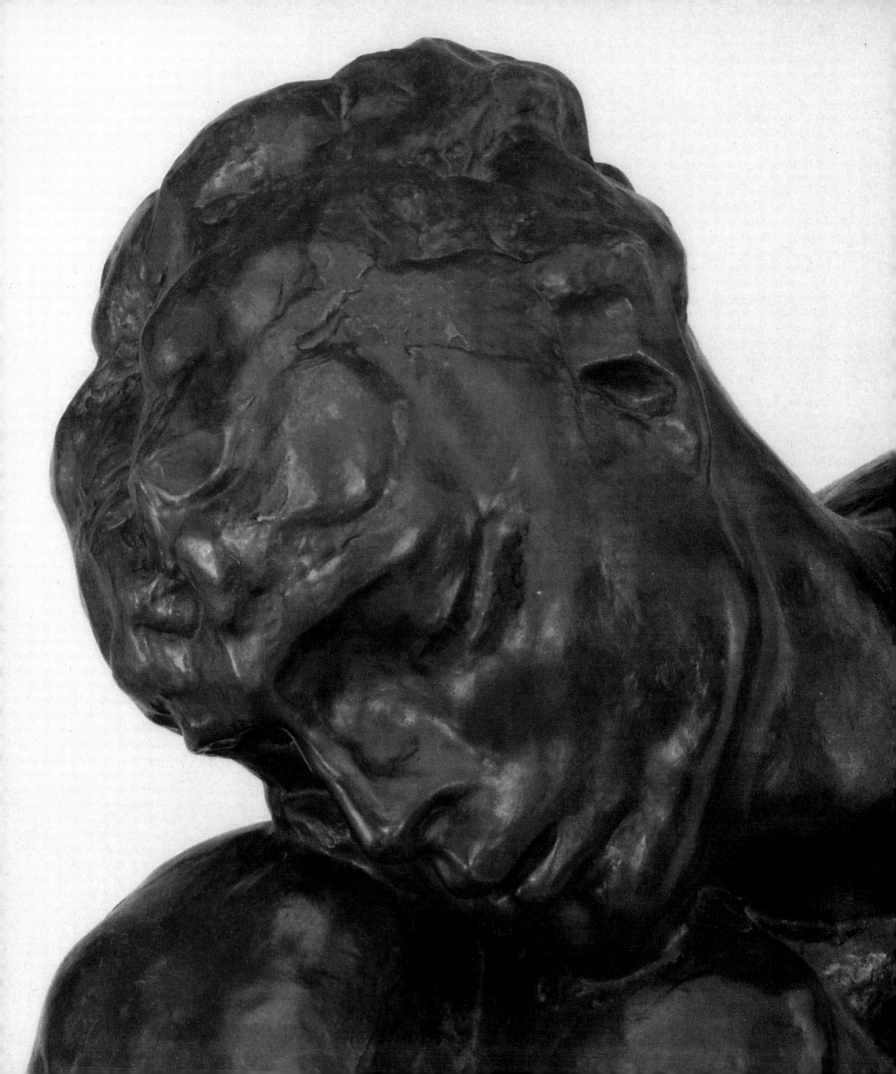

Michelangelo's *Crouching Youth* (in Leningrad) or the *Cupid* (also known as *Narcissus*), misattributed to him at the time and now assigned to Cilio. On a visit to London Rodin may have seen the Cilio sculpture at the Victoria and Albert Museum where it had been since 1866.[28] Adolescent boys could be asked to perch on a bended knee in order to display the harmonies of youthful perfection (this happened in the drawings of 'damned lovers' like the *Circle of Lovers* (D5630), and the sculpted version at the bottom on the right pilaster). The position that Adèle had spontaneously adopted (and was asked to hold), was flagrantly immodest. Not only did she expose a rarely seen part of the anatomy—the gap between the stretched haunches—but her hand touched her breast, an overt sign that she was aware of her sexuality and aware of being watched. Something about the sculpture's unearthly expression, defined by the pronounced Gothic cheekbones and open mouth, distinguishes her from the look of the usual hired models, those who pout and feign shyness, the 'Angelica' types. If anything, her type, with parted lips and dark sensuality, reminds us of Delacroix's ravaged women.

Adèle in her own right was an artist's favourite and was mentioned by name in a number of letters, as well as, unusually, having a sculpture named after her. In May 1882 the artist Gustave Natorp, who had been studying with Rodin, writing from London expressed his admiration for 'the versitility of your talent and your ability to sing in every register', adding, in reference to their mutual friend the young Robert Browning: 'Browning vous envoi milles choses et un bien bon bonjour à Mlle Adèle.'[29] Seeing the sculpture we are privy to Rodin's attraction to Adèle because of what he siphoned from her: it comes out as something intimate and untrammelled. In terracotta the rugged bumps and hollows of the body give the whole the look of a relic or forest spirit, whereas the 30 cm bronze is slightly sleeker and more demure. With both versions it is fair to say, though, that the uninflected vessel-like volumes of the Neo-classical Venus type, so long associated with perfection and idolatry, were rejected and something which began with *St John* and *Eve* taken further. The peasant earthiness of the models encouraged Rodin to take liberties with the material side of the interpretation of flesh and bone and, by pure manipulation of the soft clay, derive a biomorphic equivalent. The articulations between the lumps and hollows start to be, if anything, like the geometries of Nature: of trees, rock, and landscape.

Gradually Rodin, perhaps sensitive to insinuations that his work was vulgar or even pornographic, and certainly, in the eyes of many, exaggerated and ugly, developed a simple and utterly sincere defence, repeated many times over during the next thirty years. It was based on his absolute belief that a new work of art was more than the clever, competitive novelty of a class of people called artists and was instead something in its own right revealed by the artist's eye 'grafted to his heart'.[30] As told to Henri Dujardin-Beaumetz in 1913 his experience was invariable:

> I state quite clearly that when I have nothing to copy, I have no ideas; but when I see nature showing me forms, I immediately find something worth saying and even worth developing. Sometimes one believes that there is nothing to be found in a model, and then nature suddenly reveals something of herself, a strip of flesh appears and that scrap of truth reveals the whole truth and allows one to leap with one bound to the absolute principle that lies behind things.[31]

The *Crouching Woman* was to become the upper half of the famous sculpture *Je*

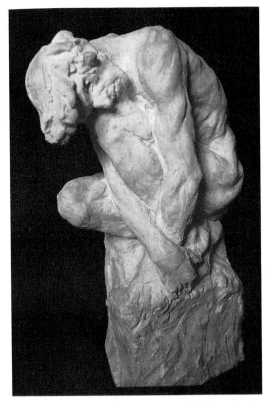

112 Michelangelo, *Crouching Youth*, The Hermitage, Leningrad.

111 (facing page) *Crouching Woman*, 1880–82, (detail of enlargement), The Josefowitz Collection (cat. no. 105).

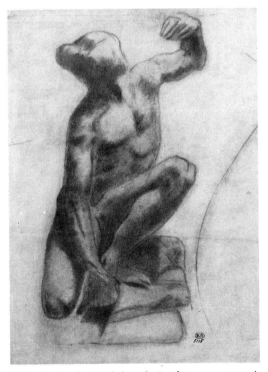

113 *Study after Michelangelo* (sculpture now attributed to Cilio, Victoria and Albert Museum), Musée Rodin.

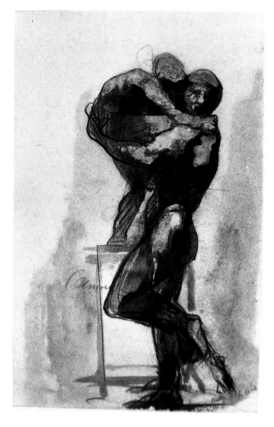

114 *Faun and child*, Goupil Album, pl.113.

115 *Faun and child*, Vase de Shanghai, 1880, location unknown (Vitta sale 1935).

116 *Dante falling backwards*, Musée Rodin (cat. no. 65).

117 Michelangelo, the prophet *Jechonius*, Sistine Ceiling.

118 *Falling Man*, 1882, B. Gerald Cantor Collections (cat. no. 71).

suis belle. The lower part is the *Falling Man,* an arch-backed, muscle-bound figure called by contemporary journalists an 'Atlas' or 'Hercules'. The union of the two probably existed by the end of 1882. In its own right it is an unforeseen masterpiece. Alternatively, it can be so closely compared with *enlèvement* subjects from Carrier-Belleuse's studio and from Sèvres that it is highly predictable. Rodin had himself been indoctrinated with this theme: many of his drawings depict a maiden with long hair braced aloft by a strong suitor-cum-abductor, their bodies staggered and held away from each other. Related graphic interpretations include the staccato-stroked *Dante falling backwards,* a wash-and-line profile study of a man with child raised overhead and the 1881 etching. Two goblet-shaped Shanghai vases and accompanying drawings called *Faun and child* and *Woman and child,* designed probably in the summer of 1880 (certainly before the end of Rodin's employment at Sèvres in December 1882, though the vases were possibly glazed and fired later), predicted *Je suis belle* quite precisely, but they in turn seem derivative in as much as Michelangelo's Prophets and *Ignudi* on the Sistine vaults are a clear source.[32]

To create *Je suis belle* Rodin balanced the sculpture of the *Crouching Woman* horizontally, her back uppermost, held by the *Falling Man*. Working in three dimensions he modified the top-heavy, club-like silhouette of the *Faun and child* and devised a double cone with its virtue of perfect symmetry. A sculpted mound allowed both of the man's legs to come off the ground. The vortex was made eloquent by the lovely V-shape of his lean thorax. With *Je suis belle* Rodin began to act on impulse and do whatever was necessary to reach a level of feeling. The woman's right hand on her ankle had to be severed and a new one added, one which dropped down so that the gaps between the bodies could be eliminated. Under strong light the mass consists of ridges of sharp reflected light and dark undersides. The treatment borrows, from painters as well as from sculptors, vigour, rhythm and an idea about contiguous forms. Even so, the

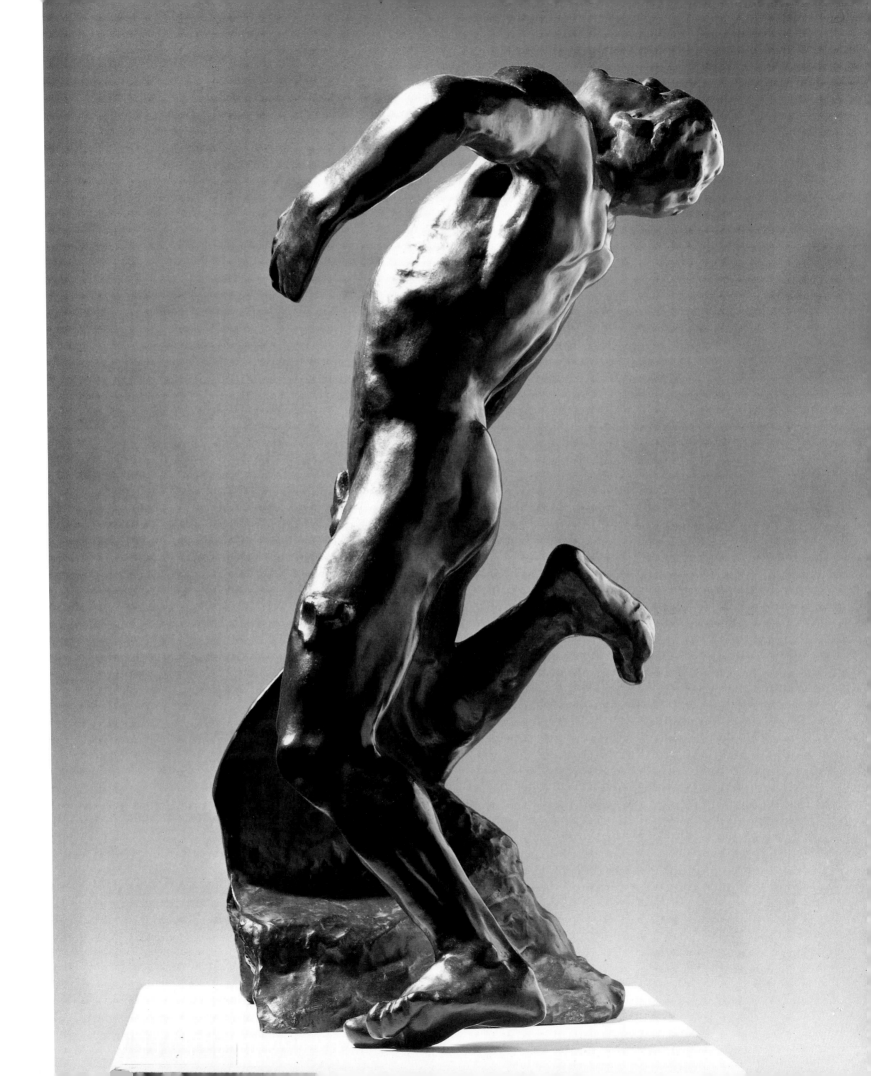

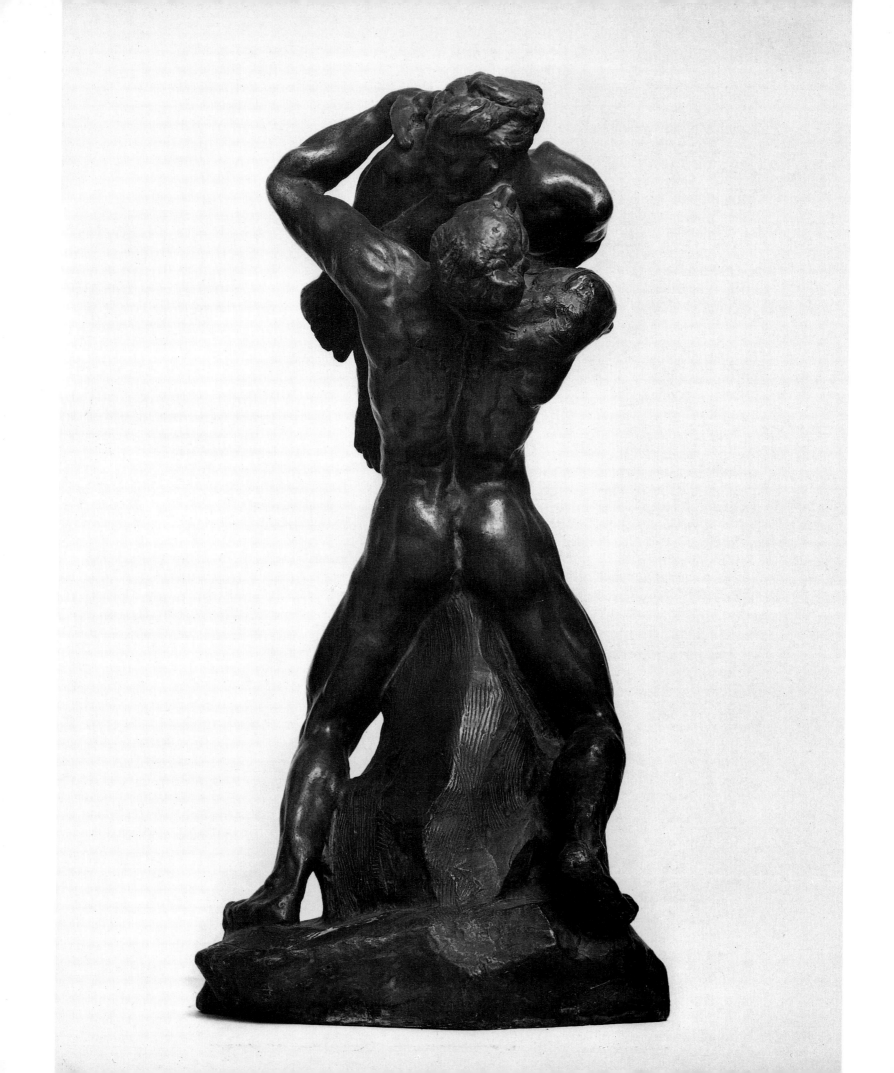

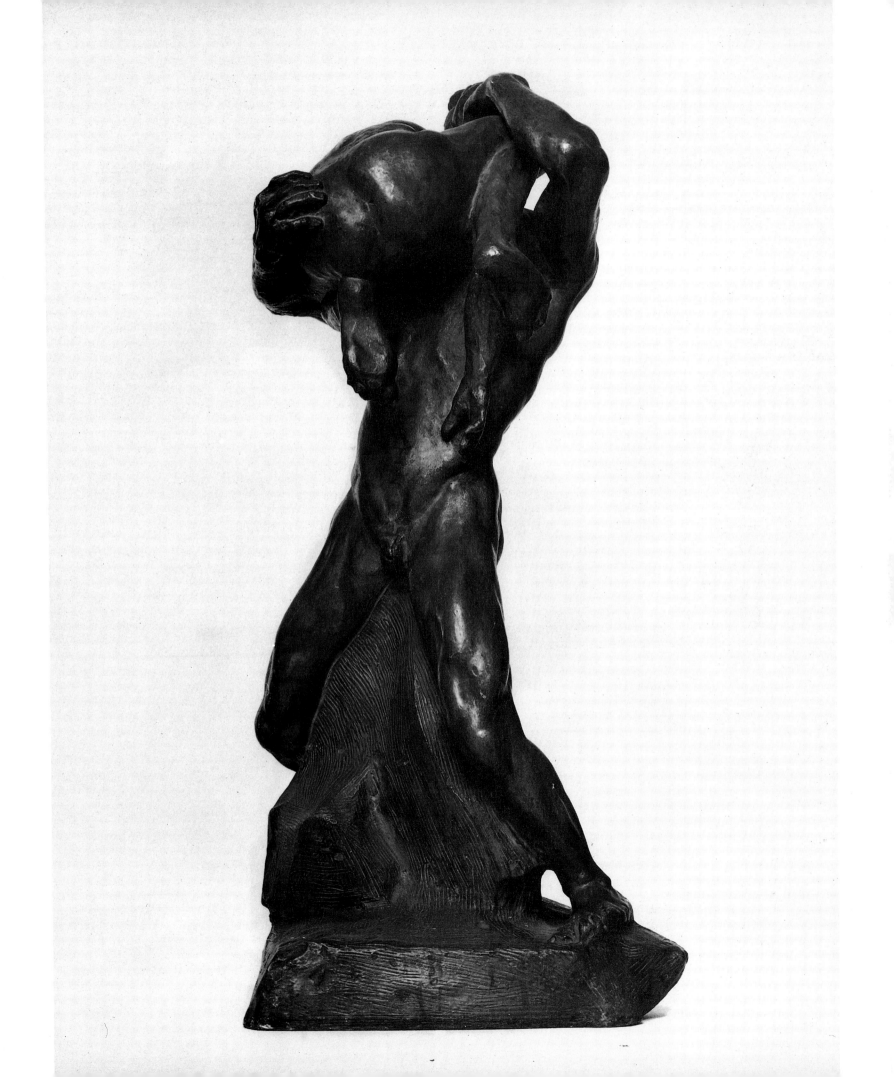

translation of Adèle's unique exposure of her longing into a rhapsodic, folded-up creature was new and magnificent.

Originally entitled *Carnal Love* and also called *Le Rut,* even before it was shown at the Galerie Georges Petit in the summer of 1886 *Je suis belle* caused a sensation among critics: 'No one has ever succeeded so well in expressing the savage onslaught of Desire and the furious cries of the flesh.'[33] Sometime before it was cast in bronze in 1887 the base was inscribed with the lines from Baudelaire's poem 'Beauty' and the sculpture thus acquired its present title:

> I am beautiful as a dream of stone, but not maternal; And my
> breast, where men are slain, none for his learning,
> Is made to inspire in the Poet passions that, burning,
> Are mute and carnal as matter and as eternal.[34]

Je suis belle is complete in its own right; it is one of those images, like *The Thinker* or *The Kiss,* which lodges itself in the brain, not as a mere example of Rodin's erotic fantasy, his pairing of images, but as a paradoxical thing with a unity all of its own. The balance between blatant and discreet is compounded by the fact that, when the man holding the woman aloft was added to the *Gates,* on the upper section of the right pilaster, the man's back was turned to the viewer and therefore the woman was sunk into the frame and more or less disappeared. The most provocative aspect of the original *Crouching Woman,* her exposed backside, was deliberately not shared with the viewer.

The placement of *Je suis belle* on one of the side pilasters conformed to a pattern: these narrow areas seems to have been heavily influenced by the experiments at Sèvres, parallel in date. In terms of *The Divine Comedy* they were identified by nineteenth-century visitors to the studio as representing Limbo and thus an area suitable for a chorus of nameless sufferers to be contrasted with the named protagonists who were to occupy the central panels. Once Rodin began actually inserting small figures in large slabs of clay, very likely doing so flat on a table, he dispensed with the horizontal divisions of the traditional niches.[35] The body postures were pulled askew so that most alignments were along diagonals which in turn created a chain of figures running from bottom to top. In a sense it was as if the friezes which ran around the central band of the larger Sèvres vases, such as *Le Jour* and *La Nuit,* had been set on end. The slightly illogical but evocative sequence of mythological cycles on the vases was unified by a rising and falling line, like a garland. Now, as these images were re-aligned vertically on a much larger scale, a further issue for consideration was whether to make the forms swelling or submerged. A number of couples were transferred intact from the vases—a woman with an infant raised over her head, the centaur clutching a satyress and the older woman and kneeling girl, who in the reinterpretation burrows herself into lap of the now more realistic, wrinkled hag. These characters brought with them a rather somnambulant, Bacchnalian air which made plausible their uninhibited, amoral behaviour. Left behind were the vegetal embellishments, the mannered, spikey feet and the contrast of milky glaze and translucent background. The pairings are compressed into tighter spaces relative to their size and the interstices are made of cruder, amorphous matter, textured by the knife on clay and the liquidity of poured plaster. Indeed the lithe, feline qualities of the slender, living models Rodin was studying encouraged him to register their inner energies by delicate depressions and bumps which came alive under raking light. The rippling effect of active flesh was magnified by the sepulchral settings.

119 and 120 (preceding pages) *Je suis belle*, 1882, Ateneumin Taidemuseo, Helsinki (cat. no. 72).

121 *Je suis belle*, on upper right pilaster of the *Gates.*

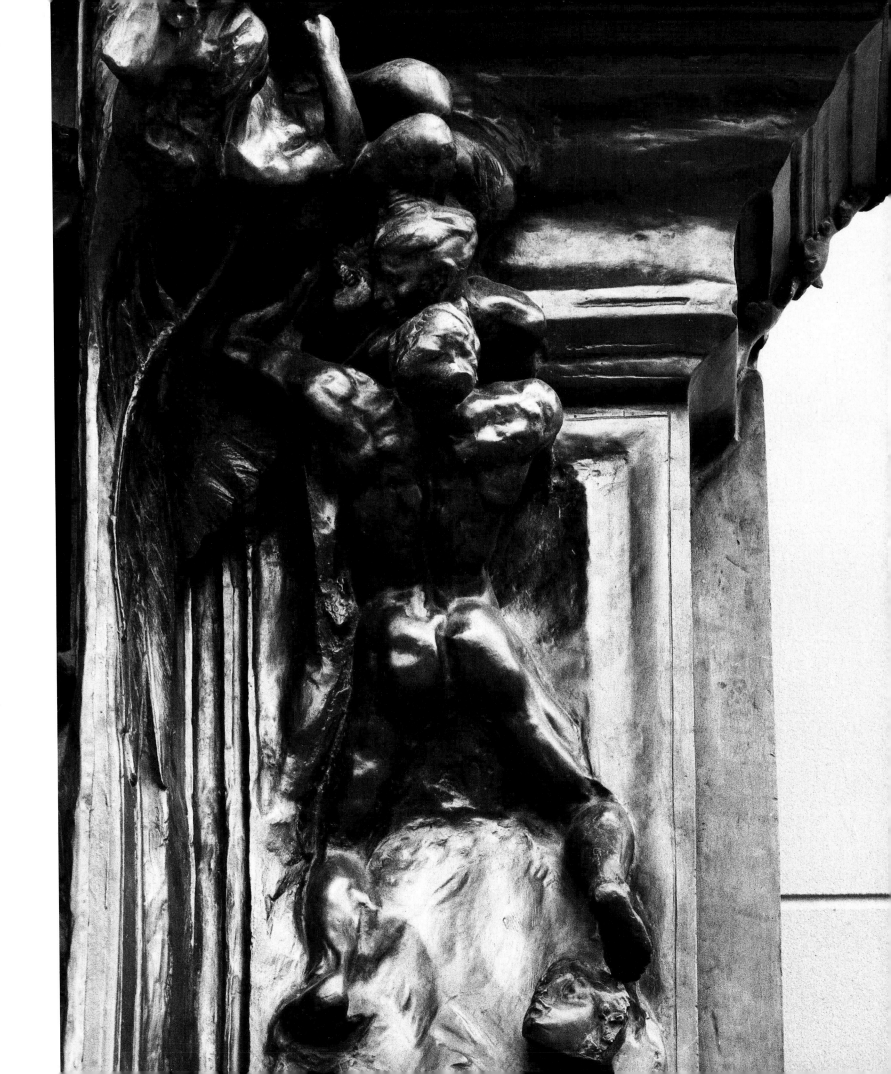

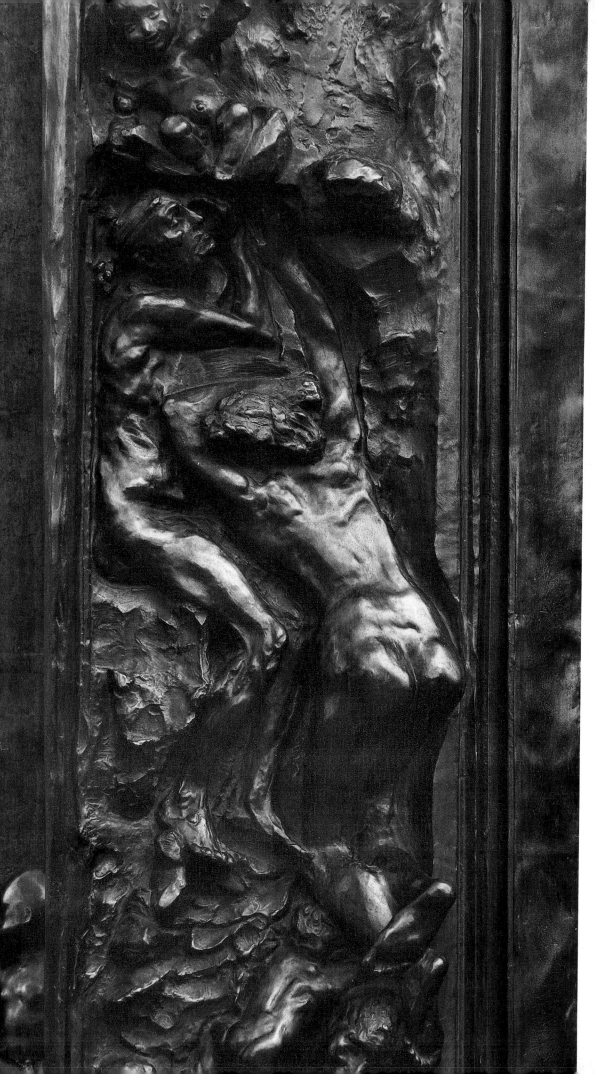

122 Lower section of the left pilaster of the *Gates* with the old woman and young kneeling woman.

123 Middle section of the right pilaster of the *Gates* with a seated woman and child.

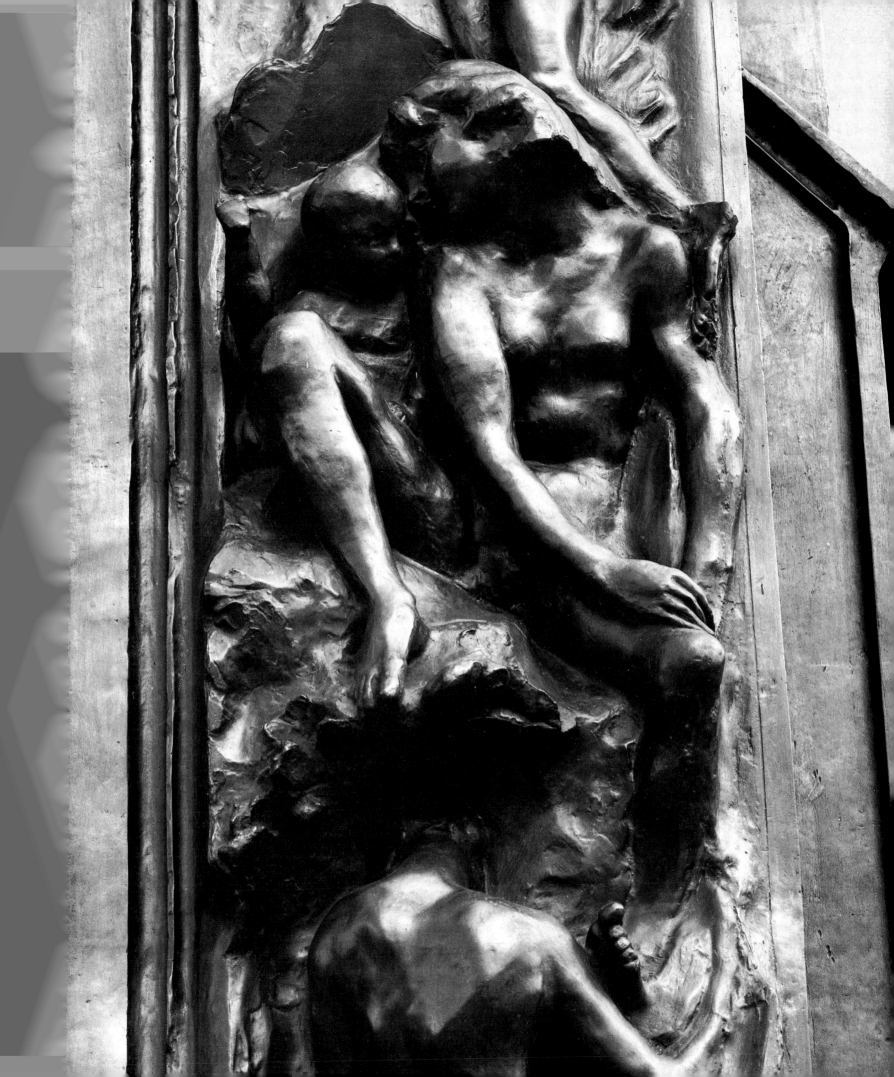

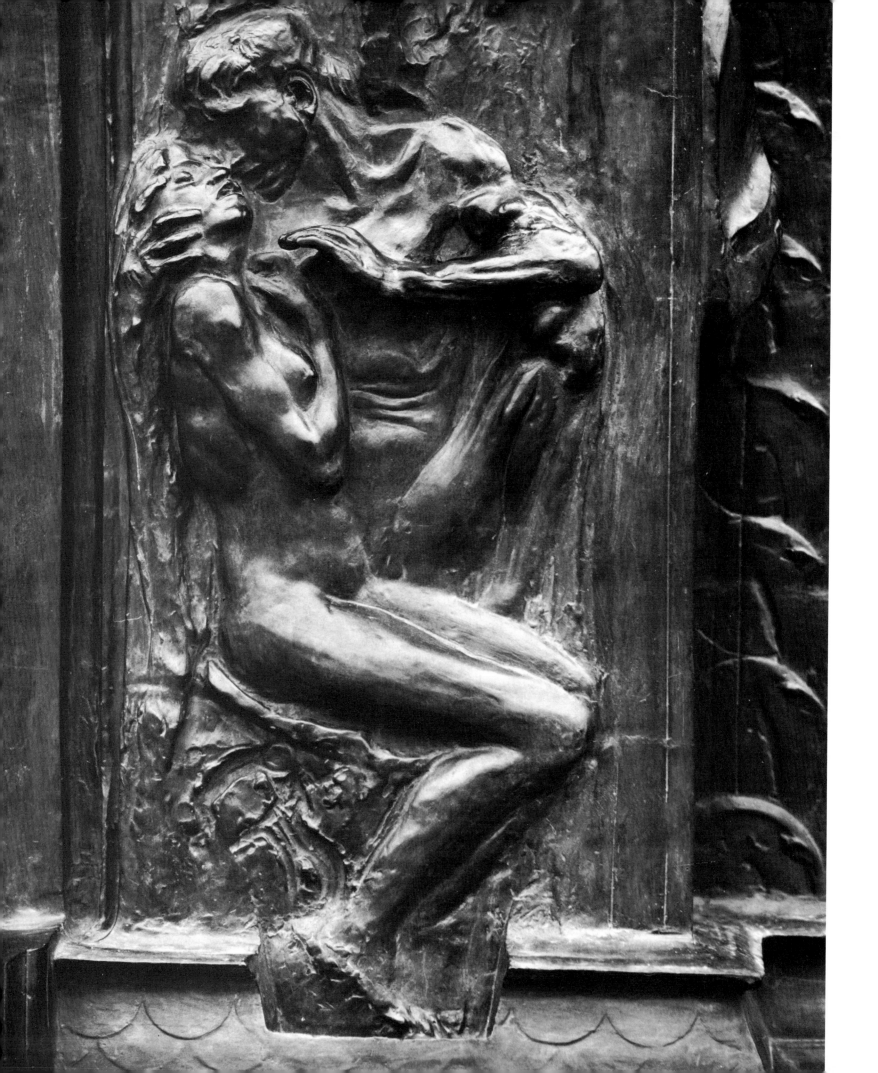

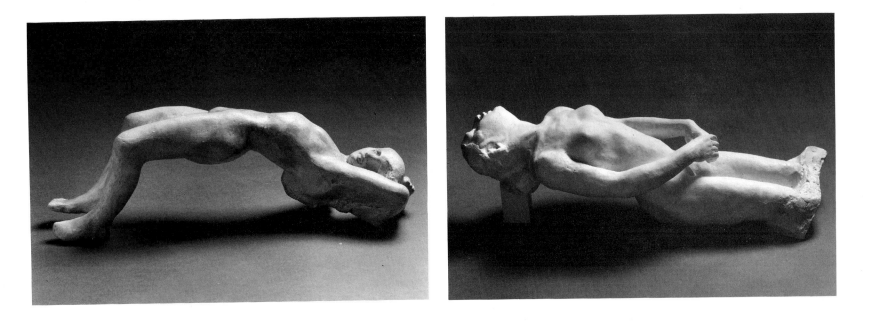

As Rodin moved into the open areas of the *Gates* and started to insert rather grand architectural mouldings the procedure became almost self-determining. There were indications of his commercial craft background in the in-filling, beading and repetition of forms; but he simultaneously followed academic methods whereby measuring, and progression from sketch to larger *études* preceded the final, scaled-up version. Rodin, always a believer in specialist skills, could at last afford to engage the help of numerous practitioners, many of whom were 'sculptors' in their own right (as opposed to the less creative *metteurs au point* or the finishers). It had been his intention to model the figures for the *Gates* in wax and apply the waxes to plaster backgrounds prior to the bronze casting, but in view of the estimates for the casting in bronze this promised to become too expensive. Instead, the clay sketches were turned over to technicians to be cast in plaster at an early stage, while still rough and ambiguous, or to be translated into armatures. As soon as a negative piece-mould existed Rodin had the alternatives of a clay squeeze, or positive, to continue working on or a plaster cast to contemplate, test and, if desired, dismember, revise and move slowly to a conclusion. He could also add clay to plaster and recast. Assistants were asked to make piece-moulds and take plaster casts sometimes on a daily basis. Those most able to comprehend Rodin's sensibility began modelling the enlargements and marble versions.

Rodin found he could be at his most imaginative when he had several dozen pieces in progress at one time (and, after 1884, several studios, some kept secret). It was his habit to work every day from before eight in the morning until late at night, often, as Edmond de Goncourt noted in his journal with pity, 'standing or perched on a ladder, this crushing labor caused him to retire to his bed at night after an hour of reading'.[36] From visitors' accounts it seems Rodin's sorcerer's talent produced its own momentum. He was 'forever improvising form, and this he plants in his door, studies it against the other figures, and takes it out again, and if need be, breaks it up and uses the fragments for other attempts'.[37] After the models and workers had left, he remained in his studio to experiment with the plasters. His criteria for the inclusion of a whole or part of a figure in the *Gates* became increasingly dependent on subjective trial and error: many improvisations and insertions were made by candlelight; combinations of works with

125 *Kneeling Man*, before 1889, Musée Rodin (cat. no. 83).

126 *Damned Woman*, Musée Rodin (cat. no. 87).

124 (facing page) Lower section of the right pilaster of the *Gates* with lovers.

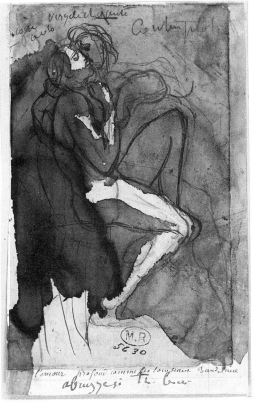

127 *The Circle of Lovers*, Musée Rodin (cat. no. 99).

128 *Fugit Amor*, *c.*1883–4, Musée Rodin (cat. no. 76).

129 *Twilight and Dawn*, Musée Rodin, Ph2781.

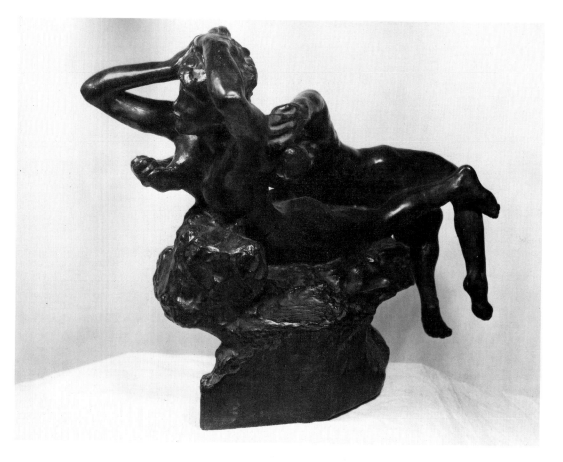

L'ANGE DE LA PRIÈRE

130 Line engraving of *L'Ange de la Prière* from Léon Maillard, *Auguste Rodin*, 1898.

131 *Fugit Amor* on right door panel of the *Gates*.

unrelated iconographies and of divergent scales were tried and kept. The still disturbing expression of unfulfilled passion, *Fugitive Love,* came from such an uncanny pairing of two alien bodies, back-to-back: the Prodigal Son who stands upright in the *Gates* and a woman with back arched and head raised like a ship's figure-head.[38]

Postures that were not feasible structurally were achieved by propping up the fragile plasters and recording the results through photographs. Rodin did not himself take the pictures but directed the photographers to record certain angles and constructed around the three-dimensional objects still lives and environments with the aid of patterned cloths, distorting points of view and special light effects. On top of the prints Rodin frequently sketched notes to himself in pencil; thus, on one view of the Thinker positioned on the bare scaffolding, his hair is envisaged as if a back-combed headdress—in contrast to the pressed helmet shape ultimately chosen.[39] Photographs of temporary set-ups were translated into illustrations as if they had a real-life identity. For example, at the end of a chapter of the 1898 biography of Rodin by Léon Maillard, a photograph shows one air-borne figure diving onto another, accompanied by the caption '*L'Ange de la Prière*'.[40]

As soon as Rodin began formulating his ideas for the broader areas of the *Gates,* the tympanum and the central panels, the idea of a sequential or hierarchical organization with didactic overtones seemed to recede even further from his mind. He called the portal his 'Noah's ark' and it started to be identified with him and his curious crowded studio rather than with a public commission. About 1885 it became understood that the state no longer intended to build a

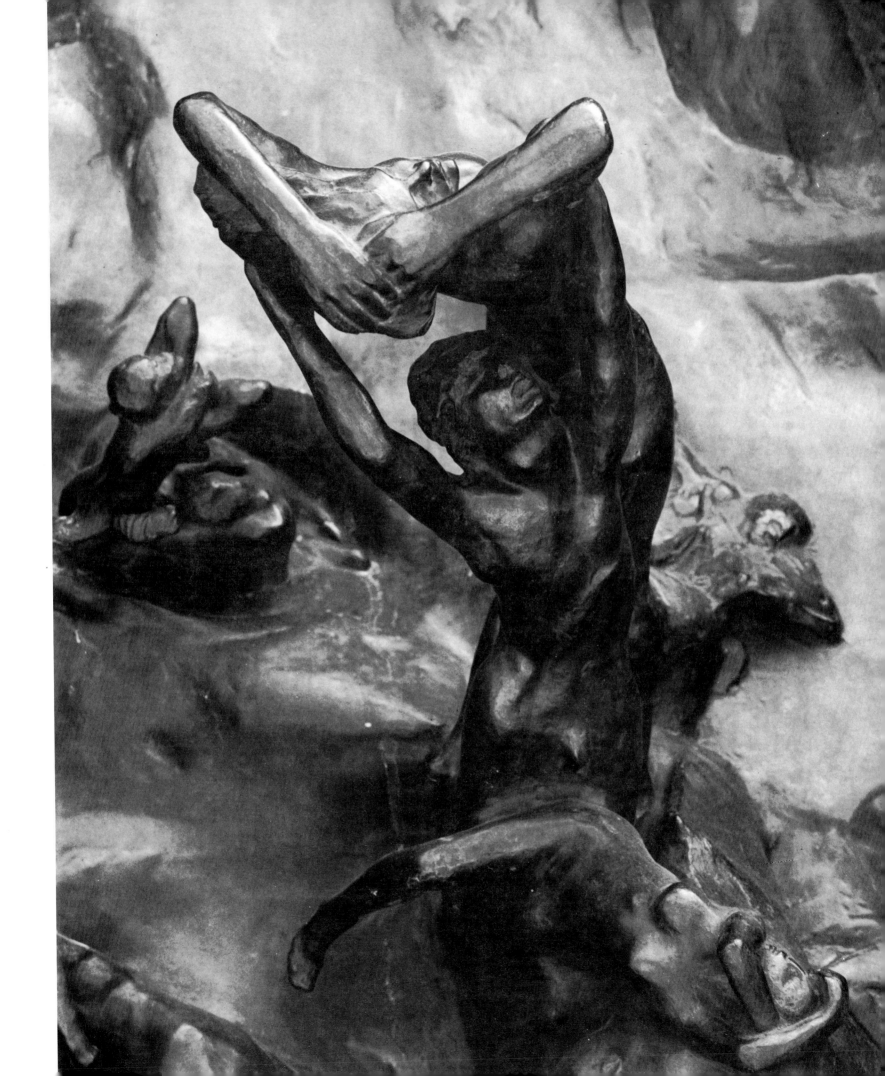

new Museum of Decorative Arts and thus delivery of its intended doors related to no particular deadline. Outwardly Rodin continued to promise termination in the near future and estimates for casting were made in 1884 and 1885; but judging his activity from the payments requested and made, the pace slackened drastically after 1885 and probably no work was done between 1888 and 1899. It would be wrong to suppose, however, that Rodin simply submerged himself in the manipulative process and made his perceptual judgments at random in formal vacuum. Rather, he carried in his head strong, specific blueprints of the art of the past as well as a sophisticated sense of the interdependence of the whole 'plan' and the rich, discursive, symbolically loaded parts. When he climbed his ladder to immerse himself in a passage hidden behind a moulding, or calculate the inclination of the back wall of the tympanum so that it should appear rectangular from the ground perspective, he seems to have associated these building decisions with the creation of something sublime and thus with the monumentality but ethereal intangibility he remembered from 1875, epitomized by the facade of Reims Cathedral and the walls of the Alps.

An equally meaningful and useful source for both breadth and fragmentation within a field came from painting, particularly large-scale, chiaroscuro historical painting. Shortly after meeting the American sculptor Truman Bartlett in November 1887 Rodin explained to his sensitive interviewer that, working in the rue de l'Université, he had given himself over to criteria lacking the usual expository value:

> I had no idea of interpreting Dante, though I was glad to do something in small nude figures . . . My sole idea is simply one of colour and effect. There is no intention of classification or method or subject, no scheme of illustration or intended moral purpose. I followed by imagination, my own sense of arrangement, movement and composition. It had been from the beginning, and will be to the end, simply and solely a matter of personal pleasure. Dante is more profound.[41]

This confession might seem to make light of the raw agony of Ugolino and the undefinable poignancy of the silent, small female figures. Actually, what Rodin said was true: soon after starting on the Gates he had accepted his lack of desire or gift for the 'profound' interpretative thinking of Dante, and thereby found himself free to assemble a discursive work without a master plan and without the human protagonists and predicaments being labelled 'good' or 'evil' in either a religious or metaphysical sense. Many unidentified figures or parts reappeared, giving the impression of a tribe: gods and earthly beings, inbred like the characters of Ovid's Metamorphoses, were joined by furls and billows to the craggy landscape of the vertical surface. The terrain became not equatable to any one aesthetic but in part baroque and claustrophobic—reminiscent even of St Theresa's alcove in Bernini's chapel—in part a disturbing wasteland, and in part a trellis with the contents hung precariously on the straight edges. Towards the end of the work an element of art-nouveau sinuousness resulted in whirlpools and curled waves suitable for translation to elaborate cast-ironwork. When Rodin prepared the plaster for exhibition in 1900 and circumstances prevented the reassembly of the background and high-relief groups before the opening day, he allowed it to be seen denuded, thus as more an abstract landscape than ever before.[42]

In recent years the thematic source and sculptural achievements of the Gates have overshadowed its affinity to the logic and techniques of painting which in

132 Lower right panel of the Gates with Avarice and Lust.

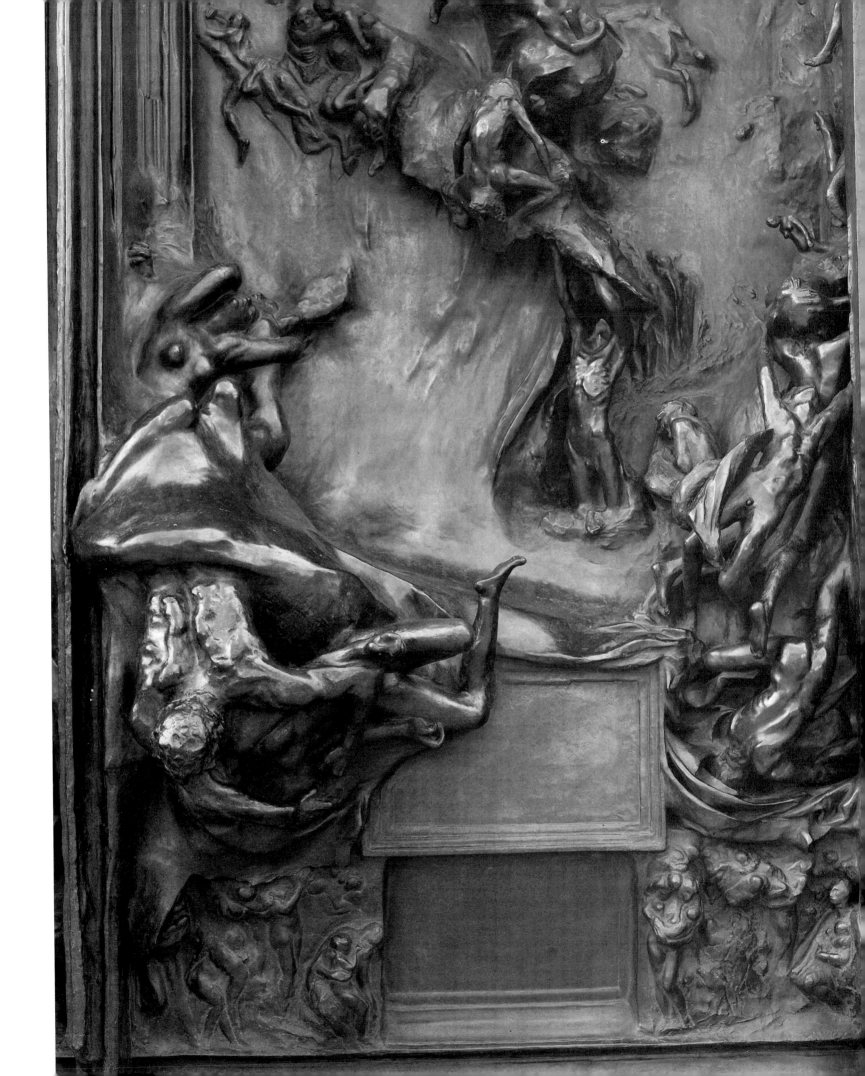

133 Eugène Delacroix, *The Death of Sardanapalus*, 1828, Musée du Louvre.

134 Théodore Géricault, *The Raft of the Medusa*, 1819, Musée du Louvre.

135 Eugène Delacroix, *The Shipwreck of Don Juan*, 1840, Musée du Louvre.

136 Left panel of the *Gates* with the *Falling Man* and *The Thinker*.

Rodin's lifetime was taken for granted, not necessarily in a complimentary way. In 1883 Geffroy had introduced Rodin as an artist akin to Delacroix, and in 1885 Mirbeau likened him in certain respects to Rembrandt, Rubens, Veronese, Michelangelo and Ribera, but declared Rodin and Delacroix as two geniuses of the same race.[43] All his life Rodin visited museums and churches and associated each great artist with a quality to which he also aspired. Thus he admired the 'illumination' in Rembrandt's painting, calling it evidence of 'the absolute vision that became his own of the form created by light'.[44] Claude Lorrain and Turner were artists 'who consider nature a tissue of luminous and fugitive visions'.[45] The antecedents for his specific attraction to volumes twisting in space existed in Michelangelo and Rubens. But it was in the art of Géricault and Delacroix that Rodin identified the contrast of harsh corporeality with a non-objective sense of matter (in other words, impasto) that he needed and sought after.

Not surprisingly Rodin seized on the piecemeal methods of the painters of large historical compositions. The phenomenon of celebrating parts over and above their relevance within a resolved composition was an innovation of the Romantics.[46] His mind dwelt on a part so exclusively that, as he worked it beyond the notion of an anatomical copy, it became something 'growing' in its own right. The units could be treated as non-verbal, subconscious messages of yearning and discovery. Very often the use of extreme torsion or up-ending lifted the partial figures from the composition, giving them the psychological magnitude and lurid glow found in painting. For example, on the right in Delacroix's *Massacre at Chios* the bare torso of a girl prisoner, whose arms are wrenched up in chains by the fearsome mounted soldier, provides a strong precedent for the *Torso of Adèle* whose arched body beckons with the same potency. In Delacroix's *Death of Sardanapalus,* the figure kneeling at the bedside is a prototype of the fragment *Desinvolture*. There are also comparisons between specific figures in the *Gates* and Géricault's *Raft of the Medusa*. The two cadavers thrown forward in the lower corners of the painting have the extruded, sinewy look of the torso of the Prodigal Son. They lie on either side of a foreshortened body (for which Delacroix is said to have posed) which has been reduced to a head and shoulders, the muscular volumes slightly squared and surrounded by dark impasto. This kind of abbreviation was familiar to Rodin and had indeed appeared in the 'black' gouaches, for example, in *Ecoinçon* and the study of a seated figure with bent head (D2034), inscribed 'la vielle étude mon joint endormi. Sybelle'. Rodin may well have also responded to the same head-on abbreviation in the central figure at the bottom of Delacroix's *Shipwreck of Don Juan* (1840). What he was specifically interested in was the way the head and spread-open arms could be treated as a fixed sign available for insertion into his own composition to punctuate what might seem at first glance a confusing mass of gesticulating bodies. He positioned the Falling Man above and below the lintel on the *Gates* (once the right way up and once upside down) so that the most salient part is just this double arc of the raised arms with the skull circle in the centre. It remains in the retina not because it is bizarre or hard to decipher but rather because of the opposite. The shape was what Matisse called a sign; in one way its repetition was a short-cut and in another a way of avoiding the irrelevancies and innuendoes of a descriptive or Realist approach. Matisse's explanation of Delacroix's use of signs applies equally to Rodin:

Because Delacroix composed his paintings on the grand scale. He had to finish off, at a certain place, the movement, the line, the curve, the arabesque

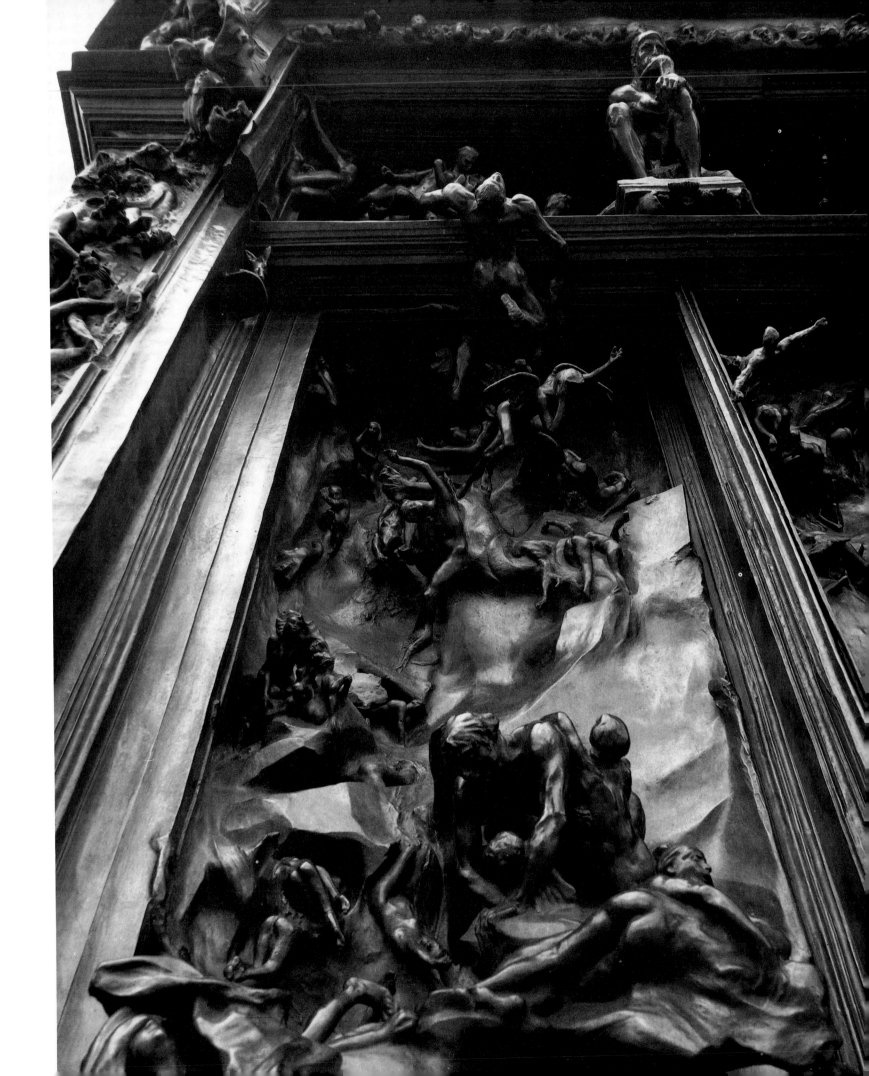

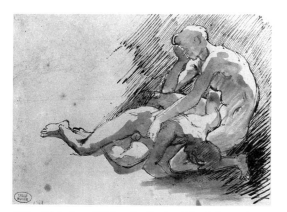

137 Théodore Géricault, *Study of the father and son for the Raft of the Medusa*, Musée des Beaux-Arts, Lille.

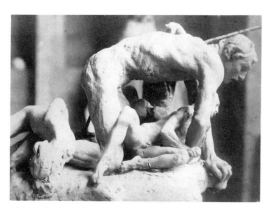

138 *Ugolino and his children*, 1880–81, clay, Musée Rodin, photograph by C. Bodmer, (cat. no. 257).

139 *Sketches for Ugolino and Medea*, 1870s, Musée Rodin, D153–159.

that ran through his picture. He carried it to the end of his figure's arm and there he bent it over, he finished it off with a sign, don't you see a sign! Always the same sign, the hand, made in the same way, not a particular hand but his hand, the claw . . . The painter who composes on the grand scale, carried away by the movement of his picture, cannot stop over details, paint each detail as if it were a portrait, portray a different hand each time . . .[47]

In 1881 Rodin resumed work on the Ugolino story, which was to form the left-hand central panel on the *Gates,* and tried once more to think of the relationship between the central protagonist and his doomed sons with which he had been fascinated since the 1860s. Thirty-odd drawings have been catalogued; many are of seated parent and clambering or outstretched child. When Rodin started posing Pignatelli as Ugolino and other adult or adolescent models for the sons, close parallels developed between his conception and the father holding his dead son in the *Raft of the Medusa.* Géricault had himself varied his approach to these figures: several preliminary drawings are careful naturalistic renderings, others concentrate on the silhouette of one element or the pattern of the interlocking pair under strong light.[48] In some the father and son have equivalent physiques so that the seated figure cradles the face-down body spread over his legs as though grieving for a dying lover. Working in the rue de l'Université with a variety of plaster casts, Rodin also departed from the concept of the upright, stoical patriach, placed him on all fours and allowed the sons to squirm underneath. The consequences of political hubris are seen to lead to a bestial end: the parent sprawled over his litter, mouth open, must suffer wordlessly.

The development of the group of Ugolino and his sons, and its enlargement is interesting because it points to aspects of Rodin's affinity to Romantic painting which do not end with the *Gates* but go on to dominate both the partial figures important to the late period and the monument he was about to begin, the *Burghers of Calais.* The change has its origins in the breaking-down of human bodies and activities by the Romantics into volumes and articulations. In the first respect, it is the meat-like shapes and colour of the amputated units of leg, head, shoulder and bony feet that make the connection. Although it is not proven that Rodin was an *habitué* of mortuaries as Géricault was, he did visit hospitals, among them the Hospital Laennec.[49] Throughout his life he made masks and drew heads with the hollow eyes and mouths of the dead, while the sculpture *The Martyr* presented a female body with the grotesque deformations and rigidity of a corpse. In his studio, surrounded by what Geffroy called a 'cemetery', on account of the hundreds of white plasters, Rodin began to saw through his forms and to reassemble the parts in a manner which stressed their carnal aspect. In many places on the *Gates* the way the fragments project suggests drowning or burying alive—for example, the arm shooting out from the corner of the right door-panel and the topsy-turvy girls on the upper right of that panel. On close examination the top and bottom halves of many figures do not match, as happens with the eldest son of Ugolino.

Rodin was discovering in constructing his doors that part of portraying what he called in Delacroix the 'truthful power of expression' was a matter of showing modern man looking on aghast, realising that the advance of civilization through science could not diminish the degree of barbarity latent in mankind. The hair-raising descriptions by Corréard and Savigny of the fanaticism, atrocities and stupidity on the shipwrecked Medusa which reached and riveted the French public in November 1817, and informed Géricault's realism, were symptomatic

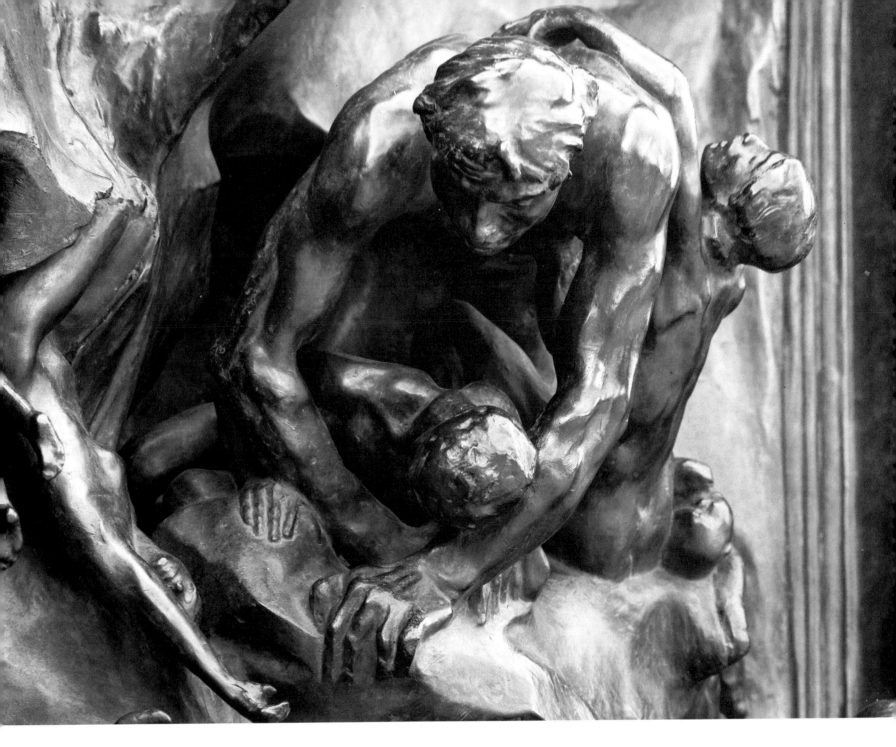

140 *Ugolino and his children* on the *Gates*, left panel.

of the way contemporary society learned about itself. By the late nineteenth century newspaper accounts of wars and disasters were beginning to be reinforced by photographs. Rodin later enthused about Delacroix's *Shipwreck of Don Juan*: 'hunger and distress tragically convulse the faces of these ship-wrecked people, because the somber fury of the colour portends some horrible crime'.[50] As entries to the Salon reveal, artists were interested in the phenomenon and look of life-threatening, barbaric occurences: they were moving from stories of Cain and Abel and the Universal Flood to real-life tragedies. Rodin's friend Alfred Roll, for example, painted another raft scene, *L'Inondation*, which was shown in the Salon of 1877; ten years before Manet had painted the *Execution of Maximilian*.[51] One could say the art form began changing in tandem with the new awareness of dramatic events beyond the heroic.

Although Rodin had tried to symbolize the futility and suffering of an event in

79

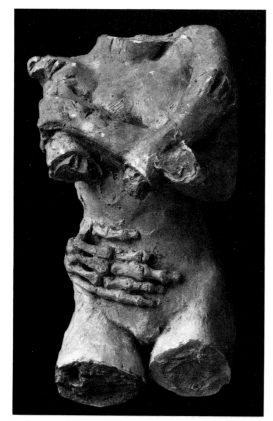

141 *Female torso with hand of a skeleton*, Musée Rodin (cat. no. 90).

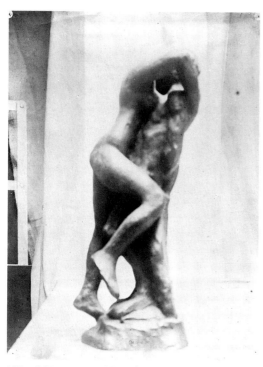

142 *L'Emprise*, c.1885, photograph by E. Druet, after 1896, Musée Rodin (cat. no. 250).

his own time, the Franco-Prussian War, in the monument *Call to Arms,* he was not really interested in the documentary, re-creation of history. Instead his contribution to a modern sense of the horror of mankind's bloodthirsty instincts was to manufacture an unqualified measure of wretchedness by the heap of bodies under Ugolino and the crowded cage of nude bodies within the tympanum. The result at first seemed to his contemporaries a disorganized, inferior idea of composition and an insult to the legend of the historical thirteenth-century figure of Ugolino della Gheradesca. It did in fact set a standard for a multi-part, non-uniformly scaled sculpture that required the spectator to be mobile and imaginative. And it conformed to Rodin's belief that the individual's sense of worth and his morality had been degraded by the onslaught of the industrial age.

Rodin's techniques and sense of composition clearly borrowed heavily from painting, but in doing so foreshadowed the future of painting—of Cubist space, collage and the simultaneous viewing of different facets of one solid. In time the 'techniques' suitable for extremely passionate or violent subjects like Ugolino applied equally well to other, less dramatic, more ambiguous contexts. The academic distinction between *études* and finished works seemed less valid and Rodin moved intuitively between subjects, amalgamating disparate studies under no external pressure, but simply for his amusement. A reporter who came to the rue de l'Université wrote:

I remember a time when the walls, the floor of the studio, the turntables and the furniture were littered with small female nudes in the contorted poses of passion and despair. At the time, Rodin was working under the influence of Baudelaire's book, which he had recently read. He seemed to be intoxicated with it. With the rapidity of spontaneous creation, a countless host of damned women came into being and writhed in his fingers. Some of them lived for a few hours before being returned to the mass of reworked clay.[52]

In a matter of minutes one of the Lilliputian populace could appear to scale the straight edges of the frame of the *Gates* and cascade down the plaster slopes. The scattered, weightless feats were much like those which appear in dreams. Bartlett observed that the frame seemed composed of mouldings which acted like the shores of an overflowing sea of uneasy souls.[53] The same small figures that, viewed on their modelling stands, appeared as magnetic objects, began *en masse* to be used for ever more arbitrary compositional effects.

This improvisation influenced the composition of the pilasters but is more evident in the tableau-like tympanum which ostensibly represented Purgatory, the Arrival on the left and the Judgment on the right. At first glance, especially from ground level, the tympanum looks like a jumble of young female bodies seized by fits of passion, hysteria and sorrow. Close up, photographs reveal imbedded in the back wall skeletons and a head of a warrior, and hanging above on the cornice a row of heads, some horrifically desiccated and sepulchral. Below the tympanum in the central panels and along the mouldings the human forms were twisted off their normal upright axes and partially submerged until convex elements like the thighs and breasts floated to the surface and became non-specific volumes. Across the width of the central panels one detects sweeping rising and falling movements, clockwise in direction, but even this 'plan' is contradicted by geometries across the divide, as, for instance, the channel which runs from lower right to upper left circumscribing an enormous triangle in the bottom left corner. After the reassuring rectangularity, recessional space and

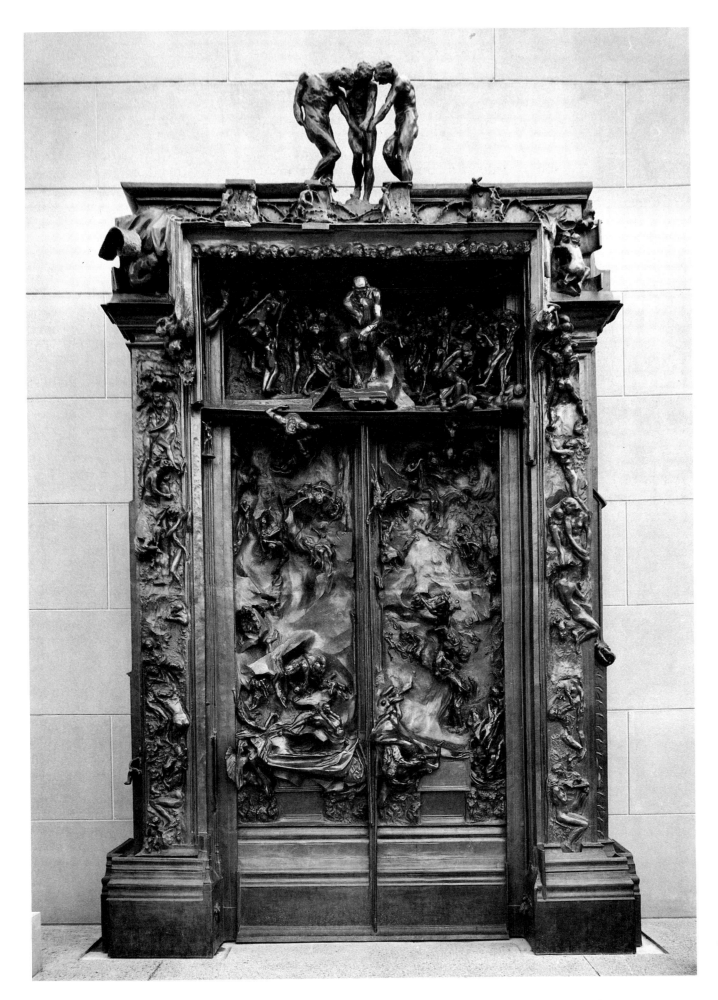

143 The *Gates of Hell*,
Stanford University
Museum of Art.

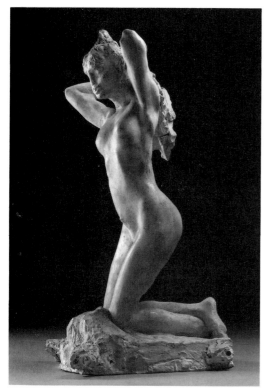

144 *Kneeling Fauness*, 1884, Musée Rodin.

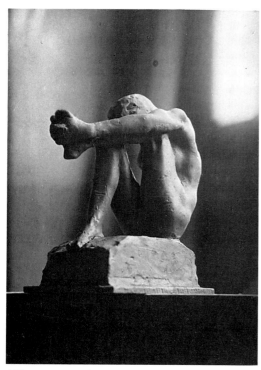

145 *Despair*, photograph by E. Druet, *c*.1896, Musée Rodin (cat. no. 248).

monolithic conception of human anatomy established during the Renaissance and the verisimilitude of Realism, what Rodin was suggesting was his own multi-focus perspective punctuated with signs and the uniformity of a made-up population. Compared one to one in their versions outside the *Gates* the stiff, seam-marked figures are so routinely nymph-like, one might presume a lack of concern with individuality. To their maker the repetition and anonymity corresponded to an anxious need to work within his own syntax, to identify wholly with the preoccupations and look of the models. Accumulating component parts to stand available in his mental reserve and to lie around him on the floor and shelves was part of Rodin's preparation for composing straight from his own resources. In time it became impossible for him to claim the poses of his models were unrehearsed; more often they fell into a position which he recognized as being meaningful, as a sign or generator of intense emotion. Thus, the *Kneeling Fauness* was reworked as the more seductive *Toilette of Venus* and eventually translated in the 1890s to a voluptuous beauty holding back her heavy tresses called *Morning* under the stimulus of the famous model Carmen Visconti.

Throughout his life Rodin's rapport with his models extended beyond having a focus for his eyes while his finger's and mind shaped and inflected surfaces. The degree to which they were sometimes collaborators comes across almost painfully clearly, causing us to be reminded of Baudelaire's mixture of dependence, homage and imprisonment in his relationships with Jeanne Duval and Madame Sabatier. Standing 5 feet 7 inches, with a reddish beard and blue eyes, Rodin's own gaze was described as 'lively, penetrating, naive, malicious'.[54] Throughout his life he was lecherous and very many women did succumb to his charisma and ardour; but equally, because of that his reaction to female beauty was intoxicating and obsessive. His art showed a radical absence of decorum. In most people's minds models were inferior beings improved by the Classical poses and allegories imposed on their otherwise mundane forms. Rodin had a less arrogant idea, indeed he admitted his addiction to their presence and his dependence on their individuality:

> A model may suggest, or awaken and bring to a conclusion, by a movement or position, a composition that lies dormant in the mind of the artist. And such a composition may or may not represent a defined subject, yet be an agreeable and harmonious whole, suggesting to different minds as many names. The physical and mental character of a model regulates to a degree, this affinity. A model is, therefore, more than a means whereby the artist expresses a sentiment, thought or experience; it is a correlative inspiration to him. They work together as a productive force.[55]

In a photograph taken around 1900 Rodin hovers so close to a passive model, her chemise dropped, her breasts bared, that he seems to breathe her ambient presence and appropriate it for the small effigy he is modelling. When, in the same year, Stephan Zweig observed the by-now sixty-year-old master working he observed that the same euphoria could be sustained after a model had left the room and Rodin was working in remembrance of the individual's presence:

> Rodin was so engrossed, so rapt in his work that not even a thunderstroke would have roused him. His movements became harder, almost angry. A sort of wildness or drunkenness had come over him; he worked faster and faster. Then his hands became hesitant. They seemed to have realised that there was nothing more for them to do. Once, twice, three times he stepped back

without making changes. Then he muttered something softly into his beard, and placed the cloths gently about the figure as one places a shawl around the shoulders.[56]

Rodin's hired girls, lying on the sofas for hours while he was modelling, can be imagined to occupy in his mind sealed-off imaginary enclaves where the artist and the beguiling muse exist for each other. The relationship resembled that described by Baudelaire in 'Jewels':

> Naked, then, she was to all of my worship,
> Smiling in triumph from the heights of her couch
> At my desire advancing, as gentle and deep
> As the sea sending its waves to the warm beach.
>
> Her eyes fixed as a tiger's in the tamer's trance,
> Absent, unthinking, she varied her poses,
> With an audacity and wild innocence
> That gave a strange pang to each metamorphosis.
>
> Her long legs, her hips, shining smooth as oil,
> Her arms and her thighs, undulant as a swan,
> Lured my serene, clairvoyant gaze to travel
> To her belly and breasts, the grapes of my vine.[57]

146 *Despair*, photograph by C. Bodmer, *c*.1893, Musée Rodin (cat. no. 247).

Once Rodin became accustomed to the unselfconscious look of naked people, he started producing figures that were, in the words of Rilke, 'listening to one's own depths'.[58] This is descriptive of many subjects tucked away in the *Gates*, or never used but made at the time, which are bent at the waist, for example, *Sorrow* and *Eve eating the Apple*, as well as those with only the head bowed, like *Eve* and *Despair*. Given the predominance of women in these poses, there is always a two-way circuit. The subject is lost in thought, day-dreaming, meditating; by virtue of such concentration she is in theory oblivious to the rest of the world and so the spectator is permitted the freedom to scan her body. Yet, as soon as the model is observed mysterious signals are exchanged. Under Rodin's gaze the quivering shoulder blades, upturned soles of the feet and the raised buttocks are indications of the shared electricity. The *Crouching Nude* of 1880–82 was pliable, opened out like a flower exposed to sunlight. In *Despair* the girl's head is bent, one leg pressed close to her chest, the other flexed, her hands wrapped around the right foot. Over a period of years Rodin had a sequence of the photographers he respected, Charles Bodmer, Eugène Druet and Haweis & Coles, take pictures of this small work.[59] Head-on in the study, as photographed by Druet, she was reduced to a tear-drop shape, the concentrated mass predicting the late watercolours in which the human form is deliberately aligned so that no limbs project and its silhouette can be compared with objects, most famously with Greek vases.[60] Viewed sideways and obliquely, *Despair* suggests an architectural force based on triangles that is as engineered as the welded steel sculpture familiar in the twentieth century. Whereas the simple geometry and lack of context of this small figure was to be recalled in many of Rodin's late drawings, some with precisely the same theme, such as *Seated Nude, a foot under the chin,* at times Rodin lapsed into near caricatures of narcissistic or sexual gratification. The sculpture *Woman seated with her foot in the air,* later enlarged, has an insouciance and gymnastic exaggeration bordering on vulgarity as do far too many of the late drawings.

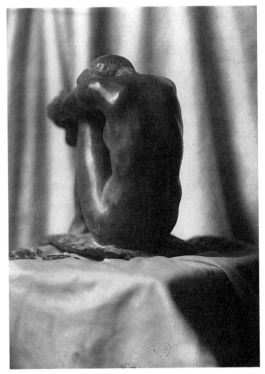

147 *Despair*, photograph by Haweis and Coles, 1903–4, Musée Rodin (cat. no. 249).

148 *Danaïd*, 1884–85, Musée Rodin.

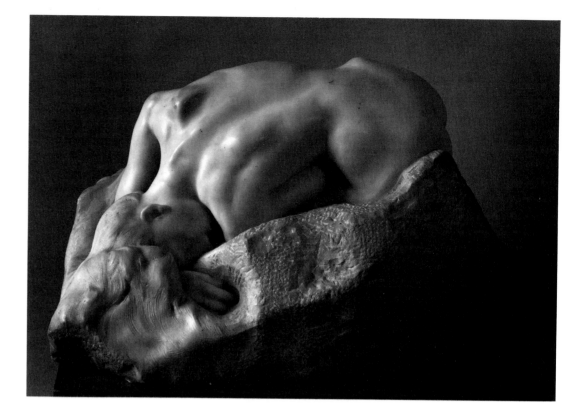

149 *Vase de Saigon*, 1880, with scene of siren and nymph, The Josefowitz Collection (cat. no. 25).

150 *Invocation*, 1886, Musée Rodin (cat. no. 84).

Possibly the most exquisitely formed sculpture of a woman bending is *Danaïd*. The mythological association seems neither a burden nor gratuitous. In Ovid's account Danaïd, like her sisters, is condemned to draw water in the underworld in payment for slaughtering her husband on their wedding night. In Rodin's work the kneeling girl's head is lowered to the ground so that the highest point of her body, the nipped-in waist, connects the two triangles of her upper and lower halves. The figure-'8' form was explored first in the *Vase de Saigon* on the side with the reclining siren. In the round the invented solid geometry is no longer ideogrammatic but depends on a twisting that raises the waist until it is the fulcrum between cascading hair and succulent loins. The marble versions of *Danaïd* exploit the luminosity of the material and its associations with primeval rock-beds and ever-glowing crystals.

In many instances the swooning, inward-looking nymphs were sculpted so as to attach them organically to their bases. Lumps of pinched or knife-marked clay or rough chiselled marble grew around and under the figures. Of the many reasons for Rodin's lifetime habit of giving certain figures more than technically adequate supports, one was his desire to associate his process with Nature's so as to remove the element of pomposity and finish which preoccupied the Ecole. Rodin did not so much 'eliminate' the base as treat transmutation as a fact:

> Nature offers symbols and synthesis on the breast of the strictest reality. It suffices to know how to read them. Sometimes a knot of wood, a block of marble, by their configuration have given me an idea, the direction of a movement; it seemed that a figure was already enclosed there and my work consisted of breaking off all the rough stone that hid it from me.[61]

The description fits the gouache and sepia textures of the Dante drawings which ranged from slimy to crusty or eroded and which were made starker and more

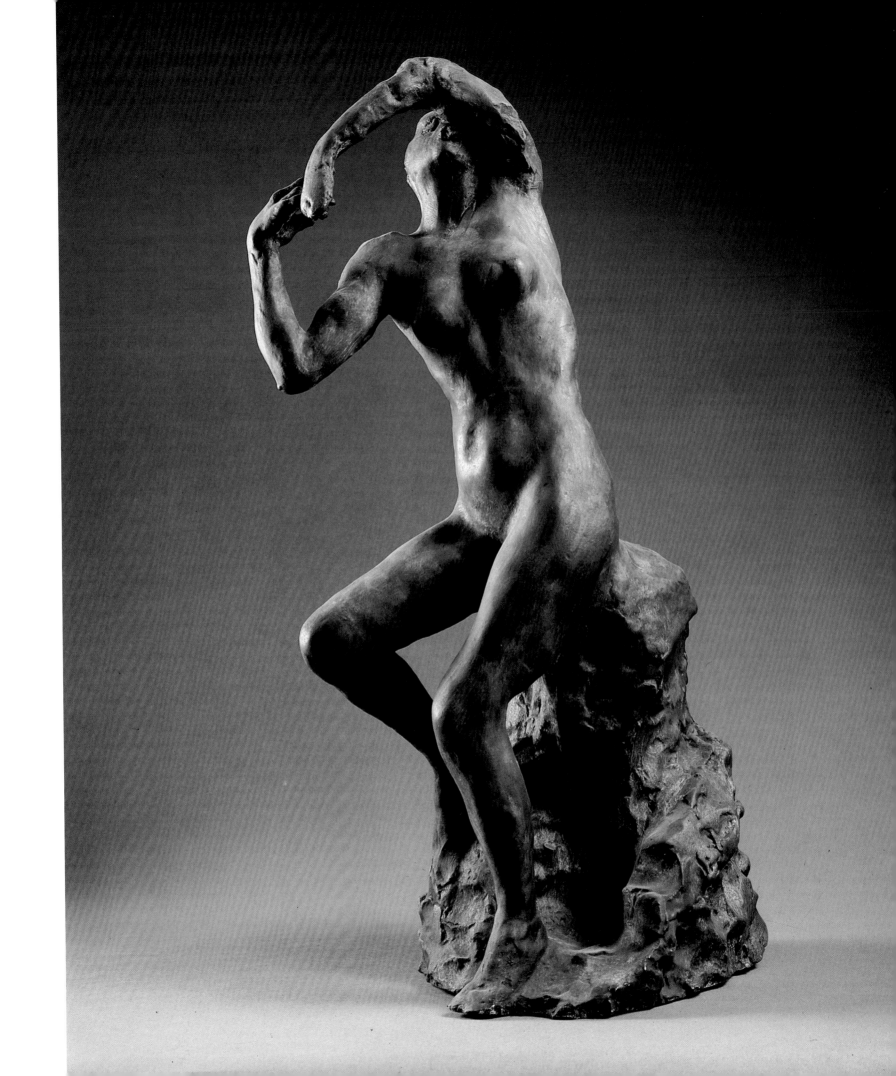

independent of the artist when cut out and collaged onto a new surface, as happened in the biomorphic group of father and sons annotated 'la chêne'. Rodin was more than capable of understanding the rallying cry of the next generation, 'la taille directe', which described those who believed the guidance of a pointing machine and maquette hindered the discovery of pure form. Where Rodin differed, say from Brancusi and Moore, was in his overwhelming desire to make each element, the shoulder blade or elbow or stump of a severed arm, so vital that the shape on its own could take the viewer's (and author's) breath away because it would seem to have an unpredictable existence of its own.

Rodin's library contained several copies of the *Metamorphoses* as well as Ovid's complete poems and the *Art of Loving*. It was not uncommon in the late nineteenth century to read Ovid: the Symbolists did, and he was still popular with the generation of Maillol and Faure. Ovid's view that the downfall of mankind was caused by physical desire accorded with the importance Rodin attached to what he admitted were the 'stirrings of the brute'.[62] These might be reprehensible in themselves but in the service of creation provided the stimulus and the yardstick by which one made art and judged its power to arouse strong feelings, the drive of the 'maddened beast'. Acknowledging the unstoppable

151 *La chêne*, Goupil Album, pl.52.

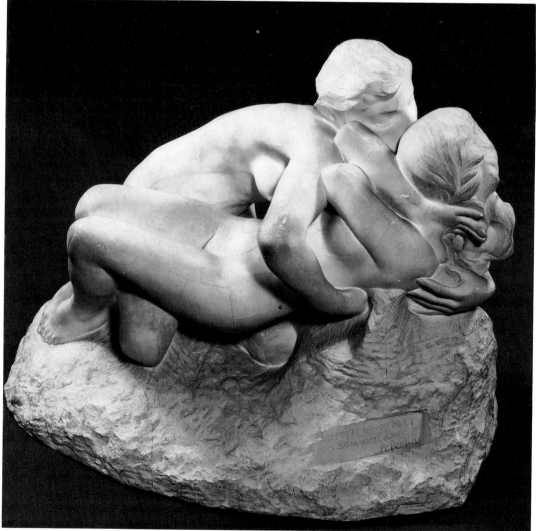

152 *The Metamorphosis of Ovid*, 1886, Victoria and Albert Museum (cat. no. 79).

flow of transgressions fuelled by the male species—especially greed, conceit and brutality as well as ordinary lust—as positive when harnessed to creativity, was one way of offering a view counter to the more common nineteenth-century one of the downfall of man being attributable to Eve alone and completely regrettable. Rodin believed in a special license for creative minds but its permissiveness clashed at times with his conventional Roman Catholic upbringing according to which lust was something to be fought and adultery sinful.[63]

Comparisons between Rodin's attitudes and those of Hegel, Schoenhoper and Sigmund Freud have been made. The problem about ascribing an influence or even similarity is Rodin's easy absorption of current beliefs without ever engaging in a true dialectic. Freud classified and analysed parts of human behaviour patterns which had already fascinated Rodin and his contemporaries: the idea of frenzy bordering on hysteria, carnal appetites allied with incest, and accidentally associated images belong to late nineteenth-century art.[64] Hegel's ideas, no doubt repeated by Charles Morice, a critic and collaborator from the

154 *La Mort des amants*, Musée Rodin (cat. no. 100).

155 *Satan and his worshippper* (cat. no. 103).

157 (facing page) *Torso of the centauress*, Musée Rodin (cat. no. 45).

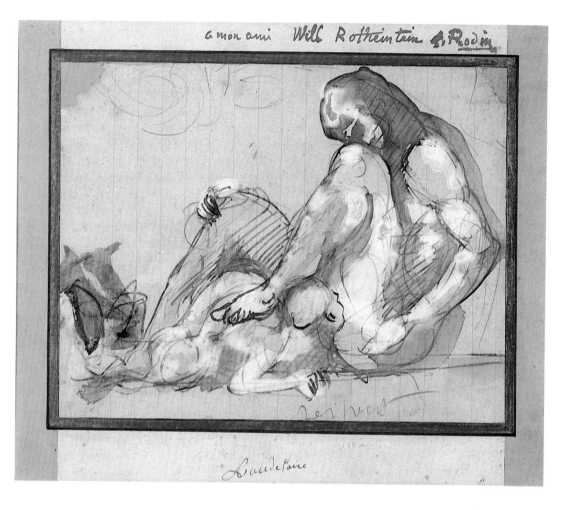

156 *Minotaur*, c.1886 (cat. no. 119).

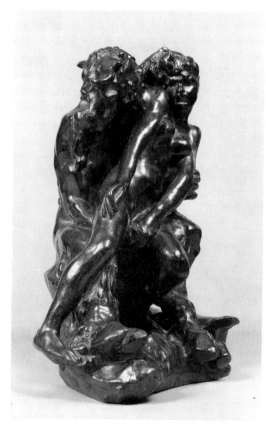

late 1890s, about life as a process of becoming would have appeared to Rodin as a logical and true, indeed in accordance with his persevering approach to themes and materiality upheld over a lifetime.[65] The cycle of developing, revising and reassembling parts and contemplating a specific feeling and contour for years or even decades was part of Rodin's strength and in keeping with his respect for the mystery of visual forms.

Rodin's English friend, the Symbolist poet Arthur Symons, understood his philosophy, if it can be called that:

> Rodin believes, not as a mystic, but as a mathematician, I might almost say, in that doctrine of 'correspondences' which lies at the root of most of the mystical teaching. He spies upon every gesture knowing that if he can seize one gesture at the turn of a wave, he has seized an essential rhythm of nature. When a woman combs her hair, he will say to you, she thinks she is only combing her hair: no, she is making a gesture which flows into the eternal rhythm, which is beautiful because it lives, because it is part of that geometrical plan which nature is always weaving for us. Change the gesture as it is, give it your own conception of abstract beauty, depart ever so little from the mere truth of movement, and the rhythm is broken, what was living is dead.[66]

Rodin conceived the tympanum of the *Gates* in such a way that it could accommodate a crowd of small figures with generic identities. *Invocation*, a seated woman with arms raised in a loop, is conceived as if her form had been pulled from a single lump of clay, continuous from foot to fingertip. The

depressions and swellings depart from straightforward anatomy in order to express a concept of transparency—that is, the inner life of the subject, physical and emotional, determines the modulations on the exterior surface; but these depend as well on the sensibility and circumstances of the particular artist, so that the irregular shapes—bulges, valleys, transitions and under-cuts—are not fortuitous or expressionistic but necessary. The equally beautiful *Torso of the Centauress* was made of an assembly of a torso and the head from *Fugitive Love,* thrown back, mouth open, large in relation to the torso which seems drained of fat and was cut off at the top of the legs. Previous formulas for the most connotative parts of the body, particularly in the breasts and pubic dome, were ignored, with the result that no one part detaches visually from the fragment: the metaphor of the soul struggling to rid itself of bestial desires is within. Not all works were made with such perfect economy. The reclining girl with legs in the air who lies on the floor of the tympanum, head to the viewer, called *Study for a Damned Woman,* is cruder too in her shamelessness. Yet the idea of transferring a position of extreme informality and intimacy to the edge of the proscenium-stage-like architecture of the tympanum makes up in its boldness for the lack of surface reverberations.

By 1884 Rodin was producing small sculptures by the dozen and, perhaps frustrated by the way they were theoretically destined for minor roles in a monument now with an uncertain ultimate location, he started enlarging a few to life- or nearly life-sized scale, thus preparing for casting in bronze and exhibiting. The increase in scale went with a more ambitious idea of confronting the viewer with a surrogate human who was unlike previous images of women as passive, untrustworthy beings or mere objects. Rodin's muses would introduce the existential option; they would make man go beyond the 'stirrings of the brute'. Moreover, it is not too far-fetched to claim that as a result of the accident of meeting in late 1883 a remarkable artist, Camille Claudel, and observing closely her presence and body, Rodin himself made a transition. The superb modeller with a quasi-scientific interest in mankind's moments of passion and suffering became the author of works that invoke the tone, pace and unnerving introspection of a particular woman—sculptures more uncompromisingly candid than anyone else had realised. Many of these sculptures, both those dating to the years of their early romance, 1884–88, and those touched by remembrance are saturated with a voluptuousness and with allusions as unmistakably descriptive as those buried in Shakespeare's sonnets that fix his dark lady and their illicit love.

Prior to meeting Camille, Rodin had begun to value the company of women more intellectually stimulating than Rose could be. Thrust into prominence by the scandal over the *Age of Bronze* and the commission for the *Gates,* he was invited to fashionable salons such as that of Mme Edmond Adam whose guests included Antonin Proust and Pierre Loti, or that of Mme Henri Liouville who introduced him to Henri Becque, Stephane Mallarmé and Guy de Maupassant.[67] Rodin remained ill at ease in intellectual society and faithful to his long working hours; however, contact with another class made an important difference. He began inviting men of letters, fellow artists and admirers to the studio and asked several to sit for their portraits. After a visit by Liouville and his wife in December 1883, Rodin wrote, thanking them both for coming and adding sincerely: 'The emotion you show when you see me working and your appreciation of my work make me happy and stronger. I can breathe, and I feel confident.'[68] His need to communicate one-to-one on a visual and spiritual level

became a habit; many of the most perceptive and welcome visitors to the rue de l'Université were women, among them Mariana Russell and Mme Alfred Roll, and later on artists like Hélène Wahl, the writer Judith Cladel, the dancer Loïe Fuller and singer Georgette Leblanc, and other intelligent girls of good breeding, like Hélène de Nostitz. Gradually Rodin's formerly unsophisticated but not surprising self-pity, founded on early neglect, was countered by an appreciation of the possibility of challenging but supportive criticism.

When Rodin was asked in about November 1883 by his friend Alfred Boucher to take his place instructing several young female students who were working together in a studio on the rue Notre-Dame-des-Champs, he encountered two fledgling sculptors of undeniable, intuitive ability: one was Camille Claudel and the other her English friend, Jessie Lipscomb, from Peterborough.[69] Camille, as the nineteen-year-old, middle-class daughter of a barrister and the elder sister of the future diplomat and playwright, the uncompromising Paul Claudel, had already submitted work to the Salon the previous spring. Her family's fears for her respectability were confirmed when she became Rodin's pupil and mistress. Photographs record the fresh voluptuousness of this auburn-haired girl, her full cheeks and lips, the clear, even brow and not least the distracted wild look of her pale green eyes. By November 1885 she and Jessie Lipscomb were installed at the rue de l'Université as Rodin's student/assistants, with Camille referred to in letters as his 'femme de travaille'. She frequently accompanied Rodin on visits to the country, even, according to Victor Frisch, staying with him at the Renoirs' in Cannes. After January 1888 they spent long periods living together in the dilapidated but evocative Louis XVI rooms of the eighteenth-century mansion, known as the 'Clos Payen' or the 'Folie Neubourg', in the 13th arrondissement, near rue de Croulebarbe.

160 *Camille Claudel, c.1886.*

Camille's uncommon spirit and concentration was apparent and remarked upon by others. She became an intimate friend, in about 1888, of the young Claude Debussy, and was the subject of several of Goncourt's entries in his Journal. On 8 March 1894 he wrote: 'Evening at the Daudets'. The Claudel girl, Rodin's pupil, was there, wearing a sleeveless blouse embroidered with large Japanese flowers. She has girlish look and beautiful eyes, and makes witty comments with a heavy peasant accent.'[70] From the beginning her intensity bordered on the hysterical and soon after she became Rodin's mistress he was writing to Jessie Lipscomb while the two girls were in Peterborough asking her to intercede on his behalf, referring to Camille as 'our dear obstinate female', 'she is so talented and so simple', and asking Jessie to continue to plead 'my case although it is hopeless'.[71]

161 La Clos Payen (or le Folie Neubourg), Paris (now destroyed), Musée Rodin.

Rodin seems to have treated her art seriously from the beginning. Whenever questioned about his influence on her style, which is undeniable, he stressed the reciprocal nature of their relationship; he told the critic Mathias Morhardt: 'The joy of always being understood, of always seeing my expectations surpassed has been one of the greatest joys of my life as an artist.'[72] Thinking of the originality of her art, he made the sincere statement so often quoted: 'I showed her where to find gold, but the gold she found was her own.'[73] Even after they parted around 1897 Rodin remained steadfast and sincere in his advocacy, recommending her work to critics and collectors and in his will stipulating that a room in the future Musée Rodin be reserved for her sculpture. Octave Mirbeau and Rodin both considered her 'quelque chose d'unique, un revolte de la nature, *une femme de genie*'. It can be fairly said that, given the lack of opportunity for female sculptors in the late nineteenth century, Claudel's work was able to blossom in

158 (facing page top) *Torso of the centauress*, Musée Rodin (cat. no. 45).

159 (facing page bottom) *Study for a Damned Woman*, 1884 (cat. no. 89).

162 Camille Claudel, *Giganti*, 1885, Musée des Beaux-Arts, Cherbourg.

the professional environment of Rodin's busy studio where other talented sculptors like Jules Desbois were working. Rodin's criticism and the example of his persistence probably made Camille more adventurous and less susceptible to a latent naturalism verging on the hackneyed. She began modelling her own versions of several of Rodin's well-known sculptures: a crouching man, a squatting woman, terracotta sketches of an embracing couple roughly made and several excellent portraits of Rodin's studio models such as the one entitled *Giganti,* the tormented young man with the deep-set eyes of Rodin's *Danielli.* Her much-reproduced bust of Rodin executed in 1888 compared the severe contour of his skull with the lively mass of his beard.

Several of the most Rodinesque subjects were also sculpted by Jessie Lipscomb with much the same freshness and plasticity but never the same interest in the idea of the correspondence between extreme emotion and the life of the material in the hands of the artist. Moreover, it may be that the fanaticism and melodrama of Camille's sculpture had an influence on Rodin's work, on pieces such as *Orpheus and Eurydice leaving Hell* (*c.*1889) and the Hercules on the *Monument to President Sarmiento.* Claudel's *Clotho* and her *La Valse* use webs of clay fabric to suggest the claustrophobic, entangling misery of a doomed love affair. In 1888 she made a feminine interpretation (called variously *Cacountala, The Abandoned* and *Vertumne et Pomone*) of the embrace of a man on bended knee pressed to the bare, warm front of a seated woman which is seen in Rodin's *Eternal Idol.* In Camille's work the girl expresses her passion in an unmeasured way, as though it has soaked through her body and been squeezed out so that she is left powerless. Paul Claudel, in a typically insinuating tone, stressed the difference between Camille's interpretation of the theme and Rodin's *The Kiss*; he claimed that, whereas Rodin's Paolo holds the woman and 'is sitting down so as to take best advantage of the fact . . . [that] she as the Americans say "delivers the goods"', the man in Camille's sculpture embraces not merely an object but an ideal; the pure woman 'is silent, heavy. She surrenders to the weight of love. One of her arms dangles loosely, like a branch laden with fruit. The other covers her breasts and protects her heart, the final refuge of her virginity.'[74] It is true the girl seems both ardent and chaste; her downcast face and dangling left arm, like that of Rodin's Michelangelesque *Adam,* are clear symbols of submission.

Camille's masterpiece *L'Age Mûr* is expressly autobiographical. A kneeling girl implores a standing man to come to her but he feels powerless to resist the stronger pleas of an older woman. The preliminary studies have the simplicity of avant-garde theatre: three unadorned, unidentified characters are asking for unobtainable assurances. In the final bronze a curtain of clinging matter around the rapacious older woman exaggerates the confusion of the shrunken, quivering man who has lost his physical and emotional equilibrium. Anne Pingeot, writing about *L'Age Mûr,* which is in the collection of the Musée de la ville de Paris, recognized that Camille departed from the stable solids which Rodin and most sculptors used as their 'plans': 'she forced the spectator to recompose the next, inevitable phase in his mind's eye'.[75] Curiously there are sculptures and drawings of Rodin's made in the early 1890s, for example, the *Sorceress* (1895) and the *Hero* (*c.*1896), which draw on the same equation between desolation or madness and an oblique composition. Rodin's 1887 drawing for the Baudelaire poem 'The Wine of Lovers' shares this beseeching attitude.

Camille continued to exhibit regularly at the Salon and works of hers were included in Rodin's exhibitions abroad, for instance, that in Geneva in 1896. A few late pieces, like the jade *Gossips,* are inspired and even humourous; many

163 Camille Claudel, *L'Age Mûr,* 1896, Musée de la ville de Paris.

more such as *Perseus and Gorgon* are mannered.[76] Despite the efforts of Rodin, Morhardt, Mirbeau and others to convince collectors and officials of Camille's importance, and despite the fact that her work was shown regularly at the gallery of Eugène Blot in the early 1900s, she gradually ceased working as her mental health deteriorated. During these years she became a recluse with macabre and self-destructive habits until in 1913, following complaints by her neighbours on the quai Bourbon, the starving, crazed Camille was sent to a hospital where she remained in care, pathetic but not utterly mad, until her death thirty years later.

Strangely, although Rodin could be fairly accused of treating women in many sculptures as though they were palpable and febrile, the sculptures which are specifically identified with Camille's body are saturated with an addiction to her mysterious powers that was removed from the ordinary kind of physical idolatry. *Meditation* is the piece most descriptive of Camille's specific vulnerability and sensuality, and yet the work is hardly a direct reaction to her form. The legs come from the study for *Eve* (in turn inherited from Michelangelo's Slaves) and the face is not portrait-like but classicized, with bulging eyes and aquiline nose. Only the middle, the torso, has the thick, short-waisted, ripe look of Camille. So exaggerated is the contraposto, that the line between the raised left knee and its counterpart is at right angles with the shoulder axis. This pincer movement enshrines the erotic stomach mound, not regular itself but conveying what Rodin called 'the infinite undulations of the valley between the belly and the thigh'.[77] Measuring only 78 cm in the first version, a bronze set on a small oval mound, (and designed to be placed in the right-hand corner of the tympanum of the *Gates*), *Meditation* is a drawing-room sculpture, albeit an exceptional one. The more it is looked at from above and below, the more marvellously syncopated and indispensable appear the pattern of triangles.

In the version enlarged to 158 cm, known as the *Inner Voice,* the arms and knees have been roughly removed leaving a jagged surface of broken plaster. Seen from the right, huge feet grow out of a bulbous base and are echoed by the cluster of half-spheres on the chest. From the front the bracket-like bend suggests a quiet sadness and her role as guardian of female secrets, while from the left the lopsided mass of head and shoulder leans like a swaying tree-top, just remaining upright by virtue of the spindly remains of the legs. The messages the mind receives synthetically and intuitively are more like the cyclical ideas of Indian sculpture, simultaneously ominous and beneficient, active and still, than the geometries of Western art to which Rodin subscribed in his Michelangelesque phase. The *Inner Voice,* placed in the Salon of 1890, was one of the first obviously fragmented works to be exhibited; the iconoclastic reference clear enough. Rodin explained to Vollard his method of improvising something seen afresh in a new size:

> I am giving away one of my secrets. All those trunks that you see there, so perfect in their forms now that they no longer have heads, arms or legs, belonged to an enlargement. Now, in an enlargement, certain parts keep their propotions, whereas others are no longer to scale. But each fragment remains a very fine thing. Only, there it is! You have to know how to cut them up. That's the whole art.[78]

Rilke observed that in the mid-eighties the character of Rodin's description of desire changed. His youthful transcriptions of Michelangelo's flaccid, self-contained *Ignudi* were giving way to a fascination with a world beyond the call of

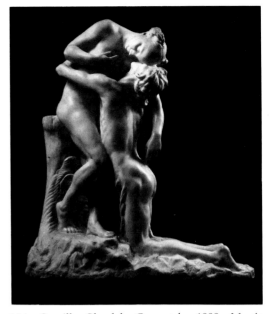

164 Camille Claudel, *Cacountala*, 1888, Musée Rodin.

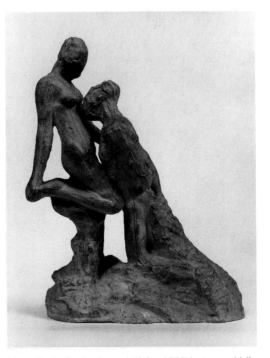

165 *Study for the Eternal Idol, c.*1889 (cat. no. 116).

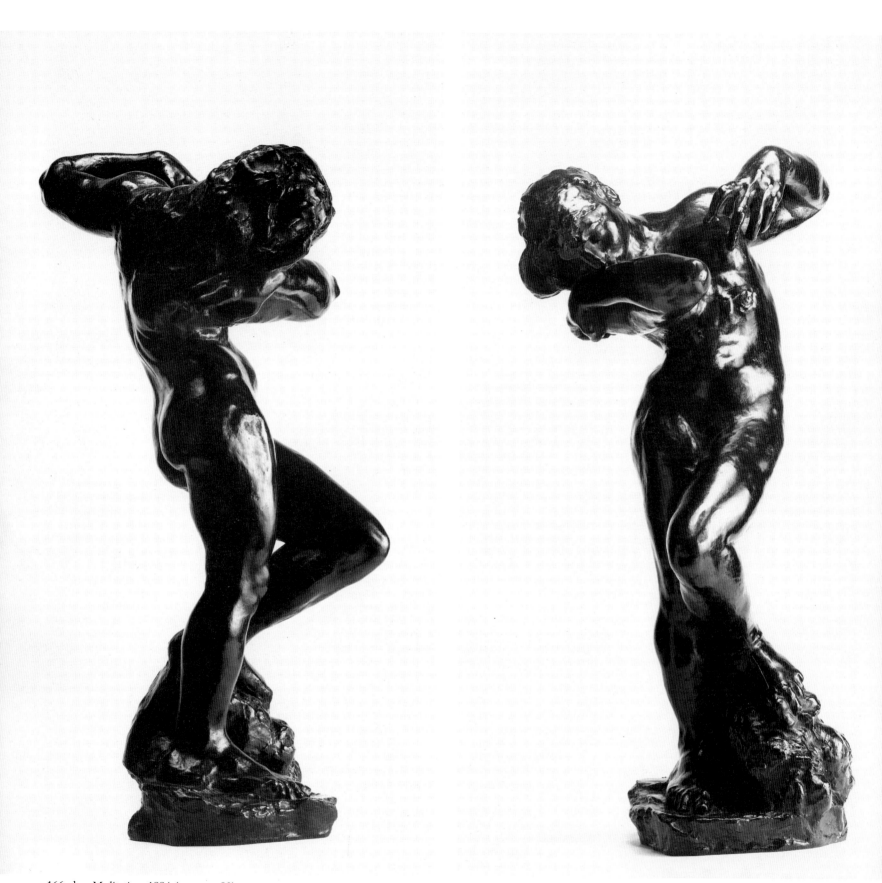

166a,b *Meditation*, 1884 (cat. no. 80).

167a, b *The Inner Voice* (*Meditation* without arms), Victoria and Albert Museum (cat. no. 106).

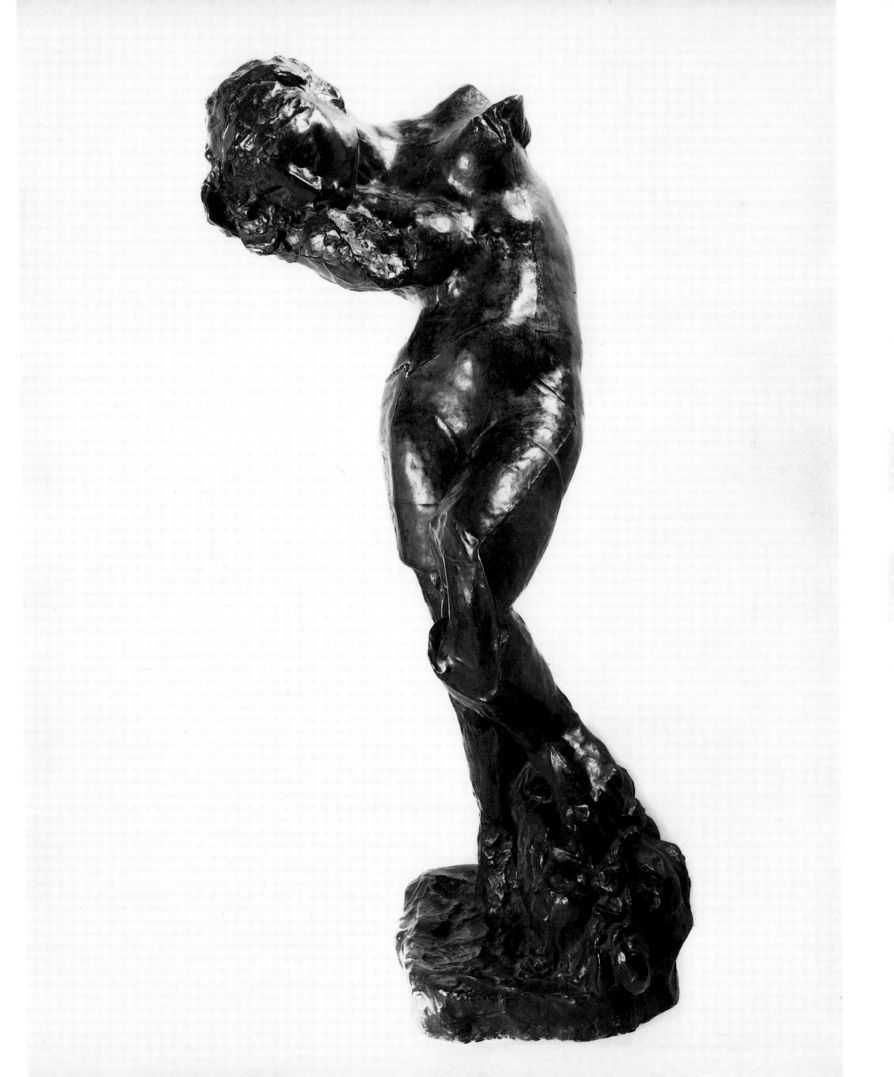

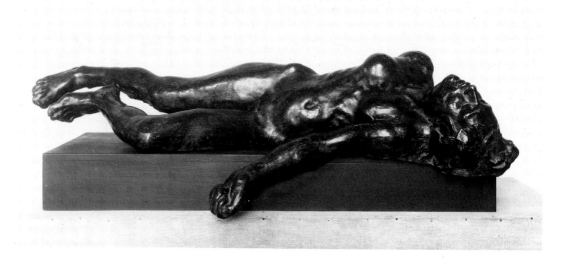

reason, and beauty. Statues appeared, as the young poet put it, 'unknown to the great Florentine'.

> The depths of nights of love unfolded to him: dark expanses full of lust and grief, in which, as in a world still heroic, there were no garments, where faces were extinguished and only bodies mattered . . . here were vice and blasphemy, damnation and blessedness; and suddenly one understood that a world which concealed and buried all of this, which tried to act as if it didn't exist must be very impoverished. It existed.[79]

Many pairings of fragments are no longer at all appealing or even biologically comprehensible. More and more indirect references are made to abstract momentums—of rolling or dividing or withdrawal, at the same time ponderous and weightless, disturbing what Hannah Arendt identified as the 'bodily part of human existence that needed to be hidden in privacy, all things connected with the necessity of the life process itself . . .'.[80]

The stiff figure with arms outstretched and neck wrenched called *The Martyr* was inserted several times in the *Gates*. It is not necessarily a portrait of Camille, but the convulsive state expresses Rodin's mistress's self-destructiveness and doom, especially in the adaptions made after 1885. When the enlarged *Martyr* is shown as a reclining figure, face upwards, it overhangs awkwardly any plinth, speaking clearly of the paralysing effect of an excess of passion. Floating above a kneeling figure in the sculpture *Orpheus Imploring the Gods* (1892), it is used in a composition which was favoured by the Symbolists, to suggest the unique rapport between an artist and his muse. But Rodin's interpretation, perhaps influenced by the agonies he and Camille were suffering because he refused to abandon Rose, shows in the face and in the strong, straining physique his compassion for her pain, more intense because of her inability to conform to society's ways and thus her inability to recover from the termination of their relationship. Small studies of the mid-1880s, like the tiny standing couples *Sin* and *The Ascendency,* project the woman as the more rapacious partner. In *Sin* a rubbery figure with tentacle-like arms and legs wraps herself around her stiff partner, who was described in Rodin's exhibition catalogue of 1900 as her 'unresisting prey', reflecting Rodin's and the period's interest in perversion and in women as vampires. Curiously Rodin chose to include this minute, obscure piece in his entry in the international exhibition at the Galerie Georges Petit in

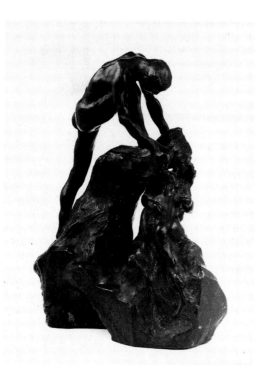

169 *Polyphemus and Acis*, *c*.1886, Fine Arts Museum of San Francisco (cat. no. 113).

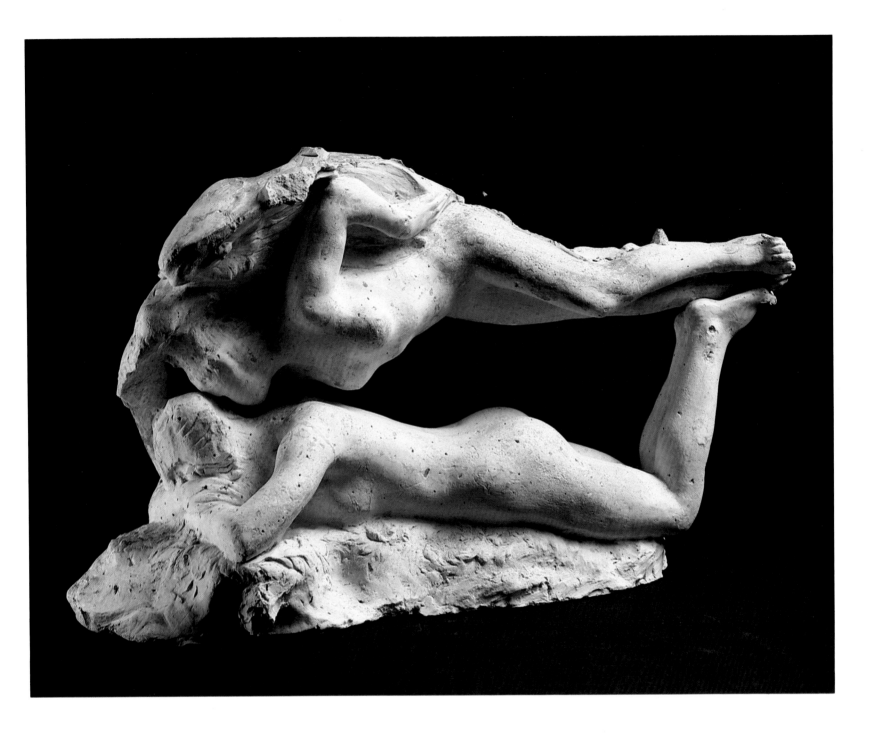

170 *The Dream* or *The kiss of the angel*, before 1889, Musée Rodin (cat. no. 91).

1886 where the more easily understood and commercial *Fallen Caryatid* and *The Kiss* were displayed. Rodin was committed even at this early stage to observing both the appealing and the threatening sides of unrestrained physical passion. His candour, which shocked most viewers, was a part of his honest admission that he too was caught up in the irrational course of love, that he could not provide a framework like Dante, but only those observations he knew were true to life.

The marvellous reclining figure, face down, called *Earth* (1884) expresses feelings of solitude, of 'listening to one's own depth', without depending on the beguiling contraposto of *Meditation*. Static when viewed laterally, at three-quarter angles the biomorphic volumes set up a seismic cadence. *Earth* can obviously be read metaphorically, the primal being representing humanity raising itself from pre-Dawn chaos. Equally *Earth* is part of Rodin's rejection of

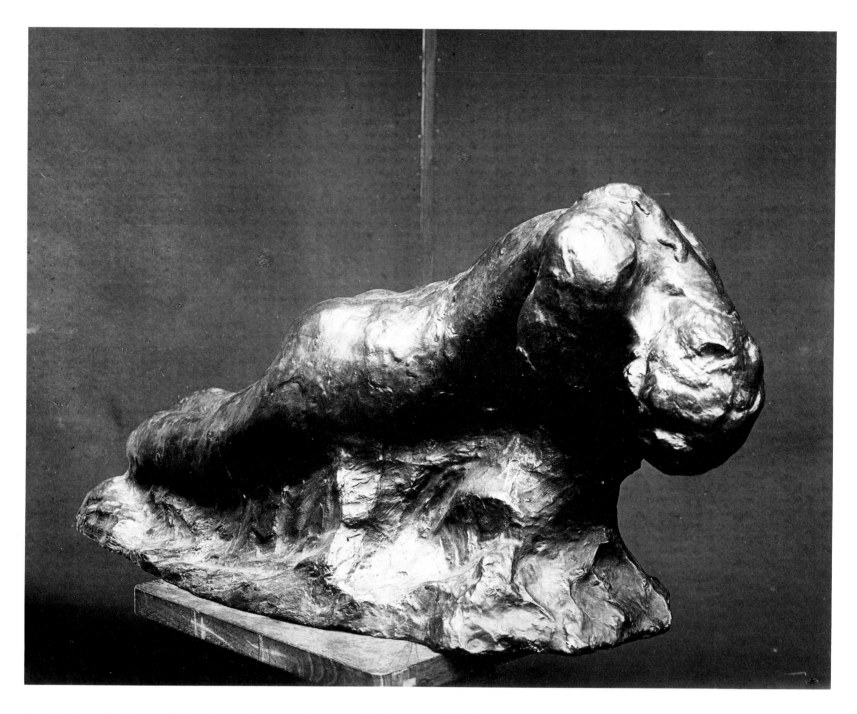

171 *Earth*, 1884, photograph by E. Druet, Bibliothèque Nationale, Paris.

the monolithic view of the human body and his fixation with the delicate balance between a state of consciousness and unconsciousness. A work entitled *The Dream* is a quieter, more lyrical version: the kneeling siren, smooth-skinned and wholesomely seductive, lies on her stomach, while balanced on her shoulders and buttocks is another girl with a wing-like appendage (who eventually turns into the *Illusion of Icarus,* a future sculpture). When, in a little-known sculpture, this second female is turned on her back, she becomes a young girl half raised from her rocky bed by the kiss of a male phantom. The analogy with pubescent awakening is obvious but the work seems also to consider the intellectual awakening of the female, the sexes reversed from the normal male creator and female muse.

When around 1885 the figures for the *Gates* had become a force of their own and Rodin was content to let them stand in the studio, available, because he liked

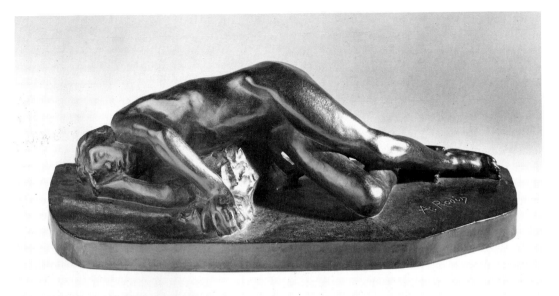

172 *Fatigue*, before 1887, B. Gerald Cantor Collections (cat. no. 88).

making minor changes and working in their company, he continued to be obsessed with the idea of coupling, particularly with permutations and hybrids of existing pieces, very often of different scales. The idea of a process of continual transmogrification suited his additive, meditative view of art and accorded with his understanding of 'coupling' in both senses of the word, the making of new meanings and new geometries through observation of Nature's patterns:

> The most important thing about love is Coupling; everything else is simply a mass of details. They may be charming, but they are no more than details. It is the same with Art; we need the essentials, the planes . . . volume—height, width and depth—has to be respected and rendered accurately from all sides, and, I repeat, it is the movement of these volumes which establishes a new equilibrium. The human body is a walking temple, etc., and, like a temple, there is a central point around which the volumes settle and spread.[81]

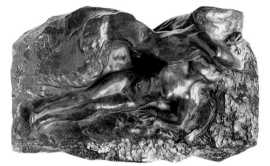

173 *Young woman kissed by a phantom*, 1880s, Reading Museum and Art Gallery (cat. no. 111).

The rude force that began with the *Crouching Woman* and was developed in *Meditation, Martyr* and *Earth,* turned into almost a mystical fascination with the primeval matter which could be identified with the male and especially the female principle. As limbs or heads are broken off and forms made monstrous by enlargement, the clay is treated variously so as to suggest the sliced, pinched or aerated look of volcanic rock or of throbbing living matter. For every serious work, there are curiosities such as the *Zoubaloff Fauness* who appears to be eating her hair in a orgasmic fit, but is formally a marvellous sequence of cross-axes. Rilke wrote to Clara Westhoff of a conversation with Rodin during which he fixed on the term 'modelé' as an explanation for the unpredictable happenings in the studio: 'on all things on all bodies, he detaches it from them and after he has learned it from them he makes of it an independent entity, that is, a work of sculpture'. This theory and practice are epitomized by the 'Iris' figures of the 1890s and the many life drawings that followed. Both are inconceivable without the commission for the *Gates of Hell* which led Rodin beyond his own expectations. After several years of experimenting with small writhing bodies in a turbulent field he was absorbed in the haptic force of art. Nothing polite or visually diminutive could excite Rodin's imagination sufficiently to portray the 'depths of nights of love'.

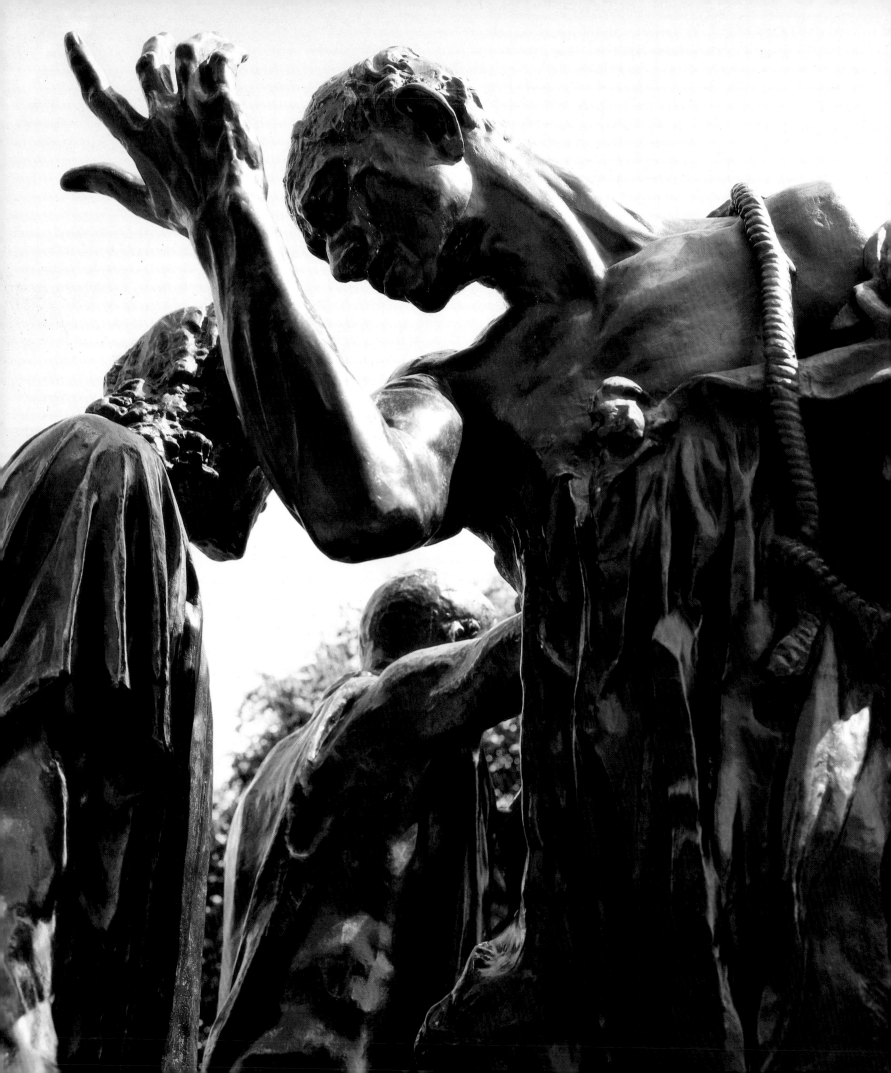

The Monuments

AFTER FOUR YEARS' intensive work, by the autumn of 1884 the unity of the *Gates of Hell* depended on an impression of erogenous activity and sweeping lines with no stable focal point. The original narrative idea of compartments had been turned into a quintessentially pictorial concept. The change had originated with the advent of the mesmerizing feline figures like *Adèle* and the *Prodigal Son*. Rodin was continually modelling hand-held images, mainly female, and then combining them into intertwined units which were arranged optically against a flat background, some upside down or partially submerged. Instead of a hierarchy of principal and subsidiary scenes, Rodin allowed a flux controlled by colour—that is light and shadow—and density and space. Each female portrayed had an aroused, sinuous aspect to her physical being, but very little facial character. Many were conceived as mute, inward-looking and thus anonymous. When these women enticed men into their spheres they rapidly became frenzied and their movements angular and distraught. The whirlpool nature of the design of the *Gates* was repeated in each of its elements.

This complicated project which intrigued Rodin—and his audience—to the extent that he could never disengage or conclude it, was certainly not representative of his entire ambition for his sculpture. He had set out to observe the physiques of common people. His declared moral stance was that the meaning of life was best expressed by actions taken directly from nature, not fabricated by art styles or allegorical conventions. In a way the *Gates* were a contradiction and their miniaturist scale an anachronism in terms of his development: Rodin's ideal image of the male species, at least, was an alert, naked, life-sized figure with a readable physiognomy and unrehearsed gesture. And yet the *Gates* had so changed Rodin's ambitions and practice that he could hardly contemplate a large multi-figured piece, such as the *Burghers of Calais*, without opening his ideas to the pictorial and psychological possibilities.

Rodin's career had been launched by his interpretation of the lithe soldier Neyt who modelled for the *Age of Bronze*, and it was still his most widely known sculpture. He had been very excited when the critic Edmond Bazire in his article of September/October 1883 on the Salon had seen that 'this standing figure of a slender, handsome young man has all the rugged grace of primitive times, when creatures could show themselves without any regard for civilized prudery'.[1] As a point of democratic principle Rodin himself believed each individual, regardless of age or social origin, was intrinsically noble, each a microcosm of the divine maker. Thus, the peasant Pignatelli, 'that rough, unkempt man' who expressed 'in his bearing, in his features, in his physical strength all the violence, but also all the mystical character of his race', could be called upon to represent his historical figure of St John the Baptist. He, in turn, was described by Rodin as 'a man of nature, a visionary, a believer, a forerunner come to announce one greater than himself'.[2]

In his treatment of the first completed sculpture for the *Gates*, *The Thinker*, Rodin had tried to demonstrate his belief in the coincidence of utmost naturalism and universality. He faithfully interpreted the physique of a plebeian model

174 *The Burghers of Calais*, Palace of Westminster (detail).

101

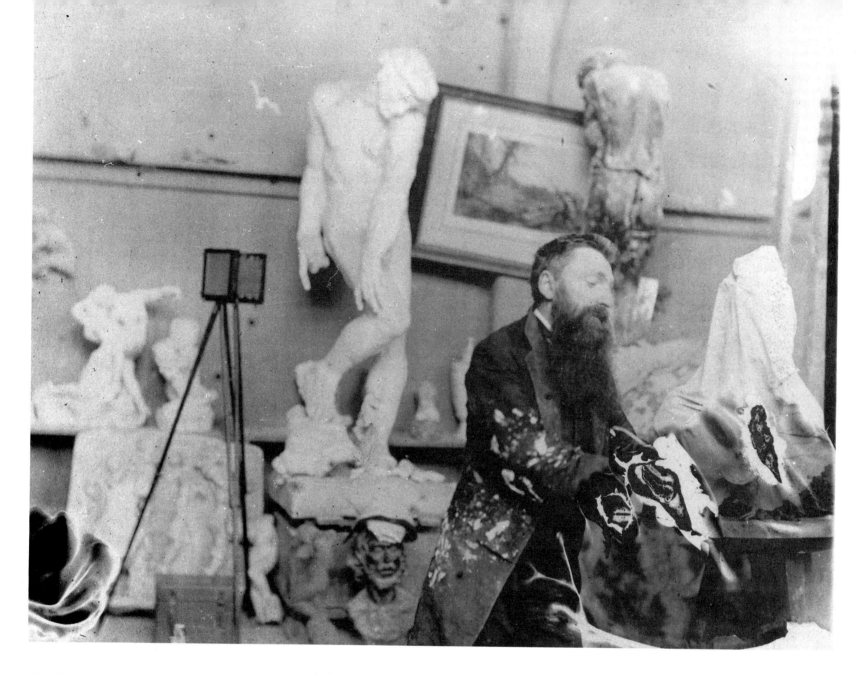

175 Rodin in his studio with *Adam* and *Eternal Springtime*, *c*.1887, collection of the grandson of Jessie Lipscomb.

while at the same time shadowing the poses on the Medici tomb. The emotional constraint, evident in the free interpretation of muscle-bound parts and the facial expression which combined comprehension and bewilderment, was 'realistic' in a new way. Formally, however, *The Thinker* was a self-contained figure, one best seen in isolation, hence rather out of place presiding over the confusion and freedom of the *Gates*.

An opportunity to return to working on large-scale, heroic figures came to Rodin just as work on the *Gates* was reaching a climax in late 1884. Calais intended to commemorate the rescue of the city in 1347 with a statue of the leading burgher, Eustache de St Pierre.[3] Hearing that he might receive the commission, Rodin set to work on a maquette for the monument which would encompass in addition the other five burghers who had offered their lives (but whose names were not all known until 1863). Once the commission was official he hired more assistants and rented a second studio, a 'large shed' at 117 boulevard des Vaugirard, promising to finish the staggering task by early 1886.[4] The second establishment soon contained a conceptual and formal alternative to the Dépôt des Marbres.

The forthright Edmond de Goncourt made his first visit to both locations in April 1886 and characteristically summed up Rodin's lack of overall direction in an instant. He arrived at a point when Rodin was nearing completion of three burghers, each measuring over two metres, and was about to put on public display for the first time at the Galerie Georges Petit several of the radically sensuous figures intended for the *Gates*. Goncourt described Rodin as a man 'with common features . . . a head suggesting gentle, stubborn obstinacy—a man such as I imagine Christ's disciples looked like'. What caught his attention was the contrasting ambience of the two studios; he recorded in his diary: 'the boulevard des Vaugirard contains a wholly realistic humanity; the studio of the Ile des Cygnes [i.e. the rue de l'Université] is, as it were, the home of a poetic humanity'. In between the massive clay figures of the burghers he observed a model 'stripped to the waist who looked like a stevedore', whereas in the other studio there was 'a whole world of delightful little figures' which he compared to the tumultuous multitude in Michelangelo's *Last Judgment* and to Delacroix's crowd scenes.[5]

Although divided, crudely speaking, by their imaginative versus realistic themes, the two commissions actually progressed by much the same method. That is, from the start the *Burghers* profited from the way Rodin had been handling the 'research' activity of the *Gates*. In the years before his talent was recognized, Rodin, with limited resources and anxious to impress, had been prepared to persevere with the modelling of monolithic figures such as the ruined *Joshua* and the ultimately fragmentary first *Ugolino*. The clay was worked and re-worked until it stood for the sum of his feelings on the subject. By 1884, after four years' frenetic activity on the *Gates*, his attitude had changed and he had grown accustomed to deriving inspiration from quick sketches of the model in a moment of arrested action. The initial ones were deliberately impressionistic and provisional. As the ideas were stepped up in scale and detail an intentional diffusion would enter his process: he not only allowed himself time for experimentation and chance but he deliberately separated out the ideas into individual statements. A complex theme was best conveyed not by a compendium of thoughts injected into a single statue, but by a tableau-like composition within which there was a spatial and structural as well as an emotional dialogue.

An assistant of a later period, Victor Frisch, described how Rodin worked: 'his gaze would be fixed on the model while his hands shaped the yielding clay—which no more demanded his eyes than the keys of a piano require the constant vision of the musician'. After twenty or so miniature modellings each more precise, the bodies becoming individualized, the plaster casts were made. The concept was scaled up in stages. At each, plaster casts were kept 'so that they might be drawn out of their cupboards to serve in other figures'. Once he reached the final scale, he slowed down and 'it might be more months that this clay statue would stand in the studio, carefully kept moist so that the master's hands could refashion it still, before he gave the order, and the workmen came to make the final casting'.[6]

The first maquette for the *Burghers of Calais*, like those for other commissions, announced the germ of Rodin's idea and served as part of the formal agreement. Maquettes and studies often justified Rodin's pursuit of a particular concept when at later stages the advisory committee began to voice doubts. Progressively more detailed studies were tendered in return for what he called the 'petites provisions' that kept the studio financed.[7] As with other sculptors the studies were ways of testing and rejecting poses and arrangements. What was unique to

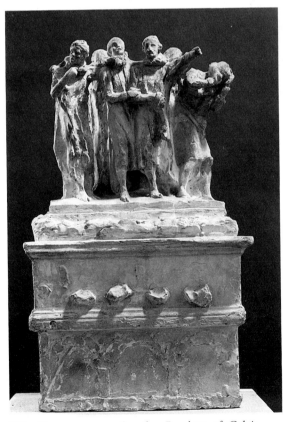

176 First maquette for the *Burghers of Calais*, November 1883, Musée Rodin.

177 Assemblage of the *Head of Pierre de Wiessant* and a female nude, Musée Rodin, S404.

Rodin was his taste for the intermediate stages as works of art in their own right. This accorded with his relish for the accidents of the piece-mould casting process: the seams, air bubbles and dollops of liquid plaster, as well as remnants of the clay stage—the supporting mounds and finger and cloth imprints. All these were placed on a par with the artist's own touch. By the mid-1880s manoeuvres like sawing off appendages, resetting joints and grafting on foreign parts were becoming essential to the highly staged but deceptively natural effect: each extension and each cavity had to be orchestrated, the eye kept moving from one element to another. Rodin defended the synthetic process: 'When painters and sculptors bring together different phases of an action in the same figure, these do not proceed by reason or by artifice. They express quite naively what they feel.'[8]

Fascinating and full documentation exists for the *Burghers of Calais*. More than one hundred three-dimensional studies survive, nearly all in the reserve collection at Meudon. They include not only the maquettes and familiar one-third sized studies, but a mass of heads, headless figures, hands, feet and distinct sequences of one element, such as the facial masks of Pierre de Wiessant and Jean d'Aire. The final monument measures $2.21 \times 2.45 \times 2$ metres and exists today in eleven casts, the first executed in 1889 and finally installed in Calais in 1894, and three more completed in Rodin's lifetime.[9] Additional to the stock of preparatory works and the bizarre use of partial figures (like the montage of a female torso and a head of Pierre) are the numerous commercial reductions that began to be editioned and marketed in the 1890s. The written documentation centres on the correspondence between Omer Dewavrin, the mayor of Calais, and Rodin, starting in November 1883 and continuing regularly until August 1895. The letters refer to the artistic, political and financial issues connected with the commission, and, like the voluminous press coverage, suggest that the ten-year saga was of great interest both to the local population and to the Parisian art world.

Rodin's name was recommended to P. A. Issac, the chairman of the Advisory Committee, by Jean-Paul Laurens, a painter friend and neighbour of Rodin's in the rue de l'Université.[10] The suggestion was a credible one given Rodin's by now regular entries in the Salons. New work consisted of much admired portrait busts (including one of Laurens in 1882) and was reinforced by the increasingly esteemed large figures, the *Age of Bronze* and *St John the Baptist* which reappeared in exhibitions in Paris and London in the period 1882–84. Rodin had rapidly become respectable in the eyes of politicians, some of whom he met in fashionable salons like Henri Liouville's. Rodin, on his part, through his attentive letters assured the Calais committee that the subject would occupy the forefront of his efforts; he welcomed the opportunity to make a work which embodied both patriotism and sacrifice.[11]

Rodin's point of departure was a particular passage from the fourteenth-century chronicle of Jean Froissart. It described the six prosperous leaders of the city, dressed only in sackcloth and bound by a halter, about to set out for the camp of England's King Edward II to sacrifice themselves in return for the lifting of the devastating eleven-month siege of Calais. Rodin thought immediately of creating the kind of spectacle re-enacted in religious processions when the crowd witnesses the martyrs being led away. In the first maquette the burghers were literally bound together by a thick rope, the implied humiliation contrasting with their courageous demeanours. The figures were arranged in a ring, four in front, two at the back, and raised on a rectangular coffer which in reality would set them well above head-height. Rodin explained to Dewavrin that 'the

grouping of the six figures sacrificing themselves has an expression and an emotion which can readily be shared. The pedestal is triumphal and has the rudiments of an arch of triumph, in order to carry, not a quadriga, but human patriotism, abnegation, virtue.'[12]

The roughly sketched and crudely bunched figures showed uncanny similarities to the damned souls which had filled Rodin's notebooks. Characteristic of both were punched-out eye sockets, open mouths, a straight line of brow and nose and especially an emaciated skull. The use of ragged draperies reinforced an impression of ghostly outcasts. The earliest sequence of individual sketches for Pierre de Wiessant actually suggests a direct link to a cowering *Small Shade* presumably intended for the *Gates*.[13]

In the back of his mind it is very likely that Rodin was haunted by the imponderable reserve of Gothic sculpture, for example, stately figures like *Synagogue* on Reims Cathedral. Moreover the lumbering pace of the slowly moving mourners depicted on medieval tombs and tympana suggested the sleepwalking rhythms which befit the trauma of the real-life ordeal.[14] However, historical sources were relevant only to one part of his message. Rodin was also after indisputably living facial expressions and gestures, ones more pliant and vulnerable than those in medieval prototypes. He instinctively sought a combination of the Northern European, post-Renaissance graphic realism in the faces and hands, like that present in the Rubens portrait he had copied in Antwerp, and the abstraction of Gothic carved draperies which would add mystery, cadence and unity to the dense grouping of his monument.

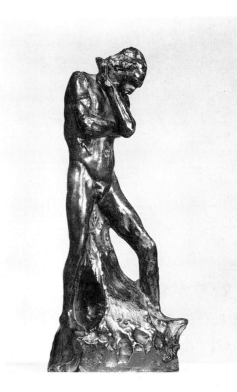

178 *Small Shade*, *c*.1885 (possibly study for a burgher).

To achieve an idiom expressive of his unique longings, Rodin undertook a pragmatic course of action. He informed Dewavrin: 'I intend to make expressive studies of heads for Eustache de St Pierre's companions by making portraits of people from the area.'[15] By the spring of 1885 he had contacted his friend the painter Jean-Charles Cazin, a native of Samur near Boulogne, asking him to pose for the bearded leader. Cazin replied enthusiastically: 'I am ready to pose for your figure of Eustache de St Pierre with a halter around my neck, and with bare feet and arms. I believe that I am in some way descended from this excellent man on my mother's side, and he himself would approve of your choice, for I admire the simple grandeur of his act.'[16] The basic idea of honouring Pignatelli's physiognomy in order faithfully to reconstitute reality was now taken one step further. By closely observing the features of a model from the Calais region and recording them week by week in a serial fashion, by casting one clay variation after another, Rodin set out to achieve an unmannered yet anthropologically accurate portrait.

The recent experience of working on the bust of Victor Hugo was perhaps at the back of Rodin's mind when he decided upon a 'scientific' approach to ethnic type and a element of phrenology. The eighty-one-year-old Victor Hugo had only reluctantly consented to let Rodin enter his house in the spring of 1883 and had refused to sit. Rodin had been obliged to place his modelling stand on the veranda and to dart inside to catch quick pen-and-pencil sightings.[17] These he approached rather like calliper recordings: each defined a directly lateral or overhead view of Hugo's head, the contour line of the skull transcribed from a single vantage point. Sometimes as many as a dozen 'takes' were juxtaposed on one page. In several the skull was supplemented by the man's sparse hair and beard, rendering his imperious look. Marvellous and forceful as the drawings are on their own, Rodin obviously found himself somewhat under-equipped when it came to translating these sketches into a dignified portrait of a man already

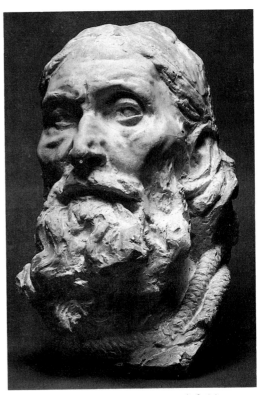

179 *Head of Eustache de St Pierre*, definitive state, 1886–87, Musée Rodin (cat. no. 126).

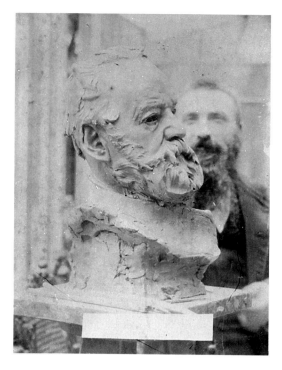

180 Rodin with his *Bust of Victor Hugo*, *c*.1883, Musée Rodin (cat. no. 262).

181 (above centre) *Twelve studies of the head of Victor Hugo seen from various angles*, Musée Rodin (cat. no. 130).

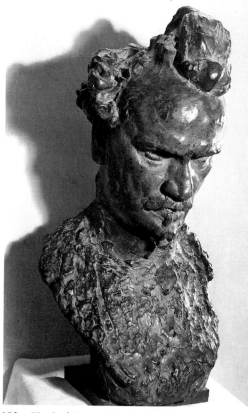

183 *Head of Henri Rochefort*, 1884, Musée d'art et d'histoire, Geneva (cat. no. 122).

elevated to the status of demi-god: 'I would go and look at him, and then, with my head filled with the expression of an image which combined the properties of Pan, Hercules and Jupiter I would go back again to memorize a feature, a wrinkle or a fold of skin.'[18]

Less reverence and more eye-to-eye contact with the subject clearly encouraged Rodin to take liberties in his subsequent portrait bust, that of Henri Rochefort (1884). This infamous editor and pamphleteer possessed wiry hair divided in shocks and counterweighted by a moustache and goatee. Manet's paintings of Rochefort (exhibited in the Salon of 1881) had allowed these identifying characteristics to convey the man's irascibility.[19] Rodin treated his clay a bit like impasto, pushing in undercuts and ridges to move the eye across the terrain of the skull and the hair, down past the recessed eye cavities and the line from the tip of the nose to the beard, to stop at the agitated dappled marks that represented his shirt-front. The several modes of handling were juxtaposed instinctively. Although Rochefort accused Rodin of spending whole mornings placing and removing single pellets of clay, clearly at some point Rodin plunged his fingers in the soft medium. Volumes were exaggerated in order that the air around the sculpture become as agitated as it seemed in real life; the tentative drawing on the surface that existed in the portraits of Legros and Laurens grew more plastic roots.

The sequence of heads of Pierre de Wiessant exemplify in an eloquent way Rodin's twofold method of observation and interpretation. The model was probably that of the actor Coquelin Cadet, a friend of Cazin, who volunteered to collaborate, enthusing: 'Would you like me to pose as a man of the people? I was born in Boulogne-sur-Mer, and I am therefore a true son of the Pas de Calais. It would be perfectly natural, and it would give me pleasure to be a model for a great sculpture.'[20] Capable of holding an expression of interior anguish (as the Japanese actress Hanako was to do much later when she posed for Rodin), Cadet seemed to draw in air to feed his soul through all his orifices; thus the ears are tipped forward, the bony nose has distended nostrils, the lips part and eyelids nearly close. Whereas the earlier mascarons and furies partook of a rather gross,

106

vessel-like convention using black eye sockets and circular mouths to describe the contrast of exterior shell and interior void, Rodin's marvellous modelling of the surface membrane of Pierre's face subtly connotes mobile flesh. It sends light and tremors across and through the porous substance. The 'colouristic' surface enlivenment which Rodin had learned in the studio of Carrier-Belleuse seems by comparison to offer a mere caricature of personality. The nearest equivalents are drawings like the *Mask of Minos* which use the same overlay of lines between folds of flesh.[21]

The existing documentation suggests that the bodies of all six burghers were built independently of the heads, probably from professional models like the stevedore whom Goncourt observed.[22] In the tradition of David and his followers Rodin insisted on completing the nudes in the final scale before draping them. He explained to Dewavrin that this process was essential not only for truth but for efficiency: 'I have my nudes, that is to say the underpart which is made, and that I will have pointed in order not to lose time. You will see that it is what one does not see which is the principle thing.'[23] The intermediate-sized figures (67–104 cm high) made in 1885 and 1886 are among the finest of Rodin's sculptures, far superior to the over-familiar reductions of the final versions. It happens that they are consummately beautiful in plaster; when translated to bronze the linear elements like the fingers and tendons frequently become harshly prominent. Emphatic in their postures and dominated by the organic power of the exaggeratedly large hands and feet, the nudes somehow escape looking rhetorical or indeed ridiculous. They are rugged and simple in their structures, true to what Bartlett was observing about Rodin's beliefs: 'His scientific leanings are now so strong that he works much from a geometrical point-of-view. Having become master of his art-instincts he now ordains processes of working. He dreams, reflects, and organizes.'[24]

184 Coquelin Cadet, actor, Comédie française.

182 (facing page top right) *Victor Hugo, three-quarters view*, British Museum (cat. no. 131).

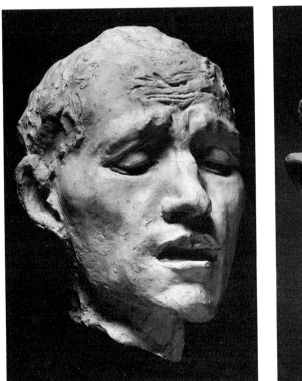

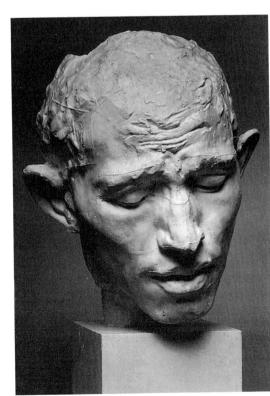

185 *Head of Pierre de Wiessant (type A)*, 1885–86, Musée Rodin (cat. no. 124).

186 *Mask of Pierre de Wiessant*, 1885–86, Musée Rodin (cat. no. 125).

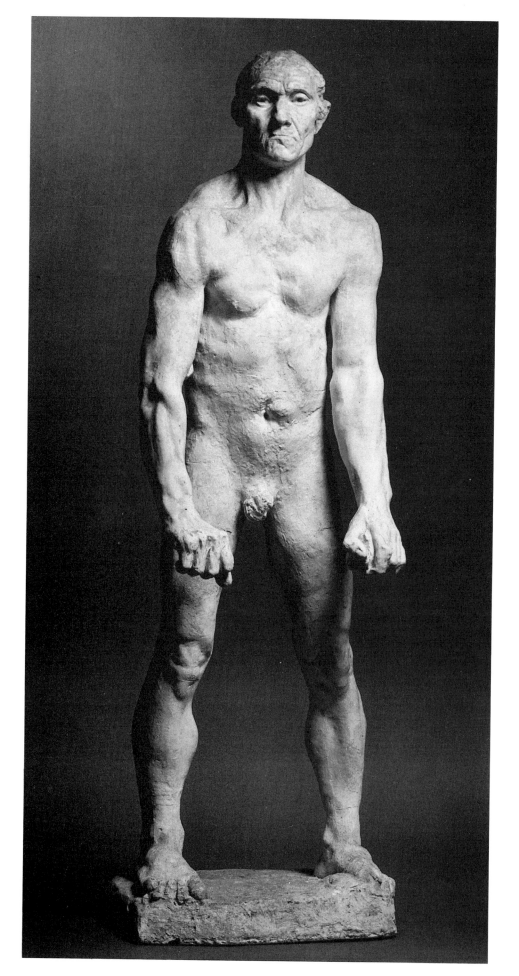

187 *Jean d'Aire, nude study,* 1886, Musée Rodin
(cat. no. 128).

188 *Jean de Fiennes, nude torso for second maquette,*
1886, Musée Rodin.

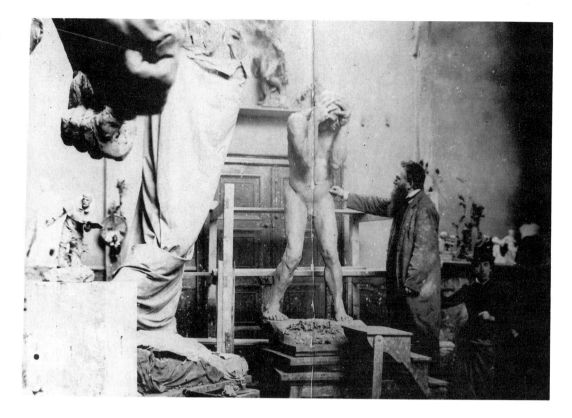

189 Rodin with nude figure of Andrieu d'Andres and Jessie Lipscomb, *c.*1887, collection of the grandson of Jessie Lipscomb.

190 *Shade*, illustration opposite title-page, *Les Fleurs du Mal*, 1887–88.

In fact a change in the 'architecture' of the human body helped to place on stage figures that were ordinary citizens unexpectedly contemplating their own deaths and equally sacrificial heroes effectively engaging the melodramatic appetites of the bystanders. Rodin found neither Michelangelo's contraposto nor the static planes of Classical art could direct him to the possibility, which he sought, of entering the spectator's space. This he achieved by using simple configurations, mainly oblique triangles, each frame so inclined and twisted that even in isolation they convey simultaneously anticipation and withdrawal, imminent mobilization and paralytic fear.

The gaunt, nude figure of Eustache is characterized by the erratic contour of his withered flesh. The strange oblong voids are electrified by the jerky silhouette which eats away the limbs and trunk. Pierre de Wiessant's thin body has a graceful bow-shape which draws our eye to the pelvic fulcrum where all the forces seem to balance. The outstretched arms of Jean de Fiennes catch his tunic at the hips and thus construct a diamond-shape that accords mysteriously with his hestitant expression. The defiant Jean d'Aire belongs to Rodin's ape-like interpretation of primitive man and his descendants; the man's grip on the huge horizontal key stops the downward thrust by the canny resort to an A-form. Andrieu d'Andres was to have the same stubborn force—powerful arms wrapped around his head, legs spread and the body symmetrical. Naked and potent as he appears in the photograph acquired by Jessie Lipscomb in mid-1887, after the addition of the final drapery and raising of the left leg he lost the brute clarity and was made pathetic.

The taut muscular units of all six have a ripeness, a broadness and a syncopation that is entirely different in nature from the previous *écorché* components such as were found along the stomach of *Adam* and the back of *St John*. Curiously the frontispiece in the copy of *Les Fleurs du Mal* which Rodin illustrated in 1887–88 is a variation of an earlier *écorché Shade*. Redrawn during this period, it picks up the same convincing continuity between concave and

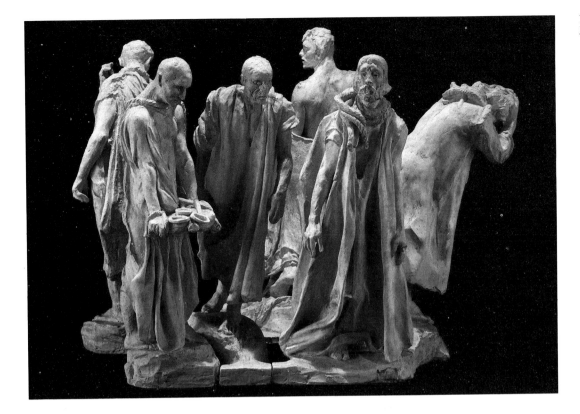

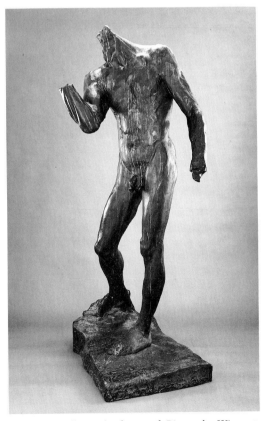

192 Study for nude figure of Pierre de Wiessant, c.1886, Minneapolis Institute of Arts (cat. no. 129).

convex units. The sheaves of clipped lines now part to imply swelling volume. Although the neck tendons are tucked into the collar-bone with more flourish, and are thus more denatured, than their sculpted counterparts, the gesture of self-address is like that of *Pierre de Wiessant* in the final nude version. The staccato line of his bent arm and twisted head, which here ends in long macabre finger-nails and a grimacing mouth, has a scissor-like compression which speaks of unnameable torments of the soul.

The second maquette which was sent to Calais in July 1885 for public display announced Rodin's revised idea for the grouping and the base. The six figures of equal height would be placed on the paving stones of the square, giving the impression that they were mixing with the daily life of the town.[25] Although the radical concept was applauded in the national *L'Intransigeant*, the official committee and local critics were appalled by the informality of Rodin's idea and the lack of a pedestal. Rodin's response to their published criticism appeared in the Calais *Patriote* on 19 August 1885. He denounced the hackneyed but still Academically-proscribed pyramidal composition for monuments and explained that his cube looked to the indigenous French Gothic tradition. Rodin spoke of his priorities, the force of the modelling and the equality of the whole as art, implying that he had no intention of compromising his vision but would go on following 'mon esprit and mon coeur'.[26] With relief he told the art critic Léon Gauchez that at last everything 'is arranged to my satisfaction, I am freer and they are leaving me the responsibility . . . though I am taking into account their suggestions'.[27]

Six months later the local banking firm of Sagot, which held the subscription and large amounts of municipal funds, failed, placing the project in jeopardy. It was Dewavrin's wife Léontine who broke the bad news on 21 February 1886. During the next three years she frequently acted as Rodin's 'intermediary' and by the warmth of her letters assured him that Calais still wanted his sculpture.[28] In fact, as so often seems to have happened, the extension of the period before the

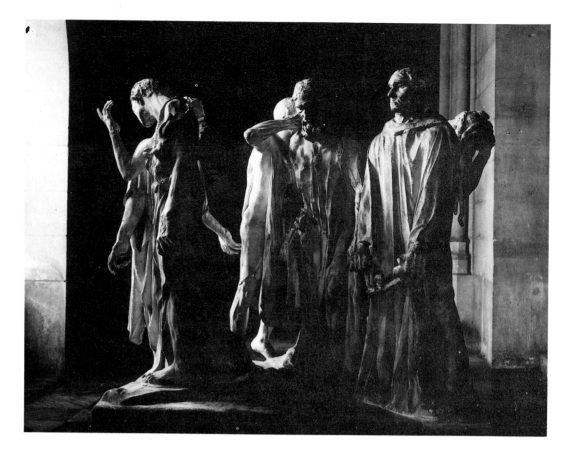

commission was officially needed benefitted Rodin's way of working. In this interval he exhibited the figures as individual works in 1887 and 1888 and saw them together in his large exhibition in 1889. As over-life-sized protagonists they returned to Rodin's art a degree of self-identity. In a sense, the six male figures existed as Rodin's rugged companions, his men of the people. As one critic put it, they 'emerged from the mud of the Middle Ages' to demonstrate 'conscious suffering, the admirable expression of human sacrifice'.[29] No one could any longer fairly accuse Rodin, as some had been prone to, of merely parodying Baudelaire in the outdated language of the eighteenth century.[30]

When, in 1887 at the Galerie Georges Petit, Rodin's perceptive supporter, Gustave Geffroy, saw the first three figures, *Eustache de St Pierre* and those later identified as *Jean d'Aire* and *Pierre de Wiessant*, he immediately made the essential correlation between Rodin, the '*ouvrier*' who had also experienced great privation and humiliation, and the figures themselves. They were not mere depictions, he explained, but each a corporeal presence, like that of a living person. The artist had begun the nudes 'before he even thought about the arrangement of the draperies, he placed beneath them skeletons, nervous systems, and all the organs of life and of creatures of flesh and blood . . . They also represent man's ephemeral existence and his sorrows. They bear the mark of the sadness which is the unavoidable characteristic of all great works.'[31]

The anguish and doubt expressed by all six figures were not simply staged or imagined states of mind. In the summer of 1887 Rodin himself suffered his first serious period of 'irresolution'.[32] Promising to send the favourable newspaper reviews of the exhibition at the Galerie Georges Petit, Rodin told Mme Dewavrin: 'I have had considerable success in Paris, and I can tell you that everything goes well with my art', but, he confessed, 'I am very nervous and have no enthusiasm, the beautiful spring countryside leaves me cold. I need a

break from thinking and need to vegetate for several seasons. It is difficult . . . I should travel like you, but it is difficult . . . I have neither the time, nor the will, nor the money, nor the energy.'[33]

Rodin's depression may well have been initiated or aggravated by the uncertainty surrounding his relationship with Camille Claudel. Genuinely insecure about his worth in the eyes of Camille, in the previous summer of 1886, when she and Jessie Lipscomb were staying in the English girl's home in Peterborough, he complained to Jessie, his confidante: 'I am at this moment passing through a region of very ugly fancies', by which he meant he found himself unable to respond to the normally dependable source of inspiration and peace, Nature. This inertia was coupled with Rodin's awareness of the pitfalls of fame, especially the public expectation of superhuman attributes in all senses— and with his long-lasting, bitter sense of suffering injustice and being misunderstood. He worried about what the women were thinking:

> I am afraid of having been pedantic in sending you newspaper clippings but it was not due to vainglory. I thought that perhaps I should gain a little more of your esteem and of your friendship.. Perhaps the contrary occurred and what I thought would do good causes derision. I know that girls look specifically for success and yet laugh at it and moreover they are right.[34]

By August he was somewhat recovered and able to suggest that they meet him in Calais and together tour the neighbouring towns, that cherished area between the Beauvais of his adolescence and the Flanders of his young manhood. However, he added that he realised it depended 'on the caprices of Miss Camille'.

This was only one incident but it typifies a pattern and the insecurities that plagued Rodin for the rest of his life. Truman Bartlett, who met Rodin in 1887, described the sculptor's diffidence, and his strong memory of and sensitivity to public mockery:

> He talks art as he makes it . . . though tormented by a turbulent imagination, his savage tenacity carried him safely through . . . of nothing does he speak with so much warmth as of the hearty appreciation and continued friendship of his first art friends who gathered around him in 1877–78–79.[35]

Rodin had such faith in the simple principles on which he believed his art was founded, that he was incapable of comprehending why others should question its integrity. Moreover, when he talked of his ideas in comparison with those of Michelangelo he felt he was doing so on behalf of the school of 'Nature' not himself. His favourite critics reinforced his historic perspective. JoAnne Culler Paradise, writing of Geffroy, found 'Rodin's friendship with the great art of the past is a leitmotif of the critic's writing.'[36] Whereas the Ecole still imitated and falsified Classical art, Rodin's patient study of Nature was true in spirit to the Greeks, who, as he pointed out, lived in a society where the nude body was commonplace.

By nature shy and largely self-educated, Rodin constructed a monologue as a way of expressing his ideas to strangers. Looking at the aesthetics of each civilization from the Greeks and Assyrians to the eighteenth century he found something to praise in each while bitterly lamenting the materialism and destruction of the craft tradition in his own age.[37] Camille Mauclair, an early biographer, was sensitive to the private emotions behind this way of dealing with the pressure of receiving strangers avid for the master's word. He explained:

The slowness and apparent embarrassment of his speech and the pauses in his conversation give special significance to what he says, moreover Rodin has acquired of late years a genuine ease as a talker and even as a writer. He speaks of his creations as though they existed apart from himself . . . Rodin reduces friendship to tacit agreement upon the essential subjects of thought, and it is only if one meets him upon one of these points that one takes a place in his remembrance or his liking. He does not put his faith in individuals but in general ideas. He is surprised at his own eminence and his intelligence is outdone by his instinct. That is how it comes about that he does not always know how to name the beings that he has delivered. He contents himself with repeating that work lovingly done is the secret of all order and all happiness.[38]

It could be said that Rodin's increasingly mystic cast of mind and his interest in presenting plastic images as if entities with an existence and a meaning greater than the particular label or period theme was directly contributory to the shape, the finish and the final siting of the *Burghers of Calais*. The complete plaster was unveiled at the Galerie Georges Petit in 1889, part of an installation which juxtaposed 145 paintings by Monet and 36 sculptures by Rodin. The exhibition was itself a hugely successful event, establishing Rodin's genius and range internationally. By introducing so many works in progress and still in plaster, the atmosphere was one which reinforced Geffroy's direct identification of Rodin as a 'worker'. The artist was not instructing but confiding his own experiences and fears.

By the force of an intense sympathy with his subject, and keen perception of the historic narrative the artist has been able to build up the whole drama, and set before us time, place, attitude, and above all, the chords of human feeling vibrating in the scene. With the eyes of his mind he saw those six men marching along a road of briars and flints.[39]

In interviews Rodin stressed his eagerness for each spectator to live vicariously their experience; he told the reporter for *Le Temps* that the group was composed not only

of people who happened to be there that day, but of all of us, and of all who read about their great deed . . . They asked me for 'Marseillaise' gestures. I refused. I wanted to show my burghers sacrificing themselves quite simply, as people did in those times, without signing their names to their deeds.[40]

Probably in late 1890 the plaster figures went to the new studio on the boulevard d'Italie.[41] At some point the individual, two-metre plasters on chess-piece-like stands were brought temporarily into the beautiful wood-panelled rooms at the Clos Payen to be contemplated in peace. There they were photographed by Druet between 1896 and 1898 as though they were Rodin's companions, set before a carved mantel and mirror, lined up in two rows (a second *Jean d'Aire* replacing *Jacques de Wiessant*). In the prints the dark expanse overhead emphasizes the luminosity of the plaster and adds to the dream/nightmare, rather Pompeian, petrified atmosphere. The bunched heads and bodies remind us of the disembodied stares and stiff gestures of the Shades drawn in ink; however, the burghers' musculature and facial realism lodge them within the category of surrogate humans.[42]

Rodin's next major commission, the *Monument to Victor Hugo,* united female and male prototypes. In retrospect it seems a predestined fourth act in a strange

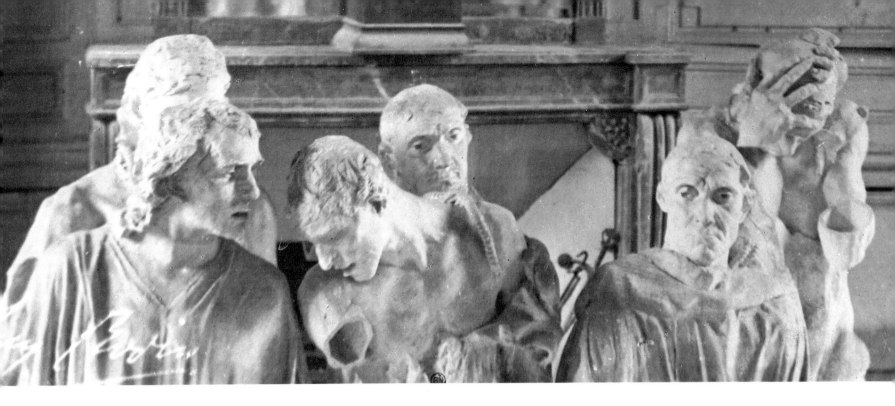

drama about the relationship between feminine intuition and male rationality. Moreover, stylistically it combines the nervous Romantic *volupté* of the *Gates* and the slow-moving sorrow of the volumetric, spatially arresting *Burghers*. The opportunity to work again on a large scale came when Rodin was invited in September 1889 to design a massive statue of Victor Hugo for the north transept of the Panthéon as part of a grandiose scheme of one hundred sculptures. The organizers were eager to proclaim the secular ideals of the Third Republic and no subject more epitomized their message than a monument to the popular spokesman of the people, Victor Hugo. He had himself remained in exile for eighteen years in protest against the government of Napoleon II.

It is often said that the *Monument to Victor Hugo* was a failure. The historical argument is buttressed by an alleged comment of Rodin's to Judith Cladel, that in the work he succumbed to the mania of the age and overloaded his composition.[43] Looking at the project in its historical and political context demonstrates the way in which Rodin's aesthetic had by this point become so eccentric and so at odds with official taste that, despite his professed desire to build monuments for the State, he was incapable of thinking along conventional lines. It is true that the version authorized by the organizing committee but never installed in the Panthéon—only cast in maquette form—the *Apotheosis of Victor Hugo,* is an example of Rodin's penchant for allegorical work.[44] But the large plaster *Victor Hugo and the Muses* which he entered in the Salon Nationale of 1897 and which was much later cast and sited at the roundabout where the avenues Victor Hugo and Henri Martin meet is actually an under-appreciated masterpiece. Like the *Burghers of Calais* it is an anti-monument and not a monolith nor the triangular pile the Ecole ascribed to. Despite the improbability of the action and the combination of one real and two imaginary personages, a strange intimacy exists between the three. The occupation of space, the conceptual puzzle and handling of light results in one of Rodin's most eloquent and confessional monuments. It has the dreamy amplitude and overloading of the gouaches, and borrows something of the *Gates,* recalling, for example, the *mélange* of bodies in *Ugolino and Sons* and the introspective *Thinker* sitting in front of sprawled female nymphs filling the tympanum.

194 *The Burghers of Calais*, photographed at the Clos Payen by E. Druet, *c.* 1896–98, Bibliothèque Nationale, Paris.

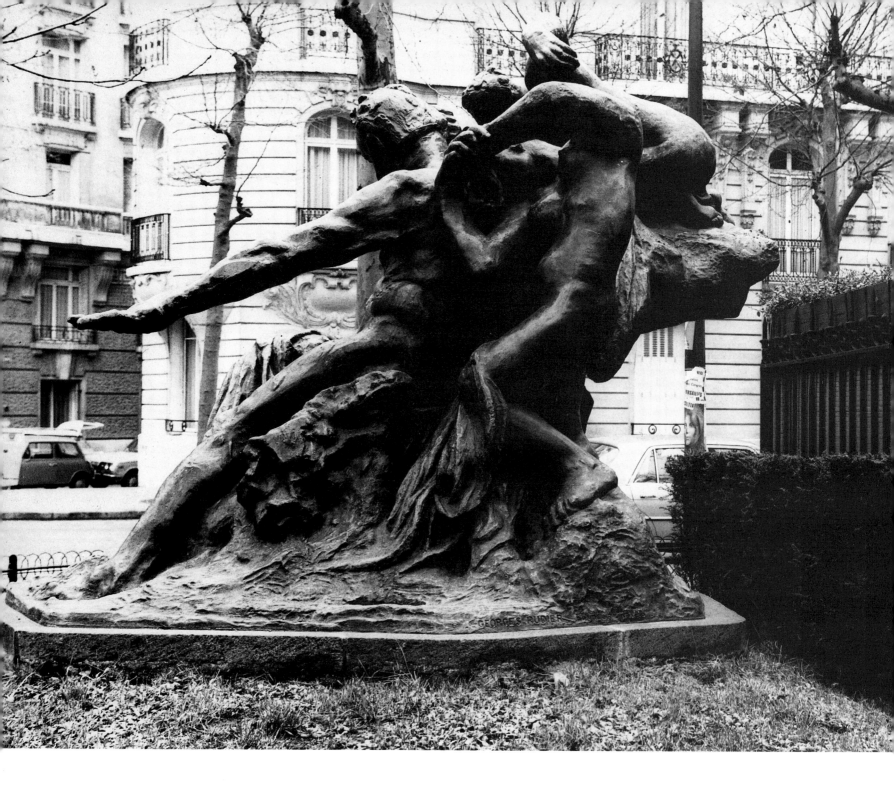

195 *Victor Hugo and the Muses* (or *Monument to Victor Hugo*), bronze, avenues Victor Hugo and Henri Martin, Paris, inaugurated 1964.

Typically Rodin's initial approach to the official invitation had not sounded overtly revolutionary. After deciding to seat Hugo and place behind him three female muses, he spent the first months tightening the allegorical reading.[45] Each muse would represent one of Hugo's familiar works: on the left the seductive flavour of *Les Orientales*, in the centre the frightening *justice vengeresse* of *Les Châtiments* and on the right 'une figure idéale' descended from the curvaceous faunesses via *Meditation*.[46] Set high, in order to sweep down and whisper in Hugo's ear, they were to allude to the mysterious way thoughts and cogent metaphors came to a genius meditating in solitude. Nothing about the theme of the artist and muse thus far was surprising. What became predictive of the final

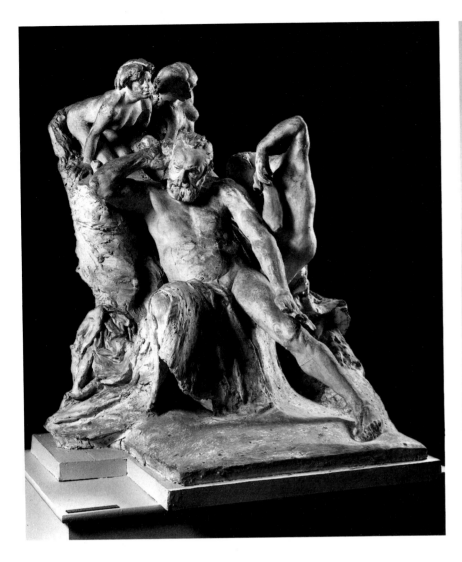

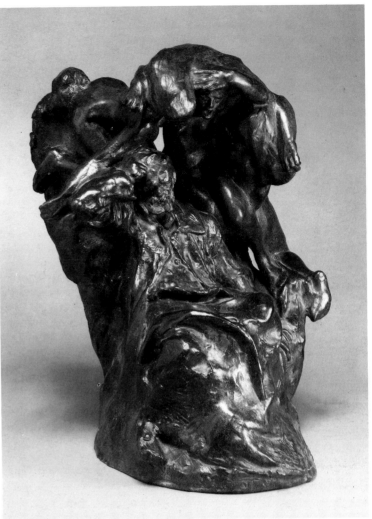

shocking effect was that Hugo appeared naked. Rodin was no longer looking for a symbol of gentle, cerebral inspiration but for a way of visualizing how untamed carnal energy stoked the fires of creative drive. The contact between the bodies was as charged as that famous meeting of fingers between God and Adam in the Sistine Chapel. The Biblical precedent for Hugo's extended arm reminds us of the influence on Rodin of the Romantic ethos. Anita Brookner has written:

> This gradual elision of the boundaries between sacred and profane is one of the most fascinating stylistic accomplishments of the Revolution. It was to be one of the main platforms of Romantic symbology, which summoned up so many synonyms for the sufferings of the artist that the sufferings of the gods, or even of God, were inevitably involved. In this way, as Baudelaire noted, Delacroix was a direct descendant of the revolutionary generation.[47]

Just previously Rodin had confided to Bartlett that he wanted to design his own tomb on the basis of the early sketch he called *The Sculptor's Dream* in which the artist 'musingly works while the shadows of his cherished fancies silently assemble around him'.[48] In 1880 they took the form of flying cherubs, descendants of the buzzing cluster of infants around the head of 'Spring'. Now, ten years later, Rodin was working daily in a studio inhabited by unselfconscious temptresses, both his artificial Galateas and the models he paid to be at his disposal. A sculpture of *c*.1890, the curiously prosaic *Sculptor and his Muse*, treats

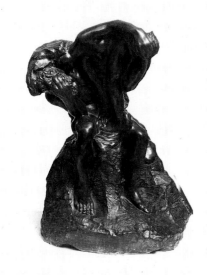

198 *The Sculptor and his Muse*, The Fine Arts Museums of San Francisco (cat. no. 114).

199 *The Apotheosis of Victor Hugo*, 1890–91, Philadelphia Museum of Art (cat. no. 135).

the theme of the artist and muse explicitly. A young girl positions herself around a seated, middle-aged man in such a way that she can at once caress and be caressed, their state of arousal analogous to the enveloping lines of her hair streaming down his back and the undulating volumes within the solid block. Rodin admitted his addiction: 'Feminine charm which crushes our destiny, mysterious feminine power that retards the thinker, the worker and the artist, while at the same time it inspires them—a compensation for those who play with fire.'[49]

During the winter of 1889–90 Rodin began separating the muses in the Hugo monument, making it obvious by the increasing horizontality that the composition was designed for intimate viewing and would be at odds with its pendant sculpture in the south transept of the Panthéon. That was to be Injalbert's *Mirabeau*, a standing figure propped against a busy curtain of allegorical embellishments. No doubt alert to Rodin's indifference to orthodox grandeur, that which he called theatrical, the committee demanded that a full-scale painted montage or *chassis*, based on a photograph of the maquette, be constructed so that the scheme could be judged in the context of eighteenth-century ecclesiastical architecture. Predictably, seeing the result, they demanded that Hugo be raised above eye-level, thus making Rodin's original idea seem utterly confused and unacceptable.[50]

On 19 June 1890 the committee informed Rodin that his proposal had been rejected. A compromise was found: Rodin began developing a standing figure for the Panthéon (the *Apotheosis of Victor Hugo*) and was promised an outdoor site for the yet-to-be-completed seated Hugo project. Annoying, indeed demeaning, as the committee's interference in artistic issues must have been, by freeing the sculpture from the politically complex scheme and allowing Rodin once again to continue at his own pace, the intervention was probably fortunate. As a rejected work it could somehow be that much more his own, and could withstand a perpetually unfinished look—one that declared Rodin's feeling for the studio as museum, and the Salon as atelier. The plaster submitted to the Salon in 1897 arrived in a shockingly crude state; Hugo's arm propped by an iron bar, a gap at the shoulder, the armature inside the Tragic Muse exposed. Rodin's indifference to finish was obviously his way of saying that artists should make art out of the facts and circumstances of their lives. It was like Picasso's famous reminder, 'we painters make our pictures in the way that princes make their children—with dairy maids', that is, with the material closest to hand. In Rodin's case the plaster-dipped cloths, the frame, the recycling of earlier figures and evidence of the new presence in the studio of acrobat-models constituted the milieu with which he identified.[51]

Victor Hugo and the Muses is a conflation of a documentary and invented protagonist; a symbol of the lonely genius, the dreamer and the artist who can communicate with a wide public. As such it is infected with Rodin's own sense of alienation and experience of being idolized. To accomplish this monument Rodin felt compelled metaphorically to step inside Hugo's skin, at least as thoroughly as would an actor learning a part. In 1891, with his friends Gustave Geffroy and Eugène Carrière, he even travelled to Guernsey to experience Hugo's place of exile. In a sequence of studio photographs taken some time later, he poses for the camera against his plaster edifice, his stocky bearded figure more than coincidentally resembling his *Hugo*. In a famous Steichen photograph Rodin stands with the *Hugo* and *The Thinker* and in one by Haweis and Coles (*c*.1904), the earlier bust of *Victor Hugo* faces plaster casts of *Meditation*; the intimacy

200 *Monument to Victor Hugo* at the Palais Royal, 1909. Photograph by F. Bianchi, Musée Rodin (cat. no. 264).

201 *Monument to Victor Hugo*, last project, *c*.1897. Photograph published by Manzi-Joyant, Musée Rodin (cat. no. 267).

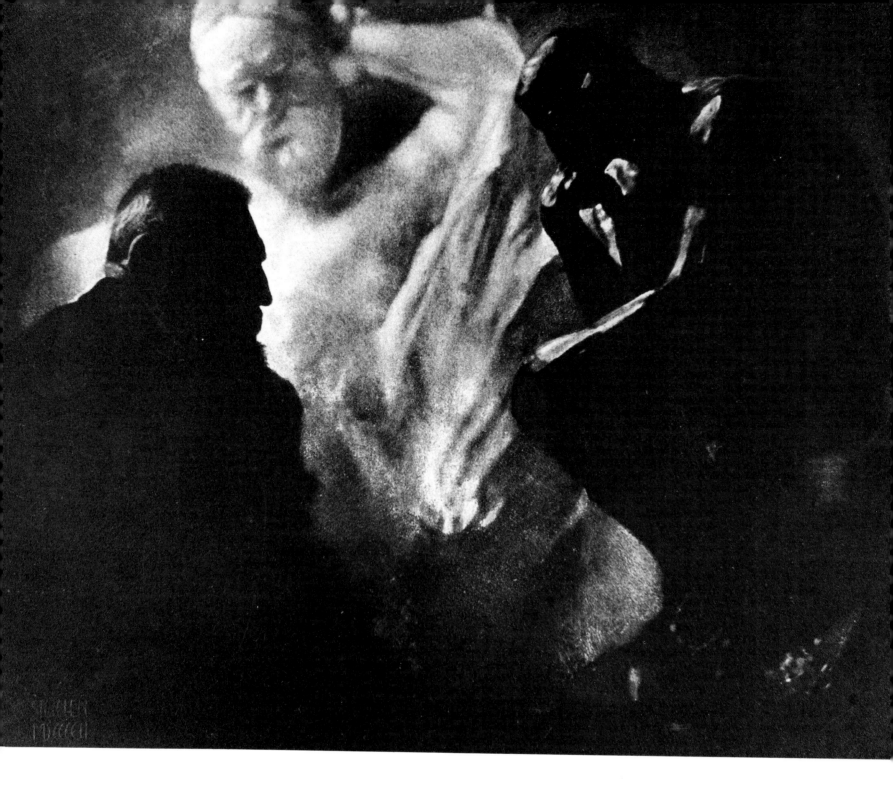

202 Eduard Steichen, *Le Penseur-Rodin*, for *Camera Work*, April 1906, Royal Photographic Society (cat. no. 269).

alludes to the special meaning of these works. The Tragic Muse is uncannily close to the enigmatic figures of the early gouaches, particularly the genderless, bullet-headed children who struggled over the parents, centaurs and captives like *La Force et La Ruse,* or the ghostly struggling lovers who carried a deathly air, whereas the 'ideal figure', or Inner Voice, was an enlargement of the manifestly female form of *Meditation*, associated with Camille.

When *Meditation* was perfected in 1884 on a small scale for casting in bronze, her serpentine spine and the triangles of the folded arms were harmonious and self-sufficient. Enlarged disproportionately in the head and feet for the Hugo monument, she acquired an awkwardness; the head–hair–neck block and broad

120

flanks lent a slightly soporific, equine quality. In the large plaster version light spills softly over the sensuous curves onto Hugo's manly bust suggesting the conspiracy between the Bacchanalian centaurs and abducted nymphs. In a letter to the Ministry to request additional funds to purchase another marble block, Rodin explained:

in order to capture the grandeur of the expression, I have been obliged to enlarge my composition, so that the figure of the Tragic Muse at the top will no longer fit into the original block I was granted, and which is now taken up with the enlarged Victor Hugo and with the figure representing the Inner Voice.[52]

The figure raised aloft, the Tragic Muse, recalls the concertina energy of the also elevated Crouching Woman in *Je suis belle*. However, this female with her enormous, outstretched left arm is so powerful that, like a jockey, she seems to urge on Hugo's odd chariot. The third muse, eventually not incorporated, is the work known independently and infamously as *Iris, Messenger of the Gods* (or the *Eternal Tunnel*). Conceived from a model who lay obligingly on her back, one leg caught by her hand and the other providing support, even horizontally she is pivoted by her sexual centre. Raised vertical, with the vagina rotated, the orgasmic metaphor becomes obvious. It has been written that acrobats acted as models for this work and the other Iris figures. Certainly their sinewy physiques and exhibitionist poses seem to have imaginatively permeated the forms.

Rodin was at this time infatuated with the can-can dancers and saved an article

203 *Centaur carrying away two women*, c.1883, Goupil Album, pl. 31.

205 Rodin and the *Monument to Victor Hugo*, 1898. Published as 'Nos contemporains chez eux', Dornac, Musée Rodin.

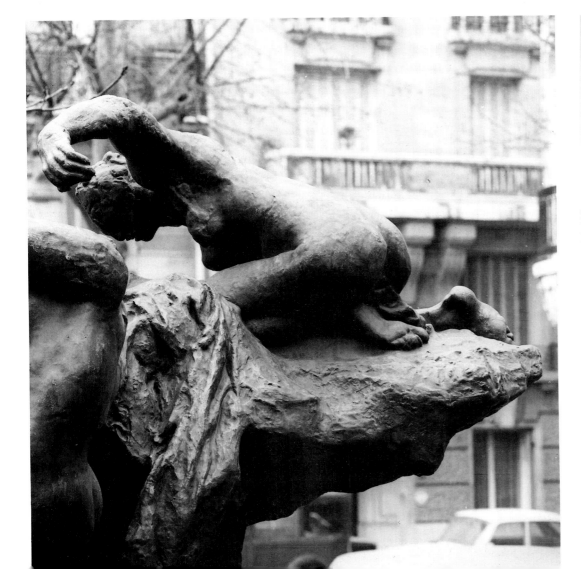

204 The Tragic Muse detail of *Victor Hugo and the Muses*, avenues Victor Hugo and Henri Martin, Paris.

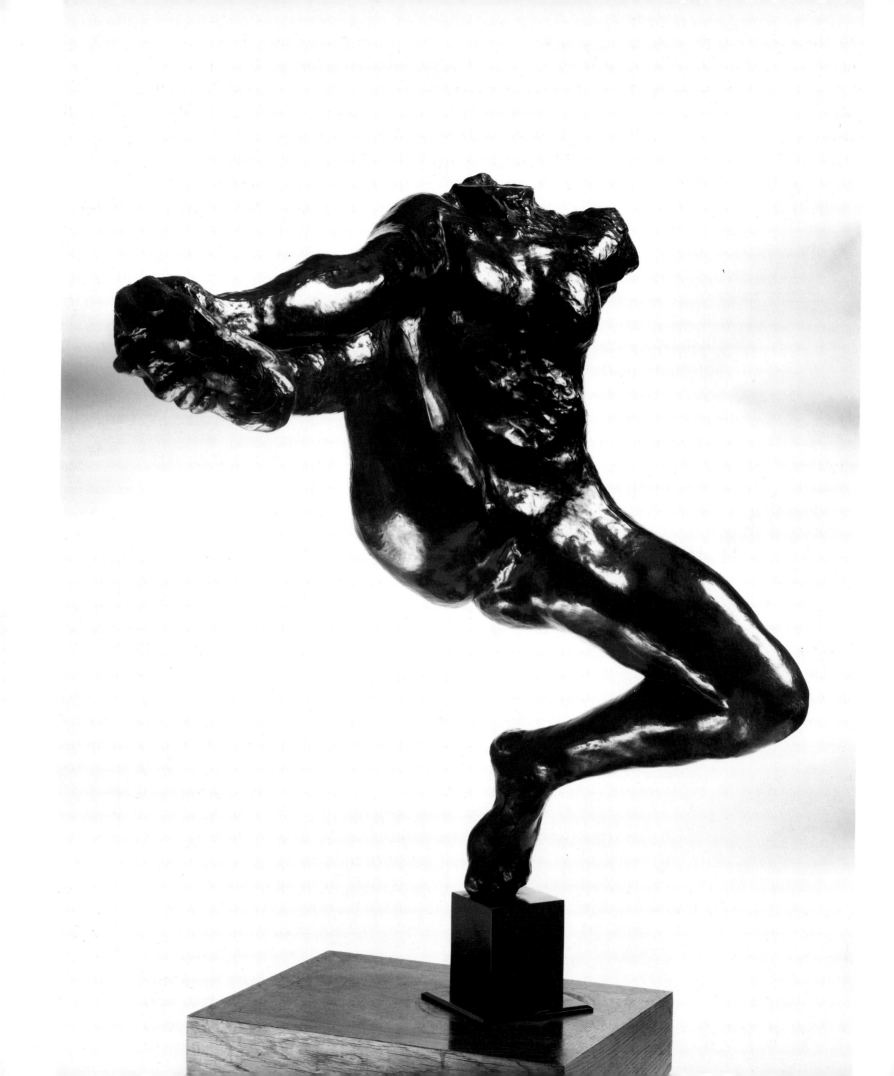

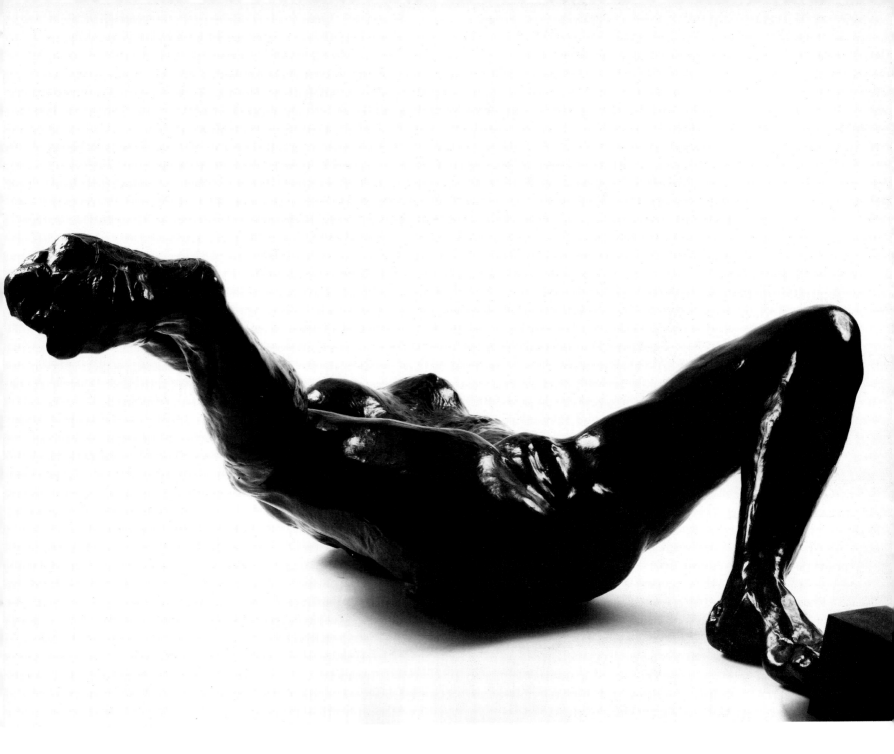

in the September 1891 *Gil Blas* on the Chahut dancer Grille d'Egout. He was also fascinated by the 'apache' or hoodlum girls on the rue de Lappe.[53] What is significant is that the studies of female dancers, frequently called after the goddess Iris, meant a great deal to Rodin's artistic pride; because he felt they were the most elemental, undiluted expressions of his thinking, he insisted they accompany the purchases and gifts to public museums which he arranged, each time embarrassing the local officials. Thus the *Tragic Muse* was sent to Geneva in 1896, the *Inner Voice* to Sweden in 1897 and the *Crouching Woman* to the Victoria and Albert Museum in 1914.[54]

The composition of the Victor Hugo monument relates indirectly to Rodin's hermetic habits in the nineties. In 1889 he disappeared for the first of many extended visits to the French countryside to record and meditate on Gothic

207 *Iris, Messenger of the Gods, c.1890–91* (cat. no. 144).

206 *Iris, Messenger of the Gods, c.1890–91* (cat. no. 144).

123

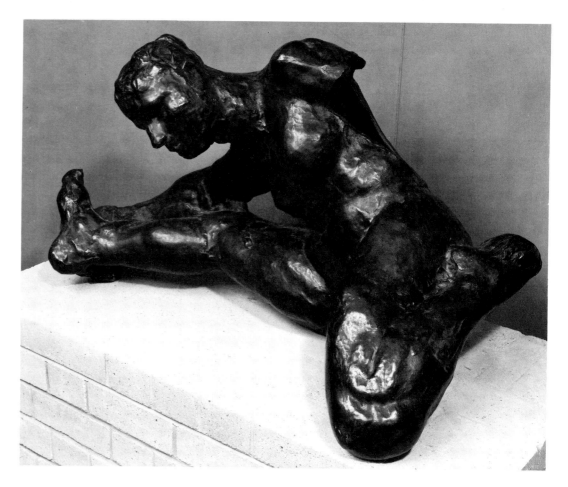

208 *Crouching Woman*, c.1891, Victoria and Albert Museum (cat. no. 145).

209 Architectural drawing, Musée Rodin, D3390.

architecture. Camille Claudel accompanied him on many of these pilgrimages. One senses they were Rodin's way of coping with not only the demands on his time which celebrity brought, but the cluttering of his mind with the commercial side of his expanding workshops and indeed with his own tendency to manufacture hybrid works along mythological lines. The drawings he made of the exteriors and interiors of churches are austere by contrast. The simple ink renderings are codes to describe the fall of light on concave/convex silhouettes (pilasters, mouldings, tiers) with the occasional description of facades and details of the sculptural programmes.

One hundred reproductions of architectural drawings were juxtaposed with Rodin's words, dictated to Charles Morice, for the book *Les Cathédrales de France*, published in 1914. The text reinforces the association of the cathedrals with places of retreat from the corrupted industrial society of the late nineteenth century.[55] The profiles and structures common to humans, plants and Gothic architecture are continually stressed, as they were in Rodin's conversation and life studies. A typical passage concerning the correspondence reads:

> Of course I loved Gothic lacework when I was young; but it is only now that I understand the power of that lacework. It rounds out the profiles and fills them with sap. Seen from a distance, these profiles are like ravishing caryatids leaning against the door-frames, like plants trained along the straight lines of the wall, like consoles which lighten its weight.[56]

The notion is simple enough but the application to three dimensions sophisticated and unprecedented.

Starting from the extraordinary impact of Hugo's outstretched arm with its

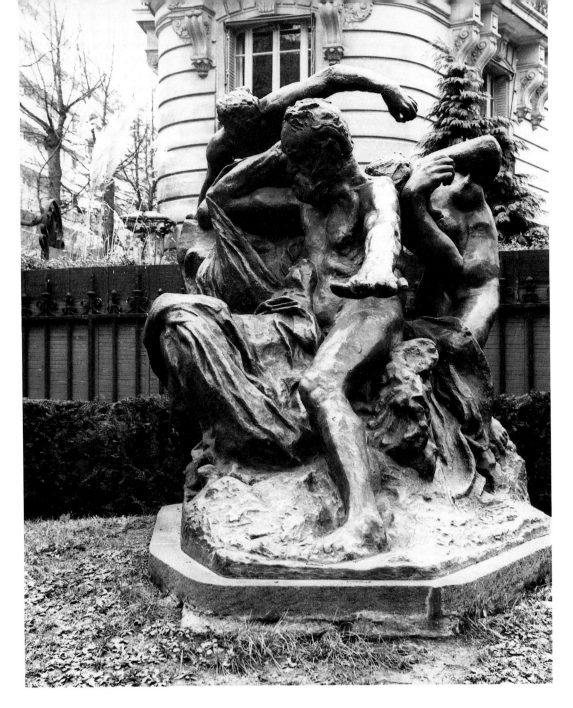

enormous, flexed fingers and their alignment to his stiff left leg, Rodin invaded the spectator's space on all fronts. Shapes appear before our natural focal point on Hugo's face, thus creating haptic distortions on the periphery. These seem as true to experience as the loopy feet and erratic silhouettes in the late drawings which tended to run off the page as a consequence of Rodin keeping his eyes on the page. It could be argued that the very active handling of the rocks and limbs overloads the assault. But the baroque passages are executed within the scale and grandeur of those huge paintings Rodin admired in the Louvre, like Rubens's *Embarkment of Maria de Médicis to Marseilles* or the Romantics' canvases. In both these paintings and Rodin's sculpture the eye settles momentarily on voluptuous details (in the Hugo monument intense passages like the toes protruding from the flanks of the Tragic Muse) which might be disruptive if they were not supported by the buoyant rhythms of the whole.

Walking around the vast rhomboid-shaped sleigh with its sequence of views, some of which threaten to unbalance the whole, gives us a measure of our

personal distance from each mass. The meeting of psychological and kinetic reception of information that is a strength of post-war sculpture has here a precursor. Particularly alike is the cantilevering of diagonals and the workman-like exposure of method. It suggests the daring and balletic drawing of constructed steel sculpture by artists as varied and original as Anthony Caro, Phillip King, Mark du Suvero and David Smith.[57] Rodin explained:

> 'For light serves, in conformity with depressions and reliefs, to give the eye the same sensation that the hand receives from touch. Titian is as great a modeller as Donatello... The great concern of my life is the struggle I have maintained to escape from the general flatness.'[58]

The marble version of the Hugo monument, shown at the Salon of 1901 and erected in the gardens of the Palais Royal in 1909, removed the muses; but Hugo, in god-like isolation, was lifted onto a sensational tier of stone slabs. Speaking of this almost minimal solution, and his *Monument to Balzac*, Rodin explained that both were intended as testaments to his belief that well-modelled sculpture sustains the air: 'L'air est en effect un des mes principaux soucis.'[59]

Much of what was experienced during the *Hugo* commission was echoed in that for the *Monument to Balzac*. Balzac was another towering symbol of the anti-clerical spirit of the age. Rodin answered the flattering but already controversial invitation from the Société des Gens de Lettres in July 1981 with the same positive attitude of his last three commissions, again optimistically estimating a mere eighteen months for completion and delivery. Gathering information with painstaking thoroughness during 1891–92, Rodin took account of the previous representations of the head and body of Balzac from sources as diverse as daguerrotypes and caricatures and consulted Balzac's tailor to obtain clothes the writer's precise shape. He read and re-read the novels and visited Touraine to familiarize himself with local character and type. His personal identification with the subject became obsessive. Like the *Gates of Hell*, Balzac's *The Human Comedy* set out to probe every aspect of fleshy temptation. Balzac was himself another lascivious, short man who worked day and night. Rodin respected the energy of someone 'who above all sets to building an immortal monument, who boils with passion, who frantically violates his body'.[60] His monument had to convey the fact that great men must be judged by unconventional standards; their tunnel vision is a reflection of the uncontaminated spiritual force that leads them to interpret Nature so that others can see what Rodin called in the same statement the 'synthesis of the whole'.[61]

When he began the sculpture he obviously had thoughts of converting Balzac's eccentric physique into a structural virtue. The riveting *Naked Balzac* of 1892 is a sculpture which needs no 'setting'. Indeed, it ignores everything else in its surroundings. A rooted look comes forth from the double cone, legs so spread over the gross mound that they had to be artificially extended to counterweight the immense stomach and powerful, folded, wrestler's arms.[62] On top of this mountain is a face intelligent and ever-hoping. A drawing, which Rodin perhaps made from (not of) the sculpture, equates the pot-bellied, spade-shaped Balzac with the facade of the church of St Jacques and St Christophe at Houdan. Rodin's need to make a symbolic bridge between forms, like his analytic comparison between volute lines and female curves, speaks of a realisation that he can indulge in his impasto-like squeezing and shaping of clay, in a way that no one else had done, making charged fragments, only once the charismatic force of the living Balzac had been endowed with a fixed sign, a readily identifiable profile.

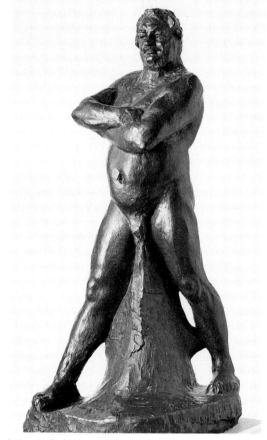

211 *Naked Balzac*, 1892, Musée Rodin.

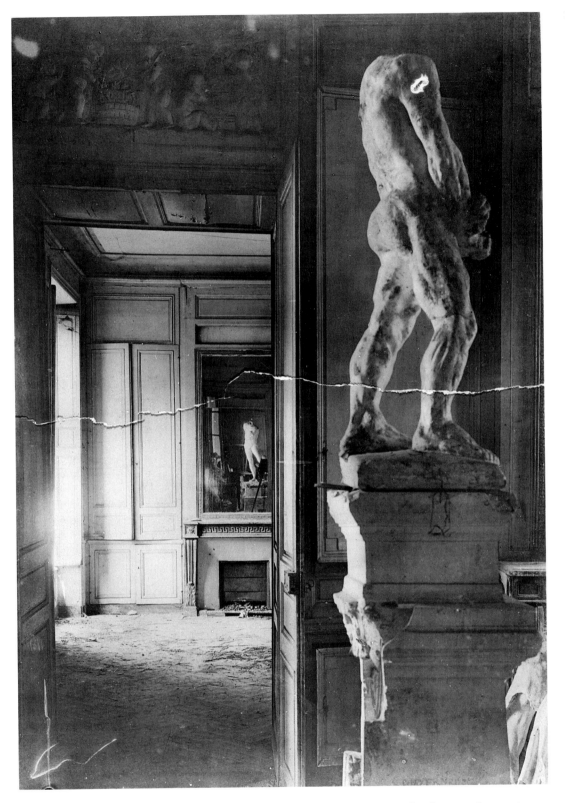

The *Naked Balzac* with folded arms of 1892, is composed of muscular units so distorted and bizarrely distributed that they represent the achievement of what Rodin deemed to be the artist's duty: to look for form in Nature and bring out 'grace, vigor, amorous charm or the untamed fire' by taking form, 'amplifying it, exaggerating the hole and the bumps so as to give them more light'.[63] Despite the organic sturdiness of the man's frame, the effect of the articulations between masses is to communicate foolishness as well as courage. The second well-

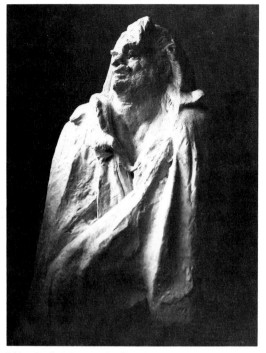

212 Definitive study for the *Monument to Balzac*, 1897. Photograph by E. Druet, Bibliothèque Nationale, Paris.

213 Study of dressing gown for Balzac, plaster, Musée Rodin.

214 *Head of Balzac*, stoneware, Musée Rodin (cat. no. 138).

known nude study *Naked Headless Figure Study for the Final Balzac ('F')* (1896) prepares for the defiance and poignancy of the final monument. The model has the compact muscularity and normal proportions of *Jean d'Aire*. When draped with an imitation of Balzac's famous dressing-gown or monk's robe, the sole reference to what is underneath is the oblique angle of the cloth at the point where it shrouds his erect penis held in his hands. The gown is like a carapace which protects the mysterious, vulnerable inner nature of the person. It is as if Rodin found in the end that his image of Balzac could not be one of flesh and blood; an apparitional presence had to be projected.

Many trial states of the elements introduced around 1897, a monk's robe and a demonic large head, exist. Plaster-stiffened fabric was arranged over and over again (as many as sixteen times) on casts of the second *Naked Balzac*.[64] The head, modelled separately and progressively enlarged, was treated like that of Henri Rochefort (also enlarged by Lebossé, Rodin's famous collaborator and technician in 1897–9), that is, chunks of clay differentiated by deep cavities were turned into equivalents for Balzac's brave, convulsive, idiosyncratic nature. The vulgarity of the lank hair and sneering lips makes the ceramic version of the head seem not a ridiculous Toby jug but perfectly plausible, even tragic.

Not surprisingly the fact that Rodin took eight years to resolve the monument is related to his own cycles of depression, ill health and manic over-work. The distress he was causing Rose as he stayed away for long periods was countered by his worship and anxiety for Camille whom he still described in 1895 as 'this woman of genius (the word is not out of place) whom I love so much for the sake of her art'.[65] His state of unease was also the direct result of the critical backlash which gathered force in the nineties. He especially relished official honours, like the Cross of the Chevalier of the Legion of Honour awarded in 1887, and feared that the accolades might suddenly come to an end. Several critics knew exactly where to find his Achilles' heel. A few, like Félicien Champsaur, were previously admirers who had supported the underdog Rodin but were now cynical about his lionization. Champsaur in *Gil Blas*, September 1896, traced Rodin's rise from humble origins and blamed his admirers for his loss of direction and the modesty appropriate to his class:

A horde of subservient supporters settled in around the unfinished portal, shrieking with enthusiasm. And when he reflected that the pressure of his thumb in the clay was a startling manifestation of the synthesis of human thought, or that his white plaster silhouettes, those victims of lust contemplated every afternoon with little cries from ecstatic worldly snobs or fainting hysterics, were blows struck for the renewal of art in an exhausted world, the poor sculptor began to demolish his portal in a morbid pursuit of tormented Michelangelo-like effects. And ultimately, his brain first intoxicated, then softened by all the hosannas, he could do no more than pronounce memorable words, worthy of a man definitively installed as resident genius.[66]

The pressure on Rodin greatly affected his ability to concentrate, and he complained of being persecuted and misunderstood. When his close friend Alphonse Legros returned to London in March 1896 after visiting Rodin, he addressed his 'brave ami': 'You seemed to be very worried when I passed through Paris. Write to me and give me some good news. It would give me great pleasure to learn you have recovered your tranquillity of mind and your equilibrium. You were born to create. The only pleasure is that which comes from work.'[67]

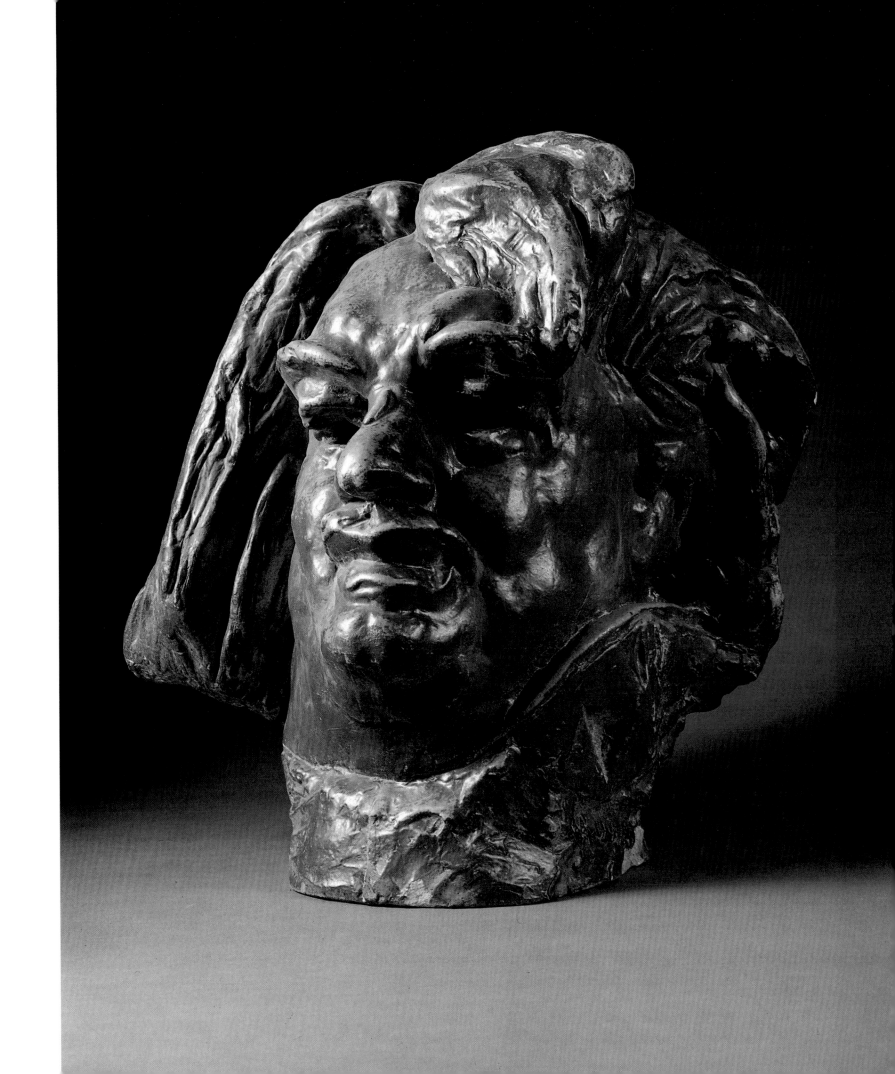

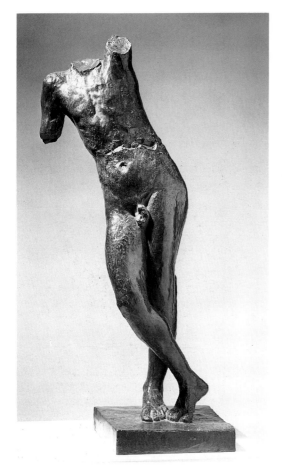

215 *The Spirit of Eternal Repose*, c.1899, B. Gerald Cantor Collections (cat. no. 148).

Immediately prior to entering the 2.6 metre high plaster *Monument to Balzac* in the Salon in 1898 Rodin was nervous about whether the work was any good. The people who mattered most to him reassured him that being a great and unforeseen masterpiece it would survive. Although Camille Claudel was now no longer his mistress, Rodin sought her opinion, and she wrote back that it was 'a real discovery and gripping'.[68] However, despite support from artists, the public reception was overwhelmingly negative and the committee refused to countenance erecting the monument. Rodin brought his *Balzac* back to Meudon. By September 1898 he was speaking of his 'defeat' and refusing to let even his old friend Constantin Meunier arrange for *Balzac* to be seen in Belgium.[69] With time Rodin came to feel he had been right to produce a symbol, one neither an allegorical composite nor a naturalistic portrait: 'Nothing I have ever done satisfied me so much, because nothing cost me so much, nothing sums up so profoundly what I believe to be the secret law of my art.'[70] Yet conceptually or formally he could take the idea no further; it was a unique marvel of subliminal expressiveness, Gothic in origin, but lingam-like in its monolithic simplicity.

In spite of the scandal and anguish which *Balzac* caused him, Rodin did not become utterly disillusioned with the prospect of making monuments. In the next decade he took on several more projects including a monument to Puvis de Chavannes and one to Whistler. Both were commissioned by artists' societies to commemorate painters with whom he had first-hand acquaintance.[71]

A bust of Puvis de Chavannes already existed, one he had made in 1890. During the sittings the painter had criticized the way Rodin was interpreting his head. In one letter he complained it was made to look arrogant ('contraire à mon nature'); in another he thought the long hair and beard seemed objectionably anachronistic.[72] Ten years later, with Puvis dead, Rodin clearly felt free to attempt to convey his unfettered response to the serenity and pastoral simplicity

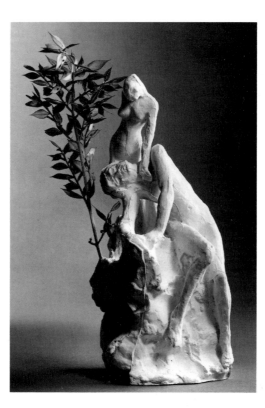

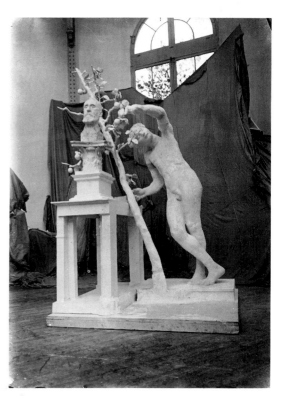

216 *Small group with two people*, Musée Rodin, S2841.

217 *Monument to Puvis de Chavannes*, from 1901, Musée Rodin (cat. no. 256).

218 *Farewell*, 1892, Musée Rodin (cat. no. 191).

219 *Camille Claudel in a Phrygian Cap*, c.1886, The Josefowitz Collection (cat. no. 123).

of the painter's own works. A torso, probably made in Belgium as early as 1876, the *Génie Funérale* was set next to the bust, now elevated by an ornate plinth.[73] Rechristened the *Génie du Eternal Repos*, this figure acquired one of the Iris-type heads, thus becoming a kind of lumpen faun with the deep-set eyes and withdrawn expression of the Shades. A large apple-tree branch was placed on the same diagonal as the inclined figure, stressing the Classical association with the guardian of the door to Hades.

Seen by Arsène Alexandre and Rilke around 1904 and photographed, the assemblage, with its undigested poetic inferences, relates not only to late drawings, but also to the smaller combinations of artifacts with heads and bodies with which Rodin was experimenting in his leisure.[74] Some, like the nude with book known as *Ecclésiastes* and the curious torsos inserted into antique vases, have an insularity that suggests Rodin was making them during one of his deliberate periods of solitude when he retreated to the little house, La Gouette (a former laundry), in the grounds at Meudon.[75]

The sequence of heads which Rodin continued to make of Camille Claudel, in contrast, never seem like hybrids. They have in common her perfect oval face with smooth brow and straight nose. *Camille Claudel in a Phyrigian Cap* (1884), draws away the hair, stressing the rare intensity of her introspective intelligence. Reworked in the 1890s as *Farewell*, the same uncorrupted features are set upon a cast plaster block, her hands placed at her mouth. The sexual connotations of this gesture are softened by the tender suggestion of adolescent confusion. As many people have remarked, the sculpture *Farewell* and its companion piece *Convalescence* seem to anticipate Camille's withdrawal a few years later into her own terrible paranoic world.[76] The marble versions, in which the head seems to sink back into amorphous matter, strengthen this impression of helplessness.

At the peak of Camille's career, in 1905, a female reporter visiting the studio found her 'un peu faroche'.[77] In Rodin's sculpture *La France* a stronger, more

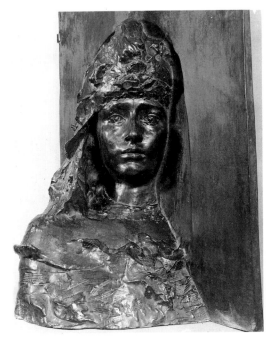

220 *La France*, 1904, Victoria and Albert Museum (cat. no. 192).

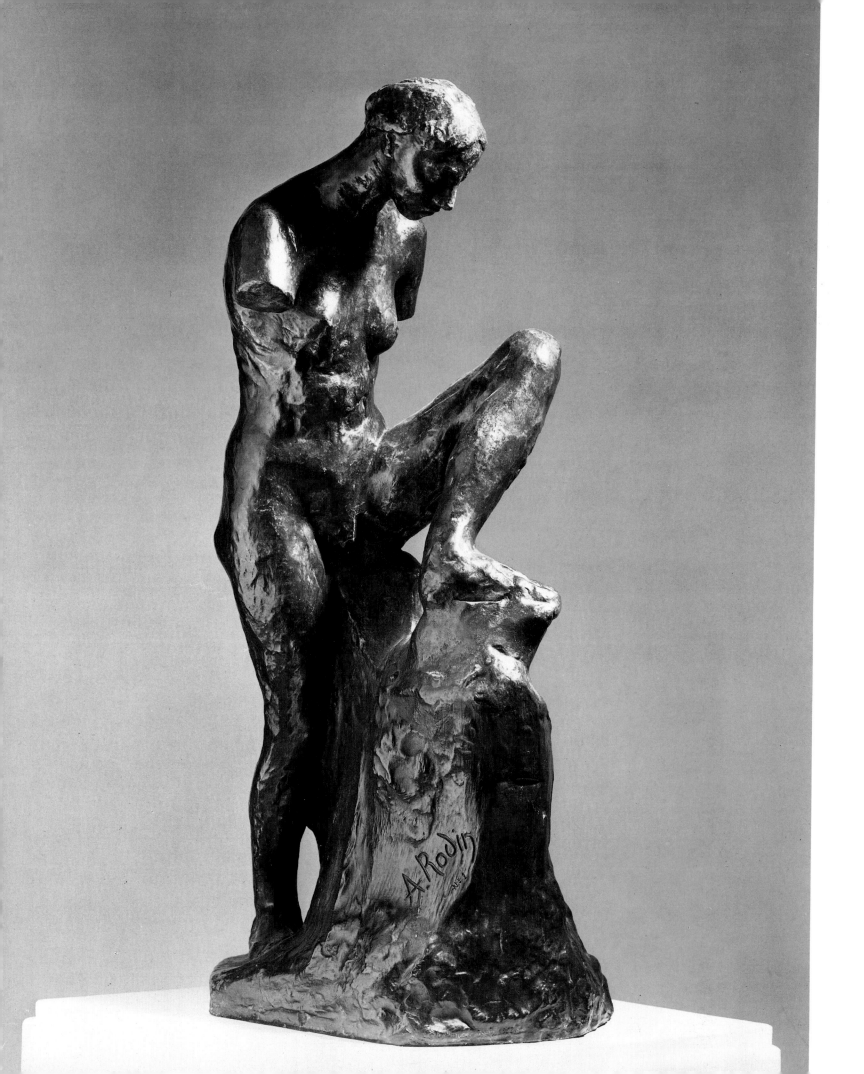

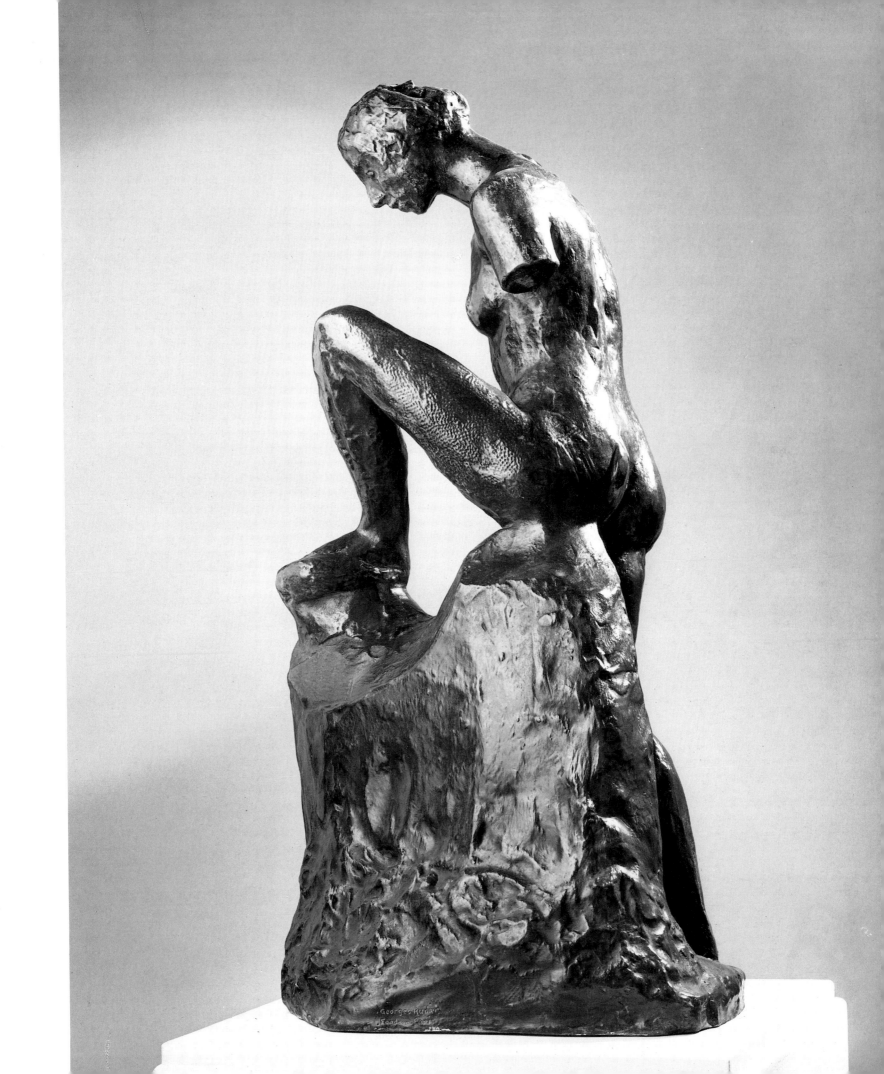

223 *Muse of Whistler with drapes, c.*1906. Photograph by J.E. Bulloz, Musée Rodin (cat. no. 266).

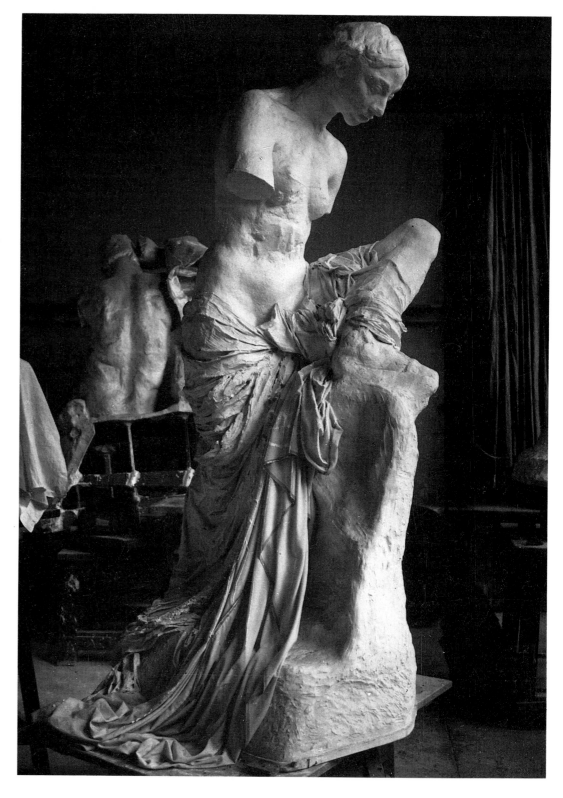

221 and 222 (preceding pages) *Project for a Monument to Whistler, c.*1903–8, Stanford University Museum of Art (cat. no. 151).

mature head of Camille is set against the niche broken into an upright plaque. Probably assembled around 1904, Rodin changed the work's name according to the occasion. It was 'St George' in honour of Edward VII's visit to the studio and when it was donated to Glasgow University. At another time the piece was entitled *The Byzantine Princess*, causing scholars to reflect on its possible correspondence with the nineteenth-century vogue for early Christendom, at the time associated with licentious cruel heroines.[78] What Rodin's work undeniably

does is reflect his longing for his mistress's uncommon sanctity to be immortalized, almost in protest against the degrading madness which had started to coarsen her face and form by the age of forty.

The last of the single-figure monuments related to its official subject in only a tenuous fashion. Instead of a posthumous portrait of Whistler, which Rodin refused to make, he offered the English committee led by James Pennell a standing woman: 'a heroic figure of fame, or the triumph of art and of one man over the artlessness of the world.'[79] Beginning the piece in 1904, Rodin chose as his model the British painter Gwen John, who had herself met Whistler when she attended classes at the Académie Carmen in 1898–99, and who became one of Rodin's mistresses. Her strange, inclined pose with raised leg was adapted from Classical art (as was Degas' fascination with a similar Greek sculpture of a woman fastening her sandal).[80] In fact the raised knee in the Whistler monument was supposed to support a plaque with Whistler's head in bas-relief. Very soon the particular sensuality of Gwen John permeated the work, affecting Rodin's treatment of her flat pelvis, her inward-looking, quiet features, and the unexpected febrile tension of the pose, with its long lines of back and leg.

Although Rodin kept on promising the increasingly impatient committee and its subscribers a monument one day, six years later his answer to the question of exactly when it would be finished made it clear that his *Monument to Whistler* was not merely a project but a piece of himself. He told the reporter for the *Morning Post* in 1910:

> I am unfortunately a slow worker, being one of those artists in whose minds the conception of work slowly takes shape and slowly comes to maturity. I lay my work aside while it is yet unfinished, and for months I may appear to abandon it. Every now and then, however, I return to it and correct or add a detail here and there. I have not really abandoned it, you see, only I am hard to satisfy.[81]

It was as if this solitary female figure of a person who meant a great deal to him had become another of his companion sculptures. In daily life Gwen John's attentions were unwanted, yet Rodin encouraged her painting and told her that she had 'great faculties for feeling and thinking'.[82] As with Camille Claudel, he recognized her artistic vision as not only original but outside his own grasp. Keeping her surrogate image as a work in progress—as he had done so endlessly with *Balzac*, *Hugo* and other pieces, in spite of the outcry from anxious committees—was a way of keeping his hand on the girl's pulse, preserving her as a unique muse. The proposed outdoor sites for the final bronze on Chelsea Embankment and outside Whistler's birthplace in Lowell, Massachusetts were hardly as important to Rodin as the devotional magnetism of the large, ungainly figure with its linen draperies standing in his own studio. The concept of sculpture which is lived with, because it is vital, incomplete and reaches out to the viewer's way of positioning and moving his own body—the guiding principle of the *Burghers of Calais*—had become implanted in Rodin's mind. The *Monument to Whistler* is not unresolved so much as intentionally left expectant.

224 *Head of the Muse of Whistler*, c.1905, The Metropolitan Museum of Art (cat. no. 149).

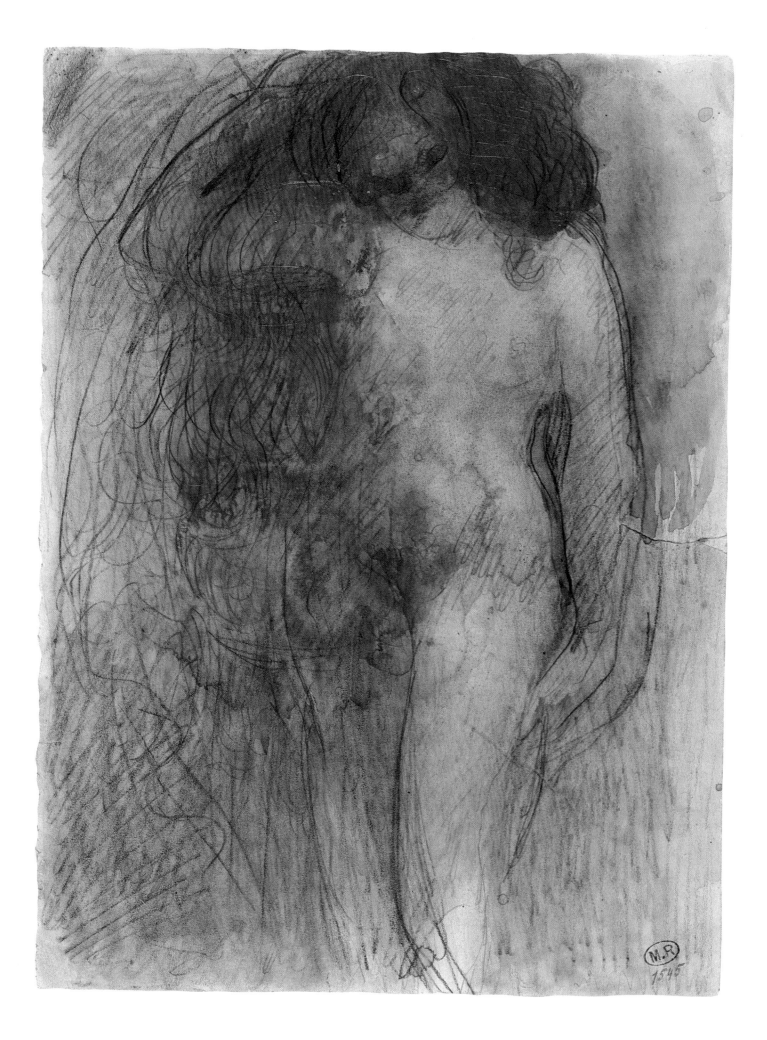

M.R
1545

The Late Years

IN A CURIOUS WAY drawing as an activity came to have much the same creative function in Rodin's art in the last twenty years of his life as it had in the early period leading up to the *Gates of Hell*. Working on paper once again meant being able to note down spontaneously ideas as confessional, or even mawkish, as repetitive and as poetic as he wished. The results were easily gathered for Rodin's private contemplation and often at a later stage annotated, embellished or frequently ruined. As soon as one sheet fell to the ground another was begun. The fluency and abundance that became the norm was in itself a way of preparing a foundation for experimental three-dimensional ideas. Many of the remarkable late sculptures, for example the dancers of 1910–12, sprang not from conscious striving or extrapolation as did *Balzac,* but from an outpouring of casual ideas and techniques on paper. The late drawings, like the notebook studies of his visions of Dante and Baudelaire, brought out a shamelessness. For Rodin, as for many artists, that impulse was in itself a stimulus to make original art, and to enter areas which no one else had previously explored.

The situations in 1880 and 1895 are, of course, not parallel in every respect. In the earlier period Rodin was struggling to formulate his radical vision of figure sculpture and at the same time to win professional recognition. In the later period his reputation was so monumental that he was treated rather like an oracle, a one-man movement—the person responsible for returning to sculpture the universality and dignity of Michelangelo, and the touchstone for a younger generation as diverse as Bourdelle, Matisse and Brancusi. In addition to carrying the torch for 'modern' sculpture, by 1895 Rodin was running a formidable business. Copies of his images were supplied to collections world-wide. From the letters and invoices preserved in enormous quantity in the Rodin archives it is obvious that he was personally supervising the vast number of armature-makers, casters, enlargers, founders and finishers.[1] In his own studios he was working in collaboration with talented sculptor/assistants like Victor Peter, Bourdelle and Despiau (who were making marble versions of Rodin sculptures) and also looking after foreign pupil/sculptors like Victor Frisch, John Tweed and Malvina Hoffman. In 1895 Goncourt noted that the workshops were engaged 'in ceaseless production', but that Rodin was suffering from 'the vexations which in the painters' and sculptors' careers are inflicted on artists by art committees'.[2]

The propagation of Rodin's art occurred on an unprecedented scale. With the encouragement of friends such as the Swiss critic Mathias Morhardt and the Czech sculptor Joseph Maratka retrospective exhibitions were staged in rapid succession: after Geneva in 1897 came Brussels and a tour of Holland in 1899, his own Paris pavilion in the place de l'Alma in 1900, Vienna in 1901, Prague in 1902, a five-city German tour in 1904 and smaller shows in London, Pittsburgh, New York, Buenos Aires and so on.[3] The first of many serious monographs, those of Léon Maillard in 1898, Judith Cladel in 1903 and Camille Mauclair in 1905, demanded Rodin's attention, as did the published interviews with him, such as Paul Gsell's in 1911, and Gustave Coquiot's and Henri Dujardin-Beaumetz' in 1913. Special issues of art journals devoted exclusively to Rodin were prepared, starting with *La Plume* in 1900.[4] After the lavish facsimile album

226 Installation of the exhibition organized by the Manes Society, Prague, 1902. Musée Rodin.

227 Installation of the exhibition organized by the Manes Society, Prague, 1902, interior. Musée Rodin.

225 (facing page) *Standing woman with hand in hair,* Musée Rodin (cat. no. 183).

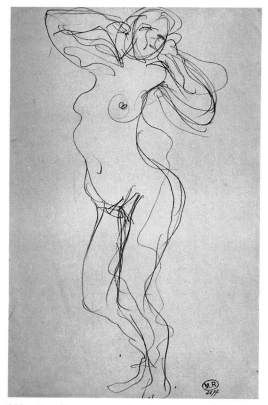

228 *Standing woman, hands behind neck*, Musée Rodin (cat. no. 165).

of early drawings produced by the house of Goupil appeared in 1897, Rodin illustrated a limited edition of Octave Mirbeau's *Le Jardin des Supplices* in 1899 with 20 tipped-in plates lithographically reproduced, and Ovid's *Elegies* with line engravings from his drawings. Meanwhile official attention kept increasing: Rodin received several honorary degrees, became President of the International Society of Painters, Sculptors and Engravers, was regularly visited by royalty and famous dignitaries at his studios and was fêted on his many foreign tours.

When we consider Rodin's late drawings, some 7,000 in number, their lightness and whimsicality should be seen against this background: something Rodin could do without assistance, keep physically and conceptually undiluted, and yet annex to his philosophy of art.[5] What Rodin was allowing to go on in his studios was equally heart-felt but in a sense self-perpetuating. Originally he had followed Carrier-Belleuse's example and competed for commissions in order to obtain the capital to run an expanding sculpture business. While these official awards still came his way, the growing demand was for marble and bronze copies of famous works for private patrons, the majority foreign and thus future museum benefactors like Mrs John Simpson, Alma de Bretteville Spreckels and Carl Jacobsen.

Rodin was himself fully convinced, as an evangelist on behalf of the anti-Neoclassical naturalism of his work, of the morality of editioning and copying his pieces so that they could be enjoyed by a wide public. Providing copies of the most accessible sculptures, as he had started to do during the Belgian years, simply opened the path to an appreciation of the more difficult ones. Between 1887 and 1894, for example, the firm of Griffoul made bronze casts of *The Kiss*, *Faun and Nymph*, *Kneeling Fauness*, *Ugolino* and the Victor Hugo group, and at the turn of the century Barbedienne and other founders were casting *The Kiss* in various sizes, 50 at 72 cm, 105 at 38 cm, 95 at 24 cm and another 69 at 61 cm.[6] Collectors, like Edward Warren Parry, commissioned replicas of the famous pieces (Parry's was the largest marble version of *The Kiss*, now in the Tate Gallery), and in their contracts stipulated sizes and details.[7] Far from avoiding this proliferation of his images, Rodin obliged, believing works of art and Nature were there for contemplation, and contemplation was what made man happy. He told Gsell: 'The man free from want, who enjoys, like a sage the innumerable marvels that meet his eyes and mind at each moment walks on the earth like a God. He becomes intoxicated admiring the beautiful beings full of vigor who display their quivering fire around him . . .' He continued with a soliloquy that brought in 'young muscles', 'buzzing bees', 'rustling wings', Apollo dispersing the clouds and so on.[8]

Rilke, who met Rodin in 1902 and acted as his secretary in 1905–6, was in a position to witness the way Rodin treated the many people who made the pilgrimage to the rue de l'Université and out to Meudon. They encountered not a prophet but someone more a dreamer whose charisma was quiet and most radiant when the man was spied working. If visitors wanted to know the secret of his genius Rilke observed that the master

> shrugs off the imputation of inspiration, and claims that there is no such thing—no inspiration, but rather only labour—and then one suddenly comprehends that for this creator receptivity has become so continuous that he no longer feels its coming, because it is no longer ever absent; and one divines the ground of his uninterrupted fruitfulness.[9]

This attitude speaks of a subtle change from the self-critical Rodin of five years

previously who declared in *Le Journal* in 1898 that 'Balzac, rejected or not, is none the less a line of demarcation between commercial sculpture and the sculpture that is art that we no longer have in Europe.'[10] After 1900 he became especially vulnerable to the society women who flocked to the studios as though they were shrines to beauty and truth and demanded he sculpt their portraits.[11] Rather than particularize their features, Rodin distanced his interpretations from the present by softening their elegant, studied looks of spirituality with an ethereal ambience that sought to associate these faces with the greater collective consciousness of all civilizations. The upturned faces, which Rilke called antique cameos, Rodin interpreted in marble so that, as Rilke explained, 'In these faces, the smile never settled anywhere, but flits across their features with such misty softness that it seems it must vanish with every intake of breath. The lips are enigmatically sealed; the wide, staring eyes look through everything into an eternal, moonlit night, into a dream.'[12] The conventional upper-class features of Lady Warwick, John Winchester de Kay, Miss Eve Fairfax, Countess Anna de Noailles and dozens of others have this generalized, veiled look. Occasionally Rodin went further. After executing several very beautiful likenesses of the painter John Russell's handsome wife Mariana in the late eighties, in 1896 he adapted the plaster for allegorical ends. In one marble her head is crowned, *Pallas with the Parthenon*, and in another covered, *Pallas with a Helmet*.

The sculptures where we find overt exterior references may now seem either very hackneyed or at best evidence of Rodin's links with the Symbolists. Many compositions that place nubile protagonists in actions signifying mythological counterparts appear forced and indeed the visual life of the carving demeans the original modelling. It is true that beautiful and memorable sculptures were

achieved by these means; even so they rarely feel as authentic as casts from the *moulages à bon creux*. Critics close to Rodin were sensitive to this difference. Defending the *Tragic Muse* in 1897, Mathias Morhardt declared Geneva's new acquisition was 'the finest flowering of his modelled work . . . This is a work which has not been dishonoured by any assistant or by any retouching.'[13]

The more famous Rodin became the more he tried to avoid an egocentric focus and to divert adulation by suggesting in its place what Rilke observed, that creativity is merely the combination of hard work, native instincts and contemplation of the finest examples of the art of the past. As if to prove this theory Rodin encouraged visitors to all three of his establishments, the studios at the Dépôt des marbres, the suburban estate at Meudon and the crumbling mansion, the Hôtel Biron, on the rue de Varenne. Each location was a mixture of studio and museum. Visitors on Saturday afternoons to the rue de l'Université, where the plaster *Gates* was returned after the 1900 exhibition, saw tables laden with piles of drawings and half-completed studies (but only a crude stove and bare furnishings). Those invited to Meudon found a similar studio-cum-storeroom with a jumble of plasters, including the *Tragic Muse* perched on a fluted column, the large versions of *Victor Hugo* and *Balzac*, and pigeon-holes containing tiny plasters. Outside in the portico Rodin arranged his work intermingled with objects, as he did in the landscaped gardens where, for example, a large, draped, *Jean d'Aire* overlooked the pond and a Greek torso stood in front of a curved bench.[14] On the walls of his and Rose's modest home, the Villa Brillant, at Meudon and at the Hôtel Biron there were paintings by Rodin's favourite contemporaries, including Van Gogh, Renoir, Falguière, Monet, Carrière and Ignacio Zuloaga.[15] Also in the elegant reception rooms of the Hôtel Biron where he spent long periods, notably during his liaison with the Duchess of Choiseul from 1908 to 1912, there were modelling stands with sculpture—Rodin's and others—large plants, curiosities and the walls triple-

230 *The Good Fairy*, *c*.1900, clay. Photograph by E. Druet, Bibliothèque Nationale, Paris.

231 Garden at Meudon with *Jean d'Aire*, Musée Rodin.

232 *Crouching Woman*, plaster, at Meudon, seen as a caryatid. Photograph by J. E. Bulloz, Musée Rodin.

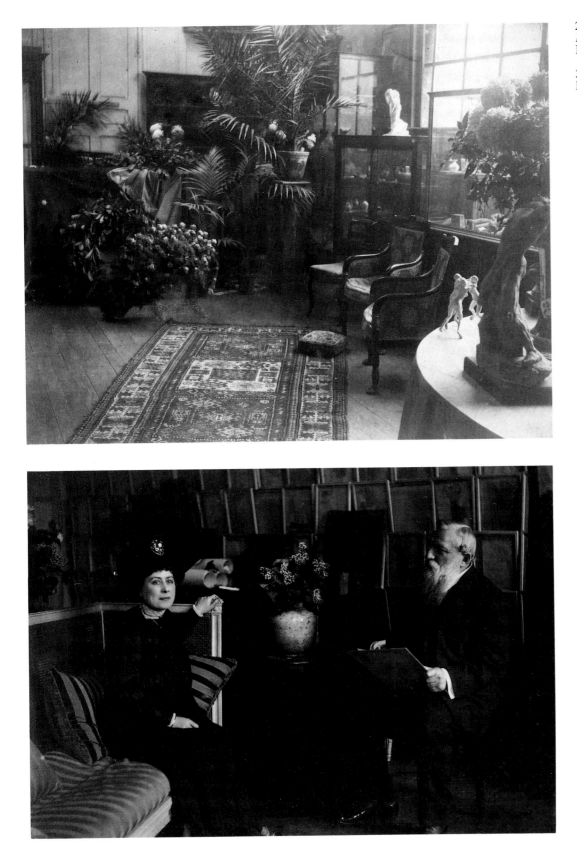

233 Interior at the Hôtel Biron with the *Three Faunesses*, *Andrieu d'Andres*, and *Falling Man*, Musée Rodin.

234 Rodin with the Duchess of Choiseul at the Hôtel Biron, *c*.1910, Musée Rodin.

hung with banks of recent drawings. The collection of artifacts and prints he started accumulating in the 1890s ranged widely—Egyptian, Etruscan, Indian, medieval, Japanese and Chinese sculpture as well as antique fragments and Attic

235 *Seated nude with hand on forehead*, Musée Rodin (cat. no. 219).

vases, Gothic architecture and, at Meudon, the entire salvaged facade of the eighteenth-century Château d'Issy.

Two essential qualities of the late drawings relate to this eclectic but stimulating environment. One is the object-like reading of the body and the other the indiscriminate preservation of everything he drew. Both suggest that Rodin's purpose was not to achieve each day a masterpiece but simply to engage in the habitual in order to keep open the option of an accidental discovery. All of the drawings were unpremeditated in the sense that, with his eyes fixed on the model, Rodin took down the outlines in pencil. The assuredness of his rapid handwriting resulted in silhouettes that are so infected by gravity and a superb radial knowledge of the human body and its internal articulations of mass that the shorthand alone gives precise information about the orientation of the subject to the vertical as well as the spatial relationship of the model to the artist's drawing-board. Almost never are there indications of chairs or floor, much less of the room; on the contrary the bodies lie in a vacuum. The warm Sienna gouache which fills many of their interiors further detaches them from the page, and, as a result, the subjects are removed from the mundane circumstances of hired girls posing for an artist and become instead deliberately timeless and contextless. Their bareness is in itself tactile: curvaceous brown bodies hovering on bare white sheets are like the Tanagra carvings which Rodin removed from the vitrines and handed to visitors to handle. Many figures have a shape that the brain could apprehend without the aid of light, much less narrative or perspective.

The other attitude of mind expressed in Rodin's practice of drawing with his eyes on the model, as if hypnotically, and then immediately beginning another, relates to his notion of communing with other artists, both named and anonymous. Rodin explained patiently to those who sought clarification, novelty or judgments about good and bad works, that the true artists who devoted themselves to observing, drawing and modelling, worked under a force greater than themselves: 'The revelations of drawing allowed Rodin to penetrate deeper into nature day by day. Familiarity with the collection of antiques in his villa "Les Brillants" helped him to understand how to translate it. He advocated a less direct art, but did not explain clearly what he meant by that . . . He talked a lot about the relationship between volumes and transitions.'[16] On another occasion he explained: 'Albert Dürer, Leonardo da Vinci and Michelangelo are strange pilgrims who seem to have visited shores from which no one before them has returned. And so, all the masters give us a glimpse into something we can neither see nor fully comprehend.'[17]

After Rodin's death in 1917 when the boxes of drawings were numbered, some 'signed' and all registered as part of the estate, they became works of art by the master. In a sense the blanket authenticity and value—that of Rodin's overall greatness—is false. Anyone who looks through them one by one will find that in the parade of bodies very many sketches are not only feeble but trivialized by the idiotic smiles and pseudo-seductive airs of certain models.[18] Hundreds were begun so large on the page, that the space ran out and they ended up visually incomplete or else with missing parts relegated to a free corner. Meandering, flabby lines, scribbles and the dull evenness of tracing bring a great number down to a fairly dreary standard. Many are utterly repetitive and others obscured by accidents of the wet medium.

What is never felt during the weeks it takes to go through the cylinder boxes is a sense of Rodin's attention being elsewhere or even diluted. The individual

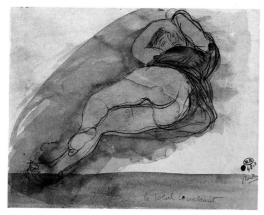

236 *Le soleil couchant*, Musée Rodin (cat. no. 231).

drawings are each fixations and are so infected by Rodin's magnetic attraction to the naked female body and complete unconcern for other people's opinions that they exude a poignant, indomitable air. The messages come directly from his libido and pay homage to the natural beauty of every woman. When the oeuvre is broken down by technique, mode, subject, attractiveness or chronological groupings, some of this *raison d'être* is lost. In any case the quantity, the random cataloguing, the lack of dates and the coincidence of divergent styles work against achieving a meaningful or scientific system. The best of Rodin's scholars have recognized this danger and this paradox.

Kirk Varnedoe, one of the few art historians to go through the complete Musée Rodin collection in the 1970s and to attempt to define modes, summed up his sharp, strong re-evaluation of the late work. He admitted his 'skepticism defeated, inadequate' to the total experience of the late works:

> These are not documents of idle self-indulgence, but of heated, driving fascination, the displaced locus of the same intense seriousness that motivated Rodin's draftsmanship from its beginning. The recurrent themes of death and the conflicts of consciousness that compelled the young man's work have here been supplanted, in the spirit of the aging artist, by an ecstatic obsession with the mystery of creation taken at its primal source.[19]

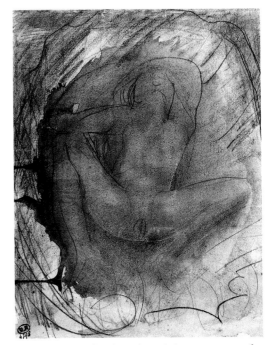

237 *Reclining female nude with legs apart, seen from front*, Musée Rodin (cat. no. 239).

In fact, as we have recently come to have access to earlier drawings (like the 1985 Musée Rodin acquisitions from the Liouville collection, pls. 78, 260), we realise that their range extends beyond the masculine images of self-address that have been assumed to be at the centre of Rodin's early thinking.[20] The majority of the Sèvres and later gouaches made in 1880–83 after Rodin had begun working in his large studio on the *Gates* were in fact investigations into physical desire. Both the sluggish, gouached, neutered characters and the wiry ink protagonists continually engage in various forms of coupling, many of a sexual nature. There are embraces of unequals (centaurs and nymphs, children and adults), deadly battles, cannibalism, copulation and satiated immobility. A proportion refer to death but when they do the interest is nearly always on cadavers feeding on flesh, the mortality of the body itself. Whatever the nominal subject, the nexus of physical passion was studied for its three-dimensional potential.

In the period when Rodin's waking hours were nearly all committed to ambitious sculptural projects, between 1883 and 1890, most of the drawing that went on was probably in the form of quick scrawls. Frisch recalled that 'Rodin made sketches, three, four—in a day, literally scores of drawings from every point of view. Just an arm perhaps, or the head against the whole body. Some of these were crumpled, tossed on the floor; others were left lying, to be gathered later and studied. After an hour, a day, a week—as the work moved him—his hands would reach for the clay. . .'[21] Yet most of the examples that survive and are thus called Rodin's drawings of the middle period, or late eighties, are not the informal notations but rather the book illustrations or etchings. Uneven in quality, indeed usually awkward and unresolved, they make up a thin chain of graphic ideas which with hindsight exposes the preoccupations at the forefront of Rodin's mind. Curiously the struggle Rodin had in the eighties to endow his drawings with certain qualities paid off in the nineties when the life drawings became immediate and evocative because of just the same fixations on ambience and line. The break from the beautiful, 'imaginary' Dante drawings had come, as has been mentioned, when in the early eighties Rodin chose to provide ink

drawings to illustrate sculptures rather than accept the greyed tonal lithographs usually derived by printers from photographs. By so doing, he could translate the strong contrasts of the raking light of the photographs into patterns of dark hatching and clear volumetric highlights. Even so the majority of drawings in this technique, such as the *St John* sent in 1883 to the *Gazette des Beaux-Arts*, seem rather artificial; the dry contour curbs the disparate hatching but does no more. The artist's fidelity to the distorting powers of the camera lens, such as the excessively large feet, is the only sign of unconventionality.

In contrast the drypoints Rodin executed between 1884 and 1888 after his busts of Victor Hugo, Henri Becque and Antonin Proust possess vitality in spite of the mixed facture. Their features are built up faithfully and patiently in hatched line following the code of the photographs until, at the periphery, the artist's manual control is allowed to relax and a spray of swift lines shatters the boundary and secures the bulky heads to the flat surface. Roger Marx, who was the first to write on all Rodin's graphic works, noticed how excited Rodin became by the etching needle: 'With it, he attacks the metal with a violence that fades into a caress when the brutal outlines of the lay-out give way to a network of fine intersecting lines; they follow the outline of the model, and inscribe its every inflection into the metal.'[22]

The next graphic developments occurred in the course of illustrating Paul Gallimard's copy of *Les Fleurs du Mal*. This commission, arranged by the architect Frantz-Jourdain, was reluctantly executed by Rodin on the collector's copy of the 1857 first edition between October 1887 and the end of January 1888.[23] The twenty-seven subjects drawn in the margins of the poems and as frontispiece, and the several inserts in fact give an excellent view of the contrast of techniques which Rodin was prepared to use at the time and also of the discrepancy between his desired effect and his means. As so often before and after, his images adjust to an alien milieu—here Baudelaire's verses—not by design but by virtue of a surreal correlation between the verbal passages and the illustrations. When Rodin's scenarios from his private world are floated onto stark white paper they carry with them a bewitched sensual pungency as strong and fatalistic as Baudelaire's own claustrophobic word-pictures.

The circuitous route from sculpture to photograph to drawing was Rodin's chosen method for six of the Baudelaire illustrations. The mythological and literary titles often seem to complicate the transitions and associations which are themselves simple reflections of Rodin's sensibility. He apparently took, for example, a photograph of the small plaster of two women which he called *The Death of Adonis* and then, with the aid of opaque wash, doctored the photograph in such a way that the lovers seem to be protected by a canopy. The theatrical effect, suggestive of a photographer's studio fantasy, when translated to fine ink lines somehow has the melancholy of the heady, velvety interiors evoked by Baudelaire's verses. Another drawing based on the nervous *Kneeling Fauness*, by now sculptured in her more *fin-de-siècle* guise as a voluptuous temptress, interprets her massive carved tresses as a train of hatched marks that obviously echoes the shape of the adjacent typography.[24]

Often it is the preliminary sketches, which show Rodin unconcerned about anyone else's opinion, that are the most riveting. One based on the small sculpture for the *Gates*, the *Metamorphoses of Ovid*, was inscribed with the words: 'le Printemps adorable a perdu sa fraicheur'. Its subject is a cool transcription of the embracing girls, now turned upright, drawn gingerly as if truly in their brittle plaster state. Around this staged vignette is a nest of scribbled black lines

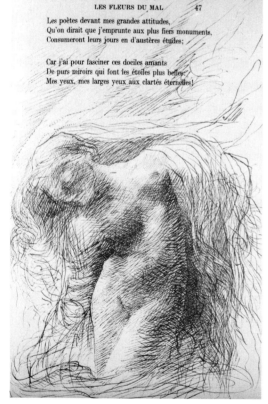

238 Illustration for 'La Beauté' in *Les Fleurs du Mal*, adapted from the sculpture *Meditation*, 1887–88.

and spots. In the final illustration for the poem 'Femmes Damnées' Rodin allowed a more naturalistic adaption with bed and flowing hair, the emphasis on the illicit embrace. A sketch comparable in its physicality to *Le printemps a perdu sa fraîcheur* is that called *La mort des amants* after its annotation. However, the figures, one on top of the other, actually seem lifelike, as if Rodin had begun the sketch directly from models in the hope of determining the way the limbs might interlock in a sculptural interpretation.

Rodin apparently kept working drawings like this one to himself. The presentation drawings of sculpture for magazine editors on the other hand became increasingly fussy. The drawing dated 1888 that he made from his marble bust of Madame Vicuña is one surviving example.[25] It suffers from his idea of a respectable drawing. Her wistful beauty is enhanced by light strokes that soften her carved turban and further simulate the silkiness of her skin. Tempering this rendition of the marble are flashes of sepia and gouache splattered around the bust in order to enclose the block in a mysterious grey-blue, cloudy-cum-rocky background that is rather denatured in effect as the chalky surfaces and scratchy lines reflect light and this emphasizes the weaknesses of an approach that aims at the animation of inert objects.

Graphic works in which Rodin gives himself over to ungoverned impulses had begun of course with violent episodes from *The Inferno* such as *Mahommed with dangling intestines*. But in the 1880s they occur more often as if stylistic exercises. The five variations of the abduction scene of the Sèvres period which led to *Je suis belle*, of which one was selected to illustrate 'De profundis clamavi' in *Les Fleurs du Mal*, have this experimental nature.[26] The versions were literally imposed on the same, bare, chromograph-copied basic outline of the standing man and woman held aloft. The most pleasing and decorative result was used for the illustration; the others have a greater element of accident. Even so, the mixture of pen, pooled India ink and gouache threatens the comprehensibility of the action in a powerful, disturbing way, one as visionary and tachistic as Victor

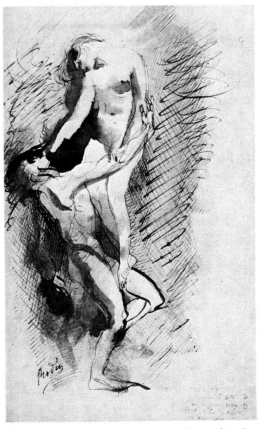

240 Illustration for 'De profundis clamavi' in *Les Fleurs du Mal*, 1887–88.

241 *Man raising a woman in his arms*, study for or after *Je suis belle*, Musée Rodin, D1913.

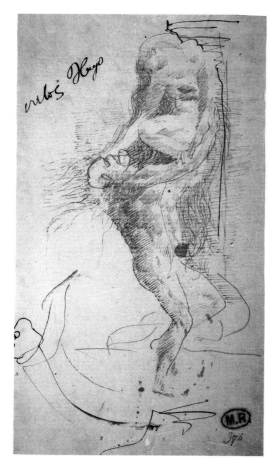

242 *Embracing couple*, from a chromolithographic process, Musée Rodin, D376.

Hugo's castles and spectres but also infected by a modern spirit of intentional interplay between solid, void and surface.

In Gallimard's copy of *Les Fleurs du Mal* there are many drawings which exemplify Rodin's concurrent, rather opposite desire to convey volumetric form by nothing more than an even lead-pencil line. His youthful copying of engravings of Roman sculpture had demonstrated his fascination with the way the Ancients depicted drapery over solids by controlled silhouettes and by rigid intervals between the profile figures in Hellenic processions. It is known that Rodin was intrigued by the realism of Attic pottery and that he was also a declared admirer of Ingres' fine line drawings, believing them not to be cold, but to result from the artist's penetrating gaze which he described as in the 'manner of a serpent'.[27]

In 1887–88, by accepting the use of an intermediate stage, that is, actually tracing direct sketches, Rodin began to eliminate the jerkiness of his observed line and replace the skeins which resulted from sequential attempts with a single, uninflected line. The process was conceptually analogous to how he registered the human body: the improved ink contour line was an equivalent to a single sight-reading of dark form against intense light. It was as if the method which the apprentice Rodin had learned from Constant and still imposed on his clay modelling was now transferred to paper, the foreshortenings at first rather conventional and timid. Redrawing the study of *Satan and his worshipper,* to become the frontispiece of Gallimard's book, *L'Imprévu,* what was gained by the sinister talons and a bloodless, even line was oddly a more stylized distancing of the loathsome act of anal subjugation. The fervent, impish boy of the original, trapped under the foot of the large figure, became denatured.

In the sketch placed adjacent to 'La Beatrice', four Satanic figures arm-in-arm are arranged so that they seem like one body rotated 180 degrees in shallow space. The satyr on the right is a relative of the Shade/Pierre de Wiessant pose but here he has been so desiccated by what Rodin himself called his 'trait' style (as opposed to 'ombre') that the effect is pictographic not summary.[28] Between the two right-hand figures appears a messy smear obviously there to correct the proportionately too great a gap between their bodies. A drawing entitled *L'Amour,* probably from a slightly earlier period (but not used in the Baudelaire commission), conveys a believable embrace; however Rodin perhaps felt uneasy with the spareness of the line and added strips of gouache highlight in the very stylized way he had learned as a decorator and had used on the caryatids, presumably to enhance the volumetric feel of the two bodies and disguise unwanted provisional lines.[29]

The first time the linear or style was applied uninhibitedly was when it was used in response to a living subject. The exotic Javanese dancers who performed in Paris in 1889 (and again in 1896) caught the attention of Gauguin, Debussy and Geffroy as well as Rodin. Goncourt records Rodin in 1891 as admitting that he had been making 'rapid sketches, which are not sufficiently imbued with their exoticism and which have something antique about them', and that Rodin was fascinated with the dancers who revealed 'a succession of movements engendering and producing a serpentine undulation'.[30] Jotted quickly on small sheets measuring approximately 13×5 cm, each traps the rhythmic gestures of a single dancer. On some a dash of blue gouache indicates a costume while a barrage of thick lines indicates his emotion. His mind is entirely occupied by the flickering received image, not by the page or by what his hand is doing.

Despite the mixed success of Rodin's efforts to transfer to his drawings the

lifelike corporeality in his sculpture, he persevered. The 1893 drypoint *The Souls in Purgatory*, which was prepared as the frontispiece for the fourth volume of Gustave Geffroy's book *La Vie Artistique*, depicts three maidens rather as if three Classical graces. What is curious is that their intertwined poses suddenly seem taken from life; their arms are much more confidently described but also more nonchalantly. Significant in view of establishing a chronology is the resemblance of the slender maiden on the right with a group of undated but distinctly alike drawings using the same nymphette figure-type. Although examples have been infrequently reproduced, these distinctive, queer sketches number about fifty. In many the girls raise their dresses or do something which suggests they are responding to the stare of an attentive artist. They are not the first Rodin sketches to show pinched, wholly linear bodies: in the upper left corner of an early equestrian study (D3778), for example, an elongated figure is inserted; but Rodin's inscription—'resurrection–jambes–enterre'—suggests he was thinking of a medieval image with an ascetic elongation.[31]

The nymphettes (from 1890 onwards) are not exactly spiritual, rather more pubescently gauche. At first the summary handling of their volumes suggests Rodin's lack of practice in drawing from the studio model as an end in itself rather than as a hasty notation to spur on a sculptural idea. Coquiot may have been referring to these sketches when he remarked that Rodin returned to drawing as a regular activity by sketching during the model's breaks simply 'le badinage d'une minute'.[32] If so, it was what models did during their breaks which became so rivetingly interesting. They climb in and out of their chemises, run their fingers through their hair, bend over double and parade impudently before the artist, reflecting the liberated atmosphere in the studio and their non-functional, indeed idle, playing. What soon evolved was a second style wherein

243 *L'Imprévu*, frontispiece for *Les Fleurs dul Mal*, *c.*1887–88.

244 Illustration of four sinners, placed next to 'La Beatrice' in *Les Fleurs du Mal*, 1887–88.

248 *Twilight*, Musée Rodin (cat. no. 154).

249 *Woman with swirling veils*, Musée Rodin (cat. no. 156).

245 (preceding page bottom left) *Souls in purgatory*, 1893, Hunterian Art Gallery, University of Glasgow (cat. no. 153).

246 (preceding page centre) *Woman lifting dress*, Musée Rodin (cat. no. 155).

247 (preceding page bottom right) *Oriental woman dancing*, c.1889, Musée Rodin, D4349.

the models are more mobile, have fuller figures and are generally jollier. It seems as if the pleasure of drawing directly from life, the revelations possible through unfiltered observation, suddenly dawn on Rodin. He moves in closer, the figures begin to occupy most of the page and sometimes run over on several sides.

A typical drawing done in the style known as his 'transitional' mode and entitled *Twilight* is of two standing girls embracing. One possesses the upturned chin and crazed expression of the left-hand girl in the 1888 study associated with the poem 'La Beatrice'; she feverishly, not stiffly, clasps the other girl, their bodies pressing against each other. The principal outlines are stressed by a broad-nib ink line which transmits the urgency of the artist's desire to experience their passion. In other transitional drawings there are tremulous, bumpy lines repeated as if his hand was guided by their restlessness. Rodin frequently elaborates the general euphoria of these fatter, jollier girls by the addition of

swirling capes and clouds of golden hair. The particular vermilion tint Rodin prefers for the skin curiously appears also in architectural drawings such as the one of the church portal at Tonnerre (D5942), suggesting that he possibly executed and embellished both figure and analytic studies sometime around 1892, during the period of his extended tours of the Bourgogne region and elsewhere to record French church architecture.[33] (A plate in the Goupil album, *Centaur and woman*, with the same hue may have been altered prior to publication in order to enliven-96. The deliberate two-stage process of recording pencil 'instantées' and then later amplifying the interiors with clouds of thin water-colour may not have happened straight away; it was apparently not commented upon before Roger Marx's review of 1897, dating it to about the summer of 1896.[35] However, after then many friends were allowed to watch the master drawing, rather as a performance. The flowery accounts of these occasions are always filled with admiration for the way Rodin was able to draw without ever looking at the paper. As Rodin put it, 'my object is to test to what extent my hands already feel what my eyes see'.[36] Judith Cladel's word 'dérouté', to describe Rodin's state of mind, accords with everyone else's reporting. Rodin sat with drawing-board on his knees at a distance of only a few feet from the model, and, as Cladel suggests, the provocation was a two-way process. The model began on her hands and knees, but finding Rodin indifferent:

> Then she stood up, placed her hands on the hips and thrust her breasts forward, pulling herself up like a growing plant, as much to relax as to find a pose by moving about; suddenly he said in a piercing voice: 'Ah! That is beautiful. Don't move! That is beautiful.' And he began to draw. His face changed. The noble severity of his features, which makes him look like a

250 *Five nude studies of a woman dressing*, Musée Rodin (cat. no. 158).

251 *Kneeling woman from behind, head thrown back*, Musée Rodin (cat. no. 168).

252 *Kneeling woman from the front, head thrown back*, Musée Rodin (cat. no. 169).

253 *Woman on all fours, in profile*, Musée Rodin (cat. no. 221).

255 (facing page) *Woman pulling dress over head*, Musée Rodin (cat. no. 186).

254 *Seated girl on knees*, Art Institute of Chicago (cat. no. 180).

Gothic figure, vanished. His face lit up with enthusiasm; his cheeks swelled out and his nostrils flared. He looked like the portrait by Carrière, and even more like the bust of Camille Claudel, but the great joy that filled him was even more obvious.[37]

What comes across in each observer's description is Rodin's hypnotic engagement with his subject. If the models are his slaves, he is also slave to them. Looking through the sheets we realise he is stalking their bodies, picking up scents, noting down habits and fixing on paper individual gestures. The young William Rothenstein on his first visit to Rodin's studio, in 1897, remembered the master not only praising their forms but 'caressing them with his eyes, and sometimes, too with his hand, and drawing my attention to their beauties'. Rodin remarked then: 'People say I think too much about women', and before Rothenstein could protest answered himself, 'yet, after all what is there more important to think about'.[38] The comment is a useful admission because it alludes to his state of mind, and therefore to his priorities when drawing: first came his curiosity about the living person and his projected fantasies; with reflection, mythological and allegorical correlations; and only as afterthought the 'look' of the drawing on the flat page.

This order is worth remembering when we are tempted to compare the content of Rodin's late art with that of his contemporaries and generalize about period preoccupations. Rodin's art is nearly always that with the least interest in moral judgments, and curiously the least air of salacious provocation. This difference comes across clearly in his treatment of Lesbian couples. From the beginning, as we know, Rodin's recording of the sexual imperative had been inclusive—intimate relationships which were not about maternal protection, procreation or even romantic love had surfaced in the Italian sketches of Leda and the Swan, rape scenes and the Medea and Ugolino sequences. The *écorché* studies had shown men wrestling, their intimacy parallel to Rodin's depictions of Dante and Virgil in each other's arms. Not surprisingly the first sculpture of two nude women, *Femmes Damnées c.*1885, and related terracottas pose lean female couples

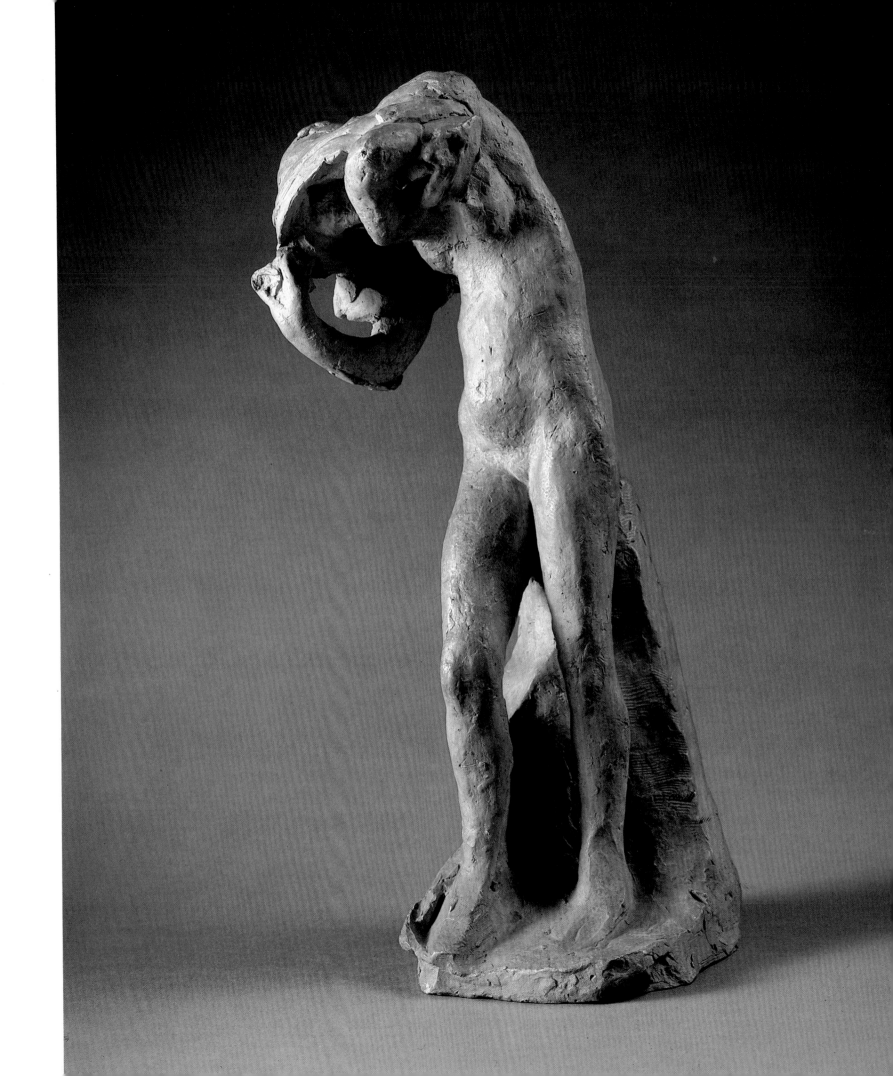

256 Model with *Meditation*. Photograph by E. Druet from 1911, Musée Rodin (cat. no. 244).

257 Model in dance pose, Musée Rodin.

as if frolicking. Their equally matched physiques and lack of inhibition verging on ungainliness—the bottom of one raised high as if in horseplay—somehow suggest that Rodin is hardly disapproving, merely fascinated.

The models for this sculpture and others of the mid-1880s were reputedly two Lesbian dancers from the Paris Opéra whom Degas sent to Rodin.[39] Charles Millard in his study of Degas' sculpture has drawn attention to an article by Jean Lorrain in 1887 which caught the attraction of using models of dubious respectability:[40]

The glittering *pupazzi* of the world of fashion and art, drunk with light and with the spirit of the boulevards. And the most seductive and intoxicating of all these puppets is the Dancer, the supreme, absurdly feminine doll, an exasperating, but delicate and very evasive vampire, with a perverse Sidonian head, the mad swirl of her skirts, the impossible wasp-waist, and the disturbing mystery of her lips, heavily made-up and looking like a splash of fresh blood on her powdered face; the modern Dancer, so bloodlessly pale and thin that she is almost macabre; the Dancer who is so dear to Degas, Forain and Willette.'[41]

Lorrain went on to name and describe the most famous seductresses and courtesans—Salome, Carabines, Josephina, Esther and others—citing the memorable evocation of their charms in the writings of Balzac and Victor Hugo. That Rodin had been infected by the late nineteenth-century interest in perversion and in homosexuality is obvious. What is interesting, though, is how different was his curiosity from that of artists whose work he knew, particularly Degas and Félicien Rops, who were also fascinated by the Lesbianism and prostitution associated with the world of dancers. A cynical element comes across in Degas' monoprints and drawings, one capable of using the nudity of the brothel or backstage as part of an interior with equal emphasis on the eroticism of inert matter—sofa, wallpaper, tub, etc. Rops, who came to Rodin's attention at least as early as 1886, dwells on the sordid details of seduction—the stockings, the lifted skirts and general trumpery—bringing in the spectator as fellow voyeur.[42] By contrast, although Rodin's imagination was stirred by stories of wicked women and although he added titles like 'vampire', 'Cleopatra' and 'Bilitis' to drawings, at heart he wanted his subjects to remain blasé, cheeky comrades paid to live in the studio. Late in life Rodin told his female secretary that he was often disgusted by the direct advances of his well-brought-up admirers. Far from boasting of conquests like a 'triumphant satyr', he wanted to preserve the illusion that anything that happened in the studio was a reflection of the beauty of Nature and thus sacred. In this spirit he invited more than one girl to bed at a time: Gwen John reported sharing his attentions with Hilda Maria Flodin, the Finnish sculptress who introduced them in 1904.[43]

Rodin's drawings certainly reveal an epicurean delight in the visual motifs of Lesbian love. When he was asked by Ambrose Vollard to illustrate Mirbeau's *Le Jardin des Supplices*, a story in which a French deputy and an eccentric Englishwoman, Clara, are lured into a Chinese torture garden and engaged in scenes of 'wild debauchery', complete with death spasms, Rodin chose to adapt ordinary life drawings with a perfectly relaxed ambience. The wash drawings, prepared by Rodin and reproduced by the master lithographer Eugène Clot between 1899 and 1900, constitute an alphabet of the ways female bodies fit together and engage in mild gymnastics or self-gratification. The dualism of the

hollows of one being the swellings of the other, conceptually like architectural volute lines, is played upon for its formal interest.[44] In these drawings and others tracings allow for positions impossible in reality: the stiff nymph with arched back (D4779 and D4719 for example) was moved around a girl of a larger scale. Another ingenious technique was to print a bare, almost mechanical tracing directly on a paper. Reduced-sized tracings were imposed on the transparent paper dividers in the book and others were used for illustrations for the articles in the 1900 special edition of *La Plume*. Very likely many tracings were not executed by Rodin, although given his approval.

The desire to retreat to a primarily female world and softer contiguous outlines, one might argue, is simply a sign of disengagement from the more angst-ridden vocabulary of the youthful artist. By moving to the South of France around the age of 50, first Renoir and then Matisse went figuratively and actually closer to the warmth and Sybaritic pleasures associated with amoral, pagan love. Rodin's immersion in the habits of his models reminds us especially of Matisse's deliberate construction of an artificial world in the studio, one in which docile nude models were able to lounge around unselfconsciously. The sequential

258 *The Embrace* (cat. no. 178).

259 *Sapphic couple*, Musée Rodin (cat. no. 218).

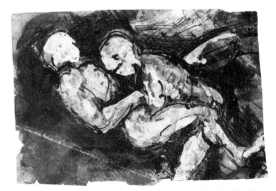

260 *Two people enlaced*, *c.*1880, Musée Rodin, formerly Liouville Collection, D7654.

261 *Sapphic couple*, Musée Rodin (cat. no. 172).

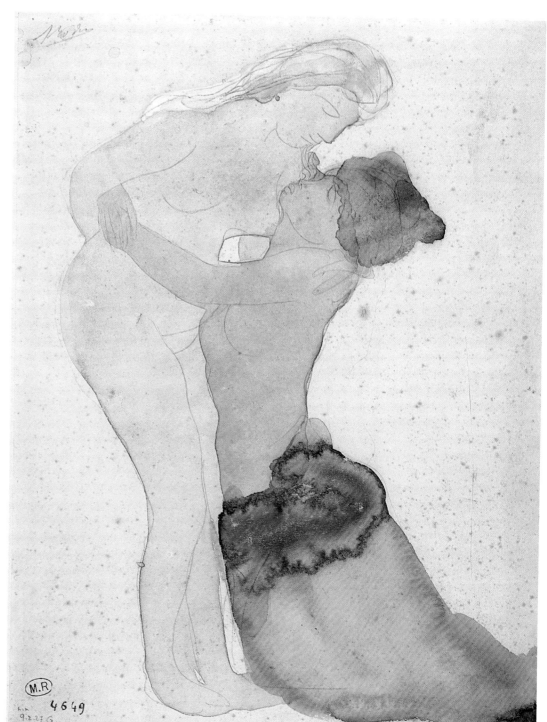

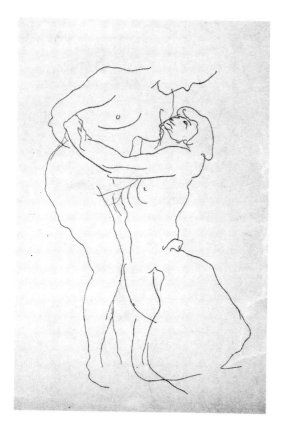

262 Illustration of *Sapphic couple* from *La Plume* (back cover), 1900.

nature of Matisse's work during the Nice period speaks of his attachment to his models and to his sealed precious environment. It comes through factually in the reappearance of the same person, the same oval mirror and the distinctive embroidered cloths on the window sill. In the thousands of Rodin drawings not only do we also notice the same model, same coiffure or tilted nose, but furthermore the same pose is carried from one to another. Large matrices of duplicate contours (often in different media and scales) could be assembled: the crouching woman with extended arm and the kneeling girl are examples (Cat. nos. 174 and 180).

Enough exists in the archives to follow something of Rodin's relationship with specific, named girls. Maurice Gillemot's article 'Les Deux Modèles' in *Figaro* in 1899, for example, described events at the rue de l'Université when Thérèse (Rey) was replaced by the well-bred Suzette de Prasles who abandoned her modesty and undressed for the artist.[45] Many models wrote Rodin affectionate, indeed flirtatious notes. Rodin boasted about his association with well-known, beautiful models and dancers (as they did about him). Among those celebrities who came to pose were Carmen d'Amedoz, Sévèrine, Alda Moreno, Georgette Leblanc and Hanako. Other talented women became part of the creative ambience Rodin liked to surround himself with, the most famous being his good friends Loïe Fuller and Isadora Duncan and the occasional visitors like Wanda Landowska, who came to play her harpsichord, and the actress Eleanora Duse, who recited poetry. There are almost no drawings that are strictly portraits (with

263 *Crouching nude*, before 1900, Herman Collection (cat. no. 182).

264 *Woman in profile, squatting on her heels*, Musée Rodin (cat. no. 175).

265 *Crouching nude, c.*1900–5, Stanford University Museum of Art (cat. no. 174).

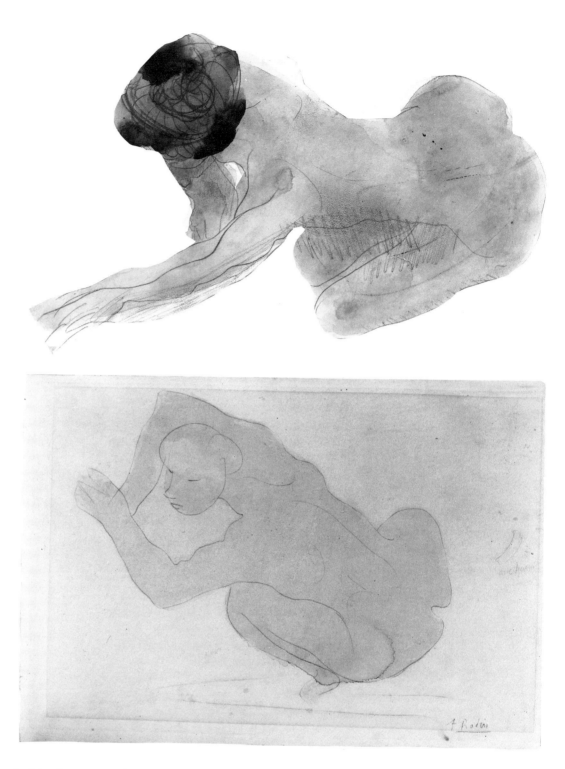

266 *Sévèrine*, Szépmüvészeti Muzeum, Budapest (cat. no. 159).

(with the exception of those of Sévèrine who delivered an eulogy at Rodin's funeral). It was rather the vitality of the enormous, swelling veils of Loïe Fuller and Isadora Duncan and the strange, jolting movements of Nijinsky that stimulated Rodin; their exoticism could be triggered perfectly well by a commonplace model imitating these new fashions in dance.

In Rodin's late drawings the lack of setting or narrative makes for him an intimate contact. Bare, three-minute outlines have the ability to conjure up the intoxicating closeness of voluptuous bodies moving about uninhibitedly in the

156

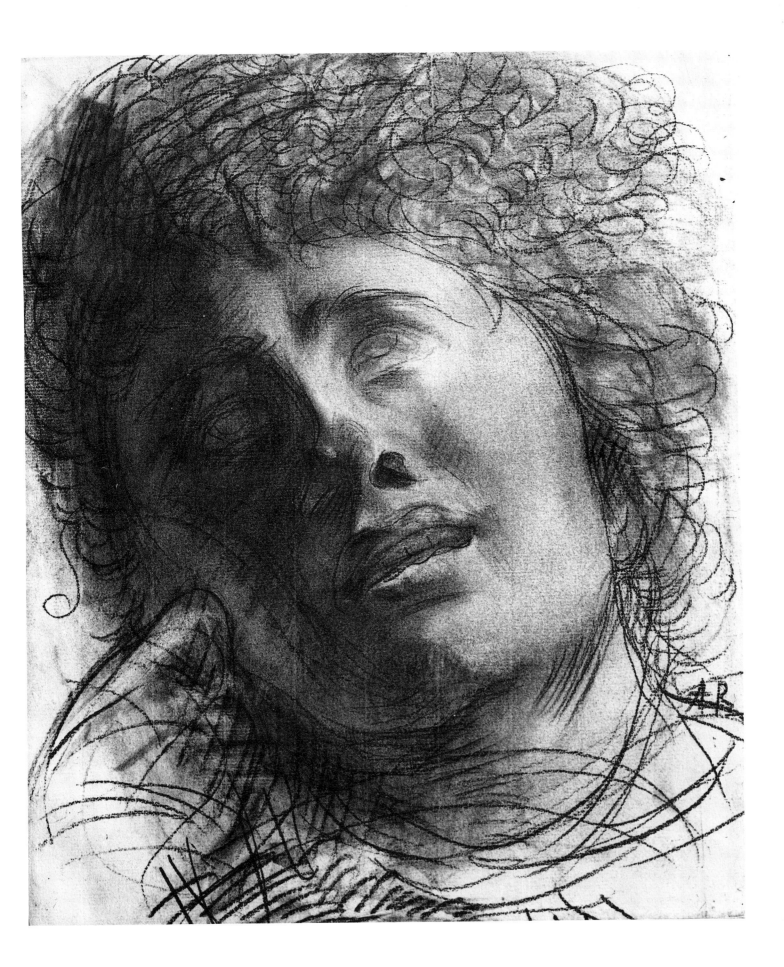

267　*Nude Dancer*, Musée Rodin (cat. no. 202).

artist's space—by implication a place where only one person is allowed the privilege of witnessing the *mundus muliebris*.[46] The term '*mundus muliebris*' is one which has been used in connection with Baudelaire; it befits men who have been brought up by women and who measure their virility against female approbation. Creativity is aroused by watching the conspiracy of all-female communities, such as brothels. Rodin's drawing studio of the late period would qualify, and so would his childhood conditioning. Not only did he have a doting mother, sister and aunt but in the background lay the shadow of his disgraced stepsister Clothide (by his father's first marriage) who had become a whore.[47] Rodin's confessional letters are addressed to women, those to Hélène Wahl being characteristic, beginning with phrases like 'I am writing to you seated beneath a tree. My eyes are still full of the landscape, and the beautiful morning soothes my mind. All this should encourage me to write better letters to you, but I find it so difficult to do so. Your friendship will improve my words.'[48] When Rodin's inclinations were unleashed in the privacy of the drawing medium, all aspects of the female species stir his emotions and stimulate heated, flickering responses. Baudelaire's description from *Le peintre de la vie moderne* takes this into account:

> the artists who have particularly applied themselves to the study of this enigmatic being dote as much on the entire mundus muliebris as on woman herself. Woman is no doubt a light, a look, an invitation to happiness, a word sometimes; but she is above all a general harmony, not only in her passing and the movement of her limbs, but also in the mousselines, the gauzes, the vast and shimmering clouds of stuffs which she wraps about herself, and which are like the attributes and the pedestal of her divinity; in the metal and mineral which entwine her arms and her neck, which add their sparks to the fire of her eyes.[49]

Reflecting upon his bare line drawings Rodin's imagination conjured up whirling veils, shells, perfumes and sun goddesses. In fact the epithets which in literal terms apply to either good or evil women, he assigns to the sheets in such a way that the inferences are interchangeable. None is exclusively appropriate. Thus titles are showered down—'temptress', 'Venus', 'Angel', 'Magdalene', 'Ramayana', 'Cleopatra', 'Psyche', 'Sabbath', 'the Flemish model', and on and on. Added to these are scribbled symbolic references—such as skulls, babies, symbols of torture, the rays of the sun and butterfly wings.

The intention was not to make the viewer forget the qualities of the original model, but on the contrary to suggest that every woman belonged to the spectral beauty in Nature.[50] Rodin's familiar exclamations about the relative loveliness of Northern and Southern skins, lean, young or voluptuous, mature figures express his genuinely catholic taste. He did not seek an ideal woman; he carefully explained to visitors that the models were his collaborators and he found even those who led humble lives more interesting than the preoccupations of fashionable or learned society. In Cladel's first book on Rodin, in the strange dialogue between the sculptor and her friend Claire, the confidentiality of the relationship is stressed:

> 'They are proud of their sculptor, boast of posing for him and say what they think. And it is so fine to study characters. One of the other girls who comes here looks like an Indian statuette. She models in order to be able to buy clothes. She sees things she likes in the shop window; she looks at them, spends a long time putting together her purchases, and so she is well groomed,

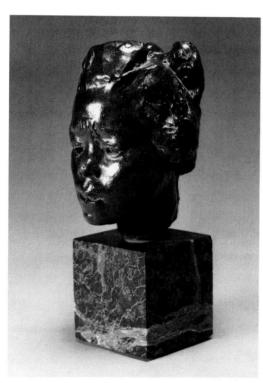

268　*Head of Hanako*, c.1909 (cat. no. 203).

smart and sweet. Art will always exist, even if artists abandon it, for women will always produce art because of the way they dress and do their hair. And when a man in love tells a woman he loves her and puts some force into his words, that too is art.'[51]

The constancy of the thousands of late drawings make believable Rodin's zookeeper-like devotion. The occasional flippant or unflattering pose speaks of daily involvement. Some sketches testify to his weariness. Like the blind Degas who keeps walking to defy the oncoming threat of death, the ailing Rodin keeps drawing even when the results are mechanical. He offers a previously unheard of phenomenon: a sculptor spending hours drawing with no intention of applying the ideas to making sculpture, no stringency whatsoever. Even so, certain clusters of drawings contain stunning works of art (the majority not yet published but their power evident even in the small reproductions of the recent inventory). The historical precedents Rodin set, rarely acknowledged, became the cornerstones of modern practices in the life drawing class: the imprint on the retina of a chance movement not a posed arrangement; simple drawing tools with line more essential than tone. Rodin modestly attributed his discovery of the importance of unprejudiced observation to a comprehension of Michelangelo which occurred when he went to Italy in 1875; an undated letter to Bourdelle *c.*1905 explains:

Once having understood, I knew that what I had found in him (movement) was in nature, and I had only not to separate that in my own sketches in order to include there what is in the antique. For this movement was there as a natural element and not as an alloy which I might wilfully have introduced; from this my drawings derive, although they come much later. Finally, I have attained naturalness which carries in itself all the schools molten together. Consequently my drawings are freer, they will cultivate liberty in the artists who study them, not by telling them to do as I do, but by revealing their own genius.[52]

Bourdelle quoted Rodin as saying in 1903: 'my drawing is the result of my sculpture'.[53] It was. No one else had shown Rodin's obsessive need to rotate ceaselessly palpable forms in a medium that was by logic capable merely of a coded, symbolic figure on a flat ground. No one had applied real force to the spare drawing implements and risked making a mess. Or mixed techniques in a way that blatantly exposed his frustration. In doing this and more Rodin gathered facts about the way the retina and the mind perceive human form that had never previously appeared on paper. Changing the outlook of life drawing, he almost fortuitiously laid a foundation for his late three-dimensional discoveries that mimicked the repetitious easy activity of these three-minute sketches and magically infused the clay with the same lack of concern for conventional anatomy or proportion.

The categories of innovation and achievement are at least five: the development of line as an instrument of haptic observation; the use of wash in the interior to amplify and objectify the subject, and the extension of this principle in the cut-outs; the use of liquid medium and annotation to overlay an imaginary, symbolic ambience; the use of the stump to blur the divisions between solid and void; and finally the free orientation of the body in space, its sexual organs seen as the pivot, allowing a circular rather than a cruciform-shaped human geometry.

As we know, Rodin transferred the lines of the body to paper unhesitatingly,

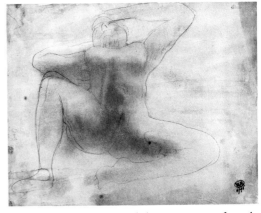

269 *Reclining woman with legs apart, seen from the front*, Musée Rodin (cat. no. 229).

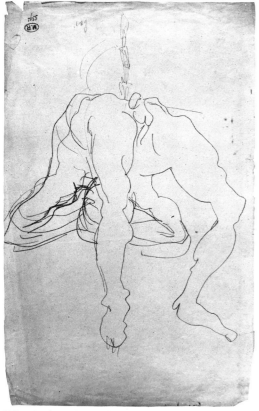

270 *Male nude with arched back, hands and feet on ground*, Musée Rodin (cat. no. 167).

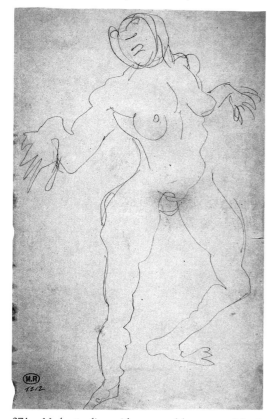

271 *Nude standing with arms and legs apart*, Musée Rodin (cat. no. 164).

272 *The Walking Man, c.*1900, K. Delbanco Collection (cat. no. 140).

his hand 'tracing them lightly, with only his brain to guide it'.[54] Actually the handling was not all of one kind but several. When he used a light lead pencil the gentle arcs often followed one after another the conventional units of hip, chest, forearms, etc. and the interior folds of flesh and chemise. Alternatively the silhouette might be drawn without lifting the pencil so that the sections merged. When this was the case the results look somewhat as if a pointing machine had run around the edge of the living form, instructing the chisel to incise the paper at the same time it was reducing the curves to the scale of the page. A robotic silhouette appears that takes no account of Renaissance perspective or of the ideograms that normally simulate foreshortening. Clement-Jain, watching this process in 1903, told his readers of 'excessive deformations, unexpected bulges'.[55]

The loopy fine line of this technique produced some of the most exhilarating and eloquent drawings. Rodin often found poses where the lines could be extraordinarily long—as with the crouching nude with extended arm which allowed a line from hip to fingertip. A high-stepping bearded man appears in this group, perhaps the same model who does a handstand with sharp points at the elbow, hip, knee and penis.[56] The almost-comic distortions—for instance the feet made of two huge toes—demonstrate a faith in optical truthfulness that we identify as modern. It is as if the artist's vision were guiding the hand without culture or reason intervening. Matisse recognized the power of the vision to take charge. He asked Aragon: 'Isn't a drawing a synthesis, the culmination of a series of sensations retained and reassembled by the brain and let loose by one last feeling, so that I execute the drawing almost with the irresponsibility of a medium?'[57] Rodin seemed to work from the premise that any formal synthesis of line with received information is best left to chance; the hand and the mind's duty was to capture the instanteous flash of life. As within the then-popular Bergsonian view, life is a succession of moments; nothing willed is as valid as the accidental.

The scalloped mounds circumscribed by the technique appear firm and actual even if they correspond to nothing we can verify. In this they seem plastic and particularly close in spirit to the hands and feet of the *Burghers of Calais* but also to the *Walking Man*. The latter is now thought to have been conceived shortly before it was first shown in the 1900 retrospective.[58] It utilizes, of course, the legs of *St John the Baptist* to which Rodin added a headless, armless adaption of the torso of 1878–80, changed by fresh clay and reduced relative to the size of the legs. The result, this three-pronged thing, is a disturbing sculpture, magnificent in its expression of form rippling under the pliable surface—what Henry Moore called 'a feeling of hardness and softness, of a surface both rough and smooth, of depressions and expansion, of hollows and swellings'.[59]

Nevertheless as a 'thing', whether a metre high, as in the first exhibited version, or enlarged to nearly two, as in the second, it is distinctly uncomfortable. What makes it so sensationally memorable is actually the art—the invented proportions, the hunched back and odd wings left by pulling soft clay. More than in any other of Rodin's partial figures the concept of incompleteness and restlessness has a visual presence; the allusion to a headless, striding labourer on his treadmill is an admiring not a condescending one. The *Walking Man* has too the implosive power and tension of the early drawings of monstrous men, like *Male nudes struggling* and the *Heretics*.[60] On paper and on clay the reinforced silhouettes intensified the light refracted between the interior mounds, themselves improvised to equate to the impression of rippling muscles.

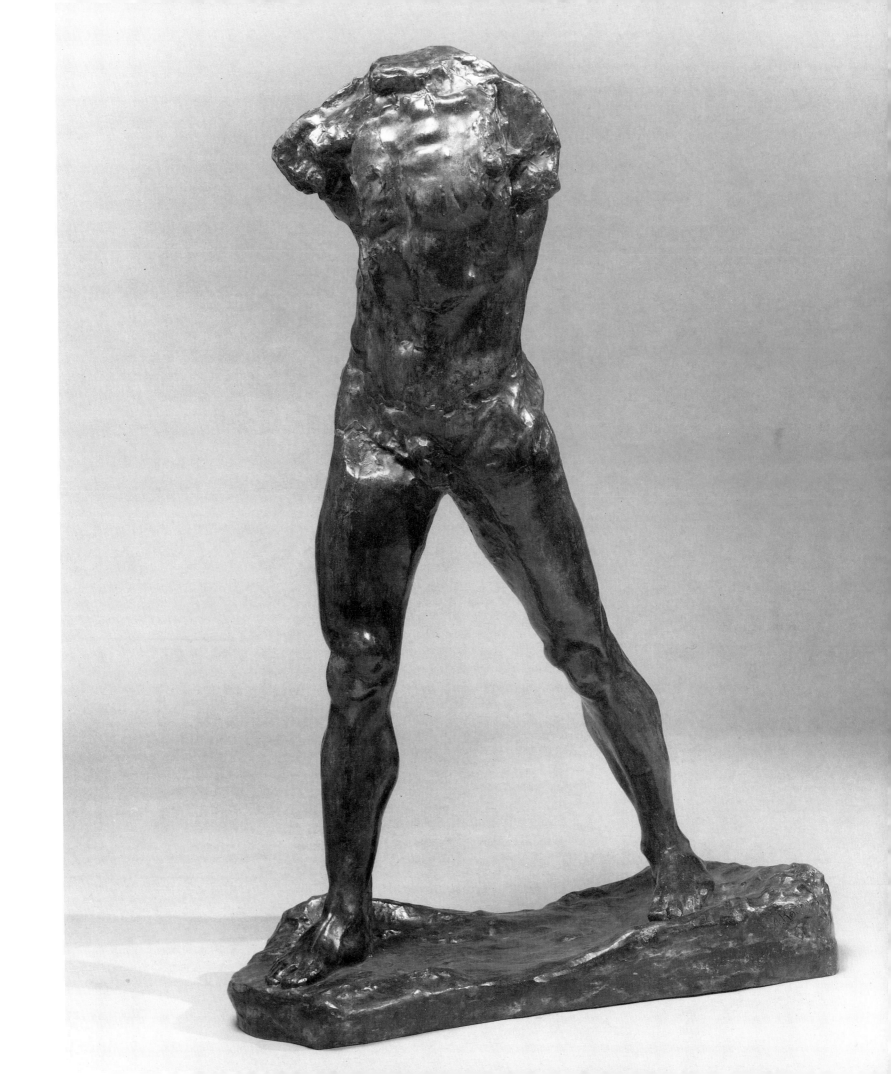

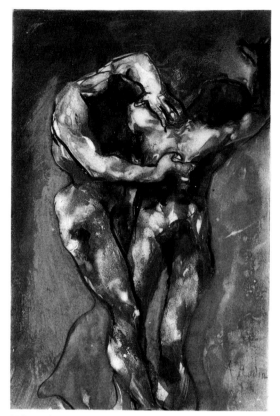

273 *The Heretics, c.*1880, Goupil Album, pl.10.

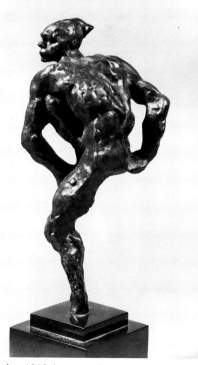

274 *Nijinsky*, 1912 (cat. no. 211).

275 (facing page) *Départ de l'Amour*, Musée Rodin (cat. no. 162).

The eccentricity of the fine line drawings of exercising figures brings across the electric atmosphere in Rodin's studio after 1895. He was employing models for their agility, even their exhibitionist techniques. Coquiot found that 'he is only interested in very supple young bodies which can, if need be, adopt acrobatic poses'.[61] With increasing resources Rodin could indulge a taste for a chaotic studio milieu. It is as if he wanted a place where he could leaven the drudgery of making the marbles and the high moral tone of the commissions by the louche behaviour of dancers of the lower classes (allegedly families of gypsies camped in the studios). Phillip Hale, the reporter for the *Boston Commonwealth*, gave his readers in 1895 this account of the room at the rue de l'Université:

In one corner were half-a-dozen Italian models, engaged to come around in case the master should want them. In another part a couple of street musicians, a man with a harp and a fiddler, were playing airs of street songs, while across the studio sat Rodin watching every movement. He wanted to do some studies of musicians. Finally, in still another part of the studio, several students—rather say apprentices—were working away for dear life. Some were pointing up a big group of the master's; one was working on a study of her own. In the whole place was breathed the atmosphere of work—work.[62]

Following the action of the model with no limit to what might be considered to be in the domain of 'art' became overwhelmingly attractive to the older Rodin—an aphrodisiac. The drawings which captured the most acrobatic feats usually employed a firmly held graphite pencil to run after the contours, one on top of another, so that skeins of lines appeared, agitating the blank spaces on either side. The drawing of a figure in profile, annotated, 'mille paliers cons brisés tiennent en l'air' (D2893), catches actual reverberations. Models stand with one leg raised, as does that in the drawing annotated 'théâtre japonois' and 'le départ de l'Amour' which was splashed with red gouache in a final extravagant gesture. The imposition of successive movements in one study, that familiar preoccupation of Duchamp and the Futurists at a later date, enters these drawings as a consequence of the artist's simply trying to establish the life of the subject on the paper, his hand responding to the model's changing silhouette—one line on top of another.

A number of sculptures with similarly agitated contours were executed during and after the nineties. The most famous is the large *Balzac*, which Geffroy likened to Rodin's work on paper, observing that he 'traces an outline which seems to move and shimmer in the light. There is a logical correspondence, an absolute correlation, between his drawings and this statue.'[63] In 1912 the extraordinary vitality of the camouflage-costumed Russian dancers in Diaghilev's troupe inspired a sculpture which is almost completely 'drawn'. The small *Nijinsky* is a few coils of clay pinched into a G-shaped knot; impromptu inflections exactly capture the special quality of the Slavic cheekbones and brows, while the body loops continuously, punctuated by the points of the elbows, knees and headdress and the voids between arms and trunk.[64] Oddly the figure-type is a throwback to Rodin's youthful alter-ego, the constricted male, head in profile with broad shoulders and rounded back that dominated early drawings and then sculptures.

Looking through thousands of sheets of drawings it is obvious that Rodin frequently felt compelled to make the human body conform to a geometric unit. The shapes appearing in the watercolours are more adventurous than one would guess from his verbal pontification on the fundamental sufficiency of the cube,

Depart de
l'amour

M.R
3970

Theatre
Japonais

276 *Woman lying on her back, with arms and legs apart*, Musée Rodin (cat. no. 233).

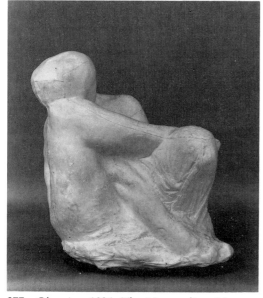

277 *Obsession*, 1896, The Metropolitan Museum of Art (cat. no. 193).

the triangle and the ellipse.[65] Forgoing anatomical exactitude Rodin made bodies bend double to become arches or cups. He imposed tripods on others by deliberately finding the vantage point where one leg was concealed. The generality of the quickly brushed Sienna wash carries associations of primitive art and in line with this there are lizard and frog-like interpretations of the human form.

Rodin's appetite for signs, for making up his own private alphabet, is insatiable in this period. There are frequently half-a-dozen variations of one image, both naturalistic interpretations and enforced abbreviations. (The seated women face to face in the illustration for the line 'a splendid creature I loved one night before' in *Le Jardin des Supplices* is treated this way.) According to Bourdelle, who watched Rodin draw after he became his assistant in 1904, the sheets were placed against a windowpane to be traced. Then, by the magical sweep of a flesh-coloured wash, the interiors were filled—darker tones often pooled on the hair and dress. The drawings were no longer records of single moments, but templates which could be reinterpreted without reference to the first effort. As Bourdelle put it: 'One may believe this retracing was the second most important moment of reflection when he gathered up what he had seen and what he had understood to crystallise his inner and outer vision.'[66]

Isolating the form from the ground by means of wash was made more sensational when the images were cut out and fixed to fresh paper. Early cut-outs like the *Centaur* study now in Philadelphia and three embracing figures called *La chêne*, had set a precedent: Rodin's scalpel was free to ignore the pencil line and where the drawing ran off the page, the form was likely to remain crudely truncated with sharp corners. The technique was most often applied to the large drawings (over 30 cm) so that, as with shadow puppets or window mannequins, the drama is deliberate: seen against white light the dark forms seem to stiffen. The event of a willed placement on an anonymous, foreign background gives even those cut-outs fabricated directly out of mottled or scribbled pencil studies a unity and *éclat*. The use of wash for interiors and the act of cutting-out compare to one of Rodin's sculptural inventions, dip-casting.[67] A hasty dip in liquid plaster gave the file-marked plaster an unblemished surface; the sharp edges and fretwork of casting seams were not only muted but shrouded. Numerous plasters were left with the dipping intact: several heads of Gwen John have this mysterious veil as does the odd, twisted, seated man, *Obsession*. The three techniques of wash, cutting-out and dip-casting were all ways of distancing the reading from the artist's hesitant or over-fussy handling, a way of allowing Rodin to escape from his own neuroses and handwriting and to respond to the stimulus of a fresh appearance.

At some moment Rodin's spontaneous recording of the idiosyncrasies of the human body viewed from random angles was supplemented by a fascination with smoothed contours and iconic simplifications. It appears these opposite modes co-existed about 1900–5. The most famous examples of the second tendency are the vase-women, those kneeling girls, arms wrapped around their legs and heads bent, who are metamorphosized into Greek amphoras. Yet Rodin claimed the discovery was accidental. Whereas at Sèvres he had actively sought shapes for vases, now, drawing with no motive, 'one of these bodies gave me, in the synthesis of it, a magnificent shape for a vase, with true and harmonious lines'.[68] Critics immediately saw the connection between the honing down of the form, the use of flat colour and non-perspective placements and the aesthetic of antique and oriental art. The watercolour *Prehistoric* is an extreme example but

164

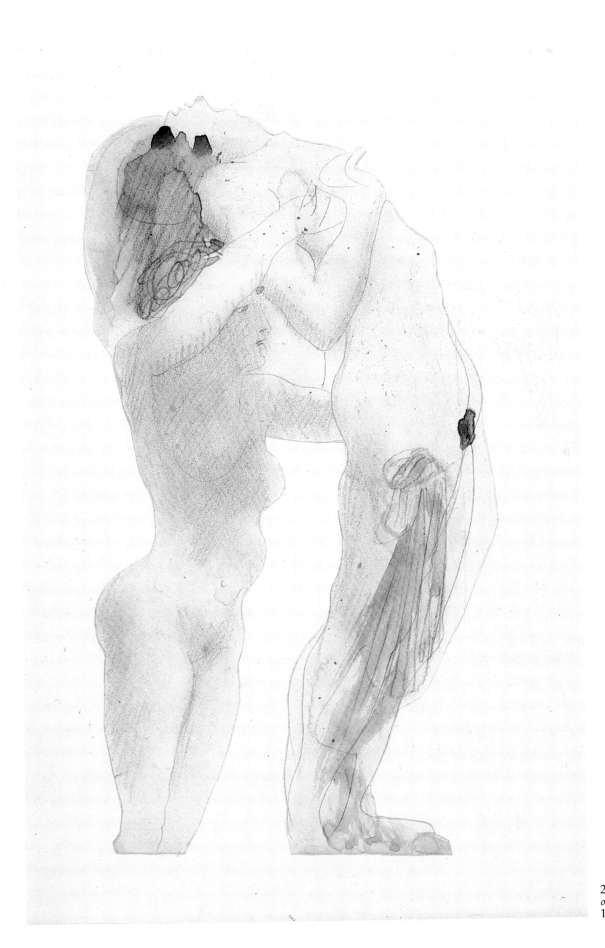

278 *Sapphic couple in profile, one nude leaning on the shoulder of another,* Musée Rodin (cat. no. 173).

279 *Prehistoric*, Musée Rodin (cat. no. 177).

280 *Dance movement*, 1911, Musée Rodin (cat. no. 205).

not unique. A nugget-like shape is floated onto a two-coloured green and blue background, thus into zones of object, ground/water and sky. One has the feeling that, encouraged by Eastern art, Rodin was drifting into a twentieth-century sensibility, rejecting the academic past and replacing it by a longer-standing tradition. One visitor remembered: 'I have heard him talk long and eloquently of the mystic creeds of the East—of Rama, and Boudha, and Isis.'[69] His biomorphic outline may equally be a reflection of years of playing with clay in his hand, turning over pebbles and fingering his collection of artifacts.

Rodin's rectangles, divided into two fields with pattern-like, ungrounded subjects, are not nearly so emphatic as those of Matisse (where intensely coloured zones and contour line alone comprise *Music* and *Dance*). What is alike is the use of a schematic but easily understood shape for the body and a turning away from the recessional treatment of space. Puvis de Chavannes' work was undoubtedly an inspiration to Rodin, as it was to Matisse. The poet Yvonhoe Rambosson in his 1900 essay described Rodin's techniques of tracing and adding wash as a 'declension' of form, the first reading executed in line, rapid and repeated, the next simpler in form and colour and then the fragment alone. He designated the last state, the ruin, being that closest to Puvis because it stirred melancholic visions.[70] Another common source for this analogizing tendency so prevalent in early modern art was possibly Persian miniatures. As early as 1897 Rodin traded with his friend Edmond Bigand-Kaire one of his Goupil albums for a book of Persian miniatures, a Greek statuette and some Eastern textiles.[71]

Of all Rodin's late drawings those of the Cambodian dancers are the best known. The story of the encounter of the sixty-six-year-old, internationally famous sculptor with the forty-two adolescent dancers who accompanied King Sisowath on his visit to France is legendary. As soon as Rodin saw the dancers perform in Paris on 10 July 1906 he was so mesmerized that he followed them on the night of the 12th to Marseilles where he was allowed to sketch his three favourite fourteen-year-old girls, Sap, Soun and Yem. Completely taken with their arm movements which seemed to ripple through their shoulders, he praised the orthodoxy of the dancers' leader, the princess Samphoudry, and added:

I recognized this Cambodian beauty in the pose of the great angel in Chartres, which is not in fact too far removed from a dancer's pose. The analogy between these eternally beautiful human expressions both justifies and heightens the artist's profound belief in the unity of nature . . . Indeed, these dances are religious because they are artistic; the rhythm is a rite, and it is the purity of the rite which ensures the purity of the rhythm.[72]

Thirty-five of these Cambodian sketches were included in the first exhibition devoted to Rodin's drawing, that at the Galerie Bernheim Jeune in 1907. In several one dancer seems to be repeated in four or more positions, somewhat like the frames of a film, sequentially rather than by Rodin's normal superimpositions. He wrote that the rhythms of their swaying bodies reminded him of flowers (and he coloured the drawings accordingly). The mix of fanciful and direct responses is special to this series although, contrary to some reports, the use of non-anatomically pertinent forms is not necessarily a discovery of the Cambodian period. It existed in the snaky ribbons of the earth-mother figures with Greek prototypes, glimpsed in photographs of the 1900 and 1902 exhibitions. The parallels between drawings like *Quittant la terre*, a striding figure in the 'Sun' series shown at Stieglitz's '291' gallery in 1910, and the equally summary sculptures of 1910–12, *Dance movements*, are unavoidable. Strangely

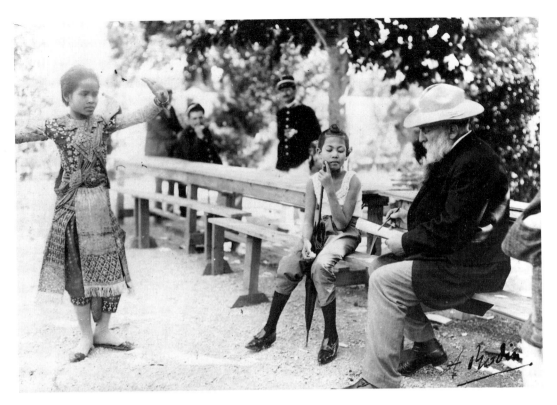

281 Rodin with the Cambodian dancers in Marseilles, July 1906. Photograph from the Bardey Collection, Harry Spira (cat. no. 270).

282 *Cambodian dancer*, Musée Rodin (cat. no. 204).

283 *Group of Cambodian dancers*, Musée Rodin, D4500.

284 *Quittant la terre*, *c.*1900–5, Art Institute of Chicago (cat. no. 176).

285 *Dance movement 'A'*, *c.*1911, Galerie Beyeler (cat. no. 206).

286 *Dance movement 'H'*, *c.*1910, The Josefowitz Collection (cat. no. 207).

287 *Pas de deux 'B'*, *c.*1910–13 (cat. no. 208).

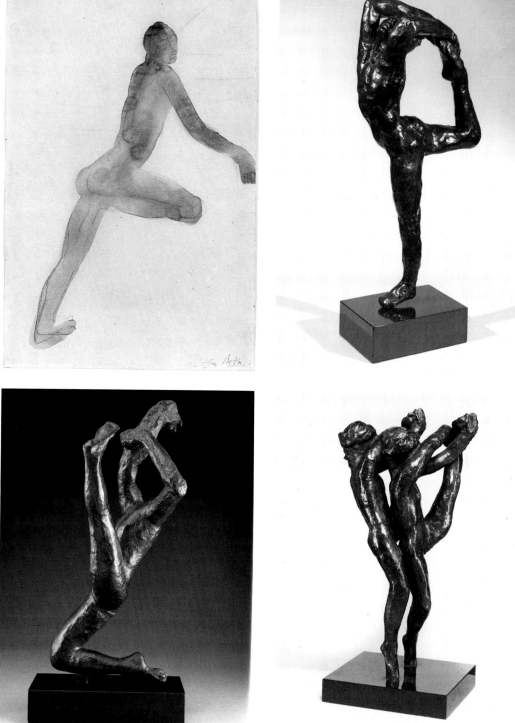

288 *The Crouching Dancer*, *c.*1910–11, The Josefowitz collection (cat. no. 209).

the line drawings which match the most famous study, *'D'*, in which the figure's right foot is raised high, are so faithful to the irregular thread of the model's silhouette that they seem conventionally graceful and, when traced, a little mannered.

Not all the symbolic references were imposed on images first prepared by an adjusted silhouette or flesh-coloured flat washes. Ordinary life drawings were given a sexual fundament by the overlay of light wash. Placing a waterline at waist level often demarcated a symbolic division between what was permitted on

public display, the head and shoulders, and what was revealed to the artist alone In the beautiful *Nude with Serpent* the subject has an innocent expression despite the overt phallic connotations of the snake slithering between her legs. Several standing nudes also press their breasts together in the familiar gesture of passion spent and then renewed. Titles like 'Egypt', 'Psyche' or 'Cleopatra' confirm the Symbolist readings.[73] The acquatic context, of course, has associations with engorgement and sexual wetness, as well as suggesting the underworld, as it did with the curled-up, weeping *Danaïd*. In these embellished drawings the swirling lines with their art-nouveau look remind us of Rodin's long-lasting fascination

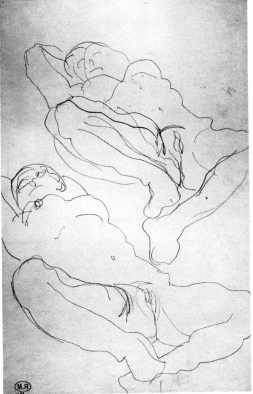

290 *Two nude studies of women lying on their backs*, Musée Rodin (cat. no. 185).

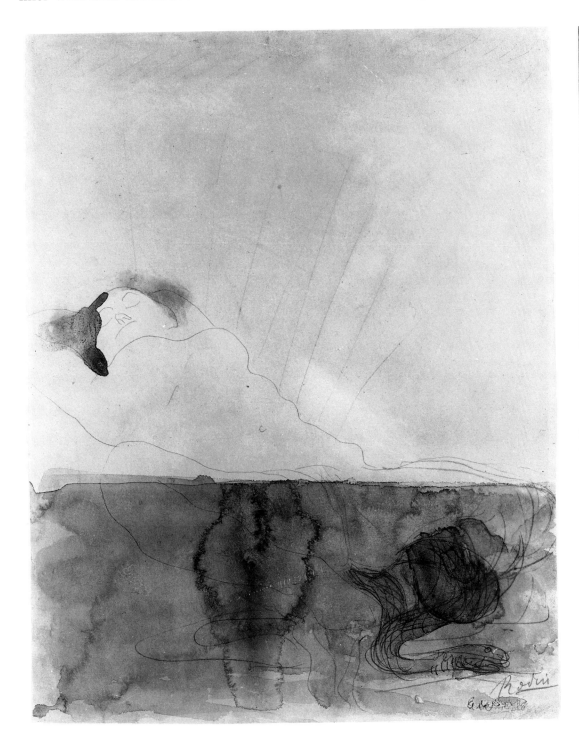

289 *Nude with serpent*, Collection of The Museum of Modern Art, New York (cat. no. 184).

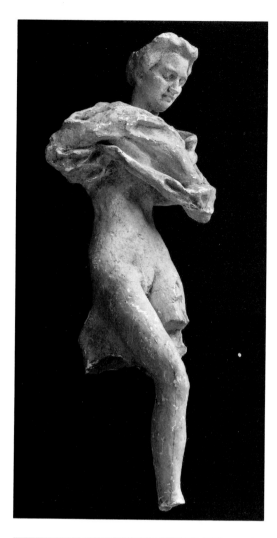

with the way the clay mounds cushioning the figures could be handled so as to suggest the grand cycle of decay and regeneration and its parallel in the everyday transformations of wet, inchoate clay, and molten bronze.

The simplest technique was probably the last to be adopted: drawing with soft graphite which is then smudged by a stump or finger, and wiped by a cloth (or finger).[74] Out of this procedure came a way of controlling light across the surface, the relative density registering shallow bas-relief or deep depressions and emphatic volumes. Rodin often mixed this technique with the repeated contour lines and webs of agitated lines across the surface. What evidence there is from the photographs of exhibitions and critical comment suggests that this technique was not commonplace until after 1900, coinciding with the same muted look in the marbles and the photographs of them by Stephen Haweis and Henry Coles (1903–5) and by Bulloz (c.1910) which Rodin favoured for their ability to bathe his sculptures in mysterious, ambient light.[75]

External influences have been mentioned in connection with this aesthetic. The paintings of Eugène Carrière are most frequently cited, given Rodin's long friendship with the immensely popular artist and the paintings by Carrière he himself owned.[76] Only a few drawings by Rodin create an all-over swirling darkness out of which faces emerge: the ambience, the Symbolist themes (such as 'the Wave'), and the sentimentality of Carrière are found more in Rodin's carvings which often have the painter's morbid air. Medardo Rosso has also been suggested as an influence on Rodin's tendency to let unformed features seem to sink back into the stone.[77] The difficulty with apportioning influence is that Rodin absorbed other art so readily that it came to inhabit his own work without conscious analysis of the source. Furthermore for every 'new' mode there is usually a germ of the same idea in a previous decade. The small terracotta *Damned Ones* which Grappe and others assign to 1882 also uses shrouded embryonic forms with incised lines. Rodin's obsession with contemplating his own art in half-light was there from the beginning, fostered by his predeliction for studying the sculpture and drawing by candlelight.

Camille Mauclair spoke in 1900 of Rodin's deliberate use of value, his trick of placing forms against a cloudy background in order to unify their interior while modelling or drawing. In 1906 Rodin mentioned to Gsell his pleasure in studying the effect of indirect light on Egyptian carving.[78] Malvina Hoffman, an American student of Rodin between 1910 and 1912, recalled in her book *Heads and Tales* the master's lessons:

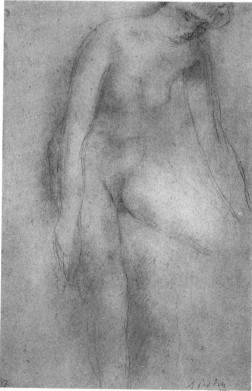

> To teach me what surfaces and planes could do to a piece of marble, Rodin would take me to the Louvre late in the day, just before closing time, and standing in silent admiration before the great Egyptian statues or the Venus de Milo would pull a candle out of his pocket, light it, and hold it up so that its light fell on the smooth, strong planes of the statues.
>
> 'This is the test', he would say to me. 'Watch the sharp edge of light as I move it over the flowing contours of these chef d'oeuvres of Egypt . . . you will see how continuous and unbroken are the surfaces . . . how the forms flow into one another without a break . . . no unnecessary dark cavities to break the massiveness, no scratchy line too deeply cut into the precious matière. They knew—those old Egyptians! They never cut away too much; they knew where to leave the details enveloped, and only suggested by the perfect outline of the stone left uncut. One feels sure of their intention and of their knowledge of anatomy; without being troubled by it.[79]

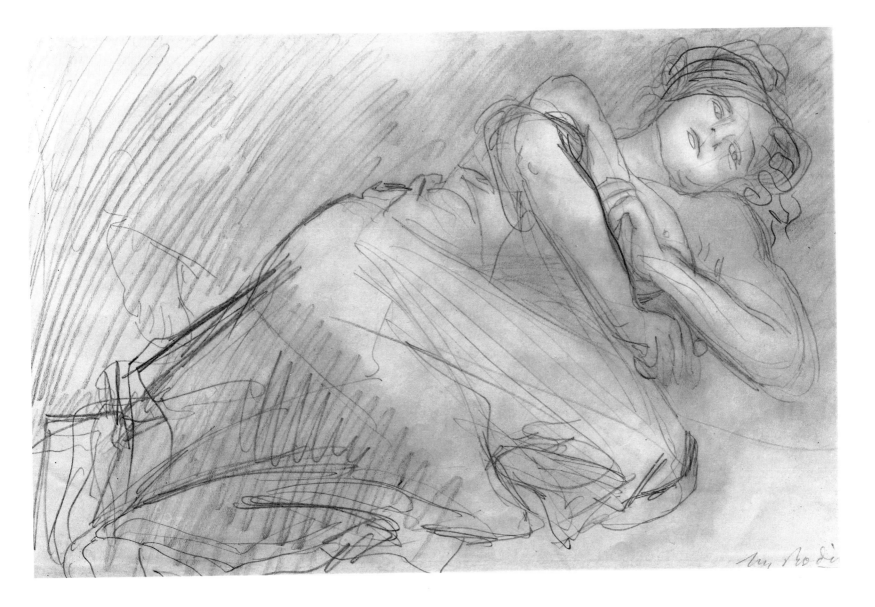

293 *The Abandoned*, c.1910, The Metropolitan Museum of Art (cat. no. 213).

When Rodin is accused of eclecticism, arbitrary mixtures of techniques and a tendency to concentrate on fragments at the expense of overall economy, there is no defence. Rodin was trying alternative strategies, and they involved mixed modes. Some were as various on paper as they were in clay, thus the continuous silhouette, the warm flesh tint, the symbolic layers, the stomp and blanketing of the whole in binding marks and washes. The images in turn became by degrees more tangible, more hallucinatory, more rock-like, or weightless, or whatever. Rodin was driven by his desire to inhabit his subject: 'I have as it were, to *incorporate* the lines of the human body, and they must become part of myself, deeply seated in my instincts. I must feel them at the end of my figures. All this must flow naturally from my eye to my hand.'[80]

What the aging Rodin is desperate to discover but cannot, as he realises, is to 'know' what it feels like from the other side. What sensations female languor, lust, Lesbian pleasing, manual stimulation and finally ecstasy are comprised of. His work manifests his own libido and the animal beauty of women, but that is all. Hundreds of drawings show women touching their sex, lying on their stomachs with fingers appearing from underneath, raised skirts on reclining girls, gynaecological viewpoints, and the pelvis alone or overlaid by spiky fingers. The models themselves do not seem embarrassed or anxious, rarely are

291 (facing page top) *Woman removing her dress*, plaster, Musée Rodin (cat. no. 187).

292 (facing page bottom) *Standing figure*, 1900–9, Art Institute of Chicago (cat. no. 220).

171

294 *Fragment, hand on genitals*, Musée Rodin (cat. no. 237).

295 *Diana or Hecate*, Musée Rodin (cat. no. 227).

296 *Psyche*, Musée Rodin (cat. no. 226).

they convulsive. The flesh is young and firm, the vaginas without pubic hair are represented by quick clipped lines similar to the shorthand depiction of mouths. The split of the legs is often so extreme that the body is conceived as three blades sent into rotation, as a pinwheel from one fixed point. Sequences of drawings, some turned 45 degrees or 90 degrees by his own inscription—'bas'—introduce the option of a non-monolithic, non-upright concept of the human form. The pair of drawings *Diane ou Hecate* (D5718) and *Psyche* (D5411), for example, spin a duplicate image around by way of stressed lines and shadows. Other circular or star-fish images submerge detail in all-over wash suggesting a nebulous, oyster-like fluidity, a symbolic location for the genesis of life. In other works structures are defined by rigid limbs on the exterior, a cage which protects the soft interior space. This is true of small sculptures made after 1900, like *Crouching Dancer* and of drawings such as that inscribed 'pour un sculpture comme un pierre d'Egypte' in which the stomp often stresses the hidden structure of the body and creates highlights (cat. no. 225).

The erotic drawings were already infamous in Rodin's lifetime. Sympathetic

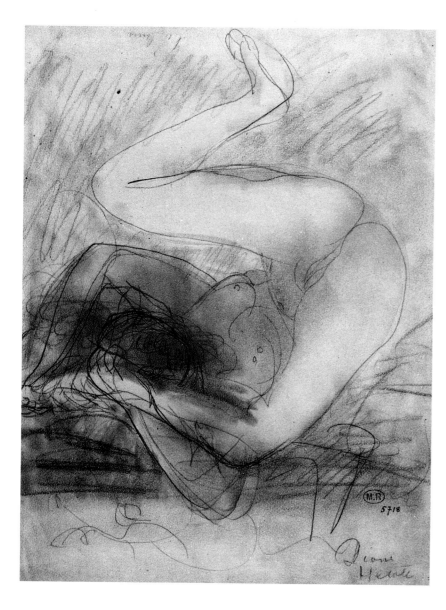

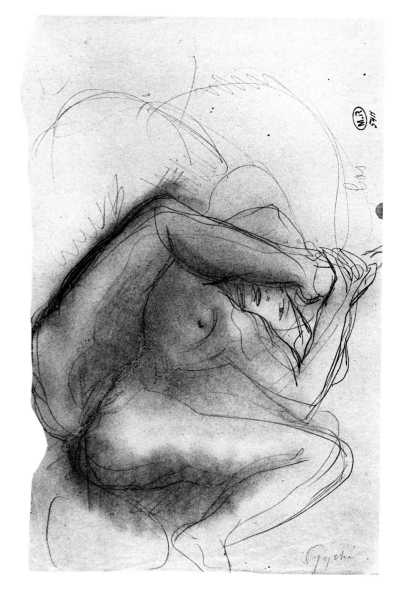

observers justified them by their scientific thoroughness; they were treated as the natural extension of Rodin's life interest in creation *per se* and perfectly acceptable if kept out of public view as a private research. By 1900 there was an alternative view, one that argued vociferously that the drawings were confirmation of the man's senility or, worse still, depravity and hence his reprehensible influence on society. They, the Iris sculptures and the alleged orgies at the Hôtel Biron encouraged by Rodin and fellow tenants such as the actor Edouard Max (who used the chapel as a Pompeian bathhouse for homosexual amusements) were all reasons cited in the years 1911–14 as to why the State should not authorize the turning of the Hôtel Biron, once a convent, into a State museum devoted to Rodin's work.[81]

297 *Assemblage, female torso and antique pot*, Musée Rodin (cat. no. 195).

There is no question but that Rodin's girls proffered the kind of end-on pose they knew their master liked; the complicity is evident. So much so that their mindless, direct looks often diminish the sexual *frisson*. What Rodin's drawings lack is a sense of actual circumstances—rarely do we find unvarnished observation—the boniness or fleshiness of imperfect figures, the neck-bands or underwear which would suggest the actual appearance of the Montmartre girls working as models. The tension and shame attached to carnal relationships in the Northern European tradition is missing, so is the wiry nervousness and the cynicism of contemporary investigations into female sexuality by Gustave Klimt, Egon Schiele or Rops. Rodin's desire for proximity and sequestered contemplation of his subjects is closest to that of Courbet, whose private commission, the *Origin of the World*, known to Rodin at least by reputation, has the same conspiratorial enjoyment of flesh.

Arthur Symons wrote a remarkable assessment of the late drawings in the already quoted piece which appeared in the *Fortnightly Review* in 1902. It took as the mainstay of its argument his instinctive reaction to the drawings themselves. Speaking of the subject of a single work he began:

298 *Seated figure raising left leg*, Musée Rodin (cat. no. 210).

> The soles of her feet seem close and gigantic. She squats like a toad, she stretches herself like a cat, she stands rigid, she lies abandoned. Every movement of her body is seen at an expressive moment. She turns herself in a hundred attitudes, turning always upon the central pivot of her sex, which emphasises itself with a fantastic and frightful monotony. The face is but just indicated, a face of wood, like a savage idol; and the body has rarely any of that elegance, seductiveness, and shivering delicacy of life, which we find in the marble. It is a machine in movement, a monstrous, devastating machine, working mechanically and possessed by the rage of the animal. It is hideous, overpowering, and it has the beauty of all supreme energy.
>
> And these drawings, with their violent simplicity of appeal, have the distinction of all abstract thought or form. Even in Degas there is a certain luxury, a possible low appeal, in those heavy and creased bodies bending in tubs and streaming a sponge over huddled shoulders. But here luxury becomes geometrical; its axioms are demonstrated algebraically. It is the unknown X which sprawls, in the sprawling entanglement of animal life, over the damped paper, between these pencil outlines, each done at a stroke, like a hard, sure stroke of the chisel.

He concluded with the advice: 'For it must be remembered that these are the drawings of a sculptor, notes for sculpture, and thus indicating form as the sculptor sees it, with more brevity, in simpler outline, than the painter.'[82]

The great beauty of Rodin's late drawings is that they do come from a manual

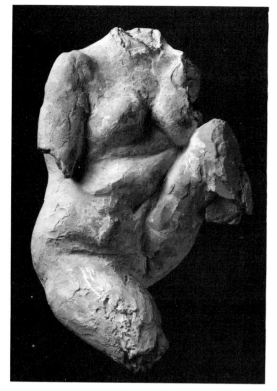

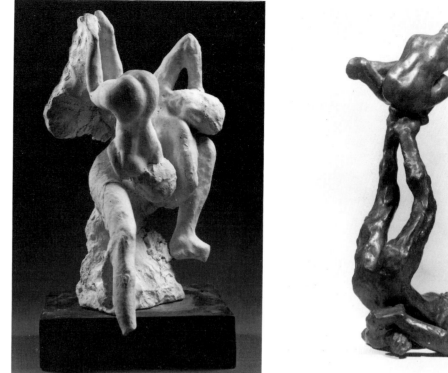

299 *Fat torso*, Musée Rodin (cat. no. 240).

300 *Assemblage of man and woman upside down*, Musée Rodin (cat. no. 194).

301 *The Juggler* (cat. no. 212).

302 Altered photograph (by Rodin) of *Twilight and Dawn*, Musée Rodin.

as well as an emotional necessity—from the same urge which drove him to make sculpture in order to surround himself with talismanic objects, vehicles which could bring him, and the viewer, into a state of aroused but peaceful contemplation. After years of modelling he possessed a sixth sense of how to translate his knowledge of the body into flawless linear foreshortening. He also knew how to endow what in truth were often grossly exaggerated units and bizarre articulations with the sort of equipoise that made them independent of any one viewpoint or orientation. The hand-held, modelling-stand figures for the *Gates of Hell*, the temporary set-ups for photographs like *Avarice and Luxury* and *Triton and Dawn*, and the environmental *Burghers of Calais* all had encouraged his unquestioning immersion in his own created world. In the late period disparate elements from his huge stock of plasters were treated as spontaneously as the pencil and paper studies. *Standing nude with woman's torso* is an example of these gravity- and logic-defying works: the curled-up female suspended on the man's hips.

Rodin's objective was not simply a kind of playful choreography. The mind that kept turning the models before his eyes was doing so in order to gather facts. The contour method of looking at the front, back and sides, and then taking in the three-quarters' view which he had used first for the *Man with the Broken Nose* had hardly been a convenience. Depending on the contours entailed looking at *every* contour. The determined young sculptor who had stood on a ladder to view the soldier Neyt in 1877 from overhead and who had made at least sixty drawings of the skull of Victor Hugo in 1883 was the same person who in 1910, tackling the bust of his fearsome American mistress the Duchess of Choiseul, depended on his extreme sense of touch rather than sight. Rodin gripped her head, it is said, between his knees while at the same time modelling her likeness by placing his thumb alternatively on the two spheres.[83] Many late sketches drawn from incredibly close range have the same myopic, inquisitive intensity. The legs and head run off the page in order to throw before our eyes bodies seen

174

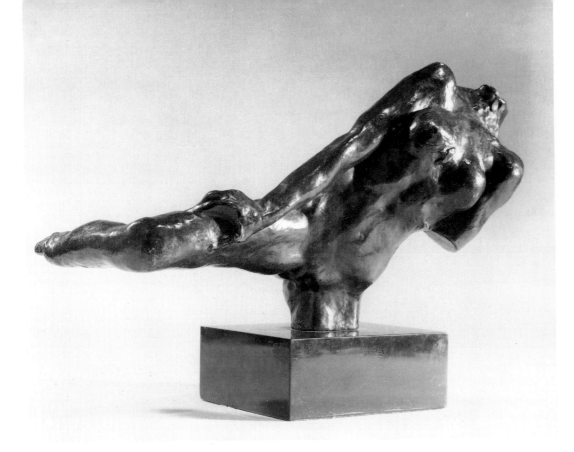

as if they really were pieces of nature and apparitions of energy. Solids hover in front of the paper which itself registers as non-existent, merely thin air.

The partial figures in this group of late, close-up studies are similar not only to the partial figures cast in plaster and bronze but also to bulky works like *Earth*, *Iris* and the enlarged *Crouching Woman*. By treating the body as a trunk and the legs as branches Rodin analogized the Y-junction of real branches and the rough bark-like surface. An 1890s' adaption of the female figure in *Avarice and Lust*, called *Flying Figure* severs her legs at mid-thigh and uses the right one as the upright, causing the pelvis to appear as a subject in its own right. Dozens of drawings, for example, *Standing Figure* (cat. no. 180) and *Nude Fragment*, have an organic quality. Indeed Rodin's treatment of the hip bones and pubic area (as in *Iris*) suggests the rounded knots and scars in real trees and eroded rocks. His obsession with the vagina is not only in reference to the location of conception but reflects an alertness to apertures in general—to a plastic sensibility. They are entrances to interior space, as were the eyes, nostrils and mouth of the *Head of Pierre de Wiessant*.

If these primal images in sculptures and drawings were elements of Nature, then the reclining figures were part of a virtual landscape complete with horizon line. A masterpiece among the late drawings with this quality is *Salammbô* (*Woman lying on her back, stretching herself*).[84] As in Arthur Symon's description, the soles of the feet are pressed together and the arms are raised over her face, obscuring it, making at either end triangular anchors which support the bridge of the arched torso. The temptations of idolatry are inescapable. Our eyes travel over the brow of the far undulating silhouette behind which a smear of dark graphite makes the light on the wiped areas glow brighter. In a sense, Rodin is like an addict using his charismatic power over women and his money which pays for the models to ensure a steady supply of raw imagery. Yet he is also the first sculptor to want to make women's sexuality important. In many of the finest drawings the subjects do tremble with excitement: some go so far as to

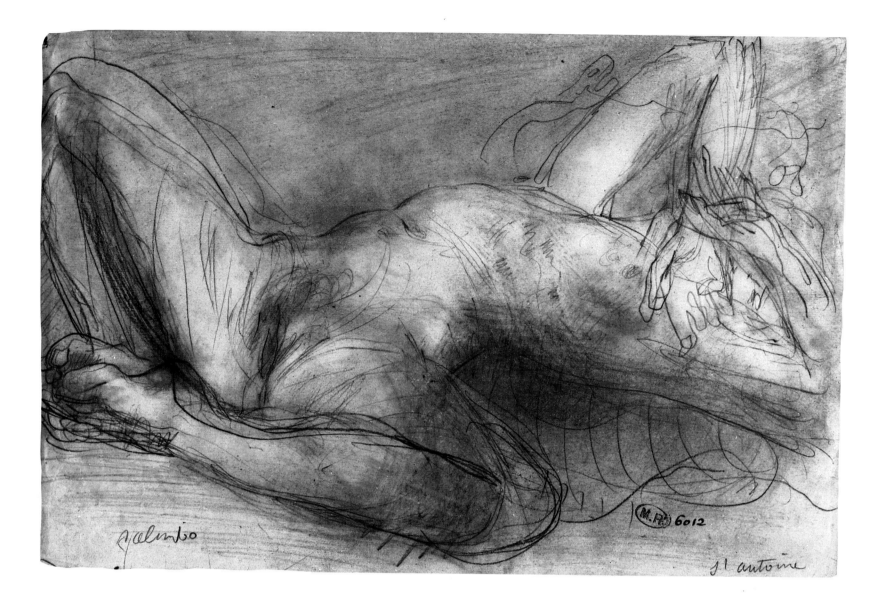

304 *Salammbô*, Musée Rodin (cat no. 236).

challenge Rodin's analytic concentration on their silhouettes, and cause him to invent an equivalent setting and geometry. The implied dialogue is like that in Flaubert's novel, *The Temptation of St Antony*, between the Queen of Sheba and St Anthony, who is mesmerized by her:

> All the women you ever met, from the girl at the crossroads singing under her lantern to the patrician high on her litter, plucking rose petals, all the shapes half seen or imagined by your desire, ask for them every one! I am not a woman, but a world. My clothes need only fall away for you to discover in my person one continuous mystery!
> (Anthony's teeth are chattering)
> If you laid your finger on my shoulder, it would affect you like fire running through your veins. The possession of the least place on my body will give you sharper joy than the conquest of an empire. Offer your lips! My kisses taste like fruit ready to melt into your heart! Ah how you'll lose yourself in my hair, breathing the scent of my sweet-smelling breasts, marvelling at my limbs, and scorched by the pupils of my eyes, between my arms, in a whirlwind . . .[85]

305 *Christ and Mary Magdalene*, Musée Rodin

On the *Salammbô* drawing Rodin wrote 'Salambô' in the lower left and in the

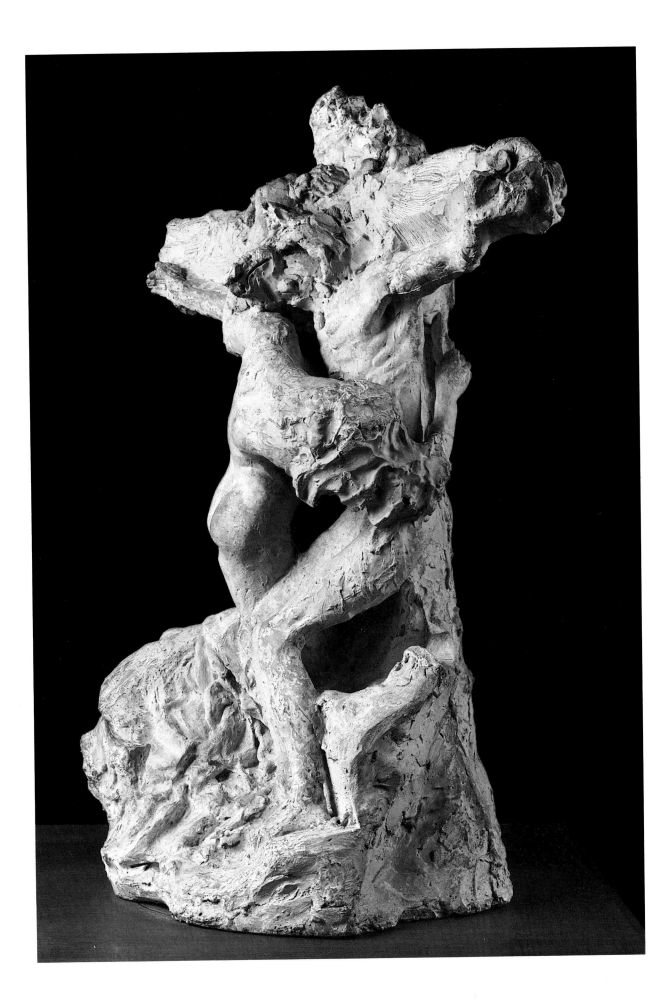

lower right 'St Antoine', making clear his identification with the oriental exoticism of Flaubert's heroines in *Salammbô* and *The Temptation of St Antony*, books which he is known to have enjoyed. Flaubert's connoisseurship of decadent, pagan civilizations was also perhaps attractive. Taking an anthropological interest rather than a historical one was common to many writers and painters in the nineteenth century. During the Oriental Renaissance of the Romantic period ideas of rebirth and individual salvation were frequently preferred to the Judeo-Christian division between the damned and the saved. The older, mystic Rodin believed in such a pantheistic, universal kind of wisdom.

The word-pictures that are expressed in Rodin's art as tactile and visual explorations are as exhaustive and illuminating as any poet's or the alchemist's. Often the most hybrid of Rodin's works have a mad passion and unexpected economy. The beautiful unorthodox *Christ and Mary Magdalene* unites the succinct form of the *Inner Voice* with the emaciated, slack body of Christ who himself fuses with the rough texture of the cross and the ground beneath. Rodin's improvisatory changes to the limbs, like Mary Magdalene's two left feet and exaggeratedly long wrists, seem not at all contrived. The spectre-like face of Christ belongs to the family of haunted spirits that began with the Shades and was treated so passionately in the *Crouching Woman* (1880–82), the head of *Génie du Eternal Repos*, the *Large Head of Iris*, and even *Nijinsky*. One of the most poignant sculptures, it is as tender but not as fastidious as Michelangelo's *Pietà*, and more lyrical but not less penumbral than Rembrandt's Depositions.

The *Salammbô* drawing, the gouaches of centaurs and women, and *Christ and Mary Magdalene* are all reflections of Rodin's understanding of the pictorial richness of Renaissance, Flemish, Dutch and Romantic painting—his remembrance of Michelangelo, Rubens, Rembrandt, Géricault and Delacroix. Their achievements in paint were placed at the service of his innate sense of corporeality, the material correlative unique to modelling, and his feelings. It is clear Rodin learnt a great deal from painting, as he did from Donatello and Greek art and much more. He left as his legacy a way of making objects in inert matters or on paper appear before our eyes as if still throbbing, and therefore tantalizing our responses.

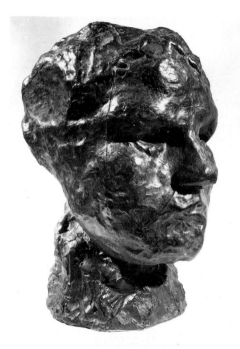

306 *Head of Iris*, *c*.1910, Victoria and Albert Museum (cat. no. 147).

Notes to the Text

The Early Years and the Drawings from Dante

1. Paul Gsell, *Auguste Rodin. Art. Conversations with Paul Gsell*, Paris, 1911, p.82.

2. Victor Peter, 'le sculpteur animalier' and professor at the Ecole des Beaux-Arts started working for Rodin in 1890 and was entrusted with many projects including the horses on the *Monument to Claude Lorrain* installed in Nancy. Emile Bourdelle studied with Rodin from 1888. As Penelope Curtis has pointed out (in a private communication), Bourdelle adopted a creative attitude to his work as Rodin's *praticien*. Finishing a marble version of *Eve* in September 1906 after ten months' work, he told Rodin: 'Une chose est très attachante. C'est le choix qui je dois faire dans votre œuvre si belle, et abandonée par endroits—mais dont les splendides indications indiquent la vonté des accords certains' (2 September 1906, Musée Rodin Archives).

3. Georges Grappe, *Catalogue du Musée Rodin*, Paris, 1944, lists 437 sculptures. When the inventory at Meudon is complete there will be approximately 800. By November 1985 acquisitions brought the drawings to 7,665; however many pages have each sketch numbered and there are numerous notebook sheets with drawings on the verso. In the 1977 catalogue for the exhibition *Auguste Rodin: Le monument des Bourgeois de Calais*, the first under the present highly professional administration, plaster studies as well as reductions were documented. Similar dossier exhibitions have been held in the Salle des Dessins and the first two of a five volume, fully illustrated inventory of all works on paper have appeared (Musée Rodin, vol. IV, D4500–6000 in 1984 and vol. III, D3000–4499 in 1985).

4. Photographs taken in Rodin's lifetime have been surveyed in Albert Elsen, *In Rodin's Studio*, London, 1980 and Hélène Pinet, *Rodin. Sculpteur & les Photographes de Son Temps*, Paris, 1985.

5. Jean Rousseau, 'Review of the Exhibition at the Cercle Artistique', *Echo du Parlement* (Brussels), 11 April 1877, cited in Ruth Butler (ed.), *Rodin in Perspective*, Englewood Cliffs, N.J., 1980, p.33.

 Camille Mauclair, who published a biography of Rodin in 1905, wrote in a published article dated after 1900 the contrary view: 'One must assign to the period between 1867 and 1877 three-quarters of all that has been seen of Rodin's sculpture. Certain works waited fifteen years to be executed in three months

 from a previous sketch. . . It is thus in this ten year period that the technique and the ideology of Mssr Rodin were formed together, and it is then that one must date the underlying construction of which his revealed works have been only the results. He had foreseen everything and has invented nothing from scratch except since 1897.' ('Notes sur la technique et le symbolisme de M. Auguste Rodin', Louis Vauxcelles collection of press clippings, Bibliotheque Doucet, Library of Art and Archaeology, Paris. Also quoted in the doctoral dissertation of Kirk T. Varnedoe, Stanford University, 1972.)

6. *Correspondance de Rodin*, I: *1860–1899*, texts ordered and annotated by Alain Beausire and Hélène Pinet, Paris, 1985: no. 237, Rodin to Hélène Wahl, 25 October 1895.

7. Anne Wagner, 'Learning to Sculpt in the Nineteenth Century', *The Romantics to Rodin*, ed. Peter Fusco and H. W. Janson, Los Angeles County Museum of Art in association with George Braziller, Inc., 1980, pp.9–12.

8. Lecoq de Boisbaudran, *L'Education de la mémoire pittoresque*, Paris, 1913. Letter from Auguste Rodin, 19 November 1913 as preface: 'Fantin Latour nous parle aussi des expéditions qu'il faisait à la compagne le dimanche avec des camarades le plus souvent à l'étang de Villebon où ils se baignaient. Ils se servaient ainsi de modèles les unes aux autres pour des observations de nu, qu'ils peignaient de mémoire le lendemain. Derrière un cabaret, à Montrouge, ils découvrent un jardin entouré de hauts murs où Lecoq organisa une classe de peinture en plein air, innovation vraiment mouie pour l'epoque.' The book describes the exercises and Degas's suggestion of a school with six floors, the beginners and the models at the top.

9. Gaston Poulain, *Bazille et ses amis*, Paris, 1932. Quoted in John Tancock, *The Sculpture of Auguste Rodin: The Collection of the Rodin Museum, Philadelphia*, Philadelphia Museum of Art, 1976, p.244.

10. Jacques de Caso, 'Rodin's Mastbaum Album', *Master Drawings*, summer 1972, pp.155–61.

11. Lecoq de Boisbaudron, note K.

12. Judith Cladel, *Rodin. Sa vie glorieuse, sa vie inconnue*, Paris, 1936. Edition of 1950, p.79.

13. Henri Dujardin-Beaumetz, *Entretiens avec Rodin*, Paris, 1913, p.14.

14. Robert Descharnes and Jean-François Chabrun, *Auguste Rodin*, London, 1967, p.24.

15. *Correspondance*, I, no. 6, Rodin to Maria, 5 September 1860, written while she was staying with her aunt and uncle, M. and Mme Hildiger.

16. Descharnes and Chabrun, p.264.

17. *The Romantics to Rodin*, pp.164–6, note by June E. Hargrove, no. 50.

18. *Correspondance*, I, nos. 8–12, Rodin to Rose.

19. 'Cette cathédrale végètale a été longtemps le lieu où mes pensées habitaient. Je la trouvais, chaque fois que je la revoyais.' Related by Constantin Meunier. Charles Rosen and Henri Zerner, *Romanticism and Realism, The Mythology of Nineteenth Century Art*, London, 1984, discuss the comparison between a Gothic cathedral and the trees of a forest during the Romantic movement and before (pp.184–5).

20. The paintings hang in the Musée Rodin. The drawing, D133, is reproduced in Descharnes and Chabrun, p.44.

21. Truman H. Bartlett, 'Auguste Rodin, Sculptor', *American Architect and Building News*, XXV, 26 January 1889, p.45.

23. In 1922 Auguste Neyt, for example, remembered Rodin's taking him home to dinner at midday and discussing his ideas, 'for he was always making sketches and always had some clay that he carried with him (quoted in Descharnes and Chabrun, p.49).

24. Seymour Slive, *Drawings of Rembrandt*, New York, 1965, p.ix.

25. Kirk Varnedoe discussed the sources of early work at length in 'Early Drawings by Auguste Rodin', *Burlington Magazine*, CXVI, April 1974, pp.197–202. These ideas were further developed in the texts in *Rodin Rediscovered*, National Gallery of Art, Washington D.C., 1981 and in *Auguste Rodin. Drawings and Watercolours*, Westfälisches Landesmuseum für Kunst und Kulturgeschichte, Münster, 1984 and London, 1985, pp.15–16.

26. Drawings D2079–2086 (Musée Rodin) show the Duchess enthroned. For examples of transitional style see *Auguste Rodin. Drawings and Watercolours*, p.54.

27. *Correspondance*, I, no. 13, Rodin to Rose, n.d.

28. Drawings D264–273 and D160–175 include this statue (Claudie Judrin, *Les Centaures*, I, Musée Rodin, Paris, 1981–82, no. 28).

29. The illustrations to Emile Bergerat's *Enguerrande* are reproduced and discussed in Victoria Thorson, *Rodin Graphics*, San Francisco Museum of Fine Arts, 1975, p.79.

30. Cladel, *Rodin. Sa vie*, p.114.

31. Gsell, *Auguste Rodin. Art*, pp.87–102.

32. Bartlett, 9 February 1889, p.65. In fact as Cladel has pointed out (*Rodin. Sa vie*, p.108) Rude remained important to Rodin and as late as 1911 Rodin acquired a copy of the *Ugolino* by Carpeaux.

33. Cladel, *Rodin. Sa vie*, p.114.

34. Judith Cladel, *Rodin: The Man and His Art, with Leaves from His Note-book*, New York, 1917, p.39.
35. These drawings, which include D285–288, D280–284, were reproduced in *Rodin Rediscovered*, p.165 and *Auguste Rodin. Drawings and Watercolours*, p.25.
36. Rodin's first *Ugolino* has been discussed often, including in Haavard Rostrup, 'Dessins de Rodin', *From the collections of the Ny Carlsberg Glyptothek*, II, Copenhagen, 1938, and recently in Albert Elsen, *Rodin's Thinker and the Dilemmas of Modern Public Sculpture*, New Haven and London, 1985. The *Ugolino* photographs were taken probably by Bodmer or Pannelier in the early 1880s. The letters nos. 17, 19 and 20 in *Correspondance* I, undoubtedly refer to this work. Claudie Judrin has written extensively on the Ugolino theme in Rodin's art, including 'Rodin's Drawings of Ugolino', in *Rodin Rediscovered*, pp.191–200 and *Ugolin*, II, Musée Rodin, Paris, 1983, p.39 (illustrated).
37. H. W. Janson, 'Rodin and Carrier-Belleuse: The Vase des Titans', *Art Bulletin*, L, September 1968, pp. 278–80. See also John Larson, 'Carrier-Belleuse: A technical study of his terracotta sculpture by John Larson', *French Sculpture 1780–1940*, Bruton Gallery Limited, Somerset, 1981.
38. The drawings of putti are represented in *Auguste Rodin. Drawings and Watercolours*, cat. nos. 20–23, and 25 (the collaged sheet); these all from Album I and no. 26 (D160–175) from Album II. Varnedoe discusses their stylistic differences.
39. This drawing, formerly Perls Collection now owned by The Art Institute of Chicago, is reproduced in *The Drawings of Rodin*, National Gallery of Art, Washington D.C., 1971–72, pl. 32.
40. *Angelica*, terracotta, 81.3 cm, after 1866, owned by Mrs H. W. Janson and documented by June E. Hargrove in *The Romantics to Rodin*, no. 49, pp.163–4.
41. Cladel, *Rodin. Sa vie*, pp.134–6 and *Correspondance*, I, no. 27, Rodin to Rose, after 10 August 1879.
42. Scholars have suggested that the actual *Torso of Adèle* was modelled in Nice in 1879 (see Elsen, *In Rodin's Studio*, p.171) and that it relates specifically to the Tritons; however, I believe it was modelled in the studio the following year.
43. *Correspondance*, I, nos. 15 and 16, Rodin to Rose, March–April 1877.
44. *Correspondance*, I, no. 22, note 6, Rodin to Rose, 26 April 1877 and note 7, 25 April 1877; and no. 18, Rodin to the President of the Jury, April 1877.
45. Rainer Maria Rilke, *Rodin*, trans. Robert Firmage, Salt Lake City, 1982, p.91.
46. *Correspondance*, I, no. 27, Rodin to Rose, and illustrations, pp.47–50.
47. Henri Dujardin-Beaumetz in Albert Elsen, *Auguste Rodin: Readings on His Life and Work*, Englewood Cliffs, N.J., 1965, pp.165–6.
48. See chronology in *Correspondance*, I, no. 28,

note 1. In view of Rodin's work at Sèvres in October–December 1879, documented as 219 hours, it seems he returned to Paris between the work in Marseilles and Strasbourg, coming back for good by 28 February 1880 at latest.
49. Roger Marx, *Auguste Rodin. Céramiste*, Paris, 1907, pp.30–31.
50. Marx, *Auguste Rodin. Céramiste*, p.26.
51. Marx, *Auguste Rodin. Céramiste*, p.31.
52. Albert Elsen, *'The Gates of Hell' by Auguste Rodin*, Stanford, 1985, p.9.
53. Octave Mirbeau, 'Auguste Rodin', *La France*, 18 February 1885.
54. Gustave Geffroy, 'Le Statuaire Rodin', *Les Lettres et les Arts*, 1 September 1889, pp.13–14, quoted in Tancock, p.287.
55. Cosmo Monkhouse, 'Auguste Rodin', *Portfolio*, XVIII, 1887.
56. Octave Mirbeau, 'Auguste Rodin', *La France*.
57. Many of the drawings were published in the Goupil album of 1897; some are now missing but those which have this chilling power and which survive include *La force et la ruse* (Musée Rodin D5087), *Centauresse et enfant* (Musée des Beaux-Arts, Lyons) and the Liouville acquisitions (Musée Rodin) from the sale of the Hôtel Drouot, 30 November 1984.
58. It is not that I argue with the contention that they are not conventional 'studies' for sculpture (see, for example, Claudie Judrin in *Auguste Rodin. Drawings and Watercolours*, p.63; Albert Elsen in *The Drawings of Rodin*, p.19), but that they are drawings with a sculptural vision, unique in kind, and unimaginable coming from a painter, and that the sculpture of the mature period is heavily indebted to what they allowed Rodin to envisage.
59. G. D'Argenty, 'Le Salon National', *L'Art*, May 1883, pp.32–8. The illustrations consist of 'Tête de Damné' (Goupil pl. 14); 'Study for *La Porte de l'Enfer*' (Fogg Art Gallery, 1943.916); 'Les Limbes' (seated woman with child in arms, Plate VII in Marx, *Auguste Rodin: Céramiste*; 'L'Enfer' (*Centaur*, Musée des Beaux-Arts, Lyons); 'The Sculptor's Vision' (i.e., *Entombment*, D7629); 'Première pensée d'un modèle' (woman and child); 'Première pensée d'un modèle' (man and child with abducted woman); 'The Kiss' (Fogg Art Gallery, 1943.912).
60. Rodin to Léon Gauchez, 13 May 1883, Vienna State Archives. Gauchez's real name was Paul Leroi.
61. For a full description of *Medea* see Tancock, pp.232–4 who dated it 1865–70. The Musée Rodin also has a plaster, S2029.
62. 'Medea' drawings include D2053, possibly D3785, one in Tokyo (possibly a fake), and many, like *Charity* (Fitzwilliam), which might be simply of mothers and children.
63. Marion Hare has researched this subject: see the guide to the collection at Stanford University Art Museum, 1985, and Elsen, *Rodin's Thinker*, p.168. No woman ever claimed Rodin was the father of her child and it is possible that Auguste Beuret was conceived

before Rodin met Rose. The *Sculptor's Soul*, a plaster sculpture of a seated figure holding a mummy-like child, relates to the image in the drawings of a parent looking away from his offspring. The child gradually becomes a more lively female muse. Albert Elsen photographed this sculpture (or similar) at Meudon some years ago, and it was reproduced by Gustave Kahn, *L'Homme et l'œuvre. L'Art et le Beau*, Paris, 1906, pp.108 and 127.
64. Letters in the Musée Rodin Archives and Reading Museum and Art Gallery. Several biographers mention Rodin's support of destitute boys, see Victor Frisch and Joseph T. Shipley, *Auguste Rodin: A Biography*, New York, 1939, p.8.
65. Vincent Van Gogh to Theo, Arles, July–August 1888 quoted in *Vincent by himself*, ed. Bruce Bernard, London, 1985, p.184.
66. *Centaur carrying off a woman* (*Nessus and Deianeira*), 1816–17, London, Private Collection. The pen, wash and gouache study *Man rescuing a woman from the flood* (c.1816, Angers, Musée des Beaux-Arts) by Géricault is remarkably close in feeling to the porcelain plaque *Le Rapt*, Plate X in Marx, *Auguste Rodin. Céramiste*.
67. Leo Steinberg, *Rodin: Sculpture and Drawings*, Charles E. Slatkin Galleries, New York, May 1963.
68. *St. John the Baptist* was published in Léon Maillard, *Auguste Rodin, statuaire: Etudes sur quelques artistes originaux*, Paris, 1898, and several others in the Goupil album (pls 1, 8, 81).
69. Dante, *The Divine Comedy*, trans. C. H. Sisson, London, 1981: *Inferno*, XXXIII, 94.
70. Claudie Judrin, *La Revue du Louvre*, 5/6, 1985, pp.428–9.

The *Gates of Hell*

1. Elsen, *'The Gates of Hell'*, pp.9–10. Elsen examined the handwritten draft of Bartlett's articles at the Library of Congress which quote Rodin as saying: 'I was glad to take [Bartlett then crossed out this word and continued] accept the Inferno as a starting point.' In 1900, speaking to Serge Basset ('La Porte de l'Enfer', *Le Matin*, 19 March), Rodin said that, asked to execute a monumental portal, 'I accepted, and with the agreement of M. Turquet, I decided to make *The Gates of Hell*'. Speaking to Gustave Coquiot (*Rodin à l'Hôtel de Biron et à Meudon*, Paris, 1917, pp.75–6), Rodin explained how he had announced to Turquet his intention of modelling a gigantic door with 'all the most moving details of Dante's great poem. My listener thought I was crazy. (One usually did far fewer figures in a commission).'
2. The *Gates*, including the *Three Shades*, measures 7.5×3.96 m.
3. The changing attitude during the nineteenth century to the nude female and to allegorical attributes was not confined, of course, to France. See Peter Fusco, 'Allegorical Sculpture' in *The Romantics to Rodin*, pp.66–8.

4. Elsen, 'The Gates of Hell', pp.35–44, discusses the architectural genesis of the Gates at length, citing both the contemporary references to Ghiberti and the suggestions that Rodin was influenced also by the reliefs of Henri de Triqueti, Andrea Riccio, the fourteenth-century Last Judgment on the cathedral at Orvieto and also Gothic and French sources.

5. This translation was mentioned by Judith Cladel in Rodin: Sa vie, Rodin's copy no longer survives in the Musée Rodin.

6. Coquiot, pp.75–6.

7. Apart from the sources mentioned above for Turquet's assent, it is also implied by his willingness and that of his successors to pay for the work in progress over the period October 1880–March 1888 (Rodin dossier, Archives Nationales, Paris), even after plans to build a new museum had been dropped.

8. Correspondance, I, p.56, no. 36, note 3 for a full description of the rue de l'Université and Rodin's moves between studios.

9. Invoice dated 6 January 1881, Musée Rodin Archives.

10. From letter in the Rodin dossier, Archives Nationales, Paris, quoted in Elsen 'The Gates of Hell', p.57.

11. Roger Ballu, report of 13 November 1882, Rodin dossier, Archives Nationales, Paris.

12. The New York Herald Tribune supplement, 2 September 1900, quoted in Elsen, 'The Gates of Hell', p.139, and Judrin in Auguste Rodin. Drawings and Watercolours, pp.68–9.

13. The bronzes are at the Musée Rodin, Paris; Rodin Museum, Philadelphia; Kunsthaus, Zurich; Museum of Western Art, Tokyo; and, the only lost-wax cast, commissioned by B. Gerald Cantor in 1977, at Stanford University Museum of Art. For Léonce Bénédite's role in the first casting see Elsen, 'The Gates of Hell', p.148.

14. Gustave Geffroy, 'The Sculptor Rodin', Arts and Letters, London, 1889, quoted in Butler, p.67.

15. Roger Ballu to Commissioner, 1882, Rodin dossier, Archives Nationales, Paris.

16. Mirbeau, 'Auguste Rodin', La France.

17. Elsen, Rodin's Thinker, chapter 1.

18. Octave Mirbeau, 'Auguste Rodin', Les Arts Français, 1918, p. 22, quoted in Elsen, Rodin's Thinker, p.130.

19. Undated letter from William Henley that mentions both his July issue ('j'ai l'idée de faire graveur les groupes en ronde') and the June one. During Alphonse Legros's visit to Paris from mid-December 1881 to mid-January 1882 Rodin finished his bust begun the previous summer (Correspondance, I, p.54).

20. William Henley to Rodin, 7 October 1982. In a letter of 1 September 1882 he thanked Rodin for a photograph of a 'bas-relief' (Musée Rodin Archives). He repeatedly speaks of Rodin's 'Paolo and Francesca' (probably The Kiss) and asks him on 10 March 1884 whether he will be entering anything in the Grosvenor House show, this piece or one of 'l'âmes désespérées'.

21. Cosmo Monkhouse to Rodin, 20 April 1884. The amateur photographs include that by Jessie Lipscomb, probably March 1887 prior to her marriage the following autumn.

22. In the sketch D6937 and others the figures of Adam and Eve are indicated. Rodin explained to Maurice Haquette his intention to have two colossal figures on either side (11 December 1881, Rodin dossier, Archives Nationales, Paris and quoted in Elsen, 'The Gates of Hell', p.60). Although they were developed separately, the Government did not agree to the costs of casting these figures and even when they existed Rodin did not place them in flanking positions by the doors.

23. Photograph of the last architectural maquette mounted on card, Musée Rodin.

24. This approach appears in drawings D1963, D1960, D1969, D1970.

25. Basset, 'La Porte d'Enfer'.

26. Natorp in Frederick Lawton, The Life and Work of Auguste Rodin, London, 1906, p.242. It is tempting to believe Rodin abandoned drawing directly from the model after this mythical 'year', however, I do not believe this happened. See Elsen, 'The Gates of Hell', chapter 3 and Varnedoe in Rodin Rediscovered. Moreover there are drawings which can be dated to these years like that annotated 'Gericault', D5930 and the Circle of Lovers (D5630).

27. Rodin to Léon Gauchez, 13 May 1883, Vienna State Archives. Sketches made on the backs of envelopes with the stamp of the French Exhibition in London in 1883 (Dudley Gallery) reveal that Rodin was drawing Egyptian and Assyrian sculpture (D3553–3557). The heads look remarkably like Rodin's studies of Victor Hugo made that year.

28. This association and Rodin's interest in the Michelangelo pieces have been discussed in Albert Alhadeff, 'Academic and Italian sources of the Early Work of Auguste Rodin', unpublished Master's thesis, The Institute of Fine Arts, New York University, 1962; and in Kirk Varnedoe, 'Early Drawing', Burlington Magazine, CXVI, April 1974 as well as in Auguste Rodin. Drawings and Watercolours, pp.24–6.

29. Gustave Natorp (b.1863, Hamburg) to Rodin, 1 May 1882, (Musée Rodin Archives). In the letter he explains that he is coming to Paris and hopes to visit the rue des Fourneaux and the rue de l'Université.

30. Gsell, Auguste Rodin. Art, p.81.

31. Dujardin-Beaumetz, p.63.

32. Apart from the documentation in Marx, the vases are discussed in the catalogue L'Art de la Poterie en France de Rodin à Dufy, Sèvres, Musée Nationale de Céramique, 9 June–25 October 1971 and in correspondence in the Musée Rodin Archives. The drawings for Je suis belle are also grouped in Rodin et les écrivains de son temps, Musée Rodin, Paris, 1976, and the facsimile edition of Les Fleurs du Mal, Geneva, 1983 in the section 'Comment Rodin a illustré Les Fleurs du Mal'.

33. Paul Giugou, 'A travers la sculpture contem-poraine', Revue moderniste, 8, 30 September 1885, where it was still called L'Amour Carnal.

34. Charles Baudelaire, 'Beauty', Les Fleurs du Mal, in Baudelaire, Rimbaud, Verlaine, ed. Joseph M. Bernstein, trans. Arthur Symons. New York, 1947, p.24.

35. See photograph of the Gates (c.1887) owned by Jessie Lipscomb with sections of the pilasters attached to the scaffolding (pl.86).

36. Edmond de Goncourt, Journal: Mémoires de la vie littéraire. Paris, 1959: Thursday 29 December 1887.

37. Camille Mauclair, Auguste Rodin: The Man—His Ideas—His Works, trans. Clementina Black, London, 1905, pp.22–3.

38. Elsen, In Rodin's Studio, nos. 83 and 84, Bodmer? Ph1350 and 1373. Albumen prints with gouache. See Pinet for the retouched photograph of Orpheus and Eurydice by E. Freuler.

39. Ph1345, Pannelier or Bodmer, albumen print with pencil, 24 × 11.5 cm, Musée Rodin.

40. Maillard, p.12.

41. Bartlett, 11 May 1889, p.223.

42. See Elsen, 'The Gates of Hell', chapters 4, 7 and 8 for stages.

43. Gustave Geffroy, 'Chronique', La Justice, 3 March 1883. Mirbeau, 'Auguste Rodin', La France, explaining that one could say of Rodin what Théophile Silvestre had already said of Delacroix.

44. Cladel, The Man and His Art, p.238.

45. Gsell, Auguste Rodin. Art, p.77. Rodin spoke freely of all these painters. Of Raphael for example he said: 'Raphael, pour eux, c'est pur, c'est nettoyé, fignolé. Certaines des ses fresques si on les montrait à part, personne ne croirait qu'elle sont de sa main. C'est peint à coup de sabre' (J. E. S. Jeanes, 'Rodin chez lui', Candide, 6 December 1934). A reproduction of the School of Athens was pinned to the studio wall.

46. Rosen and Zerner, p.46.

47. Jack D. Flam, 'Conversation with Aragon (on signs)', in his Matisse on Art, Oxford, 1973, p.95.

48. Lorenz Eitner, Géricault's Raft of the Medusa, London, 1972, and also Lorenz Eitner, Géricault, London, 1983.

49. Tancock, p.607.

50. Rodin called Delacroix's Shipwreck of Don Juan, 'admirable', because 'hunger and distress tragically convulse the faces of these ship-wrecked people, because the somber fury of the color portends some horrible crime', (Gsell, Auguste Rodin. Art, p.72). Claude Roger-Marx, 'Rodin, Dessinateur et Graveur', Arts et Métiers Graphiques, October 1931, spoke of the affinity to Michelangelo, Rembrandt, Daumier and especially 'Delacroix de Barque de Dante, de Faust et des Massacres' (p.351).

51. Rodin made a portrait bust of Mme Alfred Roll in 1882 or 1883. L'Inondation is now in the Musée du Havre.

52. Hughes le Roux, 'La Vie a Paris', Le Temps, 20 June 1889.

53. Bartlett, 11 May 1889, p.225.
54. Descharnes and Chabrun, p.69, quoting Mauclair. On 3 July 1889, Goncourt recorded Mirbeau's story that 'at a dinner at Monet's, who has four very beautiful daughters, he spent dinner by looking at them, but looking at them in such a way that one by one, each of the four girls was obliged to rise and leave the table' (quoted by de Caso and Sanders, p.108).
55. Bartlett, 1 June 1889, p.262.
56. Stephan Zweig, *The World of Yesterday*, London, 1943, ed. of 1953, pp.146–8.
57. Charles Baudelaire, *The Flowers of Evil*, trans. David Paul, New York, 1955, p.23.
58. Rilke, *Rodin*.
59. Pinet, p.68, and *Rodin Rediscovered*, nos. 93, 94, and Musée Rodin Archives.
60. Mauclair, p.70.
61. Mauclair, pp.53–4.
62. Rodin went on to explain in an article in *Antée*, 1 June 1907, that 'a work of art is always noble, even when it translates the stirrings of the brute, for at that moment the artist who has produced it had as his only objective the most conscientious rendering possible of the impression he has felt'.
63. Georges Grappe, 'Affinités électives—Ovide et Rodin', *L'Amour de l'Art*, XVII, June 1936.
64. Parker Tyler, 'Rodin and Freud: Masters of Ambivalence', *Art News*, LIV, March 1955, pp.38–41, 63–4.
65. De Caso and Sanders, p.315.
66. The *Fortnightly Review*, LXXVII, June 1902, p.9. Symons saw the *Gates* in 1892.
67. Descharnes and Chabrun, pp.69–72. Mme Edmond Adam founded *La Nouvelle Revue*. At her salon Rodin met Léon Gambetta, President of the Chamber of Deputies, who in turn introduced him to Antonin Proust, the Minister of Fine Arts, a contact instrumental in securing commissions.
68. *Correspondance*, I, p.62, no. 48, Rodin to Henry Liouville, 3 December 1883.
69. Numerous books on Camille Claudel have been published in the last four years, the most thorough being *Camille Claudel*, for the exhibition in 1984 at the Musée Rodin, Paris and Musée Sainte-Croix, Poitiers, with texts and entries by Bruno Gaudichon and chronology by Anne Rivière who was author of a biography, *L'Interdite, Camille Claudel*, Paris, 1983. There was also a novella and play by Anne Delbée, *Une Femme*, Paris, 1982 and a scholarly article by Anne Pingeot, 'Le chef-d'œuvre de Camille Claudel: L'Âge mûr', *Revue du Louvre et des Musées de France*, 4, 1982.
70. Edmond de Goncourt, *Journals*, 8 March 1894, Edition de la Bibliothèque nationale, 1915, IV, p.532.
71. Letters from Rodin to Jessie Lipscomb in the possession of her grandson in England.
72. Mathias Morhardt, 'Mlle Camille Claudel', *Mercure d'Art*, 1898, pp.709–15, 719.
73. Cladel, *Rodin: Sa vie*, p.231.
74. *Camille Claudel*, p.43 from the preface by Paul Claudel to the catalogue of the retrospective exhibition of her work, Musée Rodin, 1951.
75. Pingeot, pp.290–91.
76. *Camille Claudel*, nos. 52–55.
77. Gsell, *Auguste Rodin. Art*, p.23.
78. Ambroise Vollard, *Recollections of a Picture Dealer*, Boston, 1936, p.210.
79. Rilke, *Rodin*, p.41.
80. Hannah Arendt, *The Human Condition*, London and Chicago, 1958.
81. Cladel, *Auguste Rodin: L'Oeuvre et l'homme*, p.56.
82. Rilke to Clara Westhof 1902, quoted by William Tucker in 'Rilke's "Rodin" An Introduction', New York, 1986.

The Monuments

1. Edmond Bazire, in *L'Intransigeant*, September/October 1883, quoted in *Correspondance*, I, p.44.
2. Dujardin-Beaumetz, *Entretiens avec Rodin*, English translation in Elsen, *Auguste Rodin: Readings*, pp.165–6.
3. *Le monument des Bourgeois de Calais*. The essay by Vieville, 'La reprise du project en 1884', covers this aspect.
4. Monkhouse, 'Auguste Rodin', p.11.
5. Edmond de Goncourt, *Pages from the Goncourt Journal*, ed. Robert Baldick, Harmondsworth, 1984, pp.317–19.
6. Frisch and Shipley, p.338.
7. *Le monument des Bourgeois de Calais*, p.59, letter 45, Rodin to Dewavrin, 18 January 1886: 'J'ai l'honneur de vous demander une petite provision de deux mille francs, pour m'aider dans l'execution de mon travail.'
8. Gsell, *Auguste Rodin. Art*, p.79.
9. The casts made during Rodin's lifetime are in Calais, Brussels, Copenhagen and London. Others are in Paris, Philadelphia, Pasadena (the Norton Simon Museum), Tokyo, Basel, Washington (the Hirshhorn Museum and Sculpture Garden) and in the B. Gerald Cantor Collections (cast in 1985 by the lost-wax process).
10. *Le monument des Bourgeois de Calais*, pp.31–6.
11. *Le monument des Bourgeois de Calais*, p.42, letter 2, Rodin to Dewavrin, 20 November 1884, footnote 2, letter to Issac, 19 November 1884 (Arch. Mun., Calais).
12. *Le monument des Bourgeois de Calais*, pp.41–2, letter 2, 20 November 1884.
13. *Le monument des Bourgeois de Calais*, pp.155–6, cat. no. 16, note by Monique Laurent.
14. H. W. Janson, 'Une source negligée des Bourgeois de Calais', *La Revue de l'Art*, 1969, pp.69–70. Janson suggests the tomb of Philippe de Pot which Rodin could have known only by reproduction. I find the similarities not convincing enough to consider it as a source.
15. *Le monument des Bourgeois de Calais*, p.49, letter 20, Rodin to Dewavrin, January 1885.
16. *Le monument des Bourgeois de Calais*, p.50, citing letter of 29 May 1885 (Musée Rodin Archives).
17. *Rodin et les écrivains de son temps*, 'Victor Hugo', nos. 100–118. Many drawings were made on 'Job' brand cigarette paper.
18. Rodin interviewed by G. Drouilly, in *Gaulois*, 25 September 1909, and repeated in *L'Enlèvement* (Musée Rodin Archives).
19. Manet's painting *Portrait de M. Henri Rochefort* (1881) was shown in the Salon of 1881 and at the Beaux-Arts in 1884. The plaster cast of Rodin's bust which was in the collection of Mme Edouard Manet was purchased by Matisse in 1898. His drawing of Rodin's bust is reproduced in Pierre Schneider, *Matisse*, London, 1984, p.552.
20. *Le monument des Bourgeois de Calais*, p.49, letter 20, Rodin to Dewavrin, 21 January 1889, footnote 3, Camille Claudel to Rodin (Musée Rodin Archives).
21. The heads of Jean de Fiennes are the most sepulchral and most like the drawings and the row implanted within the *Gates*.
22. *Le monument des Bourgeois de Calais*, p.193 for the discussion of Eustache de St Pierre and Pignatelli, and p.208 for that about Auguste Beuret as the model for Jean d'Aire.
23. *Le monument des Bourgeois de Calais*, p.53, letter 30, Rodin to Dewavrin, 14 July 1885. Explaining first the inevitable change between maquette and scaled-up work in the drapery, Rodin goes on to emphasize the importance of the nudes, 'throwing draperies over a stiff figure never gives the same results twice in succession. I have my nudes, in other words, what lies beneath is finished, and I am having them scaled up so as not to waste time. You see, the most important parts are those one does not see, and they are complete.'
24. Bartlett, 15 June 1889, p.284.
25. *Le monument des Bourgeois de Calais*, p.76, letter 91, Rodin to Dewavrin, 8 December 1893: 'I had thought that if the group were placed very low, it would look more at home, and that that would do more to make the public enter the spirit of misery and sacrifice.' This was not Rodin's last word on the placement; among several contradictory ideas for the various casts, he thought of raising the cast to be placed in London next to the Palace of Westminster: 'For I have had a beautiful idea about the decoration that of the 16th century—these Burghers of Calais put on a very high pedestal 15 to 20 metres from the palace near the sides of this piece of architecture, in the same way as is placed the statue of Coleone or the statue of Guatamalata at Padua. Thus, put closer to Parliament it would make the most beautiful effect, not only would the square group gain from it but all the monument, not only the monument but also the settling of Parliament' (Rodin to Mrs Edith Tweed, 14 February 1913 (Reading Art Museum and Gallery Archives, letter translated by Eric Stanford)).
26. *Le monument des Bourgeois de Calais*, text 3, p.116: Rodin's letter of 2 August 1885, to M. Forest in response to an article in the *Patriote* that day under the pseudonym 'Passant'. The reply appeared in the *Patriote* on 19 August 1885.
27. Letter to Léon Gauchez, 14 August 1885, Vienna State Archives.

28. *Le monument des Bourgeois de Calais*, pp.59–60, letter 46, Léontine Dewavrin to Rodin, 21 February 1886.
29. *Le monument des Bourgeois de Calais*, p.124, letter 55bis, Rodin to Léontine Dewavrin, June–July 1887.
30. In Butler, the section 'The Late 1890's: A Critical Backlash' discusses the shift. An article by André Michel, 'Review of the Exposition Universelle', *Gazette des Beaux-Arts*, September 1889, printed in Butler (p.77), highlights the future division between naturalists and symbolists: 'We wonder whether, if by pushing Rodin towards an outrageous posturing of Baudelaire, his noisy friends do not risk troubling his mind, or leading him into a kind of decadent romanticism to which his true talent must at length be sacrificed. Had I the right to give him one bit of advice, I would tell him to shut his doors, to stop reading the papers, and to work alone, face to face with nature and life . . .'
31. Gustave Geffroy, 'Les six Bourgeois de Calais', *L'Avenir de Calais*, 9 June 1887, printed in *Le monument des Bourgeois de Calais*, text 5, p.118. The nearly identical text appears in the introduction to the catalogue of the exhibition at Galerie Georges Petit, 1889, *C.Monet. A.Rodin.*
32. Le monument des Bourgeois de Calais, *p.124, letter 55ter, Rodin to Léontine Dewavrin, 7 July 1887.*
33. Le monument des Bourgeois de Calais, *p.125, 1977, letter 55bis, Rodin to Léontine Dewavrin, June–July, 1887.*
34. Rodin to Jessie Lipscomb, 31 May 1886, at Woolton House, Peterborough. The suggestion of touring the country around Calais comes in his letter to her of 23 August 1886 (Archive Jessie Lipscomb held by her grandson).
35. Bartlett, 1 June 1889, p.285.
36. JoAnne Culler Paradise, 'The Sculptor and the Critic: Rodin and Geffroy', in *Rodin Rediscovered*, pp.261–2.
37. Gsell is the prime source for Rodin's pronouncements, but they are quoted also in Cladel, *Rodin: The Man and His Art,* and in Gustave Coquiot, *Le Vrai Rodin*, Paris, 1913 as well as in Mauclair and Frisch and Shipley.
38. Mauclair, pp.102–5.
39. Gustave Geffroy, 'The Sculptor Rodin', *Arts and Letters*, 1889, pp.289–304, quoted in Butler, p.72.
40. Hughes Le Roux, 'La Vie à Paris', p.2; and Rodin talking to Paul Gsell in 'Chez Rodin', *L'Art et les Artistes*, April, 1914.
41. A list of Rodin's studios and home addresses has been compiled by Frances Spar (Musée Rodin Archives). Rodin left the boulevard de Vaugirard in October 1890. A studio at 68 (or 103) boulevard d'Italie was occupied from January 1888–1902. Rodin also rented the 'Folie Neubourg' or 'Le Clos Payen' from January 1888–November 1898.
42. Druet's original photographs are in the Bibliothèque Nationale. Two of this subject are reproduced in Pinet, pls 32 and 33.

43. Cladel, *Rodin. Sa vie,* refers to the Rubens painting *Le Débarquement de Marie des Médicis* as reason for changing from three nereids to two muses, (p.173). Tancock subscribes to the theory that the monument is memorable only as separate entities (p.421).
44. Jane Mayo Roos, 'Rodin's *Monument to Victor Hugo*: Art and Politics in Third Republic'. This article (as yet unpublished), adapted from her exceedingly interesting and well-researched dissertation (Columbia University, 1981), sets out to 'examine the reasons behind the failure of Rodin's monument for the Pantheon', and thus, although a chronology for the studies is outlined, the focus is 'primarily upon Rodin's relations with the Subcommittee for Works of Art and upon the way in which politics, in the double sense of that term, affected adversely the development of Rodin's project' (pp.2–3). I believe the last project for the *Monument to Hugo* with muses is not, as a work of art in its own right, a failure.
45. In *Rodin Rediscovered,* the essay by Rosalyn Frankel Jamison, 'Rodin's humanization of the Muse', discusses this theme within the nineteenth century and within Rodin's œuvre. She makes the important observation that by 1897 'the Hugo monument had indeed become a vehicle of personal reflection' and that the *Monument to Balzac* 'conveyed his most audacious and personal concepts about genius and inspiration' (p.113). The essay is part of a doctoral thesis (Stanford University).
47. Anita Brookner, *Jacques-Louis David,* London, 1980, p.112.
48. Bartlett, 1 June 1889, p.260.
49. Quoted by de Caso and Sanders, p.50 in a discussion of the *Sculptor and His Muse,* from Cladel, *Rodin: The Man and His Art,* p.176. Compare Frisch and Shipley, pp.6 and 357. Frisch described the 'models whose—radiant vitality draws his lusty being; models who tender themselves as part of the trade, but also society ladies and "maidens of high family"'.
50. Roos, pp.23–9.
51. The Picasso anecdote is recalled in by Frank Auerbach in the catalogue *Frank Auerbach,* Arts Council of Great Britain, 1978. When the Hugo monument was entered in the Salon in 1897 it was called *Victor Hugo. Plaster group. The arm of the women is incomplete* (Tancock, p.419).
52. *Correspondance,* I, no. 232, between August 1895 and April 1897.
53. Cecile Goldschneider, 'Rodin et la danse', *Art de France*, no. 3, 1963, pp.321–35. Descharnes and Chabrun reproduce photographs of the apaches (p.232).
54. For a report on the reception in Geneva Charles Goerg, Museum newsletter, Musée d'Art et d'Histoire, Geneva, 1985; Rodin offered *La Voix Intérieure* to the museum in Stockholm but it was rejected. Twenty artists signed a petition and in the end Prince Eugène accepted it for his private collection (Cladel, *Rodin. Sa vie,* p.178). The *Crouching Woman,* also known as *Acrobat,* was one of 21 works in an exhi-

bition at Grosvenor House in 1914, Rodin decided to give its contents to the Victoria and Albert Museum when the war broke out.W
55. Elisabeth Geissbuhler has made a detailed, devoted study of Rodin's architectural drawings, identifying many of the locations and writing on their significance within his work. Her findings have been published in the *Art Journal*, XXVI, 1966; *The Drawings of Rodin*; *Auguste Rodin: Drawings and Watercolours,* and elsewhere.
56. Auguste Rodin, *Les Cathédrales de France,* introduction by Charles Morice, Paris, 1914, p.11.
57. Particular works, I believe, pursue a handling of space like that Rodin was attempting in the 1890s; that is, Caro's *Midnight Gap 1976,* King's *Shogun* (1980) and *L'Ogivale* (1981).
58. Cladel, *Rodin: The Man and His Art,* p.214.
59. Interview with Drouilly, *Gaulois,* 25 September 1909.
60. Quoted by de Caso and Sanders, p.233 from Gsell, 'Chez Rodin', pp.410–11.
61. Quoted in Tancock, p.444 from 'Rodin, L'Homme et l'œuvre', *L'Art et les Artistes,* 12 December, 1906, pp.70–71.
62. Albert Elsen, 'Rodin's *Naked Balzac'*, *The Burlington Magazine,* CIX, November 1967, p.611.
63. Quoted in Tancock, p.442 from Rodin, *Le Journal,* 12 May 1898.
64. Athena Tacha Spear, *Rodin Sculpture,* The Cleveland Museum of Art, 1967. Not only does she discuss the documentation of all the studies but she attempts to classify them and give chronological order.
65. *Correspondance,* I, no. 229, Rodin to Gabriel Mourey, a little before 13 May 1895.
66. Butler, p.31. De Caso and Sanders also discuss this association between Rodin and anarchism in relation to Balzac (p.234).
67. Alphonse Legros to Rodin, 24 March 1896. All his letters express his affection and regard for Rodin. That of 31 December 1902 regrets that he is not well enough to join Rodin in London and to visit the museums together as they did twenty years before (Musée Rodin Archives).
68. Elsen, *In Rodin's Studio,* p.182, from the Le Bossé correspondence (Musée Rodin Archives). Rodin's friends circulated a petition challenging the decision of the Société des Gens de Lettres to reject the final monument.
69. Constantin Meunier letter, undated, Philadelphia Museum of Art Archives, also cited in de Caso and Sanders, p.236.
70. Mauclair, p.592.
71. In *In Rodin's Studio,* Elsen discusses the *Monument to Puvis de Chavannes.* The principal text on the *Monument to Whistler* is Joy Newton and Margaret MacDonald, 'Rodin: The Whistler Monument', *Gazette des Beaux-Arts,* December 1978, pp.221–32.
72. Puvis de Chavannes to Rodin, 27 March 1891: 'il y a lu une sorte d'anachronisme'; and 16 May 1891: 'J'ai une grâce à vous demander une grâce tout à fait instante, c'est rendre à mon buste sa position première sans ce mouvement en arrière quasi on donne un air arrogant

contraire à ma nature . . .' (Musée Rodin Archives).

73. *Rodin,* Foundation Pierre Gianadda, Martigny, 1984, cat. nos. 61 and 79, notes by Monique Laurent.

74. Arsène Alexandre, in *Paris Illustré,* March 1904, describes seeing the monument with a small tree and Rilke, p.97.

75. Hélène von Nostitz-Hindenburg, *Dialogues with Rodin,* English translation by H. L. Ripperger, New York, 1931. She says he wrote from the small studio in the garden of 'La Gouette': 'I have lived my life for the past few months in the little lower house at Meudon. I am undergoing a cure of solitude, and am alone in this large room. I receive no one. I read a bit when I wake up in the middle of the night. The slowly awakening day intrudes. The mists also, and the beauty of autumn fills me and spurs me on' (p.66). Their friendship began in 1900.

76. Both dated by Grappe, *Catalogue du Musée Rodin,* to 1892. *Convalescence* (marble) is a modified version of *Farewell.*

77. Gabrielle Reval, interview in *Femina,* 1 May 1903, pp.520–21. She describes the sculptress preparing a marble for the Salon as giving one the 'impression bizarre d'une nature profondément personnelle, qui vous attire par sa grâce et vous repousse par sauvagerie. Tout le caractère de Mlle Claudel est dans ce retrait un peu farouche.'

78. De Caso and Sanders, pp.289–90.

79. E. R. Pennell and J. Pennell, *The Whistler Journal,* Philadelphia, 1921. In 1911 Gwen John made a full-length portrait of herself in this pose, *Girl Reading at the Window.*

80. Charles Millard, *The Sculpture of Edgar Degas,* Princeton, 1976, pp.76–7. *Dancer rubbing her knee* is compared to the classical work.

81. Newton and MacDonald, p.226.

82. Quoted in Michael Holroyd, *Gwen John 1876–1939,* Anthony d'Offay Gallery, London, 1982, p.75, from *Gwen John Memorial Exhibition,* Matthiesen Ltd, 1946. The letters are in the Musée Rodin Archives.

The Late Years

1. Musée Rodin Archives. The files for the *praticiens* and *metteurs au point* employed by Rodin record his day-by-day involvement with their work and the invoices often itemize individual works. Several assistants were talented sculptors, such as Victor Peter who worked for Rodin from 1890 to 1918 and Jean Escoula who worked from 1884 to 1900. The most active years appear to be between 1888 and 1903. Much of the pointing was carried out in the *praticiens*' own studios, as was the bronze chasing and finishing.

2. Edmond de Goncourt, *Journals,* Paris, Fasquelle edition, 1959, IV, pp.129–130. Goncourt, meeting Rodin in the train in June 1895 wrote on the 27th: 'Rodin, whom I found really changed and very melancholy on account of his low state

and the fatigue he felt from his work at the moment, complained almost distressingly of the vexations which in the painter's and sculptor's career are inflicted on artists by art committees, which, instead of helping them in their work, make them lose their time in solicitations and runnings about, time which he would prefer to employ in engraving.' He went on to comment on Rodin's worries of a 'more personal and private order' and to speculate that 'the ceaseless production engaged in during this period—the quantity of which may have even have been increased by his desire to lose himself in his work—that the majority of the pieces of sculpture betray his mood and feeling'.

3. Not only did Rodin collaborate in the selections with their deliberate mix of drawings, plasters, early, previously unseen works and finished sculpture, but he attended many of the openings. The juxtapositions and geometrical arrangements, such as the very beautiful installation in Prague, were apparently his idea in collaboration with his student Joseph Maratka. (Alphonse Mucha accompanied Rodin to Prague and his tour of Czechoslovakia and Vienna.) Alain Beausire (Archivist, Musée Rodin), has made a scholarly study of the exhibitions organized in Rodin's lifetime. Rodin received several honorary degrees (Jena in 1905 and Oxford in 1907) and made trips to Spain in 1906 and Italy in 1912, 1914–15. He was twice invited to Buckingham Palace and made a bust of Pope Benedict XV in 1915.

4. *Rodin et son œuvre, La Plume,* Paris, published in fascicles, nos. 266–71, 15 May–1 August, 1900. The issues included articles by twenty different writers, finishing with reports of the banquet in Rodin's honour. An issue devoted to Rodin of *Les Maîtres Artistes* appeared in October 1903 and *Auguste Rodin: L'Homme et l'œuvre, L'Art et le Beau* in December 1906.

5. The 'late' drawings are a loose term for the work from *c.*1892 to 1917. They constitute the vast majority of sheets in the Musée Rodin, mainly not signed by Rodin, see 'Note pour l'usage du catalogue', *Inventaire des dessins,* III, Musée Rodin, Paris, 1985. The late drawings are those most frequently faked, see Varnedoe in *The Drawings of Rodin* for a discussion of the most common 'hands'.

6. Monique Laurent, 'Observations on Rodin and His Founders' in *Rodin Rediscovered,* pp.285–93. The Musée Rodin continue to cast uneditioned sculpture (12 of each).

7. Edward Warren Parry signed a contract in 1900 with Rodin, arranged through the Carfax Gallery, stipulating that the male genitals be 'complete' and that the work be delivered in eighteen months (Musée Rodin Archives).

8. Gsell, *Auguste Rodin. Art,* p.107.

9. Rilke, p.89.

10. Rodin, letter written in reply to the refusal of the *Monument to Balzac* by the Société des Gens de Lettres on the grounds that it was a crude sketch, *Le Journal,* 12 May 1898, signed X.

11. Rilke, p.53. Alfred Stieglitz, reporting to Rodin on the success of Rodin's exhibition of drawings at '291', remarked how New Yorkers responded: 'the American woman especially seeming intuitively to grasp the elemental beauty you feel and express in all things' (17 January 1908, Musée Rodin Archives).

12. Rainer Maria Rilke, 'Les Dessins et les portraits de Rodin', *L'Art Vivant,* Paris, 1928, p.581.

13. Mathias Morhardt in the *Tribune de Génève,* 18 June 1897 (Musée Rodin Archives).

14. Rodin began collecting in the late 1890s: a letter to Hélène Wahl (*Correspondance,* I, no. 244) written in the spring of 1896 mentions an Etruscan vase. *Rodin collectionneur,* Introduction by Cecile Goldscheider, Paris, Musée Rodin, 1967–78, describes the range of his collection. Others bought for him, for example, when Bourdelle was in Marseilles in 1906 he bought objects for the collection, knowing his taste (Musée Rodin Archives).

15. A copy of Rembrandt's *Bathsheba* hung in the studio. The most famous oil in Rodin's collection was Van Gogh's *Portrait of Père Tanguy.* Rodin told Gsell that he thought Van Gogh's quality comparable to that of the primitives: 'he ignores the method of making up a painting as if it were a dish or a sauce according to the directions of a cookbook. He places himself naively before Nature and tries to translate it. Whether he succeeds perfectly, this is another story. It is certain that he does not know how to draw. It is a defect common to several Impressionists' (Gsell, *Auguste Rodin. Art,* from notes to p.xiii, p.118). His Degas was obtained from Jules Chavasse in exchange for two sculptures in an arrangement Vollard made (*Correspondance,* I, no. 244).

16. Jeanes, 'Rodin chez lui'.

17. Paul Gsell, 'Rodin par Gsell', *La Revue de Paris,* 1918, p.415.

18. I looked at all the drawings nos. 1–6907 in the Musée Rodin between May 1981 and November 1985 and later acquisitions in the Salle des Dessins, Musée Rodin in the exhibition November 1985–February 1986.

19. Varnedoe in *The Drawings of Rodin* analysed three modes of late drawings and also wrote on the chronology in general. The date of the onset of the transitional drawings has steadily moved back and is now put at *c.*1890 by the Musée Rodin (see *Inventaire,* III). The general look of groups of drawings and links between these establish a broad chronology, more so than the medium or paper or subject and the works published and photographed in 1900, 1902 and elsewhere prove that all modes, with the exception of the smudged graphite style, existed by 1900. *Auguste Rodin. Drawings and Watercolours,* includes two essays dealing with the chronology of the late work. In the first essay, 'The Transition Period' by Ernst-Gerhard Güse, Varnedoe's basic information is repeated but the author maintains that 'no

linear and logical development seems to link the Dante gouaches with the late contour drawings of around 1900' (p.177). I feel this is not the case, comparisons are numerous, for example, *Elevation of the Cross with three figures* (D143) and *Woman in profile in a dance movement* (D4363), likewise *Pluto* (D1936, with the illustration for 'La Beatrice'). Schmoll in the same catalogue repeats the suggestion that the life drawings of a bearded man cited in *Le monument des Bourgeois de Calais* are contemporary with the monument, which seems entirely improbable on visual grounds (p.212). Roger Marx's date of 1896 ('Cartons d'artistes—Auguste Rodin', *L'Image*, September 1897) for the onset of the late style with watercolour seems preferable to Schmoll's later date (p.215). The Musée Rodin have not attempted to sort the drawings into categories and have dated cautiously using publications and annotations as principal sources. See Foreword in *Inventaire*, III and IV.

20. Kirk Varnedoe, 'Rodin's Drawings', in *Rodin Rediscovered*, p.156.

21. Frisch and Shipley, pp. 112–13.

22. Marx, 'Cartons d'artistes'.

23. The facsimile edition of the 1857 illustrated copy of Baudelaire, published by Edito-Service S.A., Geneva, 1983 includes a section 'Comment Rodin à illustré *Les Fleurs du Mal*' with texts by Claudie Judrin and Robert Carlier. Earlier facsimiles were published in 1918, 1940 and 1968.

24. Elsen makes this point in '*The Gates of Hell*', p.121.

25. *Etude d'après le buste de Mme Vicunha* (Musée du Louvre, RF 16 080), shown in Bayonne in 1979 and reproduced in *The Drawings of Rodin* and elsewhere.

26. *Les Fleurs du Mal* (facsimile edition, 1983) and *Rodin et les écrivains de son temps*, cat. nos. 32–36.

27. See above, Jeanes, 'Rodin chez lui'. Numerous references to Rodin's interest in Attic vase painting exist, see Marx, 'Cartons d'artistes' who wrote that the drawings were closest to 'the pure sketches which Greek artists drew on the inner surfaces of goblets, on the bellies of amphoras and on rocks'. Also Judrin in *Auguste Rodin. Drawings and Watercolours*, p.10.

28. *Les Fleurs du Mal* (facsimile edition, 1983), letter from Rodin to Paul Gallimard, January 1888.

29. Roger-Marx, 'Rodin, Dessinateur et Graveur', p.354. This drawing is close to D3758 (*Inventoire*, III).

30. *Rodin et l'Extrême Orient*, Musée Rodin, Paris, 1979, p.101. Jacques de Caso in his doctoral dissertation (Institute of Fine Arts, New York University) also mentions Gauguin's introducing Rodin to these Javanese dancers. Rodin saw Japanese dancers in London in 1890.

31. Reproduced in colour, *Inventaire*, III.

32. Gustave Coquiot, 'Ses Dessins en Couleurs', *Les Maîtres Artistes*, 1903, p.288.

33. *Auguste Rodin. Drawings and Watercolours*, no.

34. The vermilion drawing is called *Centaur and woman* (Mrs Katherine Graham), reproduced in *Rodin Rediscovered*, p.174 and Goupil, pl. 7.

35. Marx, 'Cartons d'artistes'.

36. Anthony Ludovici, *Personal Reminiscences of Auguste Rodin*, Philadelphia and London, 1926, p.139.

37. Cladel, *Auguste Rodin: L'Oeuvre et l'homme*.

38. William Rothenstein, *Men and Memories*, London, 1927, pp.320–21.

39. Frisch and Shipley, pp.419–20.

40. Charles Millard, *The Sculpture of Edgar Degas*, Princeton, 1976, pp.88–9. His reference leaves out the names of Forain and Willette.

41. Jean Lorrain, 'La Danse', *L'Evènement*, 16 December 1887, p.1.

42. In a letter to Rodin of 8 January 1886, Mirbeau described Rops thus: 'quel merveilleux talent que Rops et quel gran esprit' (Musée Rodin Archives). Maurice Guillemot compared Rodin to Rops ('Villegiature', *L'Evènement*, 29 August 1894), since they shared 'le sadique génial de cette fin de siècle, de cette fin de race'.

43. Susan Chitty, *Gwen John*, London, 1981, p.69.

44. The girls back-to-back, *Genius* (D5050), is an example of two bodies fusing together, as are most sketches such as D5038, D4649, D4889, D5025, etc. But the smaller figure in D4754 is frequently traced and combined with women of another scale as in D5705, D5707, D5715. This happens with other couples.

45. Maurice Guillemot, 'Les Deux Modèles', *Figaro*, 12 April 1899, describing Suzette's arrival: 'en un instant, tantis que Rodin avait le dos tourné et feuilletait, penché en carton d'aquarelle la recherche d'un croquis nécessaire, elle était dévêtrée, rapide, . . .' The model Georgette was a particular favourite, and others are identified (Musée Rodin Archives) with specific sculptures and drawings, such as Fenella Lowell, a singer, with the sketch *L'Abandonée* (New York, Metropolitan Museum of Art, cat. no. 213) and Chiari with the *Sculptor and his Muse* (cat. no. 114). Hanako began modelling for Rodin when she was 39, in 1907, and returned at intervals when she was in Paris until 1911. She was introduced to Rodin by Loïe Fuller. He did not think of her as an ethnic type and indeed considered using her as the model for a bust of Beethoven (Cladel, *Rodin. Sa vie*, pp.15–16). See *Rodin et l'Extrême Orient*, pp.23–5 and Descharnes and Chabrun for references to others.

46. Michel Butor, *Histoire Extraordinaire, Essay on a dream*, London, 1969, pp.51–2.

47. Clothide, daughter of Gabrielle Cateneau and Jean-Baptiste Rodin (*Correspondance*, I, p.248). Clothide's life is referred to in Cladel, *Rodin. Sa vie*, p.75.

48. Rodin to Hélène Wahl, *c*.spring 1896 (*Correspondance*, I, no. 245).

86. Elizabeth Chase Geissbuhler who has identified so many of the locations of the architectural sketches does not do more to date work than to suggest those subjects from the interior provinces were executed after 1875.

49. Baudelaire, 'Le Peintre de la Vie Moderne', in Butor, p.52.

50. Not only do the inscriptions give this spectrum of epithets but the lists of works shown in his lifetime, for example the catalogue of the 1907 exhibition at Galerie Bernheim Jeune, show the same variety. The Hellenic preference was of course one shared with contemporaries such as Rodin's friend Stephane Mallarmé; Rodin called the memory of their mutual friend Georgette Leblanc an experience as beautiful as the look of 'une colonne grecque immobile' (*Correspondance*, I, no. 223, between 1895 and 9 September 1898). Rodin compares the relative beauty of women at length in Gsell, *Auguste Rodin. Art*, as well as in nearly every recorded conversation after 1900.

51. Cladel, *Auguste Rodin: L'Œuvre et l'homme*, pp.103–4, paraphrasing Rodin.

52. E. Campagnac, 'Rodin et Bourdelle d'après, des lettres inédites', *La Grande Revue*, XXX, November 1929.

53. Elisabeth Chase Geissbuhler, *Rodin: Later drawings, with Interpretations by Antoine Bourdelle*, Boston, 1963, p.2.

54. Marx, 'Carton d'artistes'.

55. Clement-Jain, 'Les Dessins de Rodin', *Les Maîtres Artistes*, 1903, pp.285–7.

56. The lively male figure who does handstands and is often shown in profile, one leg raised, is stylistically like the drawings attributed to the *Burghers of Calais*, but which I date with other examples of figures drawn with eyes kept entirely on the model, *c*.1900. Examples are cat. nos. 164–9.

57. Matisse in Louis Aragon, *Henri Matisse. A Novel*, London, 1972, vol. I, p.129.

58. The 84 cm version of the *Walking Man* was first shown at the Place de l'Alma exhibition in 1900 and the 168 cm one in 1907. Judith Cladel confirms this date and not the 1877 date often given. See de Caso and Sanders, pp.79–80 for full discussion.

59. 'Henry Moore parle de Rodin', *L'Oeil*, November 1967, p.63.

60. *Two male nudes struggling*, *c*.1880 (D1889) and the *Heretics*, *c*.1882 (Goupil pl. 10), both Musée Rodin.

61. Gustave Coquiot, 'Rodin: Ses dessins en couleurs', *Rodin et son œuvre, La Plume*, pp.8–9.

62. Phillip Hale, *The Boston Commonwealth*, 1895, quoted in Lawton, p.127.

63. Gustave Geffroy, *La Vie Artistique*, Paris, 1893, vol. VI.

64. Although the sculpture of the dancer (Musée Rodin S803) is generally known as *Nijinsky* and Rodin's enthusiasm for the dancer and his coming to the studio are related by several writers, including Cladel, Serge Lifar, former master of ballet at the Paris Opera argued that the figure is from the ballet *Le Prince Igor* in which Nijinsky did not dance (*Rodin*, Fondation Pierre Gianadda, Martigny, 1984, p.140).

65. Von Nostitz-Hindenburg, *Dialogues with Rodin*, p.14.

66. Emile Bourdelle, in Geissbuhler, p.29.

67. The process of dip-casting was discussed at length in *Rodin Rediscovered,* pp.137–40.
68. Gsell, *Auguste Rodin. Art,* expands on this.
69. Stephen MacKenna, 'In Rodin's Studio', *The Criterion,* July 1901.
70. Yvanhoe Rambosson, 'Le Modèle et le mouvement dans les œuvres de Rodin', *Rodin et son œuvre, La Plume,* pp.70–73.
71. *Correspondance,* I, no. 253, Rodin to Edmond Bigand-Kaire, 30 June 1897. He was the proprietor of a vineyard in the Bouches-du-Rhone and regularly sent wine to Rodin.
72. *Rodin et l'Extrème Orient,* pp.68–9.
73. The essay by Victoria Thorson, 'Symbolism and Conservatism in Rodin's Late Drawings', in *The Drawings of Rodin,* covers this subject. She discusses the significance of the titles 'Egypte' and 'Cleopatra' (p.127).

74. The description of the stump technique as the last to arrive is common, see Paul Gsell, 'Le Dessin et la Couleur', *La Revue,* 1 October 1910, p.724.
75. See Pinet, passim.
76. Robert James Bantheus, *Eugène Carrière: His Work and His Influence,* UMI Research Press, 1975. The two artists may have met at Sèvres but their friendship is documented from 1886 onwards. Mauclair dwells on the relationships between their work.
77. See Margaret Scolari Barr, *Medardo Rosso,* New York, 1963 and Tancock, p.20 among others for the possible influence.
78. Gsell, 'Chez Rodin', p.55 and Camille Mauclair, *Conference au Pavillon Rodin,* 31 July 1900, catalogue to the exhibition in the place de l'Alma.

79. Malvina Hoffman, *Heads and Tales,* New York, 1939.
80. Rodin in Ludovici, pp.138–9.
81. See above, p.108, and Cladel, *Rodin. Sa vie* among others.
82. Symons, *The Fortnightly Review,* p.963.
83. Marcelle Tirel, *The Last Years of Rodin,* New York, 1925, p.83. She was his secretary in his final years.
84. The drawing is reproduced in *Auguste Rodin. Drawings and Watercolours,* p.267. Rodin made a sculpture called *The Temptation of St Antony* in 1889 and Geffroy in his book *La Vie Artistique* discusses Rodin's interest in Flaubert.
85. Gustave Flaubert, *The Temptation of St Antony,* London, 1980, p.89, with introduction by Kitty Mrosovsky which discusses the Oriental Renaissance.

Select Bibliography

Bartlett, Truman H., 'Auguste Rodin, Sculptor', *American Architect and Building News*, XXV, 19 January-June 1889.

Butler, Ruth (ed.), *Rodin in Perspective*, Englewood Cliffs, N.J., 1980.

Caso, Jacques de and Sanders, Patricia, *Rodin's Sculpture: A Critical Study of the Spreckels Collection*, San Francisco, 1977.

Cladel, Judith, *Auguste Rodin: Pris sur la vie*, Paris, 1903.

——, *Auguste Rodin: L'Oeuvre et l'homme*, Brussels, 1908. Translated as *Rodin: the Man and His Art, with Leaves from His Note-book*, New York, 1917.

——, *Rodin. Sa vie glorieuse, sa vie inconnue*, Paris, 1936 and 1950. Translated as *Rodin*, New York, 1937.

Descharnes, Robert and Chabrun, Jean-François, *Auguste Rodin*, London, 1967.

Elsen, Albert, *'The Gates of Hell' by Auguste Rodin*, Stanford, 1985 (first published Minneapolis, 1960).

——, *In Rodin's Studio: A Photographic Record of Sculpture in the Making*, London, 1980.

——, *Rodin's 'Thinker' and the Dilemmas of Modern Public Sculpture*, New Haven and London, 1985.

Frisch, Victor and Shipley, Joseph T., *Auguste Rodin: A Biography*, New York, 1939.

Gsell, Paul, *Auguste Rodin. Art. Conversations with Paul Gsell*, Berkeley, 1984, trans. Jacques de Caso and Patricia B. Sanders from *L'Art: Entretiens réunis par Paul Gsell*, Paris, 1911.

Grappe, Georges, *Catalogue du Musée Rodin*, 5th edition, Paris, 1944.

Judrin, Claudie, (Musée Rodin, Cabinet des Dessins), *Les Centaures*, I, Paris, 1981–82; *Ugolin*, II, Paris, 1983; *Dante et Virgile aux Enfers*, III, Paris, 1984.

Marx, Roger, *Auguste Rodin: Céramiste*, Paris, 1907.

Mauclair, Camille, *Auguste Rodin: The Man—His Ideas—His Works*, trans. Clementina Black, London, 1905.

Pinet, Hélène, *Rodin. Sculpteur & les Photographes de Son Temps*, Paris, 1985.

Rilke, Rainer Maria, *Rodin*, trans. Robert Firmage, Salt Lake City, 1982, from *Auguste Rodin*, Berlin, 1903.

Rodin, Musée, *Correspondance de Rodin*, I: *1860–1899*, texts ordered and annotated by Alain Beausire and Hélène Pinet, Paris, 1985.

——, *Inventaire des Dessins*, IV, Paris, 1984; III, Paris, 1985 (to be in five volumes).

Tancock, John, *The Sculpture of Auguste Rodin: The Collection of the Rodin Museum, Philadelphia*, Philadelphia, 1976.

Exhibition catalogues:

The Drawings of Rodin, National Gallery of Art, Washington D.C., and New York, 1971–72. Exhibition organized by Albert Elsen and J. Kirk T. Varnedoe, with additional contributions from Victoria Thorson and Elisabeth Chase Geissbuhler.

Rodin et les écrivains de son temps, Musée Rodin, Paris, 1976.

Auguste Rodin: Le monument des Bourgeois de Calais, Musée Rodin, Paris, in collaboration with the Musée des Beaux-Arts de Calais, 1977. Texts by Monique Laurent and Dominique Vieville (with entries by Laurent, Vieville and Claudie Judrin).

The Romantics to Rodin, French Nineteenth Century Sculpture from North American Collections, Los Angeles County Museum of Art, 1980. Exhibition organized by Peter Fusco and H.W. Janson, with other texts by Ruth Butler, June E. Hargrove, James Holderbaum, John M. Hunisak, Fred Licht and Anne M. Wagner.

Rodin Rediscovered, National Gallery of Art, Washington D.C., 1981. Exhibition organized by Albert Elsen, with additional texts by Albert Alhadeff, Ruth Butler, Jean Chatelain, Sidney Geist, Rosalyn Frankel Jamison, Claudie Judrin, Monique Laurent, JoAnne Culler Paradise, Anne Pingeot, Daniel Rosenfeld and J. Kirk T. Varnedoe.

Auguste Rodin. Drawings and Watercolours, Westfälisches Landesmuseum für Kunst und Kulturgeschichte, Münster, 1984 (English translation, London, 1985). Exhibition organized by Ernst-Gerhard Güse, with other texts by Elisabeth Chase Geissbuhler, Claudie Judrin, J.A. Schmoll gen. Eisenwerth and J. Kirk T. Varnedoe.

CATALOGUE

THE NOTES TO the catalogue have been provided as follows:

Drawings in the collection of the Musée Rodin, Paris
Claudie Judrin

Sculpture in the collection of the Musée Rodin, Paris
Nicole Barbier

All other loans
Catherine Lampert

All dimensions are in centimetres, height × width × depth

Unless otherwise stated, all works in the Musée Rodin were part of the artist's bequest to the State in 1916. Founders and casts are listed where known. A discussion of the casts and the present-day policy of the Musée Rodin towards posthumous editioning is outlined in Monique Laurent's essay in the catalogue produced for the exhibition in Washington in 1981, *Rodin Rediscovered*.

The dates for sculpture accompanying the titles refer to the conception of the sculptures and not to the casting (the dates of reworked variations are indicated in parentheses). In general they follow the dating by Grappe, Tancock and other catalogues of their collections. The French titles established for the inventory of drawings have sometimes been abbreviated.

The references to Dante in Claudie Judrin's original text were from the Antoine Rivarol edition (Paris, 1785); however, the English translations in her notes are from Dorothy Sayers's translation (*Hell*, Harmondsworth, 1949). Those in the main text are from C. H. Sisson, *Dante. The Divine Comedy* (London, 1981).

All photographs from the Musée Rodin by Bruno Jarret unless otherwise indicated.

Early works: drawings from museums and the imagination

1

Portrait of a man wearing a cap

Graphite on cream paper pasted on to a
support, 8.7 × 5.7 cm
Part of Album I, broken up in March 1930

Musée Rodin (D119)

It is tempting to see this drawing as a self-
portrait, in which case it is unusual. Rodin
usually wore a beret rather than a cap, but the
features are recognizable as those of the sculp-
tor at the age of about twenty, in roughly
1860. This drawing is to be compared with
one mistakenly attributed to the collections of
the Musée du Petit-Palais, Paris (reproduced,
Bernard Champigneulle, *Rodin*, London,
1980, p. 17), as the tie is knotted in the same
way in both.

2 *pl. 5*

Sheet of sketches

From top to bottom and from left to right:
two statue-columns, group of two figures
embracing; inverted sketches of group of
three figures; four men walking in procession
alongside a bull; man wrestling with a centaur
Graphite, pen and brown-ink wash on four
sheets of paper pasted to a support,
26.2 × 34 cm
Verso: supplicant figure (original position of
drawing D130)

Musée Rodin (D134–138; verso, D131)

We see here further evidence of how Rodin
mounted his drawings and made them into
collages. D138 overlaps with D135, and pencil
lines have been added to the latter. The statues
of the Queens of France in Chartres Cathedral
(D134) are drawn after the etchings published
by Bernard de Montfaucon in his *Les Monu-
ments de la monarchie française* (1729, vol. I, pl.
IX), and are as schoolboyish as the *Bearers of
Gifts* from the south frieze of the Parthenon
(D136) and the *Centaur wrestling with a Lapith,*
after a metope on the south side of the same
building (D137).

On the verso, traces of a red chalk drawing
can be seen. This was probably a sketch for
the lithograph published in the Belgian satiri-
cal paper *Le Petit comique* on Sunday, 12 April
1874.

1

3 *pl. 26*

Sheet of sketches

From top to bottom and from left to right:
man leaning towards a semi-recumbent
woman; two groups of two figures, wrestling
(?); man holding back a rearing horse; two
seated figures; male nude with hands behind
back; draped figure with arm raised; two male
nudes wrestling; draped reclining figure
resting on elbow; figure carrying off children;
same scene repeated (?); reclining figure
resting on elbow; two men wrestling; woman
and child (twice) Graphite, pen and brown ink
on sheets of paper pasted to a support,
26.2 × 33.8 cm
Various inscriptions in pen and brown ink:
'bon'; 'Christ'; 'Bacchanale'; 'soldat blessé';
'profil'
Part of Album II, broken up in March 1930

Musée Rodin (D297–307)

This sheet of studies bears witness to the
extreme complexity of Rodin's art. At first
sight, it seems quite natural that the artist
should want to bring his drawings together by
pasting them on to a sheet of paper. If we look
more closely, we see that the pencil or pen
lines extend on to the support, and that they
were added after the sketches had been
mounted, in order to modify or to emphasize
the meaning of the original drawings. Still
closer examination shows that the standing
figure (D305) has been cut out and mounted
on top of a collage. Tradition has it that these
sketches date from Rodin's visit to Rome
early in 1876. The influence of Michelangelo is
present throughout, but the impetus it gives
to Rodin's inventiveness means that these are
more than copies. D301 is reminiscent of one

of the *Captives*. D304, 305 and 306 will be
recognized as reproducing the attitude of the
Apollo in the Bargello Museum, Florence. The
artist's pencil suddenly transforms D304 into
Bartholdi's *Liberté éclairant le monde;* although
the statue in New York does not have the
same twisting movement, the torch, the
crown and even the pedestal are unmistakable.
Did Rodin see the reduced-scale model of
Liberté at the Exposition Universelle (1878),
or did he see it at the inaugural ceremony in
1886? Rodin was corresponding with Barthol-
di in 1888 (Musée Rodin Archives). Whatever
the truth of the matter, the similarity means
that the dates normally ascribed to drawings
of this sort cannot be accepted without ques-
tion. D298 and 304 may represent a detail
from Vicenzo di Rossi's *Tomb of Angelo Cesi,*
which Rodin saw in Santa Maria della Pace in
Rome; Kirk Varnedoe *(Rodin Rediscovered,*
National Gallery of Art, Washington D.C.,
1981, p. 163) has identified the same detail in
another drawing (D264–273). D300 relates
either to Guillaume Coustou's *Chevaux de
Marly,* which Rodin may have drawn in the
Place de la Concorde, Paris, or to Géricault's
painting *Course des chevaux libres à Rome*
(Musée du Louvre). Rodin's interpretations of
other works always raise difficulties, no
matter whether they are well known or un-
familiar. Does D303, for instance, represent
Niobe or Ugolino?

4 *pl. 38*

Springtime *(Le Printemps)* *c.* 1878

Black chalk, 44 × 27 cm

The Art Institute of Chicago, Margaret Day
Blake Collection (1984.99 RX 14417/1)

The drawing, previously in the collection of
Hugo Perls, is similar to two drawings, *Young
mother playing with her child* (annotated 'project
de marbre', 1878) and the *Golden Age* (owned
by the Metropolitan Museum of Art). Most
historians have associated these delicately
modelled drawings with Rodin's work for
Carrier-Belleuse, which continued after his
return from Brussels, in the spring of 1877,
and probably included projects associated
with the older man's post as Director of Art at
Sèvres which he assumed in December 1875.
Carrier-Belleuse recommended Rodin in June
1879 to the Commission Municipale des
Beaux-Arts for work on the Hôtel de Ville
where he made a statue of Alembert in early
1880.[1]

The vital link between this drawing, Car-
rier-Belleuse's *Angelica* and Rodin's torsoes
with arched backs is discussed on p.20. The
drawing was shown at the Burlington Fine
Arts Club, London in 1917.

1. *Correspondance de Rodin,* I: *1860–1899,* Paris, 1985, no.
26.

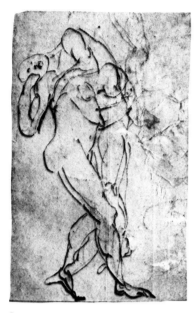

5

5

Virgil supporting Dante on his shoulders

Graphite and pen on card, 7.7 × 4.8 cm

Szépmüvészeti Muzeum, Budapest (1935–2771)

This tiny, worn drawing suggests Michelangelo's scene of the Universal Flood on the Sistine Chapel with an old man and young man fainted now recalled as possibly Dante and Virgil pressed close against each other. It is also like Goupil, pl.30, *Démon emportant un ombre*.

1. The drawing was reproduced in Claudie Judrin, *Dante et Virgile aux Enfers*, III, Musée Rodin, Paris, 1984, p.14.

6 *pl. 80*

Eve and the serpent

Graphite, black ink, grey wash on card, 13.9 × 9.5 cm

Szépmüvészeti Muzeum, Budapest (1935–2772)

The theme of a female and serpent or that of Leda and the swan is familiar in Rodin's art and in what he copied from museums. The humorous and erotic contrast of the statue-like Eve (whose pose is not that of Rodin's famous sculpture) and the lusty embrace of the serpent resurfaces in late drawings like *Reclining woman with one hand between her legs beside a bird* (D5046). The enhancement of a sense of space by the snakey line corresponds to the use of rope in the *Burghers of Calais*; typically Rodin's drawing anticipates the translation to three dimensions.

7 *pl. 15*

Two men embracing

Graphite, brown and black ink and sepia wash on graph paper, 17.3 × 8.7 cm

Szépmüvészeti Muzeum, Budapest (1935–2770)

The strips of wash laid over this *écorché* drawing increases the sepulchral quality and the affinity with bas-relief. Claudie Judrin has commented that couples, like this one, which because of their embrace we take to be lovers most often are for Rodin images of Dante and his master, Virgil.[1]

1. Judrin, *Dante et Virgile aux Enfers*, p.23.

8 *pl. 17*

Man with arms raised

Graphite, pen and grey wash, 13.5 × 5.1 cm

Szépmüvészeti Muzeum, Budapest (1935–2765)

The pose suggests a martyr or other religious subject (possibly Bertrand de Born). It is significant that Rodin kept such tiny scraps of early drawings and that they were of interest to discerning collectors. Early drawings entered the collections of Octave Mirbeau, Roger Marx and Henry Liouville during the eighties and at later dates those of Agnes Ernst Meyer, William Rothenstein and Paul de Majovszky.

9

Virgil supporting Dante

Graphite, brown ink and wash on lined paper, 18.8 × 10.3 cm
Inscribed: 'Virgile soutient le Dante lui reproche sa faiblesse la collin[e] bien lui [?].

Szépmüvészeti Muzeum, Budapest (1935–2766)

Claudie Judrin has pointed out the similarity between this group and passages in Canto XXIV of the *Inferno*.[1] For example Virgil tells Dante to rouse himself and earn immortality through hard work:

Therefore get up: control your breathlessness
By force of mind, which wins in every battle
If with its heavy body it does not sink.

You have much longer stairs to climb than these;
It is not enough to leave this lot behind;
If you have understood me, act accordingly.[2]

Rodin often seems to be addressing himself in these drawings, made during the period when he felt neglected and isolated. In the reproduction of this drawing in *Revue des Beaux-Arts et des Lettres* (1 January 1899) bands of heavy wash along one side of the figures were added, a technique indicating the area in shade common to works of the period (for

example to the sketches of figures, Budapest 1935–2773 and 2774). The declamatory, raised right arm is also repeated.

1. Judrin, *Dante et Virgile aux Enfers*, p.16.
2. Dante, *The Divine Comedy*, trans. C.H. Sisson, London, 1981, pp.142–3.

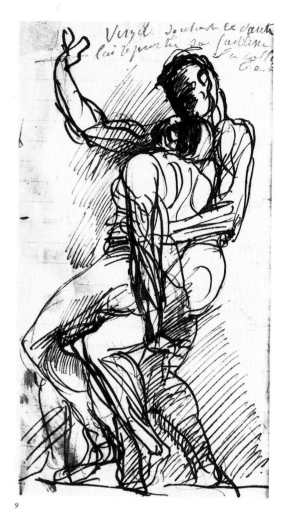

9

10

Dante throws himself into Virgil's arms

Graphite, pen and brown ink on lined paper, torn at both right-hand corners, 14.2 × 10 cm
Inscribed in pen and brown ink, top, left, and to the side: 'Caverne—Dante à la vue de la vallée [se] jette dans les bras de Virgile'; bottom: 'caverne [?]
Verso: three figures dancing in a circle; graphite

Musée Rodin (D1922)

At first sight this drawing appears to represent Paolo Malatesta and Francesca da Rimini, the couple Dante meets in Canto V of *The Inferno* and whom Rodin made famous with his group *The Kiss* (cf. cat. no. 68); even the pedestal of the group can be seen. But the indeterminate gender of the figures, and the

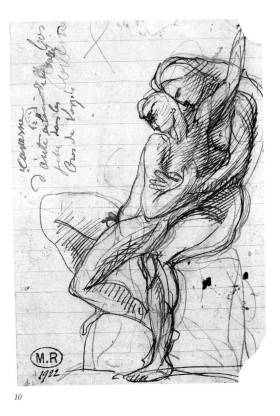

10

inscriptions in Rodin's own hand, suggest other passages in the *Inferno* where Dante sees something frightening and takes refuge in Virgil's arms. Given that he saw so many fearful sights during his long descent into Hell, precisely which episode is portrayed here is a matter for speculation. The drawing is also noteworthy for the extreme tenderness of the poses which Rodin lends his imaginary models.

11 *pl. 16*

Two figures

Pencil, pen and wash on lined paper,
17.3 × 9.7 cm

Trustees of the British Museum (1905–4–12–2)

The emphatic contour lines and swift modelling by parallel lines, as well as the more volumetric look of the bodies, suggests an artist in daily contact with models. The similarity between this drawing and that annotated 'adoration' in the Fogg Art Museum (1943.911), which has a tiny sketch of the *Gates of Hell* in the left corner with the drawing situated in the right tympanum, suggests a date for both of about 1881. *Adoration* reminds us of how preoccupied Rodin was with situating his figure groups on the portal in its early period.[1] The inscription 'ecoinson' on D2053, *Group de damnés suspendus par les bras* (Goupil, pl.157) and *Femme et enfant* (Goupil, pl.208, in *Sale of Roger Marx,*

Tableaux, Sculptures, Galerie Manzi, Joyant, 11 and 12 May 1912) all consider locations for the sketches in the *Gates*. This drawing was once owned by Claude Phillips.

1. *Adoration,* Fogg Art Museum, Grenville L. Winthrop Bequest pl.98.

12 *pl. 23*

Seated man slumped against a table, with child leaning on the table

Pen and red ink on the reverse of a sheet of photographic paper, 8.9 × 10 cm

Musée Rodin (D5427)

13 *not illustrated*

Group of figures

Graphite heightened with pen and ink,
18.7 × 13.7 cm

Annotated: 'Dante Virgile une ombre embrasse les genoux quand . . . reverra les plaines . . . Ulysse embrasse les genoux de la po . . .'

Museum der bildenden Künste, Leipzig (I.4962)

This drawing and that on the verso are in the knotty ecorché style associated with drawing of the 1870s when the constricted man seen in profile dominated his work. As Claudie Judrin has recorded the drawing was sent to the journal Pan for its November 1897–April 1898 issue (p.190) at the request of the painter Carl Koepping who kept the drawing and sent his own etchings in return. Judrin suggests that the annotation refers to Canto XXVI where Odysseus tells Virgil of his betrayal of his companions at sea.

1. Claudie Judrin, in *Auguste Rodin. Drawings and Watercolours,* Westfähisches Landesmuseum für Kunst and Kulhurgeschichte, Münster, 1984, and London, 1985, pp.327–8.

Sculptures: terracottas and plasters from the 1870s(?)

14 *pl. 39*

Maternal Tenderness *c.*1873

Terracotta, 15.4 × 16.4 × 12 cm

Musée Rodin (S818)

Formerly in the Collection Charles Morice. Gift to the Museum *c.*1930

This terracotta dates from Rodin's stay in Brussels, and was given to the critic Charles Morice by the sculptor. Most of Rodin's works from this period depict scenes with children or Cupids, and his style still reflects the aesthetics of the eighteenth century.

15 *pl. 106*

Sleep

Plaster, 40.2 × 41.8 × 30.2 cm

Musée Rodin (S1822)

This charming figure of a sleeping young woman may be a study for the marble executed in *c.*1889. Rodin returned to the same theme in 1911. In all three sculptures the head rests on the left hand and the hair hangs down on the same side. In the marble versions, the figure seems to be emerging from the block of stone, but the composition of this plaster is much clearer. The lines of the face and of the half-open mouth are cleaner, and we can see once again that Rodin worked on the figure as though it were an assemblage, adding a hand and elements of foliage to the bust. The presence of an apple suggests that the figure might be Eve.

16 *pl. 105*

Faun and Nymph

Terracotta, 35 × 43 × 29 cm

Musée Rodin (S363)

Formerly Fenaille Collection. Gift to the Museum 1958

This terracotta is known also as *Female Faun and Satyr,* and, stylistically, it is still reminiscent of the eighteenth century. Albert Elsen dates it 1886 and compares it with the silhouette of the young woman in *Desinvolture* (cat. no. 85). Although it belongs to the group of figures executed for the Bacchanalian theme of the *Gates of Hell,* it has to be seen as a complete work intended for a client, probably for Maurice Fenaille, who once owned it.

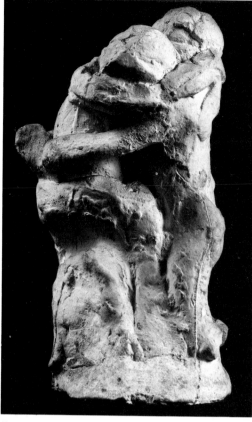

18

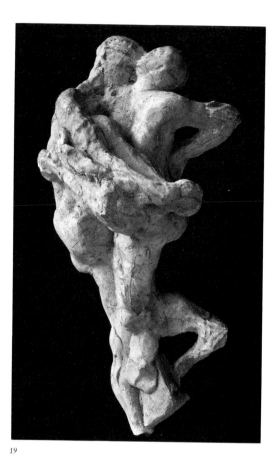

19

work in the same consignment had figures composed and executed by Rodin's friend Taxile Doat. Both were probably conceived several years previously, perhaps prior to 1879 when Rodin officially joined the staff at Sèvres.

Rodin's contribution to this vase is obvious in the curled-up siren or demi-god; the pose is characteristic, as is the sensitive modelling of the back. There is also a seated *amorino* between the neck and the spout, a lion mask below the spout and, on the base, four snails.

1. Records of the Victoria and Albert Museum.

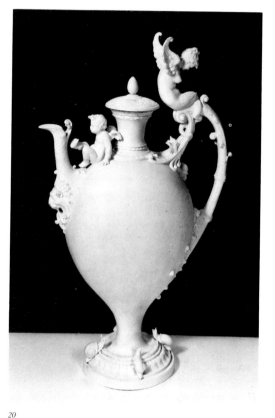

20

17 *pl. 107*

Torso of a young girl with a serpent

Plaster, 34 × 12.1 × 14.3 cm

Musée Rodin (S2118)

There is also a complete figure of a girl lying on her back, with her legs tucked under her and with her arms folded across her breast. It is a model for the body of Eve in the marble *Adam and Eve* (also known as *Adam and Eve Sleeping*), which was executed in *c*.1884. Rodin subsequently cast the bust separately. The plaster seen here is one of a number of examples, and is mounted on a cuboid plaster base. It was presumably intended to be shown in this manner.

18

The Embrace

Plaster, 9.5 × 4.9 × 4.1 cm

Musée Rodin (S5691)

Rodin's studio still contains several sketches of this unusual size. Their limbs consist of small rolls of plaster. Albert Elsen believes that these embracing figures may have been executed in the 1870s and suggests that they may relate to *The Kiss*.

19

The Embrace (or *L'Emprise*)

Plaster, 21.5 × 11.8 × 10.5 cm

Musée Rodin (S696)

This composition is in fact an assemblage of two closely intertwined figures. One of them is the Polyphemus from the *Gates of Hell* and was definitely executed after that work.

Ceramics and the manufactory at Sèvres

20

Vase with Cover 1884

Porcelain, 41 cm high
Signed: A. Carrier-Belleuse

Trustees of the Victoria and Albert Museum (53–1885)

The consignment note of the Ministère d'Instruction Publique et des Beaux-Arts, dated 12 January 1885, which followed the acquisition of four vases from the Sèvres manufactory by the South Kensington Museum described this heart-shaped vessel, no. 669, as 'bisçuit de porcelaine nouvelle, buire de blois, modelled by M. Carrier-Belleuse. Sculpture executée par Mssrs Rodin et Roger.' 'Another

21 *pl. 35*

Vase des Titans *c*.1876–78

Lead-glazed earthenware, 36.8 × 30.5 cm
Inscribed: 'Carrier-Belleuse' around the base

Trustees of the Victoria and Albert Museum (C.44–1970)

22

The Titans *c*.1876

Terracotta

Dimensions without base: I:0.29 m; II:0.33 m; III:0.28 m; IV:0.305 m

Bruton Gallery, Somerset

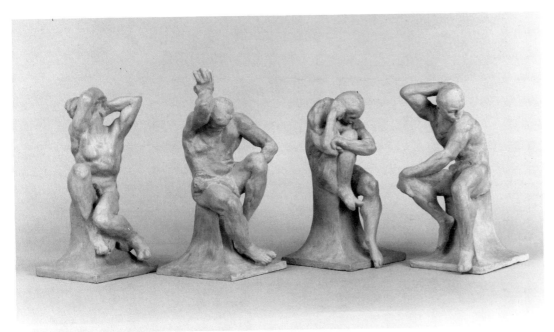

22

24

Young woman and child 1880

Small plaque in Sèvres porcelain,
12.8 × 5.7 × 1.2 cm

Musée Rodin (S2417)
Purchased from the Haviland sale, 1932

This decorative plaque is also known as *Woman holding a child*, and the chiselled contours heightened with white make it typical of the works executed at Sèvres. It was exhibited at the Cercle Volney in 1883 and was acquired shortly afterwards by Philippe Burty. It was later acquired by M. Charles Haviland, who lent it to the Musée Galliéra for the 1907 exhibition of porcelain. It was acquired by the Musée Rodin at the Georges Haviland sale in 1932.

24

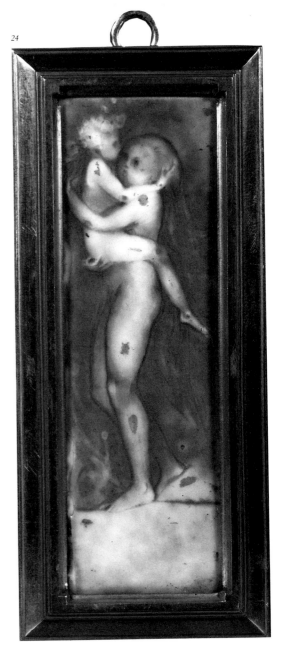

23

Reclining Titan

Bronze 28.2 × 15.5 × 30.5 cm

The Josefowitz Collection

The vase and individual Titans have received a good deal of scholarly attention because they seem to indicate the effect on Rodin of direct exposure to the work of Michelangelo during his visit to Italy in 1875–76. The positioning of the *Reclining Titan* especially recalls directly the figures of *Night* and *Day,* while the upright Titans have the deeply concave abdomen and compressed force of the *Ignudi* on the Sistine ceiling.

The scheme for the vase was probably conceived by Carrier-Belleuse who drew elegant, athletic figures supporting a *jardinière* mounted on a column (thus this vase would represent the middle section). Rodin's contribution is seen in the freshness and feeling achieved in the handling of the tiny lumps of clay which take liberties with conventional musculature. Moreover, these Titans are intensely sexual: their legs grind together and they seem as tormented and proud as Rodin's imagined inhabitants of the Inferno who filled his notebooks during the same period.

After cleaning the Bruton Gallery figures, John Larson discovered that they are cast terracotta from 12– to 15–piece press-moulds. The bases are not integral (here plaster) which suggests that the figures were modelled separately and attached to various bases, including the lumpy clay ones of the Maryhill Museum of Art (Washington State) and Houston variants. Given their association with Carrier-Belleuse's highly commercial workshop with its industrial techniques, it is not surprising that the question of the number and chronology of the Titans has been impossible to establish. The bronze *Reclining Titan* may have been an afterthought by Rodin (or one of his assistants) or perhaps cast as a favour to a friend.

1. Albert Alhadeff, 'Michelangelo and The Early Rodin', *Art Bulletin,* XLV, 1963. p.366, who notes the trend of artists in the 1870s to associate themselves with the Renaissance artists, specifically Carrier-Belleuse's desire to be compared with Michelangelo.
2. H.W. Janson, 'Rodin and Carrier-Belleuse: The Vase des Titans', *Art Bulletin,* L, September 1968, pp.278–80.
3. 'Carrier-Belleuse. A technical study of his terracotta sculpture by John Larson', *French Sculpture 1780–1940*, Bruton Gallery Limited, Bruton, Somerset, 14 November 1981–2 January 1982.

23

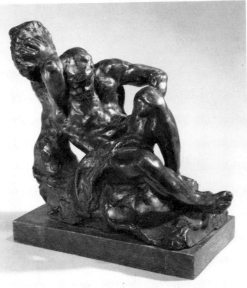

25 *pls. 48, 149*

Vase de Saigon 1880

Sèvres porcelain, 24.5 × 13.5 cm
Probably one of six copies made by Léon
Rigolet at the Manufacture Nationale de
Sèvres in 1935 (Modèle I).

The Josefowitz Collection

The pale green vase is dated by Roger Marx to
October 1880 and is illustrated by him with
two views identified as "Les Limbes et Les
Syrènes', Plate XVII, and ascribed to Rodin
and Desbois.[1]

The extraordinarily life-like quality of the
delicate low-relief modelling contrasts with
the more abrupt contour drawing of the same
date. The scene of the seated old woman and
kneeling girl was transferred to the lower left
pilaster of the *Gates* whereas the siren became
the free-standing *Kneeling Fauness* on the tym-
panum. The phallic overtones of the horizon-
tal scenes, along with their aquatic context
and siren and sea-monsters entwined and
embedded in sea-weed suggest not only the
eroticism of drawings like *Eve and the serpent*
(cat. no. 6) and the landscape of the *Gates,* but
reappear in late drawings with pooled washes
(e.g. cat. no. 231).

1. Roger Marx, Auguste Rodin: Céramiste, *Paris, 1907,
P. 43.*

26 *pl. 47*

La Nuit 1881–82

Porcelain, 31.6 × 22.5 cm
Signed: 'A. Rodin', engraved on the design.

Musée Rodin (S2416)

Rodin was invited to work at the Manufacture
de Sèvres by Carrier-Belleuse in 1879, and
between then and 1882 he executed a number
of ceramics. He decorated ready-made ob-
jects—in this case a *'seau de Pompéi'*—with
clouds of Cupids, female nudes and centaurs,
etching the silhouettes into the paste and
heightening the volumes with white in a
manner that recalls his gouache drawings.
This vase, which was originally known as *A
Midsummer Night's Dream,* has a companion-
piece known as *Le Jour* (cat. no. 27). One of
the figures on the side is a woman surrounded
by Cupids; Rodin used the same figure in the
drypoint *Springtime.*

The vase was damaged during firing, and
was therefore returned to Rodin in 1885. In
1907, he lent it to the Musée Galliéra for the
porcelain exhibition.

27 *pl. 45*

Le Jour 1881–82

Porcelain, 32 cm high

Musée national de Céramique, Sèvres

One of the most ambitious, and decoratively
complex of Rodin's vases, *Le Jour,* described
as a 'vase de Pompeii' is in the tradition of the
representation of pagan life favoured in the
eighteenth century. Roger Marx associated
the depiction of evenings given over 'to
material caresses' and 'enlaced lovers' with the
fête galantes of Watteau.[1]

Despite Rodin's technical mastery and the
beauty of his modelling his ceramic work was
not highly rated either by the administrator at
Sèvres, M. Lauth, nor by critics.[2] The brown
foundation was achieved by mixing the white
paste with nickel oxide.

1. Marx, *Auguste Rodin: Céramiste*, pp.26–7.
2. Marx, *Auguste Rodin: Céramiste*, pp.32–8.

Black gouaches: scenes from
Dante, Ugolino cycle, centaurs

PARENT AND CHILD

28 *pl. 52*

Seated woman with two children

Pen and black ink, grey wash touched with
white and green on tan paper, 14.5 × 10 cm
Dedicated: 'A. Bigand' (?)

Musée du Louvre, Département des Arts
Graphiques, Paris (RF30.146)

Rodin dedicated this drawing in 1897 to his
good friend Edmond Bigand-Kaire, the
expert mariner who not only supplied him
with wine from 1889 onwards but also with
antique art, like the figures from Smyrne,
brought back from his travels.[1] In the summer
of 1897 Rodin exchanged several drawings
(which were reproduced in the Goupil album)
with Bigand for a book of Persian miniatures
and other objects. Bigand once owned the
similar drawing of three figures (D6899).

1. *Correspondance*, I, nos. 253 and 256.

29

Madonna

Graphite, pen-and-ink wash heightened with
gouache pasted to decorative headed note-
paper from a textile firm, 15.5 × 10 cm

Bibliothèque Nationale, Paris (D.033.31)

The extended arm of the seated figure is like
that annotated 'Niobe' (D3782–3784), also on
ornamented paper and with a similar drawing
on the verso both with a loose, scraped
handling of the wet medium. In several draw-

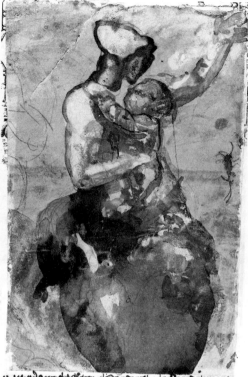

29

ings Rodin adds layers and a horizon line or
distant tree to lend a narrative air of departure
in the Romantic sense. In a similar drawing,
Shade of a woman and child, (D5603), on paper
of the same textile house—Maison Maingot et
Caron, patronized by Rose Beuret—the child
stands and the woman's head is bowed as if in
a scene of the Virgin and child. In another,
Femme tenant un enfant dans ses bras, the woman
looks to her right while the child kneels.[1]
Juxtaposed, the drawings seem almost cin-
ematographically sequential.

1. Sale of the collection of Octave Mirbeau, Galerie
Durand-Ruel, 24 February 1919, no. 40.

30 *pl. 54*

Charity

Pen and gouache on buff, lined paper,
12 × 11.1 cm

Lent by the Syndics of the Fitzwilliam
Museum, Cambridge. From the collection of
Charles Ricketts, R.A. and Charles Shannon,
R.A. (2146)

The underdrawing suggests a male figure,
head bent, who became female when the
gouache was added. The basic contour with
muscular shoulders and a projecting left
elbow appears in several drawings associated
with the Ugolino story, including *Ugolino*
(D5614) (Goupil pl.67). The children, who
change position, appear in *Man and Woman*
(Goupil pl.112) and in the drawing identified
by Maillard with the 'first day' of Ugolino's

torture.[1] Claudie Judrin, who has made an extensive study of the drawings by Rodin related to this theme, has pointed out that in several of those associated with the story nothing seems overtly tragic, and that they are similar to the studies of motherhood from the same period.[2] But the gathering-in of the two boys is especially associated with the sinister overtones; Judrin writes: 'We see a father whose eyes are turned away from his son to avoid reading in them his own distress. The very impotence of Ugolino is a source of despair.' Related drawings sometimes have as notations 'Niobe' and 'Medea', other distressed parents familiar in mythology.

This is one of the most beautiful drawings in the series; Rodin lets the gouache and ink carve form and the eye move between the spheres, visually compacted by the boundary line registered against the new support.

1. Léon Maillard, *Auguste Rodin, statuaire: Etudes sur quelques artistes originaux*, Paris, 1898, p.31.
2. See Claudie Judrin in *Rodin Rediscovered*, National Gallery of Art, Washington D.C., 1981, p.194 and rest of essay; and in *Ugolin*, II, Musée Rodin, Paris, 1983. The list of related studies steadily increases as they are compared through reproductions, in the inventories and new acquisitions by the Musée Rodin.
3. This drawing was possibly catalogued by the Carfax Gallery, 1900, as 'Trois pâques' (no. 1, which sold) or more likely 'Vierge et enfant' (nos. 16 and 22) or 'Ugolin and Niobe' (no. 8).

31 pl. 53

Mother and children c.1880

Pen and brown ink, graphite, white and grey gouache on tan paper, 18 × 13 cm

Rodin Museum, administered by the Philadelphia Museum of Art. Gift of Jules E. Mastbaum (F'29–7–168)

One of a few undeniably benign scenes of maternal love, the original has ochre and warm grey tones which go to blue-grey in the reproduction in the Goupil album (not an uncommon difference).[1] Behind the figure group in the upper left corner is a line drawing of the constricted-man associated with themes from Dante, reminding us that the notebooks of this period mixed themes and sentiments and that the overlaid ink and wash often softened the impact as well as adding volume.

1. Goupil, pl.93.

32 pl. 51

Seated figure holding a child, with a second child on her shoulder

Pen, brown ink wash and gouache on brown paper, 14 × 13.1 cm

Musée Rodin (D5601)

This drawing dates from the 1880s, and is unusual in that the figure, which is presumably a woman, appears to be undergoing a metamorphosis. The long hair on the thighs and the cloven hoof transform the figure into a female faun. It is to be noted that Rodin was increasingly drawn to mythological themes, and that Ovid gradually replaced Dante as a source of inspiration.

33 pl. 55

Woman kneeling and clasping two children to her

Graphite, pen, brown and grey washes with gouache on a sheet of paper pasted to a second sheet mounted on card, 10.1 × 15.5 cm
Signed in graphite, upper left: '*Aug. Rodin*'

Musée Rodin (D3785)

In the 1880s, Rodin frequently returned to the theme of a mother embracing her children. He often saw the theme as illustrating the legends of Medea and Niobe. The sex of the figures is uncertain, and they have been confused with Ugolino and his sons as they embrace in despair.

Unfortunately, the sheet of paper has been pasted to the centre of a gilt-edged support. The fragment of newspaper is dated 1910, which suggests that the gilt edging was added when the drawing was mounted.

34 pl. 56

Seated figure with child

Graphite, pen on graph paper, 15.3 × 8.5 cm

Szépmüvészeti Muzeum, Budapest (1935–2769)

This drawing has been associated in its present collection with the studies of Ugolino and his sons. It is typical of the pencil studies reworked to simplify the contour lines, giving them more emphasis and information pertinent to sculpture. The drawing on the verso is in the cruder *écorché* style, probably not later than the mid-1870s.

All the drawings from the Szépmüvészeti Muzeum, Budapest were formerly in the collection of Paul de Majovszky (1871–1935), a businessman who bequeathed his superb collection of drawings that included English works from Thomas Gainsborough to Frank Brangwyn but is known for its French nineteenth-century works, especially for drawings by Delacroix, Millet and Renoir. The collection was catalogued and some works illustrated in 1959 by Denes Pataky.

35 pl. 7

Ugolino

Graphite, pen, brown and red ink, grey wash heightened with gouache on horizontally-lined cream paper, torn, bottom left, 17.3 × 13.7 cm
Inscribed with pen and brown ink, upper right: 'Ugolin'
Signed in pen and brown ink, lower right: 'Aug. Rodin'

Musée Rodin (D7627)

The drawing shows Ugolino (cf. cat. no. 36) on the second day of his imprisonment, as he laments:

'I gnawed at both my hands for misery;
And they [my sons] who thought it was for hunger plain
And simple, rose at once and said to me:

'O Father, it will give us much less pain
If thou wilt feed on us...'

Rodin used the image of Ugolino crawling forward to devour the corpses of his sons as a motif for his sculpture, the *Gates of Hell*.

36 pl. 64

Ugolino in his prison

Graphite, pen and black ink, brown wash heightened with gouache on beige paper, mounted centrally on card, 14.8 × 10.5 cm
Signed in pen and black ink, lower right: 'Aug. Rodin'

Musée Rodin (D7208)
Acquired by right of pre-emption when the Marcel Guérin collection was sold at the Hôtel Drouot on Wednesday 29 October 1975

Dante meets Ugolino in Canto XXXIII of the *Inferno*. The thirteenth-century Italian count was accused of treason, imprisoned together with his sons in a tower in Pisa and left to die of hunger. Here, we see him on the fourth day of his torments. He holds his son Gaddo, who is about to die, on his knees, as the mother of Christ holds her son. For once, a drawing can be related to the lower right-hand panel of the plaster cast for the third model for the *Gates of Hell*. The drawing appears to be a preparatory study for the sculpture.

The gouache heightening brings out the livid appearance of the bodies. The powerful musculature gives a feeling of strength, and the dramatic chiaroscura lighting makes Ugolino's impotence in the face of death even more pathetic. The drawing was published in the Goupil album in 1897, and it situates Rodin in the great sculptural tradition of Michelangelo.

Satyr and nymph c.1883

Pen and black and brown ink, brown wash
and white gouache on dark tan paper,
12.2 × 8.9 cm

Rodin Museum, administered by the
Philadelphia Museum of Art. Gift of Jules
Mastbaum (F'29.7.167) (Goupil, pl.128)

The satyr initially looked to his right; re-
drawn, he faces left in a manner similar to the
horrific, screaming Ugolino in D5624
(Goupil, pl.74) which uses the same swift
angular strokes of a wide-nib pen and flashes
of brilliant light. These qualities, like the
thrusting diagonals, link Rodin's art to
Romantic painting, but, as Mauclair and
others have pointed out, the reduction of
interior details and the strong silhouette pre-
pares for the translation to three dimensions.[1]
The nymph has the slippery look of the
drawing *Virgile portant Dante evanoui*, which
Claudie Judrin has suggested may be that
described by Edmond Jacques (alias Bazire) in
his review of the exhibition at Arts libéraux
early in 1883. Certainly this work and the
Satyr and nymph correspond so closely to
Ugolino in his prison (cat. no. 36) that they
seem to be directly associated with the *Gates*,
so must be from the period 1880–82. More-
over, the slinky, elongated figure type is used
on the left pilaster in *Centaure cabré* and in the
couple nestled next to his haunches.

On the verso there is a drawing of a
standing man, nearly identical to the man in
Adoration (Fogg Art Museum) and a seated
man with a child on his lap, very likely an idea
for the Ugolino and sons group begun c.1880.

1. Camille Mauclair, 'L' art de Rodin', *Revue des revues*,
 15 June 1898, pl.606. See discussion in Claudie Judrin,
 Ugolin, II, Musée Rodin, Paris, 1983, p.48.

38

Ugolino 1882

Plaster, 43 × 36 × 36 cm

Musée Rodin (S460)

The subject for this plaster derives from
Dante's *Divine Comedy* often turned to it for
inspiration. The Pisan tyrant who was walled
up alive with his children and reduced to
eating them before finally dying of hunger
had already been portrayed by earlier nine-
teenth-century sculptors, notably by Car-
peaux. Unlike his predecessors, Rodin depicts
Ugolino on all fours, as though he had
regressed to being an animal, and the signs of
madness are clearly visible on his face. We
know that Pignatelli posed for the figure.

The sculpture appears almost unchanged in
the left-hand panel of the *Gates of Hell*, and
Rodin produced a number of variations on it;
the variation without the children is known as
Nuchodonosor. The small group was also once
known as *La Bête Humaine*. In 1889, Rodin

38

began to make bronze casts of *Ugolino*, and in
1907 an enlargement (140 cm) was commis-
sioned by the state. Mention should also be
made of the large plaster group executed with
the collaboration of Lebossé, although it is in
fact an assemblage rather than remodelled.
The various fragments were enlarged one by
one and are connected to the ground by means
of drapery; the heads were attached to the
bodies without any concern for anatomical
accuracy. The head of one of Ugolino's sons
was used for *La Tête de la douleur (Melancholy)*,
and a photograph taken in 1906 shows Lebos-
sé attempting to attach it to the body. It was
later replaced by a head from *Whistler's Muse*.

CENTAUR

39 *pl. 62*

Achilles and Cheiron

Pencil, black chalk, brown wash, heightened
with white on cream graph paper,
11.6 × 12.6 cm

Lent by the Syndics of the Fitzwilliam
Museum, Cambridge. From the collection of
Charles Ricketts, R.A. and Charles Shannon,
R.A. (2144)

There are a number of Rodin drawings which
can be specifically associated with the educa-
tion of Achilles by the centaur Cheiron, but
they involve an athletic young man. This
drawing is quite likely that entitled 'Centaure
et femme par terre' (no.5) in the exhibition at
the Carfax Gallery, London in January/Febru-
ary 1900.[1] The drawings were brought to
England by William Rothenstein and this one
sold for £8. Shannon told Rodin in a letter of
18 January 1904 that he already owned two
beautiful drawings.

The delicate addition of wash and the curled
form is common to Rodin's work as a de-
corator and appears on drawings of caryatids;
but it also anticipates the effect of the glaze on
the Sèvres vases, for example similar scenes
on *La Nuit*. Rodin began to make tiny draw-
ings of centaurs and horses running as a youth
and continued to do so in the 1870s.[2]

1. Catalogue of Carfax Gallery and letters from W.
 Williams to Rodin 28 February and 5 April 1900,
 Musée Rodin Archives.
2. Claudie Judrin, *Les Centaures*, I, Musée Rodin, Paris,
 1981–82, and Goupil, pl. 80.

40 *pl. 25*

Woman being carried off by a centaur

Graphite, pen and brown ink, with brown
wash, on lined paper, torn towards the top,
10.2 × 11.6 cm
Verso: paper rubbed with graphite

Musée Rodin (D3860)

Centaurs were one of Rodin's favourite
themes, and he saw them through the eyes of
Ovid (*Metamorphoses*) or those of Dante (*Infer-
no*, Canto XII). It is the abduction that inter-
ests him rather than the subsequent battle.
The drawing may represent Nessus carrying
off Deïanira, although it is difficult to be
certain. The swirling movement and the rapid
pen-strokes do, however, give the impression
of a woman being carried off.

41

**Dante and Virgil riding a chimerical
horse**

Graphite, pen and brown ink wash on paper
pasted to a support, 16.4 × 12.7 m
Inscribed in pen and brown ink on the bottom
of the support: 'Dante et virgile—le cheval
plus chimérique—Pégase'

Musée Rodin (D3769)

In Canto XVII of the *Inferno*, Dante has to
mount the monster Geryon in order to de-
scend to the circle of Fraud. Virgil sits behind
him to protect him from the whiplash tail.
During the Middle Ages, the chimera sym-
bolized the king of the Balearics, who wel-
comed strangers with a smile and then put
them to death. The allusion to the mythologi-
cal hero Perseus and his mount Pegasus does
not appear to derive from Dante. The draw-
ing was published in facsimile in the Goupil
album in 1897 (pl.44).

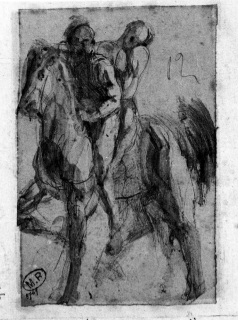

41

42 *pl. 63*

Centaur carrying away a young man

Pen, pencil, gouache, 16.2 × 14 cm

Ny Carlsberg Glyptotek, Copenhagen

This gouache is one of the beautiful series of centaurs in flight, their victims on the pillion. Others include the one illustrated in Maillard[1] and one called *Centaur and child*, (Goupil, pl.23). In both the Ugolino and the centaur series Rodin's sensitivity to the nuances between couples of different ages and scales becomes poignantly obvious, as does his debt to Delacroix and Géricault for a sense of weightiness divorced from gravity. The abduction by centaurs of childish figures, like this one, is more common than that of a fully developed woman, as found in *La force et la ruse* (Goupil, pl.43).

1. Maillard, p.29.

43 *pl. 71*

Centaur carrying a woman

Pen and brown ink, graphite, and white gouache on tan paper, 36.5 × 39 cm
Annotated: 'l'aube retour du sabbat'

Rodin Museum, administered by the Philadelphia Museum of Art. Gift of Jules Mastbaum (F'29–7–166)

As Victoria Thorson has noted, the inscription suggests that 'the revelers return at dawn from the feast of the Witches' Sabbath', and the female astride the horse may, like the snake, 'symbolize intercourse at the orgy of the Sabbath'.[1] It is possible that the angular

cutting-out and bands of wash on the ground took place some years after the original drawing was executed; however, the quick, overlaid ink strokes compare with those in drawings published in *L'Art* with a simulated cut-out effect.[2]

1. Victoria Thorson in *Rodin Rediscovered*, p.132.
2. *L'Art,* May, 1883.

44 *pl. 60*

Bacchanale

Plaster, 41.2 × 48 × 43.5 cm

Musée Rodin (S823)

This plaster was first seen by the public during *Les Centaures* exhibition of 1982, and combines the figures of a centauress with that of a Bacchante, a subject to which Rodin often returned. As Monique Laurent notes, the torso of the centauress is based upon *Meditation,* and it reappears in many other works such as *Constellation* and *Christ and Mary Magdalene.* The other figure uses the torso of Adèle.

45 *pls. 158, 157*

Torso of the Centauress *c.1884*

Terracotta, 21.5 × 10.3 × 7.7 cm

Musée Rodin (S990)

The Musée Rodin in Meudon owns a number of variations on this small terracotta torso, which was definitely conceived in connection with the *Gates of Hell,* at the time when Rodin was experimenting with Bacchanalia. It is immediately obvious that the torso was conceived independently of the figure with which it is usually associated: the transition between the base of the torso and the breast of the horse is somewhat confused, and the arms are obviously a later addition. The 'defects' are obvious in the plasters and in the bronzes cast from them, but they do not appear in the marble, which dates from *c.*1887.

SCENES FROM THE INFERNO

46

Shade: Seated Man

Pen, brown ink and grey wash on lined cream paper, 14.6 × 9.8 cm
Verso: two figures embracing, one seated, the other standing; graphite

Musée Rodin (D3771)

Rodin agreed to this drawing being published under the vague title *Ombre d'homme assis* in the Goupil album in 1897. The title is so imprecise that the drawing cannot be related to any specific Canto of the *Inferno,* but it is clearly inspired by Rodin's reading of Dante.

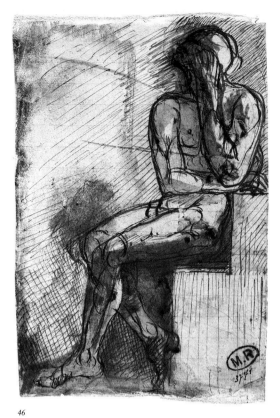

46

47 *pl. 49*

Blasphemy

Graphite, pen, black ink and brown wash on cream paper pasted to a sheet from a ledger, 16.9 × 13.9 cm
Inscribed in graphite and ink, bottom: 'ch . . . 1.bas'
Verso: figure holding a ball; graphite

Musée Rodin (D3772)

In Canto XIV of the *Inferno,* Dante describes the blasphemers, the 'Violent against God':

Great herds of naked spirits here I saw,
Who all most wretchedly bewailed their lot
.
Some on the ground lay supine in one spot,
And some upon their hunkers squatted low,
Others roamed ceaselessly and rested not.

Rodin shared the same vision, and published this drawing in the Goupil album in 1897 (pl.40).

48

Shade

Graphite, pen and brown ink on beige paper, pasted twice to centre of card support, 11.6 × 8.2 cm

Musée Rodin (D3766)

This drawing was published under the title *Ombre* in the Goupil album in 1897. Rodin himself pasted it to two different supports,

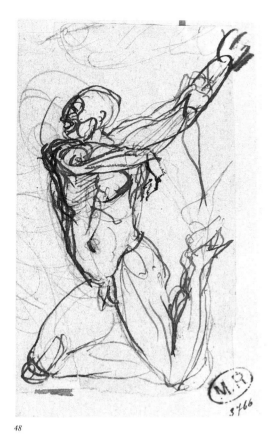

48

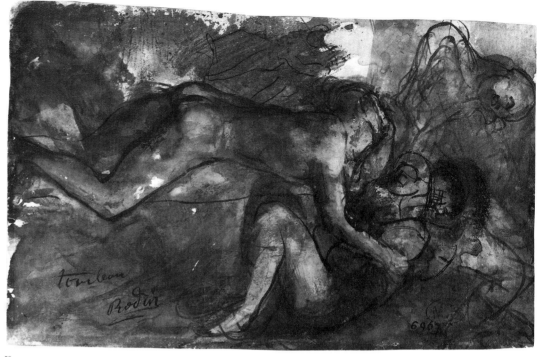

50

retouching it in pen and allowing an under-drawing to show at the edges. Rodin's cut-outs sometimes seem to restrict his vision; here the graphite lines appear to belong to a larger drawing, and he attempts to expand it by running them on to the second support. In the absence of any description, it is difficult to identify this twisted silhouette with any specific character in the *Inferno*.

49 *pl.83*

Buoso and snake

Graphite, heightened with pen and brown ink on cream paper, torn below and right, pasted to a lined support, 14 × 13.6 cm
Inscribed in pen and brown ink, above left: 'serpent Bose'; right: 'je veux que Bose'; on the support, in graphite: 'bas relief du bas'
Verso: nude figures; graphite

Musée Rodin (D1932)

In Cantos XXIX and XXV of the *Inferno*, Dante sees the thieves of Florence expiating their sins; they are punished by being attacked by snakes. Buoso, referred to as 'Bose' by Rodin, undergoes a double metamorphosis, being transformed from a snake into a man and then back into a snake. Rodin was drawn to this terrifying passage on a number of occasions, and is thinking here of using it as a theme for the original project for the *Gates of Hell*. Serpents can in fact be seen on the left-hand door of the finished version.

50

Tomb

Pen, brown wash and gouache on cream paper, 10 × 16.6 cm
Inscribed in pen, lower left: 'tombeau'
Signed in pen, lower left: 'Rodin'

Musée Rodin (D6907)
Acquired on 15 November 1931 from A. W. Leone Adolfo, Senigallia, Naples, Piazza della Borsa, 14

This project for a tomb is contemporaneous with the 'black' drawings based upon Dante's *Inferno*. If the drawing is placed vertically, it can be compared with the *Je suis belle* group of 1882. Viewed from this angle, the man is carrying the crouching woman in his out-stretched arms.

51

Mahomet with spilled entrails

Graphite, pen and brown ink wash heightened with gouache on paper mounted centrally on card, 17 × 5.2 cm
Inscribed in pen and brown ink, upper right: 'Mahomet intestins pendants'

Musée Rodin (D5633)

We are now in the circle of the sowers of discord in Canto XXVIII of Dante's *Inferno*. Here, Dante sees a man

From the chin
Down to the fart-hole split as by a cleaver . . .

I stood and stared; he saw me and stared back;

Then with his hands wrenched open his own breast,
Crying, 'See how I rend myself! what rack Mangles Mahomet!
 As in the drawing of a seated man, twisting (Goupil pl.28), Rodin has added the inscription: 'Mahomet, intestins pendants.'

52 *pl. 68*

The Shades approaching Dante and Virgil

Pencil, pen and dark sepia wash on buff paper, 18.3 × 11.7 cm

Lent by the Syndics of the Fitzwilliam Museum, Cambridge. From the collection of Charles Ricketts, R.A. and Charles Shannon, R.A. (2145)

This drawing, no. 18 in the Carfax Gallery exhibition of 1900, was one of those Rodin authorized to be sent on tour to Pittsburgh, Cincinnati and Chicago between November 1903 and March 1904, before being shown at the New Gallery, London in 1905 (no. 52).[1]
 The idea of portraying Dante and Virgil or two Shades as nearly identical was utilized by Rodin on several occasions, for example in the famous sketch, *Study for the Gates of Hell*, in the Fogg Art Museum, where the protagonists turn their heads to watch the transformation of Buoso into a reptile.[2] The sunken eyes and stressed angular contours are part of Rodin's feverish response to Dante. Although the cantos are usually misquoted, the intensity of Rodin's memory of their phrases, like incantations, conjure up images of the inhabitants of the Inferno standing or holding on precariously to the evil, vertiginous terrain

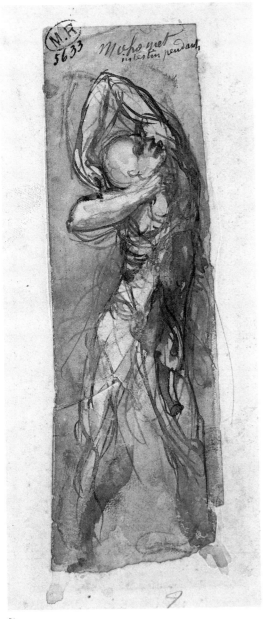

51

their depravity intimated by the carnal juxta-position.

1. The back of the drawing contains stamps identifying the drawing with the Carfax Gallery at their 17 Ryder St, St James's, address, and giving the number 320. The others listed as sold in 1900 were no. 334, the 'transformation reptile et homme'; no. 405, 'two studies of a child'; no. 333, 'trois pâques', and no. 32, the 'centaure et femme par terre' (letters of W. Williams 28 February and 5 April 1900, Musée Rodin Archives).
2. Fogg Art Museum, 1943.916.

53 *pl. 74*

Spandrel (Ecoinçon)

Graphite pen, red and brown ink, with brown wash and gouache on squared beige paper pasted to lined paper, 22.3 × 16.8 cm
Inscribed in graphite on upper part of support: 'écoinson'

Musée Rodin (D2053)

It is tempting to see these two figures, one supporting the other, as Virgil and Dante, but they could also be Daedalus and Icarus. There is, however, no evidence to prove or disprove either view. We do, however, learn from the inscription that Rodin thought of using this scene for a spandrel, perhaps for his *Gates of Hell*.

It is quite certain that the line drawing was completed before it was pasted to the support and before the application of the brown wash and the gouache. This suggests that the artist paused for thought before completing it.

54 *pl. 72*

Mask of Minos

Graphite, pen and brown wash with gouache on cream paper, cut out and pasted to card, 11 × 7.7 cm

Musée Rodin (D1933)

This *Mask of Minos* was cut out by Rodin himself, and was published in the Goupil album in 1897. Minos is an important figure in the *Inferno*, and sits as a judge alongside Rhadamantus and Aeacus. Rodin usually portrays him sitting at a table with his advisers and pronouncing sentence.

The contrast between the violent lighting of the wash and the gouache, and the light tint of the paper emphasizes the tragic appearance and stern contours of the face.

55 *pl. 73*

Masque tragique *c.1880–82*

Brown and black ink, sepia wash on lined paper, 18.8 × 12.5 cm
Annotated: 'masque tragique', 'caryatide', 'michel ange'
Szépmüvészeti Muzeum, Budapest (1935–2768)

This drawing brings together references to Rodin's work as a decorator adding small putti and grotesque images to ornamental work (like the *Vase with cover*, cat. no. 20), his fascination with Michelangelo's reclining figures *Night* and *Day* on the Medici tomb and the Florentine's humanism. His own spontaneous use of wash and ink results in a sepia and blue tonality.

The drawing was reproduced by Josef Adolf Schmoll gen. Eisenwerth, *Der Torso als Symbol und Form*, Baden-Baden, 1954, p.129. The Goupil album reproduces several masks with an Aegean aspect (e.g. pls. 14 and 81).

56 *pl. 19*

The Cruel Repast (*Ugolino devouring the head of Archbishop Ruggieri*) *c. 1875–80*

Pencil and pen on paper with brown ink, 15.9 × 20.6 cm
Annotated: 'Guidon', 'Ugolin', 'Victor Hugo', 'Dante', 'Virgile'

Philadelphia Museum of Art. Gift of Jules E. Mastbaum (F.29-7-163)

The scene depicted is central to the Ugolino story: the hero takes revenge on Archbishop Ruggieri by devouring his corpse (*Inferno*, XXXII, vv. 124ff.). The Guidon reference indicates the story of Count Guido da Montefeltro, and Victor Hugo was simply one of Rodin's heroes, whose bust or memorial work he hoped to execute. The format with reclining figure flanked by bracket figures and a back row was established, as Kirk Varnedoe has demonstrated, with the studies in the Louvre of entombments.[1] The two figures with folded arms at the back reappear, drawn in summary form in the panel indicated, in one of the architectural sketches for the *Gates*, D1969, second down on the left, suggesting that this line sketch was actively being considered for adaptation in three-dimensions. The faces of the spectators, and explicit genitals of the Count, and the pose of the right profile figure, like the 1877 *Ugolino*, are hallmarks of Rodin's work in the period 1875–80.

1. J. Kirk T. Varnedoe, 'Early Drawings by Auguste Rodin', *Burlington Magazine*, CXVI 1974, pp.198–9 and Varnedoe in *Auguste Rodin, Drawings and Watercolours*, Westfälisches Landesmuseum für Kunst und Kulturgeschichte, Münster, 1984; English translation, London, 1985, pp.15–19.

The prints and the Goupil album

57 *pl. 102*

Love turning the world (*Les amours conduisant le monde*) 1881

Drypoint etching, 20.3 × 25 cm
State two, plate mark erased

Trustees of the Victoria and Albert Museum. C. A. Ionides 870

Rodin began printing in London in 1881 under the guidance of Alphonse Legros, a master etcher. This first attempt at using the etching needle describes a cluster of nine putti like those routine to Rodin's work as a decorator and related both to drawings and to the sculpted groups of children such as *L'Idylle d'Ixelles* (1876) and cat. no. 109 which he produced under his own name. The tumbling and the crowding in space was transferred to the *Gates*, as was the absence of a specific allegory or setting. The title was inscribed on a print by Rodin in 1908.

A total of eleven prints were listed in Löys Delteil, *Le Peintre-Graveur Illustre*, VI, 1910

which was based on Roger Marx's 'Les points sêches de Rodin', *Gazette des Beaux-Arts,* March 1902. Delteil listed measurements, states, and public collections but not the edition sizes. Two obscure prints (one of a centaur and one of a wounded soldier made in 1916) were not listed. The prints and book illustrations were discussed by Victoria Thorson in *Rodin Graphics,* San Francisco, Museum of Fine Arts, 1975.

These, and the next four prints were purchased by C.A. Ionides who was introduced to Rodin's work in 1881 by Alphonse Legros and became an early collector. He asked in a letter of 19 October when a group of two children (probably *L'Idylle d'Ixelles*) would be ready.[1]

1. Musée Rodin Archives.

58 *pl. 103*

Figure studies 1881

Drypoint etching, 22.5 × 17.5 cm
Unique state (uncancelled)

Trustees of the Victoria and Albert Museum.
C. A. Ionides 869

Like the pages of Rodin's notebooks, this plate assembles almost at random motifs on his mind; thus, the man in profile with his arms overhead, present on *Le Jour*; allegorical motifs common to other artists, such as the reference to war contained in the head with snake and in the head with a reclining figure on the top, which is repeated in other drawings (like that with a helmet in Marx sale, 1914, no. 204, or the bust of Bellona).

59 *pl. 9*

Bust of Bellona 1882–85

Drypoint etching, 15 × 10 cm
State three

Trustees of the Victoria and Albert Museum.
C. A. Ionides

At the same time Rodin began supplying journals with ink drawings of his sculptures based on a photographic source, he also based several drypoints on this intermediate, two-dimensional translation.[1] This Bellona, a common allegory for 'The Republic', was probably Rodin's intended entry in a competition of 1879. Rose Beuret posed and her temper is portrayed realistically and poignantly.[2] Rodin enhanced the photographic emphasis on the dramatic side-light with more freely flowing hair than in the bronze and deeper shadows. A definite suggestion of Rembrandt in the technique and facial type is not surprising given Rodin's love of his work and the association of Rembrandt with the Belgian years when Rose posed regularly.[3]

1. See Varnedoe in *Rodin Rediscovered*, pp.203–4 and Claudie Judrin, 'Musée Rodin. Dessins acquis en 1985', *La revue du Louvre et des Musées de France*, 5/6, 1985.

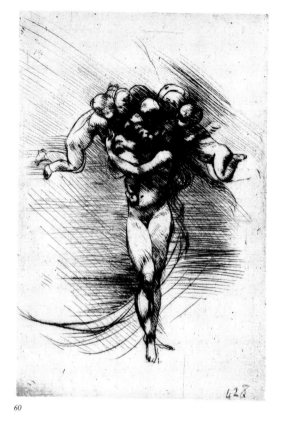

60

2. John Tancock, *The Sculpture of Auguste Rodin: The Collection of the Rodin Museum, Philadelphia*, Philadelphia, 1976, p.585 for dating.
3. Rodin inscribed the print in the Musée Rodin: 'à ma femme Aug Rodin'. He kept a copy of the Louvre's *Bathsheba* in his studio.

60

Springtime 1882–88

Drypoint etching, 14.8 × 10 cm
Unique state

Trustees of the Victoria and Albert Museum.
C. A. Ionides 428

As Victoria Thorson has pointed out, the image is the reverse of that on *La Nuit*, the 'Pompeian' vase.[1] Marx commented that the woman is both a 'Venus crowned with Amours who whisper their secrets in the drunkenness of a spring morning' and also a simple 'toilette de Venus' as well as being linked to the representation of motherhood.[2] The fine parallel lines are common to Legros' style while her voluptuous body has a volumetric presence. Rodin dated the print to 1888 in a letter to Bourcard, which may not be accurate given his preoccupation with this theme at Sèvres.[3]

1. Thorson, *Rodin Graphics*, p.28.
2. Marx, *Auguste Rodin. Céramiste*, Plate XIV.
3. Thorson, *Rodin Graphics*, p.28.

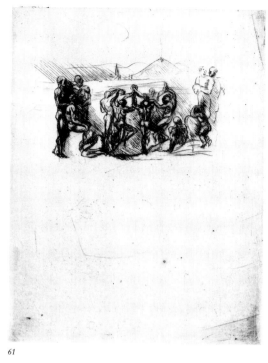

61

61

La Ronde *c.*1883–84

Drypoint etching, 22.9 × 17.8 cm
State one

Trustees of the British Museum (1949-4-11-2676)

Albert Elsen, who devoted the first scholarly article to this print, pointed out that whereas the ritual dance of figures in a circle was common in antique and medieval art, as it was in folklore, it was uncommon to find only naked men. The indication of a church spire in the background may be related, Victoria Thorson feels, to nineteenth-century iconography describing the 'climactic event, when, after the feast, there is a round dance which ends in a sexual orgy'.[1] The pagan revelries were also typical of Rodin's frieze on the larger vases for Sèvres (notably the *Bacchic Farandole* and *Le Jour*). Dante and Virgil come across three homosexual Shades who formed a circle:

And then, as naked and oiled champions do,
Eying one another to see how best to grip
Before they come to blows and hold together

And so, as they ran round, they kept their faces
Turned all the time toward me, so that their necks
Were all the time in movement, like their feet.[2]

Examining the print we find the bystanders directly related to the drawings for Dante, such as the Leipzig group of figures (cat. no. 11). The concept of one body turning in space, seen simultaneously front, back, and

three-quarters which was intrinsic to Rodin's profile method of sculpting, had in the period 1881–83 become part of his radical synthetic approach to composing the *Gates*. The *Three Shades* uses this quintessentially three-dimensional notion which makes the spectator consider the sculptural implications of working 'in the round'.

1. Albert Elsen, 'Rodin's *La Ronde*', *Burlington Magazine*, CVII, June 1965, pp.290–99. He reproduces related drawings by Rodin, as does Thorson, *Rodin Graphics*, (for example D1937 with five men and D1951).
2. Dante, *The Divine Comedy*, ed.cit., p.111.

62

Les Dessins de Auguste Rodin 1897

Book with 129 plates comprising 140 drawings by Rodin, reproduced in facsimile by the Maison Goupil, Paris, Jean Boussod, Manzi, Joyant et Cie. Introduction by Octave Mirbeau, 'Hommage à Auguste Rodin'.

Trustees of the Victoria and Albert Museum

The drawings reproduced range from linear écorché studies and tiny sketches of racing horses to the overworked 'black' gouaches made in the early 1880s. The titles which were designated with Rodin's approval establish the connection to Dante even where there is no inscription. The high proportion of studies of Shades and of parents and children corresponds to the dominant themes of these years. Comparison of the originals with the plates made by high quality photogravure indicates a slight change in colour, for example *Seated figure holding a child* (D5601, cat. no. 32) acquires a pink/blue cast in the upper left corner as plate 125. Parallel lines were sometimes added, undoubtedly by Rodin, between 1880 and 1897.

Maurice Fenaille, an industrialist, historian and collector, was the publisher of this album. Rodin sculpted his wife and frequently stayed with them in the country at Montrozier.

Je suis belle

63

Figure study of a woman and child

Graphite pencil, ink, gouache on lined paper, 61 × 45.7 cm

Trustees of the British Museum (1905–4–12–1)

The inclusion of a plinth suggests Rodin's decorative background and the influence of Clodion. The pose is like the porcelain plaque of the mother and child (cat. no. 24). The child's face is characteristically summary and ghostly, surviving as a type in the late studies of Iris. On the verso Rodin drew a winged figure.

As Varnedoe and others have mentioned, the Sèvres technique of *pâte rapportée* called for

high contrast, and the preliminary drawings often stress the tenebrist possibilities.'

Claude Phillips, who owned this drawing, was, like William Henley, an early supporter of Rodin's. When Rodin's *L'Idylle d'Ixelles* was refused by the Royal Academy in April 1886, Phillips said that by accepting 'simpering inanities' and refusing this work, the jury were in fact insulting the English public.[2] In 1900, however, Phillips called Rodin's *Balzac* a 'magnificent failure'.[3]

1. Varnedoe, in *Auguste Rodin. Drawings and Watercolours*, p.321.
2. Claude Phillips, *The Academy*, 29 May 1886, p.386.
3. Frederick Lawton, *The Life and Work of Auguste Rodin*, London, 1906, p.235, quoting Phillips in *The Daily Telegraph*, 8 September 1900.

64

Man carrying a child in his outstretched arms

Charcoal, grey and brown washes, and gouache on lined cream paper, 14.9 × 8.7 cm Part of Album III, broken up in March 1930

Musée Rodin (D377)

Rodin often drew children in the arms of men and women; the sex of the figures is frequently difficult to determine. It is possible that this example dates from *c.* 1881, when Rodin learned etching under Alphonse Legros and was working at the Manufacture de Sèvres. A rather distant connection can be established between this scene and the man in the *Je suis belle* group, with the child replacing the crouching woman.

65 *pl. 116*

Dante falling backwards

Charcoal and graphite on beige paper, torn and pasted to a lined support, 19.1 × 12.8 cm Inscribed in pen and brown ink, upper left: 'Dante' Verso: male nude seen from the front; charcoal and graphite

Musée Rodin (D1920)

Rodin often returned to the theme of a powerfully muscled man in the 1880s. The drawing probably represents Dante falling into one of the many faints that overcame him during his descent into Hell.

66 *pl. 37*

Couple with putto *c.* 1880

Pen and black and brown ink on tan paper, 19.1 × 13.3 cm

Rodin Museum, administered by the Philadelphia Museum of Art. Gift of Jules Mastbaum (F'29–7–142)

This drawing, like cat. no. 67, is identical to the design on a Sèvres vase (present location unknown) which depicts the embrace on a panel surrounded by a dark ground.[1] On the

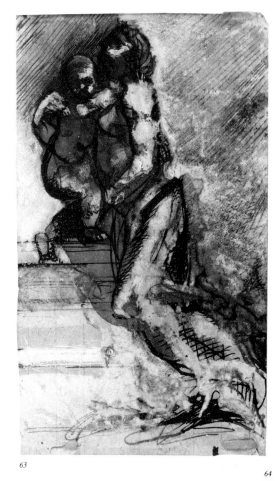

63

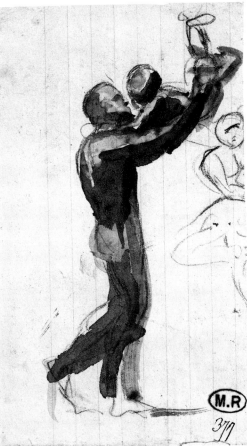

64

vase, in addition to the standing putto, there are children underfoot and vegetation, whereas on paper Rodin tested in the corner the motif of a couple holding a jardinière. The same drawing, with heavier shading and the woman's left leg raised high, was reproduced in *The Studio* in February 1929, perhaps from another instance of the chromolithographic technique reproducing the basic outline.

1. Marx, *Auguste Rodin: Céramiste*, Plate IX.

67

Embracing couple *c.*1880

Pen, black and brown ink, graphite and white gouache on light tan paper, 17 × 10 cm

Rodin Museum, administered by the Philadelphia Museum of Art. Gift of Jules Mastbaum *Auguste Rodin. Céramiste*, (F'29–7–148)

The correspondence between this drawing and the Sèvres vase *L'illusion* with the same couple (Marx, Plate V) places its execution between 1880 and 1882. The fine parallel strokes perhaps anticipate those in the dry-points of *c.*1883, *Springtime* and *Bellona* and in the sequence of drawings around the theme of 'l'enlèvement' which are associated with the sculpture *Je suis belle*, including that captioned 'Poète, prend [sic] ton luth' and those with chromolithography. The several positions of the man's legs may be evidence of Rodin trying to decide on the 'plan' which would best translate to low-relief, ceramic decoration. The thrusting chin of the man belongs to the savage Shades in the line drawings.

A nearly identical drawing with blue-green wash is in the Bourdelle Museum (reproduced in Yvon Taillandier, *Rodin*, New York, 1967, p.21).

68

Group with Francesca da Rimini

Graphite, pen and brown ink, heightened with gouache on cream paper mounted centrally on card, 19.4 × 14.5 cm

Musée Rodin (D3763)

We can readily associate this embracing couple with *The Kiss*. It is therefore not surprising that Rodin should have allowed this drawing to be published as 'Groupe de Françoise de Rimini' in the Goupil album (pl. 5). The pose adopted by the lovers is freer in the drawing than in the sculpture, but the outline of the pedestal is visible, and the use of thick gouache highlights reveals a similar desire to explore a highly contrasted light.

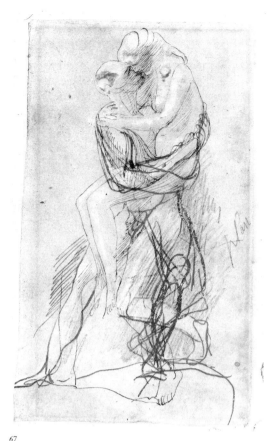

67

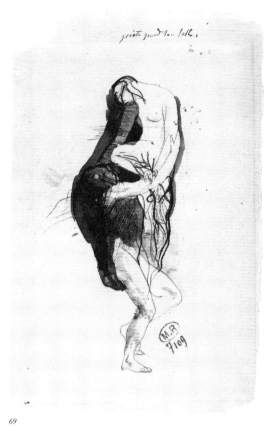

69

69

'Poet, take up your lute'

Pen, violet ink and black ink wash, heightened with gouache on cream paper, torn upper left, 20.7 × 13.5 cm
Inscribed in pen, top: 'poète, prend [sic] ton luth'

Musée Rodin (D7109)

This drawing of a man raising up a woman with his outstretched arms contains allusions to both Musset and Baudelaire. The quotation from the first lines of *Nuit de mai*, in which the muse exhorts the poet to take up his lute, shows that Rodin is thinking of Musset. The same line is inscribed on a plaster cast, but it differs greatly from the drawing.

The drawing is also reminiscent of that drawn in 1887–88 in the margin of Baudelaire's poem 'De profundis clamavi', which was itself inspired by the sculpture *Je suis belle*.

There are other examples of this drawing. They were produced by the chromolithographic process, which was quite often used in the late nineteenth century, and which allowed several clean prints in aniline ink or *violet de Paris* to be pulled without difficulty from a single drawing. Rodin produced variants by altering the thickness of the wash.

68

70 *pl. 108*

Crouching Woman 1880–82

Bronze 31 cm high

Private Collection, courtesy Browse & Darby

The sculpture of Adèle began with the rugged terracotta study, Michelangelesque in pose and handling, now in the Musée Rodin. It appears at the foot of *The Thinker*. Elsen has pointed out that not only does the gesture possibly refer to the French idiom for orgasm (foot in hand) but that the gesture of squeezing her breast 'suggests giving birth and nursing a child as if Rodin was evoking the woman's dream of having a child or her lament for a lost one'.[1] The pose is one of the first Western works of art to observe directly an uninhibited female pose, a 'primitive' state of being.

The clay version of this bronze appears in a photograph by Bodmer, and in another by Haweis and Coles of 1903–4 the form is surrounded by swirling lines, emphasizing its compact potency.[2]

1. Albert Elsen, *In Rodin's Studio*, London, 1980, p.167.
2. Elsen, *In Rodin's Studio*, nos. 31 and 80.

71 *pl. 118*

Falling Man 1882 (1972)

Bronze, 53.4 × 42.5 × 30 cm

Founder: Susse. Cast seven
B. Gerald Cantor Collections

Similar poses appeared frequently in the Dante drawings (including *Dante falling backwards*, D1920), also as a figure with arched back and raised leg tossing children overhead on the Sèvres vase *Le Jour* (1881) and the goblet *Faun et l'enfant*. Adapted to three dimensions prior to its assembly with *Je suis belle*, *Falling Man*'s feet both come off the ground to increase the vitality and symmetry. Tipped onto his back, the single figure is suspended on the underside of the lintel on the left of the *Gates*, so that only head and shoulders are visible. He was called 'Atlas' by Emile Michelet (*Le Jeune France*, July 1886).

A version with serpent was made for the collector Anthony Roux in 1885; an assemblage with the plaster was entitled *Two Struggling Figures* in 1900. The torso alone, known as *Marsyas*, has been enlarged to 59 cm and to 120 cm high and cast in bronze.[1]

1. Tancock, pp.163–7.

72 *pls. 81, 119, 120*

Je suis belle 1882

Bronze, 69 × 30.8 × 31.9 cm

Ateneumin Taidemuseo, Helsinki
Purchased in 1893. Antell Collection

The source of the two figures has been much remarked upon: *Falling Man* is supposedly a study of Pignatelli, and *Crouching Woman*, one of Adèle. The opening line of Baudelaire's poem 'Beauty' supplied the final title: 'Je suis belle, ô Mortels, comme un rêve de pierre'. The previous generic title *L'enlèvement* (or the crude English *Rape*), however, locates the theme within the variations of 'abduction', from children carried away by a person of strength with arched back, as in Bernini's *Bacchanal, a faun teased by children* (a copy is in the Metropolitan Museum of Art, New York), to the discovery of sexual passion exemplified by Paolo and Francesca.

All early visitors to the studio commented on its audacity: Paul Guigou in 1885 told his readers that *Carnal Love*, as it was first called (and later *Le Rut*) was revolutionary: 'Jamais personne n'attente d'exprimer ainsi l'attaque farouche du désir et le cri furieux de la chair'.[1]

1. Paul Guigou, *Revue Moderniste*, 30 September 1885, p. 74.

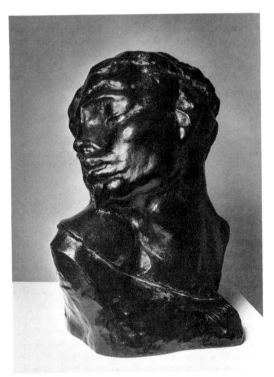

73

73

Head of Lust (Le Luxe) 1882

Bronze 38 × 26 × 75 cm
Founder: Alexis Rudier

Paul and Natalie Abrams

The head of the enlarged *Crouching Woman*, with neck turned vertical, has a supple, seductive left side and a right one cut into crude facets by the action of the knife when it was

severed. The contrast appears not wholly the consequence of the amputation, but evidence of Rodin's appreciation of the compatibility between a naturalistic and an earthy, almost Cubist, analysis of the transitions between skull, hair and cartilage.

Principal figures and groups

74 *pl. 44*

The Thinker 1880

Bronze, 68.6 × 89.4 × 50.8 cm
Founder: Alexis Rudier

The Burrell Collection, Glasgow Museums and Art Galleries

This size corresponds to the original version of 1880 placed on the tympanum, a leitmotif of past and future thought. By September 1882 Rodin was describing his figure as 'le penseur'.[1] Albert Elsen has examined many aspects of the sculpture in great detail in his monograph on *The Thinker* (1985), including its enduring position as one of the most universally popular public sculptures. It is generally agreed that the introspective figure came from the idea of Dante surveying mankind's troubled existence but was also representative, as Rodin explained, of a simple worker whose 'fertile thought slowly elaborates itself within his brain. He is no longer dreamer, he is creator'.[2] Gradually this identification with Rodin himself, a self-made man, became elaborated into his political association by Henri Dujardin-Beaumetz and others with the 'hard-working worker who successively made supple and disciplined materials furnished by nature and utilized them for social progress. It is he in the end who built the modern world and wants it worthy of his long efforts.'[3]

Elsen's book includes a survey of the caricatures and advertisements that have been influenced by this work.

1. Henley correspondence (Musée Rodin Archives).
2. Rodin's letter to the critic Marcel Adam published in *Gil Blas* on 7 July 1904.
3. Dujardin-Beaumetz' speech 'Le Penseur de Rodin', made at the auguration of the enlargement sited in front of the Pantheon, 21 April 1986, reported in *Le Temps*

75 *pls. 70, 92*

The Three Shades 1881

Bronze, 97.2 × 94 × 52 cm
Founder: Georges Rudier (1969)

Private Collection

The influence of Michelangelo and Puget on Rodin's *Adam* is clear enough: not only is the contortion familiar but so too is the gesture of the right hand with pointing finger. The *Shade*, a variation of *Adam*, is considerably more original: the left arm hangs clear of the body, the spine becomes a deep groove and

the neck is bent so radically that it forms a straight line with the shoulder giving the subject more of the denatured presence of the Shades who appeared in the tiny drawings. The pencil drawing *Three Figures with Tambourine*, now in Philadelphia, is a composite of three views of one standard *écorché* figure; however, the more descriptive, earlier arrangement of the arms actually seems more contrived. The idea of three identical figures crowning the *Gates* is extreme even for someone whose trade depended on multiple casts. Tancock has speculated that the truncated right hands may be intended 'to symbolize the powerlessness of *The Shades* before fate and the resulting ineffectualness of all their efforts'.[1] The drawing D5478 shows the *Three Shades* with *Adam* and *Eve*. Elsen, '*The Gates of Hell*', dates this to 1880–81, however Tancock places the decision between 1881 ad 1886.[2] In 1886 Felicien Champsaur reported that the figures pointed to an inscription of Dante's famous opening line: 'Lasciate ogni speranza voi ch'intrate'.[3]

This cast matches in size the sculpture on the *Gates*. Around 1898 the single Shade was enlarged to 1.91 metres and three copies were positioned at points of an imaginary triangle in the exhibition at the Société Nationale in 1902 (the joined unit of three figures was also enlarged).

1. Tancock, p.129.
2. Tancock, p.129.
3. Tancock, p.129 and n.5.

76 *pl. 128*

Fugitive Love (*Fugit Amor*) *c*.1883–84

Bronze, 37 × 44 × 20.5 cm
Founder: L. Persinska
Given by the artist to Edouard Rod

Private Collection

One of the representations of Paolo and Francesca, this marvellously enigmatic couple had many names before the present one: 'La Nuit,' 'L'Aurore', 'La Sphinge', 'La Course à l'Abime' and, by the 1889 exhibition, 'Le Rêve'.[1] It was described then by Geffroy as presenting 'La course envolée et farouche d'une femme qui emporte sur don dos en sa damnation, sa victime, l'homme inanime et rigide. Le dos de la femme se creuse, le torse de l'homme s'aplatit, ses jambes retombent, une arabesque de membres furieux et de membres morts se dessine'.[2] By 1902 it was known too as 'The Temptation of St Anthony'; Arthur Symons wrote: 'St Anthony cannot understand the woman, the woman cannot understand St Anthony. To her he seems to be playing at abnegation for the game's sake, stupidly to him she seems to be bringing all hell fire in the hollow of her cool hands. They will never understand one another and that will be the reason of eternal conflict.'[3]

1. See Georges Grappe, *Catalogue du Musée Rodin*, Paris, 1944, no. 249.
2. Gustave Geffroy, in *La Justice*, 19 May 1887.
3. Arthur Symons, in the *Fortnightly Review*, no. 77, 1902.

77

Avarice and Lust *c*.1880–82

Bronze, 20 × 39 × 30 cm

Stanford University Museum of Art (75.184). Gift of the B.G. Cantor Foundation.

Avarice and Lust reflects Rodin's shift in the early 1880s from the influence of Dante's imagery to that of Baudelaire. The man's head with open mouth derives from the Shades, but his longing to consume the frail, distressed body of the girl suggests the imaginative decadence of *Les Fleurs du Mal*. Indeed the girl's prone body with forked legs illustrated Baudelaire's poem 'Une Charogne', and on a similar sketch (D2037) (the man now a skeleton) Rodin wrote: 'elle était de ce monde ou les plus belles choses ont le pire destin' ('she was of that world in which the most beautiful things suffered the worst fate').[1]

The sculpture, known also as *Resurrection*, was photographed numerous times from above, so that its flatness and the rolling motion of the embrace corresponded to the spatial abstraction of the real experience.[2] In contrast to this succinct work Rodin treated the theme in a more conventional way in *Psyche-Printemps*, where the male becomes a ravenous satyr.

1. *Rodin et les écrivains de son temps*, Musée Rodin, Paris, 1976, p.36.
2. C. Roger-Marx, 'Le Couple', *Formes et Couleurs*, no. 2, 1946, and photographs by Druet (Ph1547 and 1548).

78

Eternal Springtime 1881

Bronze, 64.2 × 58 × 48 cm
Inscribed on pedestal: 'GRIETOUL et LORGE, fondeurs à Paris, 6 passage Dombasle'

Musée des Beaux-Arts et d'Archéologie, Besançon (933.7.1). Provenance Don Pichon.

A photograph by Bodmer reveals the clay model of *Eternal Springtime* in front of an early stage of the *Gates* (*c*.1881).[1] The theme of embracing lovers preoccupied Rodin, who intended at least one representation of the Paolo and Francesca story to occupy a major position. Although this sculpture was never placed on the doors, it became one of Rodin's most popular free-standing works. After this first edition cast by Griffoul et Lorge (between 1887 and 1894), the firm Leblanc-Barbedienne cast numerous copies in Rodin's lifetime (approximately 141) in various sizes.[2] Szépmüvészeti Muzeum, Budapest, owns a marble copy.

The breast and stomach of the male figure are surprisingly effeminate, reminding us of both the neutered figures from Dante and the semi-masculine Eve (as illustrated in Maillard). The use of the *Torso of Adèle* to construct a new kneeling figure was one of Rodin's first adaptations from a favourite part. The extended limbs on the male figure complete the lyrical treatment of volume as line.

1. Reproduced and discussed in Elsen, *In Rodin's Studio*, no. 48.
2. Monique Laurent in *Rodin Rediscovered*, p.287.

77

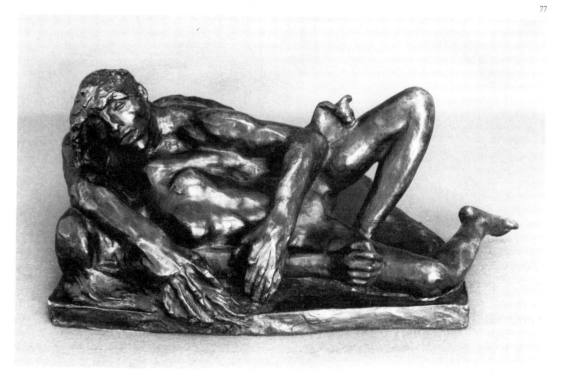

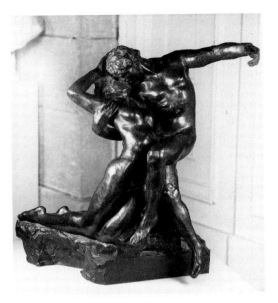

79 *pl. 152*

The Metamorphosis of Ovid *c.*1886

Plaster, 34 cm high
Inscribed on the base: 'Au poète W.E.
Henley/son vieil ami/A. Rodin'

Victoria and Albert Museum (A.117–1937)
Bequeathed by Charles Shannon, R.A., in
1937

Many couples were modelled separately, but
this embrace was clearly observed. Allegedly
the models were the same two extrovert
lesbian dancers from the Paris Opera who
posed for *Damned Women* and the nearly
identical works, *Daphnis and Chloë* and *Cupid
and Psyche*.[1] Typically the title neither de-
scribes the action nor the sexes but merely
states Rodin's attraction to mythology ac-
cording to Ovid. Rodin rotated the plaster
upright, placing the kneeling girl with back to
the spectator both on the *Gates* (upper right
panel) and in the drawing which preceded the
illustration in *Les Fleurs du Mal* inscribed: 'le
printemps adorable a perdu sa fraicheur' cat.
no. 10. On paper there is more realism and
frivolity, the woman with folded arms co-
quettishly resisting her partner's clasp.

Rodin was introduced to W.E. Henley, the
editor of the *Magazine of Art*, by Alphonse
Legros in 1881 and the two men became close
friends, corresponding until Henley's death in
1903.[2] Henley's enthusiasm for Rodin's work
was crucial in establishing important links
between Rodin and England, and in effecting
introductions to prominent writers like Alfred
Louis Stevenson and collectors like Ionides.
Rodin's bust of Henley, made in 1886, is in St
Paul's Cathedral.

1. Victor Frisch and Joseph T. Shipley, *Auguste Rodin: A
Biography*, New York, 1939, pp.420 and 425.
2. See Henley's letters in Musée Rodin Archives.

80 *pl. 166*

Meditation 1885

Bronze, 73.7 × 42 × 28 cm
Founder: Alexis Rudier, Paris

Private Collection

Meditation was placed in the right corner of the
tympanum of the *Gates* (the free-standing
version is slightly larger). The time-honoured
subject of meditation was normally a draped,
aloof personage, an allegory for male thought.
Leo Steinberg has pointed out Rodin's choice
of pose resembles the fifteenth-century for-
mula for pathos.[1] Beginning with the notion
of a statue which invites quiet contemplation,
Rodin gave the viewer something extraordi-
narily charged and made of contrasting parts,
including the stout peasant legs of his *Eve*, the
long fingers that contact the breast dome (the
result, a cross between something architectur-
al and something mystical), the primitive nose
and brow and abstract passages like the
rounded masses under the right shoulder.
Frisch and Shipley stated the connection
with Camille Claudel as fact (p. 429); other
biographers refer obliquely to the source.

1. Leo Steinberg, *Auguste Rodin 1840–1917, an Exhibition
of Sculptures/Drawings*, Charles E. Slatkin Galleries,
New York, 1963, p. 21. He cites as examples a
drawing attributed to Pollaiuolo, and Jacopo della
Quercia's *Expulsion*.

81

Danaïd 1885

Bronze, 30.5 × 56 × 43 cm

Trustees of the National Museums and
Galleries on Merseyside (Walker Art Gallery)

The vase identifies *Danaïd* with Ovid's ac-
count of the fifty daughters of Danaus who,
having murdered their husbands on their
wedding night, were condemned to Hades to
draw water through leaking vessels. Although
not placed on the *Gates*, she is one of the
studies described by Geffroy, who frequently
visited the rue de l'Université, as 'le travail de
tous les instants acompli par les yeux et par
l'esprit sont visibles comme dans l'oeuvre
variée d'un écrivain créateur d'êtres'.[1] The
union of the human form with the sculptural
matter is as successful in marble as it was in
the original clay, which is unusual. Daniel
Rosenfeld has remarked upon the early use of
the *non-finito* handling of the chisel with the
resulting raked grooves and sharp facets (a
marble was exhibited in 1889) and on the
relationship between the slope of the stone
and the concealment and revelation of the
forms.[2] One marble is in the Musée Rodin and
another in the Princeton Museum.

1. Gustave Geffroy, *Auguste Rodin*, Galerie Georges
Petit, Paris, 1889, p. 64; *Danaïd* is mentioned on p. 67.
Grappe dated *Danaïd* to 1885 on the basis of an
identification with the figure described as 'pliée en
deux' in the 1886 International Exhibition.
2. Daniel Rosenfeld in *Rodin Rediscovered*, p.96.

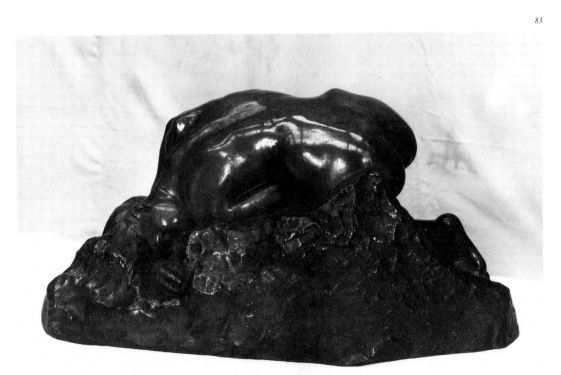

Sketches and partial figures

82 *pl. 42*

Torso of Adèle *c.*1881

Bronze 15 × 45 × 23 cm
Founder: Georges Rudier, 1959

Browse & Darby

Although nominally part of the arched-back caryatid type, this torso, with its assymetric distribution of volumes, unequivocally states Rodin's conversion to the beauty of a modelled fragment sufficient in itself.[1] Even on a miniature scale Adèle's voluptuousness comes across; indeed the addition of a head in *Eternal Springtime* (cat. no. 78) and *Fallen Angel* (cat. no. 112) makes the swooning, submissive aspect more conventional. As a flying figure it appears in the upper left corner of the tympanum.

1. Judith Cladel, *Rodin. Sa vie glorieuse, sa vie inconnu*, Paris, 1936, p. 135, suggests the torso was a study for the Triton on the Villa Neptune (1879), but it seems more likely that it represents an inevitable stylistic development. According to Frisch and Shipley, Adèle worked for Rodin for four years, *c.*1880–84.

83 *pl. 125*

Kneeling Man before 1884

Plaster, 33.6 × 12.5 × 11 cm

Musée Rodin (S824)

This figure was designed for the *Gates of Hell*, and can be seen in the upper right-hand panel. This figure of a young man recalls the *Prodigal Son* and was reworked in 1888 for the *Death of Adonis*. It seems from Judith Cladel's book of 1908 that Rodin also thought of producing a reclining version of the figure and of entitling it *L'Aiglon*, after Edmond Rostand's famous play.

84 *pl. 150*

Invocation 1886

Plaster, tinted green, 56.2 × 24.2 × 26.7 cm

Musée Rodin (S1392)

Rodin called this figure of a woman sitting on a mound *Abruzzezzi Seated*, after the model who sat for him on several occasions while he was working on the *Gates of Hell*. Women with a similar physique can in fact be seen in that work, but they are in slightly different positions. The woman sitting close to *Despair* with her legs crossed is one such example. Georges Grappe notes that this figure is reminiscent of *Suppliant Old Man*, and suggests that it might be a companion piece to that composition.

The plaster was patinated to look like bronze for an exhibition, perhaps that held in the Pavillon de l'Alma in 1900, where it was shown under the title *Aurora Awakens*. There are several other plaster casts of the figure at Meudon, together with a recent edition in bronze.

85 *pl. 40*

Desinvolture

Plaster, 65 × 34.5 × 37.4 cm

Musée Rodin (S677)

This plaster is a classic example of a sculpture executed with the help of a model; presumably Rodin was attracted to the powerful twisting movement of the pose.

86

Despair *c.*1890

Plaster 28 cm high
Inscribed on the front of the base: 'Amitié et hommage à M Phillips/A Rodin'

Trustees of the Victoria and Albert Museum (T. 78)
Bequeathed by Sir Claude Phillips in 1924

Although scarcely visible from the ground on the *Gates*, *Despair* appears on the upper left door turned inwards among other smooth-limbed nymphs. Elsen suggests that Grappe's date of 1890 may be too late, which seems highly likely given the style, relative modesty and association with the *Gates*.[1] Rodin had the work photographed by Bodmer (who worked in the 1880s), Bulloz, and Haweis and Coles, each emphasizing its enigmatic qualities and endowing monumentality through the low-angled views.[2]

1. The work was first exhibited in 1892. Grappe dated the piece to 1890 and suggested an acrobat may have posed. It was carved in stone See Elsen, *In Rodin's Studio*, nos. 93–94. Dated 1890 in *Rodin: The B. Gerald Cantor Collection*, Metropolitan Museum of Art, New York 1986.
2. See photographs in the exhibition, nos. 247–9.

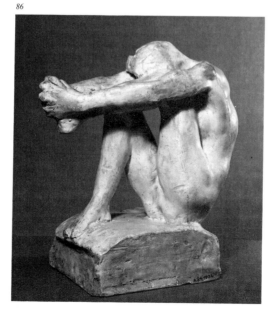

86

87 *pl. 126*

Damned Woman

Plaster, 40.5 × 14 × 12 cm

Musée Rodin (S27)

It is difficult to think of this pretty figure of a woman amputated at the knees as depicting a soul condemned to hell for eternity. The face of the woman is recognizable as that of the *Martyr*, and Rodin used it in many other compositions, as could be seen at the exhibition of nineteenth-century sculpture held at the Grand Palais in 1986. It seems that the sculpture was designed to be shown either standing or reclining, as a plaster cubic element attached beneath the neck serves as a base.

88 *pl. 172*

Fatigue before 1887

Bronze, 18 × 20 × 51 cm

Founder: Georges Rudier. Cast five
B. Gerald Cantor Collections

Fatigue, especially in the rough variant called *Misery*, is not unlike the *Martyr*; however, the pose is less ungainly and the surface more svelte. Through the intermediate medium of a photograph, Rodin used this sculpture to serve as the dead heroine lying with her lover Gäetan in an illustration to Bergerat's *Enguerrande*; he added flowing tresses and a stippled background, which give her arched and unblemished nude body a greater luminosity and seductive power. A front view was placed next to the title of 'Une Martyre' in the Gallimard copy of Baudelaire's *Les Fleurs du Mal*. Compared with earlier studies of reclining women, for example Clesinger's *Woman Bitten by a Snake* (1847), Rodin's figures seem self-contained and are not demeaned by their nakedess.

89 *pl. 159*

Study for a Damned Woman 1884

Bronze 38 cm long

Private Collection

This sculpture is typical of the uninhibited creatures crowded into the tympanum (she lies on its floor). Scrutinizing models writhing with excitement became almost a scientific pursuit in the life drawings made in the 1890s and later.

253

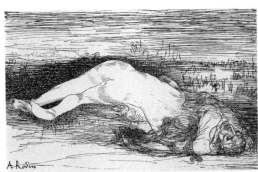

The death of Enguerrande and Gaëtan, illustration for Bergerat's book, 1884, Musée Rodin.

90 *pl. 141*

Female torso with hand of a skeleton

Plaster, 21.2 × 12.5 × 9.6 cm

Musée Rodin (S678)

A series of skeletons and skulls evoking a *danse macabre* can be seen in the background to the tympanum of the *Gates of Hell*, and this study presumably relates to them.

91 *pl. 170*

The Dream *(The kiss of the angel)* before 1889

Plaster, 22 × 37.5 × 18.3 cm

Musée Rodin (S1861)

This small group was recently rediscovered in the reserve collection at Meudon. The marks made during the process of enlargement are still visible. It consists of two juxtaposed figures. The angel derives from the *Fall of Icarus,* and the woman lying on her stomach is very similar to a woman in the *Gates of Hell.* The group has at various times been known as both *The kiss of the angel* and as *Sleep,* and is open to various interpretations. According to Judith Cladel, 'A dream visits a woman and hold back its wings with one hand so as to make no noise.' Rodin's inscription on the back of a photograph by Druet suggests a different interpretation: 'A spirit of evil from the abyss whispers suggestions to a man at prayer.'

There is another marble version of this group, with the stone binding the figures more closely together.

92

The Ascendancy *(L'Emprise)* *c.*1885

Bronze (also described as bronze mixed with gold or brass) 17.6 × 6 cm
Signed on base: 'A. Rodin'
Inscribed on base: 'L. Perzinka/Fondeur/ Versailles'

Lent by the Visitors of the Ashmolean Museum, Oxford

Around an existing stiff body of a standing man Rodin wrapped a female with coiled limbs and a pronounced spinal groove. The theme and scale are similar to *Sin (Le Péché),* which was also shown in the Exhibition of 1900. Both works suggest Baudelaire's predatory women. *The Ascendancy* was one of six works exhibited in the Galerie Georges Petit in 1885/86. Rodin had the clay version photographed from all sides.

The Ascendancy was shown at the Leicester Galleries, July–August 1931. It was bequeathed by Mr Percy Moore Turner in 1951, and catalogued as *Le Péché (Annual report,* Ashmolean Museum, p.54).

1. The confusion between the titles dates at least from Grappe, who in the 1944 edition of his catalogue uses *Le Péché* both for the woman with raised right leg and tail and this figure (nos. 180–193). Judith Cladel calls this sculpture *L'Emprise* in her *Rodin,* Paris, 1948, pl. 50 and the other work *Le Péché* (pl. 51).

93

Two Women Embracing

Plaster, 23.8 × 32.3 × 23.3 cm

Musée Rodin (S705)

This image of a Sapphic couple is constructed as though it were an assemblage, and it should be compared with the many drawings inspired by a theme that was very much in vogue at the end of the nineteenth century.

94.

Figure with raised leg *(Le guetteur)* *c.*1886

Bronze 15 × 7 × 7.5 cm

Private Collection

This unfamiliar sculpture was owned by the critic and novelist Octave Mirbeau and appears on the mantel in the photograph reproduced in Descharnes, p. 146[1]. In the sale catalogue of Mirbeau's superb collection it was described as follows 'un homme placé à la point d'une roche semble observer au loin. La jambe gauche raidie, la jambe droite repliée sur une pierre plus elevée, le corps penché, les bras croisés sur le genou.'[2] Judging by the exposed breast the figure may be female.

Often the collections of Rodin's friends contained unique works, many being gifts acquired during studio visits (and sometimes cast by the new owners) or one-off variations of favourite sculptures, such as the marble

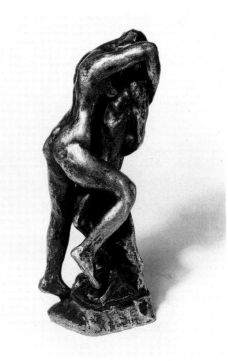

92

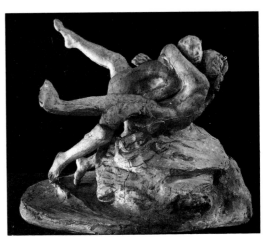

93

version of the small *Crouching Nude* which was also in Mirbeau's collection.

1. Robert Descharnes and Jean-François Chabrun, *Auguste Rodin,* London, 1967.
2. Catalogue of the Mirbeau sale, Galerie Durand-Ruel, 24 February 1919. He also owned paintings by Cezanne, Van Gogh, Monet, Pissarro and Renoir amongst others and sculptures by Camille Claudel and Aristide Maillol.

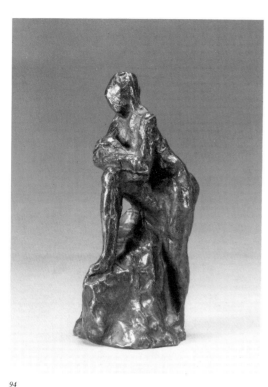

94

96

Head with Closed Eyes

Bronze, 12.3 × 9 × 10 cm
Founder: Georges Rudier
Inscribed: 'Musée Rodin 1960'

Private Collection

The head is less obviously tragic than most of those on the *Gates* but is alike in scale and anonymity. Its quietness, the negroid features and the organic interpretation of the coiffure suggest an outlook identified with the twentieth century. Better known examples of the single heads are *Little Head of a Damned Soul*, *Crying Girl* and the similar *Mask of a Woman with a Turned-up Nose*.[1]

1. See Tancock, pp.606–12 and De Caso and Sanders, pp.184–95 for discussions of similar heads.

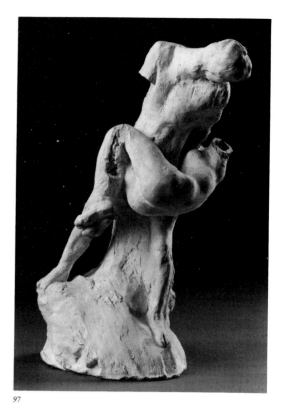

97

Drawings from the 1880s

98 *pl. 100*

Two figures wrestling back to back

Graphite on squared paper pasted to a cutting from *La Semaine française* describing an exhibition at the Dudley Gallery, London, 1883, 19.2 × 15 cm
Inscribed in graphite, right, and on the side: 'Géricault'

Musée Rodin (D5930)

This drawing is of interest in two senses. The press cutting on which the paper is mounted gives us a date. The cutting describes an exhibition at the Dudley Gallery, London, where Rodin showed the *L'Idylle d'Ixelles* group, probably between May and July 1883. It is possible that the drawing dates from the same period. Rodin has also inscribed the drawing with the name 'Géricault', and we know that he praised the painting *La Coùrse de cheveaux à Epsom* in his *L'Art*, which was published in 1911.

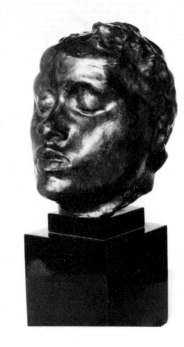

96

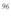

95

95

The Damned

Plaster, 17 × 16 × 9 cm
Signed: A Rodin on back

Musée Rodin (S452)

The surface of the *Gates of Hell* swarms with small groups of indeterminate figures symbolizing souls who have been damned for eternity. This small assemblage of two similar figures was also editioned in bronze.

97

Assemblage of standing man and woman's torso

Plaster, 30.5 × 18.3 × 19.4 cm

Musée Rodin (S2121)

As in S2122, Rodin juxtaposes two works: a superb torso of a woman and a standing male figure which is again surmounted by a *Polyphemus* head.

99 *pl. 127*

The Circle of Lovers (*Couple Embracing*)

Graphite, pen and brown wash on cream paper pasted to lined paper, 16.2 × 10.2 cm
Inscribed in pen and graphite, top: 'Françoise Paolo—Virgile et Dante—Contemplations': on the lower part of the lined paper, in brown ink: 'l'amour profond comme les tombeaux Baudelaire—Abruzzesi [sic] très beau'

Musée Rodin (D5630)

This drawing can be read in many different ways, and is very typical of Rodin's boundless imagination. He suggests that the couple represent the figures in *Le Baiser* (cf D3763 and D1922), but he also implies that they are Dante and Virgil. Finally, he adds an allusion to Victor Hugo's poems, *Les Contemplations*.

The drawing appears to have been executed in two stages. First, the line drawing was laid down. The sheet was then glued to another, and was reworked with the wash, which flows over on to the support. At this point, Rodin adds the inscription, 'Abruzzesi très beau'. The name is that of a model who was well known in the studios and who posed for Rodin between 1882 and 1889. He then cites from memory the second line of the first quatrain of Baudelaire's poem 'La Mort des amants', but whereas as Baudelaire speaks of 'des divans profonds comme des tombeaux', Rodin paraphrases this as 'l'amour profond comme les tombeaux'. The inaccurate quotation shows the degree to which Rodin was steeped in literature, even if his memory was faulty.

100 *pl. 154*

Death of the lovers (*La mort des amants*)

Pen and grey wash over a graphite sketch, pasted to decorative headed note-paper from a textile firm, 11.5 × 11 cm
Incomplete graphite inscription in Rodin's hand, lower left: 'La Mort des amants'

Musée Rodin (D1954)

The marginal inscription, 'La Mort des amants', shows that Rodin intended the drawing to illustrate Baudelaire's poem, but there is no such illustration in Paul Gallimard's copy. A certain taste for the decorative is apparent from the decision to paste the drawing to headed note-paper decorated with volutes, which serves as a frame.

101 *pl. 239*

The adorable springtime has lost its freshness

Pen and brown ink with traces of wash, on cream paper, 9.5 × 14.1 cm
Inscribed in pen, lower left: 'le printemps adorable a perdu sa fraîcheur'

Musée Rodin (D2013)

This delicate drawing is closely related to the version of the sculpture, *The Metamorphoses of Ovid*, which figures in the right-hand corner of the tympanum of the *Gates of Hell*; it is very faithful to the version made before 1886, in which the group is not reclining. The woman to the right of a drawing illustrating Baudelaire's poem 'Femmes damnées' also relates to this study.

The poem, 'Le Goût du néant', from which the quotation is taken, did not appear in the 1857 edition of *Les Fleurs du mal*, and was therefore not included in Gallimard's copy. Rodin in fact misquotes it by substituting 'fraîcheur' for 'odeur', and thus destroys the alliterative effect intended by Baudelaire. We can conclude only that Rodin's liking for poetry was more highly developed than his feeling for it.

102

Resurrection

Graphite, pen, grey and violet washes with gouache on lined cream paper, 9 × 14 × 3 cm
Inscribed in graphite: 'Resurection Antonio[?]'

Musée Rodin (D3776)

This is not the only occasion on which Rodin drew skeletons. Skeletons appear in the drawings he made as a young man, and can also be seen on the lintel of the *Gates of Hell*.

The skeleton embracing a woman's body appears in at least two drawings used to illustrate two poems from Baudelaire's *Les Fleurs du mal*: 'Une Charogne' and 'Les Deux Bonnes Soeurs' (D2037 and D1986).

The combination of gouache and a black ink wash dramatically expresses the pallid atmosphere of the scene.

103 *pl. 155*

Satan and his worshipper *c.*1883

Pen, pencil, ink, brown ink wash and white gouache on ruled paper, 14.6 × 17.8 cm
Inscribed: 'à mon ami Will Rothenstein'
Annotated: 'Baudelaire' and 'serpent'

Private Collection

This remarkable drawing of a youth worshipping Satan by committing the cardinal sin of an anal embrace was translated to a line drawing for the frontispiece of the Gallimard's copy of *Les Fleurs du Mal*, executed in 1887–88. More macabre in line, showing Satan with talons and horn, and called *L'Imprévu* (*The Unexpected*), it is inscribed in Rodin's hand: 'Vous avez en secret, baisé ma fesse immonde/ reconnaissez Satan à son rire vainqueur/ énorme et laid comme le monde.'

The style and man's pose are close to gouaches dated *c.*1883, particularly *Group of two figures* (D3764) and cat. no. 100 which suggests an earlier date for the gouache than the 1887–88 proposed by Thorson.[1]

It is reproduced in Rothenstein's *Men and Memories*, London, 1937 between pages 322 and 323. Rothenstein wrote of his first visit to Paris in 1897: 'I returned home with drawings of Rodin, of Fantin-Latour and of Beardsley . . . and an early drawing by Rodin, also a gift' (pp.22–3).[2] He initiated the Rodin exhibition at the Carfax Gallery in January 1900.

1. Thorson, *Rodin Graphics*, identifies the subject and dates it 1887–88.
2. *Rodin et les écrivains de son temps*, p.27.

102

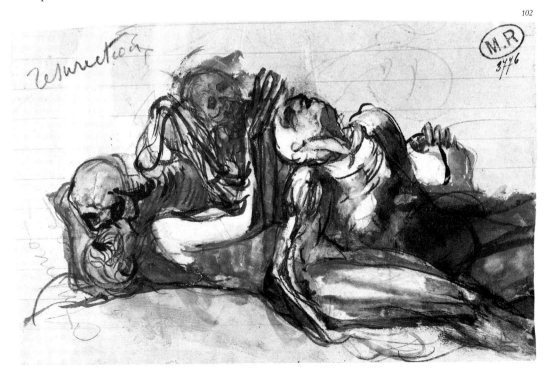

104 *pl. 101*

Man struggling with a woman *c.*1883

Ink and pencil with sepia wash on lined paper, 9.2 × 12.3 cm

Ny Carlsberg Glyptotek, Copenhagen

Haarvard Rostrup who wrote about the Rodin drawings in the collection of the Ny Carlsberg Glyptotek in 1938, felt that those dealing with Ugolino and Dante might date from the period 1860–75, but suggested that it was after 1880 that Rodin began to look again at these sketches and consider how they might translate to scenes on the *Gates*.[1] It is true, as he pointed out, that the drawing is similar to the *Group of two figures* (D3764, Goupil, pl.116). The stressed lines and shadows increase the sense of struggle and rehearse the contrast essential to defining form at a distance in three dimensions. The cutting-away of the ruled paper to a niche shape is common (drawings in the Goupil album are reduced to triangles, arcs and etc.), reminding us of Michelangelo's architectural spaces on the Sistine Ceiling, which Rodin had studied.[2] The effect of bringing the action in the small spaces forward, enhancing their potency, was used by Rodin in late drawings which were cropped or where the scale was deliberately too large to accommodate the entire figure on the page.

1. Haarvard Rostrup, 'Dessins de Rodin', *From the collections of the Ny Carlsberg Glyptothek*, Copenhagen, 1938, pp.214–16.
2. Goupil, pl. 114, *Fronton*, for example.

The enlargements

105 *pls 109, 110, 111*

Crouching Woman 1880–82

Bronze, 84 × 53.3 × 45.7 cm
Founder: Georges Rudier

The Josefowitz Collection

When the *Crouching Woman* was enlarged, according to Grappe in 1882 the forms were broadened, or, as Tancock described it, 'generalized'.[1] However, in the process a new equilibrium was achieved by tilting the body so that the right foot is several inches higher, the rocky base counterweighting the mass of the figure. The snaky branch of the right arm is punctuated by the head; the folded left thigh encases the folded left elbow and the squashed feet and fingers of the left hand merge with the medium.

Rodin considered turning this sculpture into a caryatid, as demonstrated by the Bulloz photograph in which the figure has a cloth draped over the shoulder to show how it might look reinterpreted, pl. 232.[2]

1. Tancock, p.136.
2. Hélène Pinet, *Sculpteur & les Photographs de Son Temps*, Paris, 1985, no. 12.

106 *pl. 167*

The Inner Voice (*La Muse*) *c.*1896–97

Bronze, 146 × 77 × 57 cm
Founder: Alexis Rudier

Trustees of the Victoria and Albert Museum

The enlargement and revision of *Meditation* is associated with Rodin's *Monument to Victor Hugo*, where she represented the writer's muse for 'Les Voix Intérieures'. In an early maquette with Hugo naked Rodin tried using the *Martyr* for the ideal figure, but by the time the full-scale, unfinished version was shown at the Société Nationale in 1897, this standing figure was *Meditation*. In the intermediate third and fourth projects the way her arms are interlocked suggests a gesture of listening to the waves on behalf of Hugo, the amputated knees covered by drapery. In the last project, by severing her arms Rodin streamlines the right side of the already complicated composition.

This cast was part of Rodin's gift to the Victoria and Albert Museum in 1914. Three plasters exist—in Marseilles, Dresden and at the Musée Rodin—in which the seam lines and rawness of the breaks has an especially strong presence. An edition was cast by the Musée Rodin (at the Coubertin foundry) in 1981.

107 *pl. 168*

The Martyr 1885

Bronze 32 × 154.5 × 104.5 cm

Kunsthaus, Zurich

Whichever way the figure is oriented, it remains awkward, the units wrenched into distinct entities. Used at least five times on the *Gates*, the sculpture is frequently given wings and turned face down. As such it serves to illustrate the favourite Symbolist theme the Fall of Icarus and relates to drawings, from the Dante period (like that annotated: 'icar/Phaeton' (Goupil, pl.86).[1] Rodin adapted an upright version to use in the works *Orpheus and Eurydice* (1889) and *Orpheus imploring the Gods* (1892), both in marble. Henri Lebossé's correspondence refers several times to enlargements he is making of the *Martyr*, complaining once in 1899 that Rodin's 'modelage est tellement supérieur dans cette oeuvre admirable que j'ai tout quitté pour m'y attaché spécialement ayant remis mes voyages d'affaires'.[2]

Tancock argues that the alternative title used in Zurich, *The Christian Martyr*, is inappropriate, given Rodin's overwhelming identification with the period interest in perversion and his 'tendency to identify love and suffering'. When the head is seen on its own it suggests a swooning, and when the head is

concealed the gauche availability of the adolescent body is more apparent, as it was in the adaptation intended for a pediment, *Autumn*, in Baron Vitta's house in Paris in 1897.

1. A photograph of the marble was the inspiration for the illustration to 'Benediction' in *Les Fleurs du Mal*. Tancock (pp. 186–190) and De Caso and Sanders (pp. 62 and 163) discuss the variants. Another copy was commissioned by the Galerie Georges Petit in October 1889 along with three other works in marble (*Correspondance*, I, no. 141).
2. Reproduced in Elsen, *In Rodin's Studio*, no. 100 and in Descharnes and Chabrun, p.153.
3. Letter of 25 October 1899 and subsequent references in 1908 and 1909, Musée Rodin Archives.
4. The original commission was for the Villa La Sapinière at Evian, which was owned by Mme Foa, Vitta's sister; other artists employed included Félix Bacquemond, Alexandre Falguière and Albert Besnard. See Tancock, p.188 for full discussion.

The Fall of Icarus, Musée Rodin, S1135.

108

Earth 1884

Bronze, 47 × 106 × 37 cm
Signed on the base: 'A. Rodin'
Inscribed: 'Première épreuve'

Musée Rodin (S623)

The figure lies on its stomach and appears to be emerging from a mass of mud. It was rarely exhibited during Rodin's lifetime. A smaller and earlier model completed in 1884 was designed for the tympanum of the *Gates of Hell*. Shortly before 1900 it was enlarged to roughly twice its present size, and exhibited in that state at the Pavillon de l'Alma. It may have been the same plaster cast which was shown at the Musée Rath in Geneva in 1896, in Holland in 1899 and then in Vienna, Venice, Prague and Düsseldorf between 1901 and 1904, but it is the bronze which is reproduced in Grautoff's book (1908). As well as making the enlargement, Rodin produced a variation of his model by replacing the shapeless mass of the head with a head from *Man with a Broken Nose*.

Allegorical sculptures and terracottas

109a and b
Brother and sister *c.1885*
Terracotta, 29.3 × 19 × 19 cm

Private collection

Child *c.1885*
Terracotta, 17.8 × 15.2 × 16.5 cm

Private collection

Family tradition suggests that the single child was a demonstration sketch Rodin made for his pupil Jessie Lipscomb and the brother and sister a work she admired and was given.[1] If neither are especially progressive and both borrow from the eighteenth-century tradition taught at the Petite Ecole, nevertheless their enduring freshness depends partly on their minor importance. Historically Rodin's studies of children, sometimes with their mothers, seem anachronistic and sentimental when contrasted with other works of the 1880s like *Fugit Amor* or *Ugolino and his sons,* yet the affection and observation which came out in the ink contour sketches of putti during the 1870s clearly transferred to his preference for the unselfconscious gestures of models. Actual children were brought into studios, as can be seen in the photograph of Camille Claudel modelling a gypsy mother and child.[2]

A letter written in March 1887 by Jessie Lipscomb from Camille Claudel's Paris address reveals how upset they were at Rodin's ambiguous attitude to his pupils; she states plainly: 'Vous savez je vieux vous dire franchement que nous sommes venues d'Angleterre specialement pour avoir vos conseils, et vous nous aviez promis de nous les donner ... Dîtes nous donc franchement ce que vous avez l'intention de faire avec nous.'[3] The photographs in Jessie's album, including one of the *Gates,* were probably taken in Paris that spring, as a letter of September 1887 from Miss Lipscomb apologizes for not sending them before but explains that she has been ill during the summer, and then announces her intention shortly to marry Mr Elborne and remain in England. Among Jessie's youthful sculptures is a bust of Camille Claudel which captures the sensuality of her mouth and her intensity in a manner similar to the famous photograph by César published in *L'Art Decoratif* in 1913 (dated *c.* 1885).

It was not merely accidental that Rodin was associated with the development of a number of female artists; he explained: 'women understand me better than men. They are more attentive. Men listen too much to their friends; so that they are spoilt while in the hands of the professor. Then I am inclined to find them stupid, which is certainly a mistake; for I have one or two men pupils who are exceedingly gifted. Perhaps I ought not to call them pupils since they have natural genius.'[4]

1. Conversation with her grandson, 1985.
2. *Camille Claudel,* Musée Rodin, Paris, 1984, fig. 8.
3. Musée Rodin Archives.
4. Lawton, p.276.

109a

109b

110 *not illustrated*
Triton and Nereid *c.1886*
Bronze, 37 cm high

Museum der bildenden Künste, Leipzig

Tancock associated this sculpture with *Minotaur* and commented that 'The deprivation of all but the essential limbs in this group gives a particular intensity to the expression of sensual desire.'[1] The girl is another cross between a frightened nymph and a coquette whose contorted body with its backward glance is intentionally provocative. Rodin was asked in March 1908 by John Marshall, the European purchasing agent for classical art at the Metropolitan Museum, to carve a marble version of the terracotta (which is now in their collection).[2] The scaled-up plaster, photographed by Marshall in preparation for the never-completed marble, reinvents the jagged edges of the crumbling fragment and rather classicizes the Triton, filling out his chest and beard.

Another bronze is in Dresden.

1. Tancock, pp.271–3.
2. Clare Vincent, 'Rodin at the Metropolitan Museum of Art', pp.28–9.

111 *pl.173*
Young woman kissed by a phantom 1880s (?)
Bronze, 23 × 44 × 24 cm

Reading Museum and Art Gallery

It is impossible to tell from the early photographs whether this bronze was cast from a marble, or directly from plaster: on one print the couple are envisaged as decorative caryatids and on the other the ink lines seem to be notations intended to indicate (to the carver?) further undercuts and streamlining of form.[1] A marble version lent by M. J. Peytel was included in the 1900 exhibition, and its description emphasizes the mystical aspect: 'vers ce corps delicat et tendre de jeune fille couchée et endormie s'avance et va se pencher une sorte de succube qui sort du sol comme une vapeur émanée de la terre'. The woman reappears in the sculpture *The Dream* (cat. no. 91) as the uppermost figure.

Edith Tweed, wife of the sculptor John Tweed who was a close friend of Rodin, refers in a letter to Rodin, dated 21 August 1906, to a work *Le Songe,* probably this piece. It was in the possession of the Carfax Gallery but the Tweeds came to own it and eventually passed it to the Reading Museum and Art Gallery.[2]

1. Elsen, *In Rodin's Studio,* nos. 81 (Ph1382) and 93 (Ph1381).
2. Edith Tweed to Rodin, 21 August 1906, writing from Calvados. It was no.57 in the Carfax Gallery exhibition, 1900: 'une ombre vient parler à une femme désolée', £60.

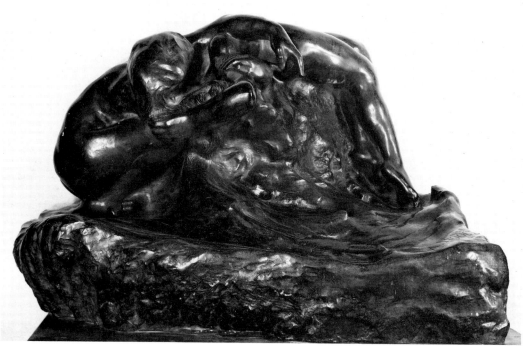

112

114 *pl. 198*

The Sculptor and his Muse early 1890s (?)

Bronze, 65.9 × 47.8 × 50.6 cm

The Spreckels Collection, California Palace of the Legion of Honour, The Fine Arts Museums of San Francisco

Unlike the traditional female muse, this girl does not simply whisper inspiring messages but offers manual stimulation and causes the seated muscular male to sway and sink into his rocky chair. Her foot caught in her hand is like Rodin's other allusions to female sexuality. In a way the sculpture seems almost a self-parody, as if Rodin realized his dependence on women as his imagination's 'powerful awakener'[1] was also the source of a vulnerability that by the 1890s generated long bouts of depression and ill health. The man's face dissolves into a satyrish idiocy and the softness of the girl, as well as the swirling hair, belong to the somewhat cloying side of the Rodin's late work with its art-nouveau overtones. The physique of the man is much like that of the older model who posed for the standing figure of Victor Hugo. This work is also thought to date from the 1890s and was definitely conceived by 1898.[2]

1. Hélène von Nostitz, *Dialogues with Rodin*, New York, 1931, pp. 75–6.
2. De Caso and Sanders, p. 52.

115

Zoubaloff Fauness 1885

Bronze, 18.1 × 10.2 × 16.5 cm
No foundry mark

Rodin Museum, administered by the Philadelphia Museum of Art. Bequest to the City of Philadelphia by Jules E. Mastbaum

On examining the sculpture Tancock guessed that Rodin composed it by taking the top of a bather and adding the furred legs and hooves of a fauness, planting the whole on a rock.[1] Throughout his life Rodin was tempted to add attributes of fauns and satyrs, from the early *Standing Figures* in the British Museum to late drawings like *Nude; woman with cloven feet lying on her back* (D3096).[2] It was common in the late nineteenth century to depict animal-women (as did Rops and Moreau) and allow them unrestrained sexual energy. Yet Rodin's faunesses are transparently human.[3]

The name comes from the collector Jacques Zoubaloff who purchased the original plaster in the Anthony Roux sale at the Galerie Georges Petit in 1914. Rodin sold a number of plasters to Roux in the 1880s giving him all rights to reproduction.[4] Philadelphia acquired the bronze through the agent F. and J. Tempelaere.

1. Tancock, p.250.
2. Grappe, no.236.
3. De Caso and Sanders, p.34.
4. Tancock, pp.250–1.

112

The Fallen Angel 1895

Bronze, 52.4 × 80.6 × 55.9 cm
Inscribed: 'A. Rodin'
Founder: Alexis Rudier

Glasgow Art Gallery and Museum

The *Fallen Angel* unites two of Rodin's early sculptures, the *Torso of Adèle* and the *Fallen Caryatid*, not merely joining them as with the *Death of Adonis*, but placing them on an imposing mound with evidence of art-nouveau flourishes and the chisel marks which suggest the bronze was cast from the stone.[1] Transformations in the work's title (it was once known as 'Illusion falls with broken wings, the earth receives him') revolved around the Icarus story, which in the nineteenth century symbolized the artist's struggle to free himself from the commonplace. In mood, the sculpture relates to the satiated, uninhibited look of the female couples in the drawings which followed, such as *Sapphic couple* (D3037).

1. It is not, however, identical to the marble in the Musée Rodin.

113 *pl. 169*

Polyphemus and Acis *c.*1888

Bronze, dark brown-black patina with green, 28.2 × 14.9 × 22.5 cm

The Spreckels Collection, California Palace of the Legion of Honour, The Fine Arts Museums of San Francisco.

Ovid's jealous Cyclops, Polyphemus, stands over his beloved Galatea who embraces her lover Acis. Rodin probably worked with the myth in mind, uncharacteristically, perhaps stimulated by Auguste-Louis-Marie Ottin's famous Medici Fountain of the same subject which was located in the Luxembourg Gardens.[1]

The figure of Polyphemus alone appears twice on the *Gates* in the upper right panel. Poses with one leg raised high were attractive to Rodin who exploited the linear quality in the *Project for a Monument to Whistler* (cat. no. 151) and the watercolour *Quittant la terre* (cat. no. 176) as well as in the studies of dancers made from clay logs *c.*1912.

The diving figure of Polyphemus is one in a heap which are drawn at the head of the chapter of Truman Bartlett's article published on 1 June 1899 in the *American Architect and Building News*.[2] Several variations exist, one reproduced in 1902 in *Art Journal* (London). This cast was purchased from Eugene Rudier in October 1949 by Mrs Spreckels.[3]

1. Tancock, p.210 from Grappe, *Catalogue du Musée Rodin, no. 200*
2. Bartlett, p.262.
3. De Caso and Sanders, pp. 168–71.

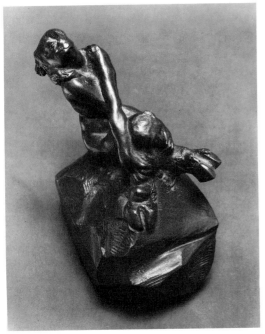

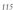
115

116 *pl. 165*

Study for The Eternal Idol *c.1889*

Plaster with traces of piece mould,
17.5 × 15 × 8.5 cm

Private Collection

The original title for the sculpture was 'The Host'. Jacques de Caso and Patricia Sanders explained, 'Through this name evokes something of the veneration and deification associated with the word "idol", in such a context it smells of sacrilege. Rodin liked to play with this confusion of carnal and spiritual; we have another example in his *Christ and the Magdelene*. In *The Eternal Idol,* the replacement of the symbolic body of Christ with the body of a beautiful woman is reminiscent of the backward masses of the satanists.'[1] The attentuation and the lack of facial detail in the sketch are like those in *L'Emprise,* which exchanges the woman's arms held behind the back for tentacle-like arms wrapped around the body. Both poses are unnatural states of passion, this one not so much about abstinence as about frustration. In the marble enlargement the faces are realistic and the male seems more worshipful.

1. De Caso and Sanders, p.65. Another plaster is in the Spreckels Collection. The Fogg Art Museum owns a marble.

117

Christ and Mary Magdalene *1894*

Plaster, 105.4 × 76.7 × 66.6 cm

Musée Rodin (S1136)

This group represents one of the few religious subjects to be found in Rodin's *œuvre*. It should, however, be noted that it has also been known by much more pagan titles such as *Prometheus and Oceanide* and *Genius and Pity*. The figure of Mary Magdalene derives from *Meditation,* and appears again in *Constellation*. This plaster, like that in San Francisco, is very similar to the marble in the Thyssen collection. In the earlier study executed in *c*.1892, the figures are more easily identified, the cross is more obvious and the modelling is not so smooth (pl. 305).

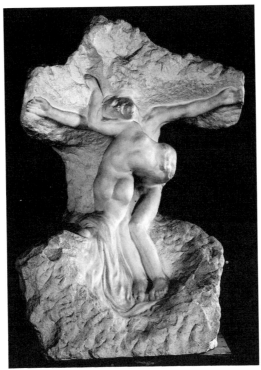
117

118

Psyche *1886*

Bronze, 36.5 cm high
Inscribed: 'à ma grande amie, Judith Cladel'

Private Collection

Very little has been written about this study. It was translated into marble (Grappe, *Catalogue du Musée Rodin,* no. 153). As a title, *Psyche* was one of Rodin's favourites, but was normally used to suggest someone more overtly provocative.

118

119 *pl. 156*

The Minotaur *c.1886*

Bronze, 34 × 25 × 25 cm
Founder: Alexis Rudier

Private Collection

According to Tancock, Rodin preferred this title to the alternative ones used, *Jupiter Taurus* and *Faun and Nymph,* and was satisfied with its loose description of Ovid's story of the half-bull creature with a captive maiden.[1] The subject and medium recall Carrier-Belleuse's revival of Clodion's eighteenth-century terracottas but the improvised modelling which

goes with the surprise attack suits more the intended undercurrent of genuine violence rather than conventional titillation. Beginning with the drawings of the seated Virgil holding Dante, like that now in Budapest (cat. no. 9), Rodin experimented with one figure placed on another's lap. *The Kiss*, with its ideal, youthful protagonists, proved both more shocking and more popular than the mythological couples where the aggressor is bestial and the object of his lust a mindless victim.

Edmond de Goncourt and Octave Mirbeau, among others, owned plaster copies of the *Minotaur* (Goncourt's is now in the Rodin Museum, Philadelphia).

1. Tancock, p.270.

120

The Bather 1888

Bronze, 36.8 × 14.7 × 19.7 cm
Founder: Alexis Rudier

Stanford University Museum of Art (78.123). Gift of the B.G. Cantor Foundation

Almost as a byproduct of the *Gates*, Rodin made numerous studies which depict women in relaxed attitudes. Grappe, who termed them 'vignettes', believed this piece might be earlier than 1888 and remarked on its correspondence to Degas's sculpture.[1] The girl's look of innocence reflects Rodin's sympathetic scrutiny of women, just as much as the *Study for a Damned Woman* and *L'Emprise* (*The Ascendency*) define his attraction to their dangerous powers; the contrast is matched in the sets of life drawings which began around 1890.

The sculpture is also known as the *Zoubaloff Bather*, from the collector Jacques Zoubaloff.

1. Grappe, *Catalogue du Musée Rodin*, no. 195.

121

Constellation 1902

Bronze, 72.5 × 44.5 × 26.5 cm
Founder: Alexis Rudier
Signed on base: 'A. Rodin'

Musée Rodin (S1096)

One of the two figures in this group will be recognized as *Meditation*; it appears also in *Christ and Mary Magdalene* (cat. no. 117) and *Siren*. Rodin often used his figures more than once, and even went so far as to create new works by assembling earlier casts. This reveals the importance he attached to the spatial arrangement of his figures. The subject is of secondary importance, and the title simply reflects his interest in astronomy and in Camille Flammarion's books. An unfinished marble on the same theme can be seen in the collections of the Musée Rodin.

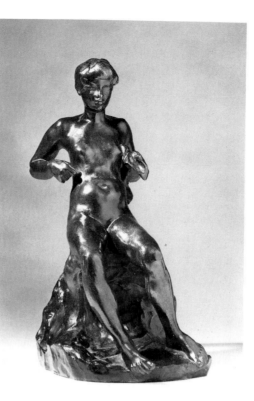

120

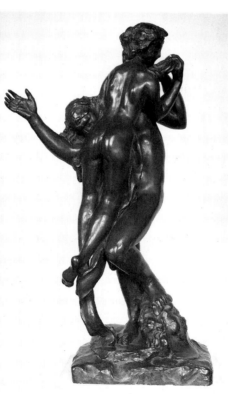

121

Portraits

122 *pl. 183*

Head of Henri Rochefort 1884 (1897)

Bronze, 74 × 42 × 34 cm
Inscribed on right shoulder: 'A. Rodin'

Musée d'art et d'histoire, Geneva

The subject is the flamboyant journalist who founded the newspaper *L'Intransigeant*. Henri Rochefort (1830–1913) began sitting for Rodin in 1884 but left, he claimed, in exasperation with Rodin's slow method of working. Rodin lamented that this irascible man, who remained his friend, 'could not keep still for a single instant'.[1] Several plaster casts were made of the life-sized version, shown first at Galerie Georges Petit in 1885/86. A copy was purchased by Henri Matisse from Mme Edouard Manet but it is now lost. The visual link between Manet's 1881 portrait of Rochefort, Rodin's bust of Rochefort, and Matisse's sketches of the sculpture and his own five heads of *Jeannette* (1910–13) also with expressive clumps of hair is intriguingly close.[2]

This enlarged, second version with a stiff collar was given to Rochefort by Rodin.[3] The date when the original bust was altered is not known but it was certainly before 1897.

1. Bartlett, 25 May 1889, p. 198.
2. Made by Pierre Schneider, *Matisse*, London, 1984, p. 532, and others.
3. Charles Goerg, 'En 1896 Auguste Rodin offre trois sculptures à la ville de Genève', Bulletin du Musée d'art et d'histoire, Geneva, 1984.

123 *pl. 219*

Head of Camille Claudel in a Phrygian Cap *c*.1886

Bronze, 24 × 13 × 17 cm
Founder: Georges Rudier
Cast twelve

The Josefowitz Collection

Rodin included a copy of this portrait of his mistress in his exhibition at Grosvenor House, which led to the donation of twenty-one works to the Victoria and Albert Museum in the Autumn of 1914. Camille's hair is held away to reveal her forehead which Rodin so admired. In age and pensiveness the face is nearly identical to *Farewell* and *Thought*. In 1911 Rodin asked Jean Cros to make a 'pâte de verre' copy, by the glass process discovered by his father, Henri.[1]

Not surprisingly no full figure with recognizable features of Camille exists. In this Rodin respected her privacy and distinction from normal models, although her body is alluded to in numerous works and, according to Frisch, Rodin 'never tired of sketching the lithe body of his dear mistress'.[2]

1. Tancock, pp. 590–92 and De Caso and Sanders, pp.285–7.
2. Frisch and Shipley, p.159.

The Burghers of Calais

124 *pl. 185*

Head of Pierre de Wiessant 1885–86

Terracotta, 28.6 × 20 × 22 cm

Musée Rodin (S311)

This unique terracotta is the earliest study for the head of Pierre de Wiessant and probably dates from either late 1885 or early 1886. It is noteworthy for the use of minor details—the wrinkled brow, the heavy eyelids and the bitter line of the mouth—to express the young man's pain. It has been suggested that the actor Coquelin Cadet posed for this study. In terms of morphology, there is a certain similarity between this face and that in the *Age of Bronze*.

125 *pl. 186*

Mask of Pierre de Wiessasnt 1885–86

Plaster, 47 × 27 × 29.5 cm

Musée Rodin (S438)

This mask is larger than the final version. The ears stand out more than in the monumental group, and both the mouth and the nose are more prominent. As Dominique Viéville notes in the catalogue to *Les Bourgeois de Calais* exhibition, this work may have been executed individually with a view to casting in bronze. The cubic plaster base which is an integral part of the whole definitely shows that it was designed to be exhibited by itself.

126 *pl. 179*

Head of Eustache de Saint-Pierre
(definitive state) 1886–87

Plaster, 37.5 × 29.5 × 35.6 cm

Musée Rodin (S412)

The head appears unchanged in the monumental group. Three earlier studies were made, two in terracotta and one in plaster. The features of this noble old man, who is torn with inner tension, are those of the model Pignatelli. The outline of the bust and of the rope around the Burgher's neck is also visible.

127

Mask of Jean d'Aire 1886

Terracotta, 17.2 × 11.4 × 11.6 cm

Musée Rodin (S93)

Rodin began to work on the heads for the *Burghers of Calais* at either the end of 1885 or the beginning of 1886. This terracotta mask of Jean d'Aire is very similar to the final version, and its strikingly Classical style make it reminiscent of a Roman portrait. It seems that the model for the face was Auguste Beuret, Rodin's son by Rose, and that Rodin wanted to capture his strength of character.

127

128 *pl. 187*

Jean d'Aire, nude study 1886

Plaster, 104 × 34 × 32.5 cm

Musée Rodin (S414)

After making a first maquette in 1884, Rodin worked in turn on each of the figures for the monument in Calais. In the second maquette, one third of which was executed in 1885, Jean d'Aire carries the keys to the town on a cushion. In the following state, he carries only one heavy key in both hands. The plaster seen here is a nude study for the final study and we can see how Rodin emphasizes the figure's musculature in order to bring out Jean d'Aire's strength and energy. The nude was enlarged in 1886, and the final figure was completed in 1887, when it was shown at the Galerie Georges Petit. Beneath the long robe, one senses the presence of the muscles which Rodin studied so carefully in the nude.

129 *pl. 192*

Study for nude figure of Pierre de Wiessant *c.*1886

Bronze, 192 cm

The Minneapolis Institute of Arts, given in memory of Walter Lindeke

When contemporary critics have defined what are in their view the modern qualities of Rodin's art, they have concentrated on aspects which this work contains very clearly. Leo Steinberg pioneered this appreciation, concluding his first discussion in 1963 as follows:

Rodin's implied space equips sculpture in three distinct ways for the modern experience. Psychologically, it supplies a threat of imbalance which serves like a passport to the age of anxiety. Physically, it suggests a world in which voids and solids interact as modes of energy. And semantically, by never ceasing to ask where and how his sculptures can possibly stand, where in space they shall loom or balance, refusing to take for granted even the solid round, Rodin unsettles the obvious and brings to sculpture that anxious questioning for survival without which no spiritual activity enters this century.[1]

The rawness of Pierre de Wiessant, with the sharp angled limbs, head turned to profile and open mouth, existed from the period of powerful *écorché* drawings such as *Dante, a shadow at his feet* (D1923)[2] The figure is the same scale and physique as the draped figure in the final *Burghers of Calais*.

1. Leo Steinberg, 'From Rodin: Sculpture and Drawings', Charles E. Slatkin Galleries, New York, May 1963.
2. Georges Grappe, 'Filiation classique d'un maître moderne. Les dessins de Rodin pour "La porte de l'Enfer"', *Formes, Revue Internationale*, Paris, XXX, 1932, p.317 illustrates this and related drawings.

Victor Hugo

130 *pl. 181*

Twelve studies of the head of Victor Hugo seen from various angles

Black pencil heightened with grey wash on lined paper, 25.2 × 21.1 cm
Verso: four sketches of a man seen in silhouette; black pencil.

Musée Rodin (D5358)

Before executing his bust of the poet in 1883 Rodin made numerous sketches. It has been reported (notably by the Goncourt brothers in their journal entry for 29 December 1887) that, unable to persuade Hugo to pose, Rodin made lightning sketches, almost all of them foreshortened, while the poet was busy reading, thinking or eating. Most show only his forehead. These impromptu sketches are far removed from the images of the hero or the patriarch which Rodin bequeathes us in his sculptures and prints.

217

131

Portrait of Victor Hugo (head-on) 1885

Drypoint etching, 22.5 × 17.5 cm

Trustees of the Victoria and Albert Museum (E.2173–1924)

This drypoint and the other variations were probably rendered from a photograph of Rodin's own bust of Victor Hugo executed in 1883. With a kind of irony Rodin emphasized the 'graphic' look of the three-dimensional version with its furrowed brow and folds of skin which in the bronze seem slightly disagreeable but on paper are treated with finesse. Soft light, sooty shadow and the flicks of the needle, used as if a pen, temper the verisimilitude and allude to Rodin's affection for this heroic figure who died in 1885. In later states (like this one, the third), the smaller head was lightened until it was pure line. The Victor Hugo prints were shown in 1889 and 1891 at the Salon des Peintres-Graveurs and reproduced in books. Victoria Thorson has compared Rodin's use of slashed strokes to the work of Tissot and Whistler and has dated the portrait series to 1885.[1]

1. Thorson, *Rodin Graphics*, San Francisco, 1975.

132 pl. 182

Victor Hugo, three-quarters view 1885

Drypoint etching, 22.9 × 17.8 cm (image)

Trustees of the British Museum (1910–7–16–32)

The contrast of descriptive modelling and wry caricature is as essential to the success of this print as to that of the others of Hugo. His bristling moustache and bumpy cranium hint at the man's charisma and over and above his literary genius. This is the second of eight states.

133 pl. 197

Victor Hugo and the Muses 1890

Bronze, 39 cm
Founder: Persinka

Private Collection, U.S.A.

This maquette was identified by Tancock as a reduced version of the second project for the *Monument to Victor Hugo*. Jane Mayo Roos has explained that 'the symbolism of these muses has loosened; though the muse on the left has remained, according to Rodin's description, the muse of *Les Orientales*, the central figure had acquired a dual symbolism as both the muse of *Les Châtiments* and *La Justice vengeresse*, and the muse on the right has become no more than "une figure ideale".'[1] This arrangement of three females, the one on the left crouching and the one on the right turned to expose her back, had already been defined

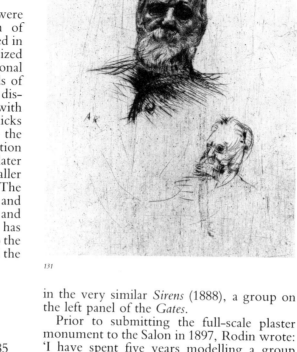

131

in the very similar *Sirens* (1888), a group on the left panel of the *Gates*.

Prior to submitting the full-scale plaster monument to the Salon in 1897, Rodin wrote: 'I have spent five years modelling a group composed of two women, symbolising voices that whisper into the poet's ear. Well, it seems to me that only a few months have gone by since I began the monument, and I regret to part with it.'[2]

1. Jane Mayo Roos, 'Rodin's *Monument to Victor Hugo*', (adapted from an unpublished doctoral dissertation, '*Rodin, Hugo, and the Panthéon: Art and Politics in the Third Republic*', Columbia University, New York, 1981), p.25.
2. Lawton, p.184.

134

Heroic bust of Victor Hugo 1897

Bronze, 70 × 60 × 54 cm
Founder: Alexis Rudier
Inscribed on left shoulder: 'A. Rodin'

Manchester City Art Galleries (1911.108). Presented by the sculptor and friends of the Gallery, 1911

The bust is a combination of observed portrait and allegorical study. Rodin was introduced to the eighty-year-old poet in 1883 by Edmond Bazire in order that he could plead with the great man to sit for yet another bust. He wrote to Hugo: 'I apologize for my insisting, but the ambition to be the one who shall have made the Victor Hugo bust of my generation is so natural that you will not reproach me.'[1] The first study, completed that year without the benefit of ordinary sittings, but based on the sketches and observation, has a certain fussiness, and compromises between

fidelity to Hugo's aging features and a concept of the man's venerability. A decade later Rodin had his own idea of what represented greatness, and invested the interpretation with a vigour more characteristic of a man in his late fifties, Rodin's own age.

The bust was probably not cut away and enlarged until *c*.1900. The relationship between the elements of craggy chest, folded skin and bumps for the hair and the cross-section of the sheered arms and rocky fragments of the body reflects both Rodin's theory of amplifying the volumes and his study of the antique. When William Tucker spoke of the relationship between Cézanne and Rodin, he drew attention to Rodin's 'intense feeling for substance, for the fullness and graspability of volume', of the Iris figures, also of the 1890s, he wrote: 'the head and projecting extremities are removed not in imitation of the classical fragment and only partially to disperse expression from the places where it is so obviously focussed in the human body—but primarily to locate expression in the pure thrust of a volume itself against space at every point on the surface'.[2]

1. Lawton, p.83. Tancock quotes Rodin's various recollections of the commission, pp.504–10.
2. William Tucker, *Space, Illusion, Sculpture*, from talks at St Martin's School of Art, Mains, 1974, pp.24–5.

135 pl. 199

Apotheosis of Victor Hugo 1897

Bronze, 111.8 × 51.4 × 61 cm
Founder: Alexis Rudier
Inscribed: 'A. Rodin'

Rodin Museum, administered by the Philadelphia Museum of Art. Bequest to the City of Philadelphia by Jules E. Mastbaum (F'29–4–44).

This sculpture of Victor Hugo standing was developed after the committee in charge of the *Monument to Victor Hugo* intended for the Panthéon had rejected Rodin's first proposal, a naked seated figure on a rock, in the spring of 1890. Despite his fame, Rodin seems to have been anxious not to relinquish altogether the commission, and obligingly devised an upright work, an Apotheosis, which would not only be suitable to the 'Genius of the Nineteenth Century' but would accommodate a cerebral muse of inspiration: 'a descending figure of Iris resting on a cloud.' Below on the rocks, Rodin told the commissioner Larroumet, 'a nereid or the water itself takes the form of the body of a woman and brings him a lyre; behind the monument Envy flies into a cavity'.[1] In practice the complex allegorical version failed to sustain Rodin's attention. On the one hand he continued the development of his original idea, shown incomplete in the Salon of 1897 and eventually carved in marble as a single figure of Hugo with outstretched arm. On the other hand he experimented with a naked striding figure, enlarged in 1901,

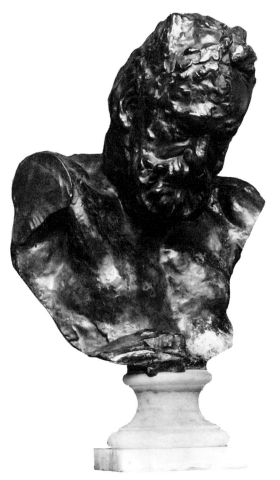

134

based on a mature model, parallel in concept and form to two contemporary projects, the Balzac studies and the *Walking Man*.[2] Similarly the enlarged and altered heroic head (cat. no. 134) suited his private researches into fragments.

1. Tancock, pp.412–23, including the quotation from Cecile Goldscheider, 'Rodin et le monument de Victor Hugo', *La Revue des Arts*, October 1956, pp.179–84. Roos dates the completion of the developed version of the Apotheosis idea to November 1893 and points out that by 1904 it was clear Rodin had no intention of clothing even this work estimated to be some 7 metres high in its final state (*Rodin, Hugo and the Panthéon*, pp.36–40.
2. Elsen, *In Rodin's Studio*, no. 90.

Balzac

136

Headless naked figure study for Balzac 1896–97

Bronze (cast 1970), 99 × 38.6 × 32 cm

Collection, The Museum of Modern Art, New York. Gift of The Cantor, Fitzgerald Collection, 1975 (436.75)

This figure, based on a more athletic second model who was described by Morhardt as standing with the left foot forward, was used in the final monument.[1] Plaster-soaked cloth was wrapped around casts until the final version with limp sleeves was settled upon. The bunchy modelling of the calf muscles and surface eccentricities reflect an aesthetic not unlike that informing Matisse's *Serf*, begun in 1900, as well as Rodin's own headless *Walking Man* adapted in the same period.

1. Mathias Morhardt, 'La Bataille de Balzac', *Mercure de France*, 15 December 1934.

136

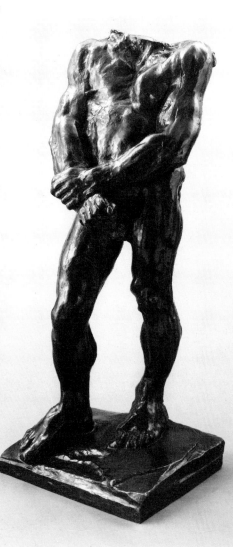

137

Study for the nude Balzac and gothic cathedral

Graphite on cream paper, 18 × 11.5 cm
Inscribed in graphite, upper right: 'cathédrale gothique'
Verso: graphite rubbing

Musée Rodin (D5318 and 5319)

Rodin made numerous architectural drawings between 1891 and 1898, when he was planning his Balzac. As he followed the novelist's footsteps across Touraine, he also took the opportunity to visit the churches and châteaux of the region. It will be recalled that his book *Les Cathédrales de France* was published in 1914 with a preface by Charles Morice.

137

138 *pl. 214*

Head of Balzac 1904

Glazed stoneware, 42.2 × 44.6 × 38.2 cm
Signed on left of neck: 'Rodin'

Musée Rodin (S1934)

Long after he had ceased to collaborate with the Manufacture de Sèvres, Rodin began to take a new interest in ceramics. He was always fascinated by different techniques, and probably saw ceramics as a means of editioning his works without using bronze. He therefore turned to famous ceramists such as Chaplet (in

1891), Lachenal (1895) and Jeanneny (1903). The latter produced several copies of the monumental *Head of Balzac* and of the *Bust of a Burgher of Calais* (Jean d'Aire) in stoneware, as well as a life-size, full-length figure of *Jean d'Aire*. These were made for the 1904 St Louis exhibition, and a number of copies were sold. There are therefore several copies of the glazed stoneware *Balzac*; the colours range from brown to green.

139

Monument to Balzac 1898

Bronze, 265 × 112 × 106 cm
Founder: Georges Rudier, 1971

Kodak Ltd, Hemel Hempstead

The history of the monument to Balzac which was commissioned by the Société des Gens de Lettres in 1891 and unveiled as a towering plaster monolith at the Salon in May 1898 is marked by most committee members' and critics' lack of understanding to Rodin's slow, sequential working methods and his desire to fuse a realistic and poetic likeness. Historians of this sculpture have seen the nearest equivalent in Lamartine's description of Balzac as someone who had 'the face of an element; big head, hair dishevelled over his collar and cheeks, like a wave which the scissors never clipped; very obtuse, eye of flame, colossal body . . .'

As early as 1894 the divisions between those who trusted Rodin's artistic judgment and those who regretted the commission initiated by the controversial President of the Society, Emile Zola, were formed along political and aesthetic lines. The pro-Rodin Naturalists (who were also defenders of Dreyfus) faced the Symbolists, who were fuelled by the Rosicrucians and were equally anti-Zola.[1] After the Committee rejected his monolith, Rodin removed it to his home in Meudon and refused to agree to its supporters' suggestion that it be cast in bronze. Numerous artists contributed to an abortive subscription including Alfred Sisley, nearly on his deathbed, and Carpeaux's widow who offered a choice of two of his sculptures to raise money. On the eve of the war Rodin considered having the sculpture cut in nearly black granite like Egyptian statues.[2] He himself questioned the thickness of the neck but told a reporter: 'But, after all, have you viewed my statue from a distance of about twenty paces to the right?'[3] It was finally cast in bronze in 1930 (for Antwerp) and in 1939 for Paris.

Eduard Steichen's moonlit photographs accord with Rodin's desire to commune with his strange creation which, he explained,

is inseparable from its surroundings. He is like a veritable living being. The same was true earlier with my *Walking Man*. The interest lies not in the figure itself, but rather in the thought of the stage he has passed through and the one through which he is about to move. This art that by suggestion goes

beyond the model requires the imagination to recompose the work when it is seen from close up.[4]

The literature on Rodin's *Balzac* is extensive and includes the catalogue to the exhibition *Rodin & Balzac: Rodin's Sculptural Studies for the Monument to Balzac from the Cantor, Fitzgerald Collection*, spring 1973 (essays by Albert Elsen and Stephen C. McGough), and an analysis of the various studies by Athena Tacha Spear in *Rodin Sculpture in the Cleveland Museum of Art*, Cleveland, Ohio, 1967.

1. See 'Balzac' by Joan Vita Miller and Gary Marotta in the catalogue *Rodin: The B. Gerald Cantor Collection*, Metropolitan Museum of Art, New York, 1986 for a discussion of this division.
2. Cladel, *Rodin Sa Vie*, pp.216–17 and 226.
3. *New York Evening Sun*, 28 May 1898.
4. Rodin in *La Revue*, 1 November 1907, p.105 (quoted in Elsen, *Rodin*, the Museum of Modern Art, New York, 1963, p.102).

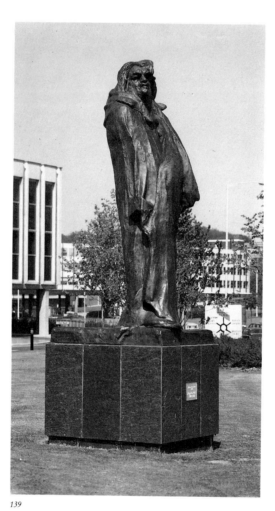

139

140 *pl. 272*

The Walking Man *c.*1900

Bronze, 84 × 28 × 57 cm

K. Delbanco Collection

As discussed in chapter three, above, most scholars have come to accept that although Rodin used the legs of his *St John the Baptist* (1878–80), and possibly a torso based on an antique figure, changes to the surface, the amputation of head and arms and the alignment were probably decisions made prior to its first exhibition in 1900.[1] Certainly the *Walking Man* meant a great deal to Rodin in this period when he was obsessed with partial figures. It was enlarged in 1905 to 2.28 metres and photographed in 1912 in the courtyard of the Palazzo Farnese.

Rilke's famous description of Rodin in this period conveys the gnarled look of this sculpture:

Oh what a lonely person is this aged man who, sunk in himself, stands full of sap like an old tree in autumn! He has become deep; he has dug a deep place for his heart, and its beat comes from afar off as from the centre of the mountain. His thoughts go about in him and fill him with heaviness and sweetness and do not lose themselves on the surface. He has become blunt and hard toward the unimportant, and he stands among people as though surrounded by old bark. But to what is important he throws himself open, and he is wholly open when he is among things or where animals and people touch him quietly and like things.[2]

1. De Caso and Sanders summarize the argument and literature, pp.78–80.
2. Letter by Rainer Maria Rilke to Lou Andreas-Salome, 8 August 1903 published in *Auguste Rodin*, Curt Valentin Gallery, New York, 1954.

The muses

141

Iris, Messenger of the Gods *c.*1890

Bronze, 46 × 42 cm
Founder: Alexis Rudier

The Josefowitz Collection

There are a number of small studies of Iris, of which this one is the most famous, having been enlarged and associated directly with the *Monument to Victor Hugo*. Another, very similar study with a head (49 cm high) was cast by the Musée Rodin in 1969 and several more exist in plaster (see cat. no. 143). Although the *chahut* dancers at the Moulin Rouge fascinated Rodin, in particular Grille d'Egout, they were of course, revealing their garters and bloomers and, as Symons described it, 'the naked skin shown above their stockings when they flung their legs at arm's length from their

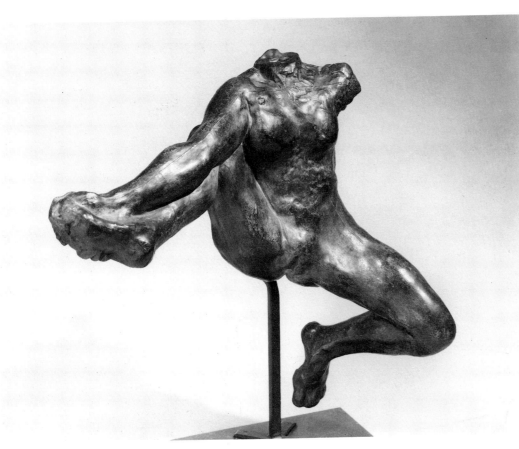

141

heads and when they did the "grand écart".[1]
The transferral to sinewy muscle was one probably informed by studio models, not these actual dancers.

1. Arthur Symons, *Parisian Nights*, London, 1926.

142 *pl. 303*

Flying Figure *c.*1890–91

Bronze, 21 × 36 × 13 cm
Founder: Georges Rudier
Cast twelve

The Josefowitz Collection

By altering the angle of the left leg of the female figure in *Avarice and Lust*, Rodin transformed his frail victim into an organic object, part tree, part wind-spirit and part dancer. From the 1890s onwards Rodin's interest in modern dance, stimulated by the Americans Loïe Fuller and Isadora Duncan and above all by Hanako's power to stand for hours on one leg, frequently resulted in inventive positions suggestive of the structural building blocks of geometry, architecture or nature. Thus, we find models in backbends conceived as bridges, others doing handstands forming tripods, and dancers in tree-like formations.

143

143

Study for Iris, Messenger of the Gods 1890 (?)

Plaster, 40 × 27.3 × 25.2 cm

Musée Rodin (S706)

The best-known of all the sculptures bearing this title is the bronze (headless in some versions) of a woman balancing on her left foot, with her right leg splayed out and held with the hand to display the genitals. Despite the similarity in the pose, the plaster version seen here does not attain the same virulence, as the arms and the legs are missing. This work and the variations on it should presumably be seen as preparatory movement studies for the other sculpture.

144 *pls. 206, 207*

Iris, Messenger of the Gods *c.*1890–91

Bronze, 83.5 × 80.5 × 40.5 cm
Founder: Georges Rudier

Private Collection

Like other studies, *Iris* was enlarged by Lebossé and exhibited independently of its original destination, in this case the *Monument to Victor Hugo*. Maillard saw it in the studio in the nineties, raised on a 'stalk of iron' as it is displayed today at the Musée Rodin. He justified its audacity to his readers at some length:

Il vit au-dessus des minces conventions mondaines qui enchaînent les rapports des êtres entre eux à une foule de considérations ne relevant ni de la morale ni de la beauté. Son rôle est plus altier, et il ne plie que sa personne 'a ces coutumes, il en excepte son art: les corps de femme donnant las plus complète gamme de toutes les volupfes, il en analyse les formes dans leur nudité, experiment les différentes phases des harmonies physiques, résumés de certitude et de passion.[1]

Intended initially to be a winged muse, the back was left rudimentary. The usual explanation that it was modelled from an acrobat cannot be disproved, but the pose is natural for a supple reclining nude.[2] There are many drawings where the model poses with a foot in hand or legs split, such as the line drawing D842, *Woman with a foot in her hands* (D4032), *Zephyr* (D4410) and many re-oriented to increase the drama, like *Psyché* (cat. no. 226).

1. Léon Maillard, *August Rodin, Statuaire*, Paris, 1898, p.127.
2. Grappe, *Catalogue de Musée Rodin*, p.85 and Elsen, *In Rodin's Studio*, no. 96.

145 *pl. 208*

Crouching Woman *c.*1891

Bronze, 53 × 96 × 53 cm

Trustees of the Victoria and Albert Museum
(A.40–1914)

Grafting together parts of several figures,
Rodin made this unusual pose self-support-
ing, the branch-like, horizontal right leg and
perpendicular, folded left leg on the ground
and the severed left arm and lumpen head at
the apex of the tripod. The course texture and
lack of delicacy are found also in *Earth* as well
as in the contemporaneous *Tragic Music*. The
work is sometimes called *Acrobat* and is usual-
ly associated with those studies collectively
titled 'Iris'. Alan Gouk in his article 'Matisse
as a sculptor' juxtaposed a reproduction of this
work and Matisse's *Reclining nude I (Aurore)*
(1907) and convincingly argued that far from
Rodin's art failing to anticipate Matisse's
search for a way of 'replacing explanatory
details by a living and suggestive synthesis', it
did just that.[1]

This cast is not inscribed. There are photo-
graphs of the work in clay in the studio and a
cast of the enlarged head (cat. no. 147) was
also part of Rodin's gift to the Victoria and
Albert Museum.

1. Alan Gouk, 'Matisse as a sculptor. Part one: "The
 Serf"—Cézanne, Rodin, Matisse', *Artscribe*, March–
 April 1985, pp.46–7.

146

The Tragic Muse 1890

Bronze, 78 × 117 × 125 cm
Founder: Griffoul, Paris
Signed on the rock at the right: 'Rodin'

Musée d'art et d'histoire, Geneva. Gift of the
artist (1896–10)

This ungainly figure was dated by Grappe to
1885; however, its leaping action is similar in
style to the studies of acrobats and dancers
*c.*1890, for example the drawing *Nude Woman
seated, her arms raised* (D1795).[1] The scale also
suggests it was begun expressly for the *Monu-
ment to Victor Hugo* in 1890 to replace the coy
kneeling girl on the left who represents
Hugo's *Les châtiments*.[2] Trying to explain the
inspiration, Rodin's friend Mathias Morhardt
said: 'Je pense donc que le sculpteur a voulu
reproduire un de ces cadavres' like those he
had remembered from Naples (or Pompeii).[3]
Following the exhibition in February 1896
at the Musée Rath, Geneva, of *Puvis de
Chavannes, Auguste Rodin and Eugène Carrière*
(forty-three plasters, bronzes, drawings, etch-
ings and photographs by Rodin were among
the 193 exhibits), the city decided to purchase
a copy of *Le poète (The Thinker)*. Rodin agreed
to charge only the cost of casting on condition
they also accept the *Tragic Muse*, then called
Femme accroupie. The sculpture was intensely
disliked, called 'a goiterous woman' and after

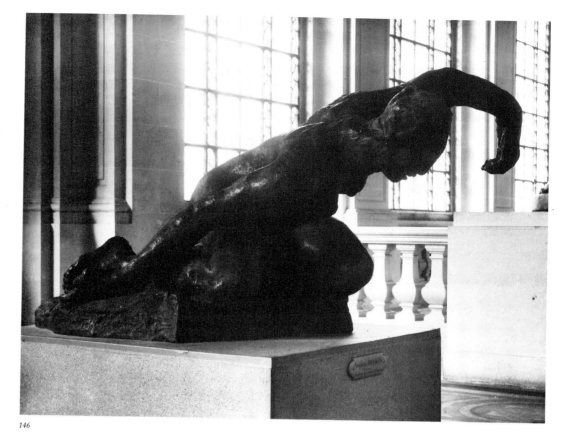

146

being hidden away and then placed outdoors
in the Observatory, eventually found its pre-
sent home.[4] Rodin at one time displayed it on
top of a fluted column (see photograph, cat.
no. 243).

1. Grappe, *Catalogue du Musée Rodin*, no. 129. Rosalyn
 Frankel Jamison also accepts this date, *Rodin Redis-
 covered*, pp.112–13, but discusses it in the context of
 Rodin's expression of 'the poet's communion with the
 voices of nature, humanity, and God'.
2. Roos. 'Rodin's *Monument to Victor Hugo*', p.22.
3. Letter by Morhardt to *La Tribune de Génève*, 9 August
 1897.
4. Charles Goerg, 'En 1896, Auguste Rodin offre trois
 sculptures à la ville de Génève', Bulletin du Musée
 d'art et d'histoire, Geneva, 1985 and Alain Beausire,
 'Les expositions de Rodin en Suisse', *Rodin*, Fondation
 Pierre Gianadda, Martigny.

147 *pl. 306*

Head of Iris *c.*1910

Bronze, 58.4 × 31.8 × 42.5 cm
Founder: Alexis Rudier
Inscribed on base with founder and 'A. Rodin'

Trustees of the Victoria and Albert Museum

Another of the sculptures presented to the
Victoria and Albert Museum by Rodin in
1914, this head was shown in 1909 and 1910,
as well as the previous year at the Secessione
in Rome, before coming to the exhibition *Art
Français. Exposition d'Art Décoratif Contem-
porain, 1800–85* at Grosvenor House in
London in July 1914 (no. 90).[1] Grappe sug-
gests that the head was intended for a colossal

version of the *Iris, Messenger of the Gods*,
although it relates more closely to that on
Crouching Woman. Lebossé was working on
numerous enlargements in the period 1910–
12, including one of the *Groupe châtiment*
which was awaiting Rodin's inspection and
modifications at the end of January 1912.[2]
Rodin made several colossal heads after
1900, including that of Jean d'Aire (64 cm
high), shown in 1905, and of Pierre de Wies-
sant (82 cm high), shown in 1909. These have
associations with classical art, but the model-
ling of *Iris* is so rough and primitive in spirit
that it is closest of all the haunted look of the
Shades, the centaurs and the head of the fallen
warrior in the *Call to Arms*, and to late
drawings made with a few quick lines.[3]

1. Ronald Alley, *Catalogue of the Tate Gallery's Collection
 of Modern Art other than British*, London, 1981, p.642.
2. Grappe, Catalogue du Musée Rodin, no. 255 and *Le
 monument des Bourgeois de Calais*, nos. 101 and 103.
3. Goupil, *L'Avenir*, pl. 18; *Centaur enlevant deux femmes*,
 pl. 31 and pencil drawings such as D1212.

148 *pl. 215*

The Spirit of Eternal Repose (*Génie
Funéraire***)** *c.*1899

Bronze, 86.4 × 38 × 31.8 cm
Founder: Coubertin
Cast two

B. Gerald Cantor Collections

An armless version with head, approximately
on this scale, was shown in Rodin's 1900

exhibition, described as 'une des plus récentes, d'une intense mélancholie, d'une grâce pénétrante et funèbre destinée à un monument commémoratif'. According to oral tradition this muse came from a terracotta, probably cast for Rodin by a Belgian friend, Thomas Vincotte, in 1877, so the break at the waist may have been accidental.[1] Asked to make a monument to his friend Puvis de Chavannes in 1899, Rodin returned to his early figure in a quiet, Hellenistic pose; at some point it stood in the doorway of his studio at Meudon, blending with the greenery, as Symons remarked. Before 1904 Rodin assembled the figure (now with arms), the bust and a branch of an apple tree, to make an extraordinary tableau known through photographs. Rodin's friends responded to its poetic logic:

the bust of the great painter (previously executed during his life) is placed upon a plain table, as the ancients placed those of their dead upon little domestic altars. A fine tree loaded with fruit bends over and shades the head. Leaning on the table behind the bust is a beautiful nude youth who stands dreaming. Placed on the ground in a garden this votive monument would show how much delicacy and caressing lightness sometimes lies in Rodin's sombre and pathetic thoughts.[2]

There are several small studies related to this monument in the reserve collection, still with their twigs (too fragile to travel), which were shown in *Rodin Inconnu* in 1962 (no. 126)[3]. The spindly youth is seated and swooning while a muse hovers over him.

1. *Rodin*, Martigny, 1984, p.122.
2. Howard C. Rice, Jr., *Glimpses of Rodin*, Princeton University, 1965, quoting Camille Mauclair from the René Cheruy papers, p.40.
3. *Rodin Inconnu*, Musée du Louvre, Paris, 1962.

149 *pl. 224*

Head of a Muse: Study for the 'Monument to Whistler' *c.*1905

Plaster, 10 cm high

The Metropolitan Museum of Art, New York. Gift of the artist (1912. 12.12.7)

Gwen John (1876–1939) was a student at the Slade School of Art where Rodin was well known through the Slade Professor, Alphonse Legros. The Slade students and ones from the Royal College pulled Rodin's carriage through the streets of London in 1902 after the banquet at the Café Royal to honour the acquisition by the South Kensington Museum of *St John the Baptist*.[1] Gwen John exhibited three paintings at the Carfax Gallery in 1900 (where Rodin's work was also shown) causing her brother to write to William Rothenstein of her work: 'the little pictures to me are almost painfully charged with feeling'.

Apart from the heads and full-length studies for the unfinished *Monument to Whistler*, there are drawings of Gwen John (drawing, or writing) in the Musée Rodin, as well as a group of her own watercolours of cats.

Books on Gwen John have naturally stressed the importance of Rodin in her life, justified in view of the passionate letters, signed Mary John, in the Archives. Rodin, however, during this period, had numerous mistresses and talented admirers and between 1908 and 1912 succumbed to the domineering influence of the Duchess of Choiseul.

1. Adrian Stokes wrote an account of this event. Rothenstein in *Men and Memories*, London, 1932, vol. II, p.65.

150

Head of Muse *c.*1906

Plaster, 24.6 × 19.2 × 24.2 cm

Musée Rodin (S1913)

The various sketches relating to the Whistler monument include numerous studies of heads modelled by Gwen John. The dimensions of the terracottas and plasters vary considerably, and there are variations in the handling of the hair, the lips (sometimes closed, sometimes parted to reveal the teeth) and the eyes (sometimes closed, sometimes open wide). Two marbles, one of them unfinished, were also executed, and give us some idea of what the monument might have looked like.

150

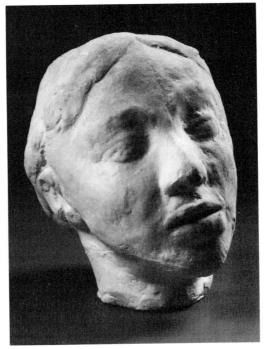

151 *pls. 221, 222*

Project for a Monument to Whistler *c.*1903–8

Bronze, 65 × 33 × 34 cm
Founder: Georges Rudier, 1967

Stanford University Museum of Art (74.52). Gift of the B.G. Cantor Foundation.

The life-sized draped Victory figure with its classical origins was damaged in a flood in the studio in February 1910. A touched-up photograph printed in *Excelsior* on 16 November 1910 appears to show Rodin working on this intermediate version of the *Monument to Whistler*. The particularity of the physical type, with small breasts and long legs, seems faithful to its living model, Gwen John, who was Rodin's inspiration from the begining. Ungainliness was part of his definition of the obsessiveness which he recognized and found beautiful in talented female acquaintances.

152

Standing nude with raised leg, writing on her knee

Graphite and watercolour on cream paper, 33 × 25.2 cm

Musée Rodin (D4786)

The stance of the model recalls that of the *Muse* in the unfinished monument to the memory of Whistler, which Rodin began sculpting in 1904. Gwen John may also have posed for this drawing. She wrote to Rodin on many occasions between 1904 and 1914.

152

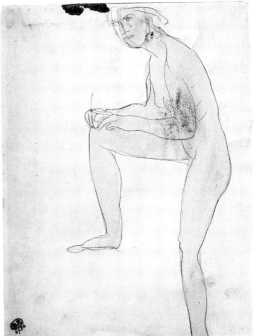

Transitional drawings

153 *pl. 245*

Souls in Purgatory (*Les âmes de Purgatoire*) 1893

Drypoint on paper, 15.5 × 9.8 cm

Hunterian Art Gallery, University of Glasgow. J.A. McCallum Collection

This image appeared as the frontispiece of the second volume of Gustave Geffroy's *La Vie Artistique* (Paris, 1893), as a wood engraving by Beltrand and Dete (between plates 84 and 85) in Léon Maillard's 1898 biography of Rodin, and in Roger Marx's article of 1902 in *Gazette des Beaux-Arts*. Representations of the three graces of classical art as three maidens arm-in-arm was common in the nineteenth century but Rodin's sketch is unusual for him in that it hints at the hundreds of informal sketches of embracing women, drawn with his eye on the model, soon to come. The similar drawing D1964 was inscribed with the alternative titles 'limbes, egalité, fraternité, limbes/liberté, Ugolin, trois grâces, la guerre'—thus a compendium of contemporary themes. In this ink sketch loose parallel lines are treated as if hatching. The pose of the girl on the left is similar to that in the drawing *Castor and Pollux* (Philadelphia Museum of Art), as well as more rudimentary studies of male figures in profile.[1]

1. Varnedoe in *The Drawings of Rodin*, p.77.

154 *pl. 248*

Twilight (*Le Crépuscule*)

Graphite, estompe, pen and brown ink wash with watercolour on cream paper, 17.8 × 11.3 cm
Inscribed in graphite, lower right: 'le crépuscule'

Musée Rodin (D4278)

This and the next three drawings can be dated to the early 1890s. Their distinguishing features are their great delicacy of line and the vivacity of the colours. The theme of the Sapphic couple appears. The marginal inscriptions added by Rodin became symbolic.

155 *pl. 246*

Woman lifting dress

Pen and black ink wash on watermarked cream paper, 17.7 × 11 cm

Musée Rodin (D2169)

Cf. cat. nos. 154 and 158.

156 *pl. 249*

Woman with swirling veils

Graphite, pen, red and brown ink, red and brown ink washes, with watercolour and gouache on watermarked cream paper, 17.5 × 11 cm

Musée Rodin (D4309)

Cf. cat. nos. 154 and 158.

157

Woman bending in front of a standing woman

Graphite, pen, red and brown ink, red ink wash, with watercolour and gouache on watermarked cream paper, 17.7 × 11.3 cm

Musée Rodin (D4370)

Cf. cat. nos. 154 and 158.

158 *pl. 250*

Five nude studies of woman dressing

Graphite, watercolour and gouache on squared and watermarked cream paper, 35.2 × 24.8 cm
Part of album XLI

Musée Rodin (D1524)

This drawing does not really seem to belong to what might be termed the 'transitional' series. In the 1880s, Rodin's imagination was all-powerful, but later he needed to observe a model at her toilet, or dressing or undressing. Towards 1890, his palette becomes very bright and luminous.

These studies predate the works inspired by Octave Mirbeau's *Le Jardin des Supplices* in about 1898, but the format of the paper is already that of the well known watercolour drawings.

159 *pl. 266*

Mme Séverine 1893

Charcoal, 32.1 × 27 cm

Szépművészeti Muzeum, Budapest (1935–2767)

Uncharacteristically, Rodin drew portraits (and sculpted one head) of the socialist journalist Caroline Rémy (1855–1929) who wrote under the name Séverine in the paper she ran from 1885–88 *Cri du peuple*.[1] Supposedly these studies were made in gratitude for her defence of Rodin's work, or possibly to commemorate the publication of her first book in 1893.[2] She delivered a eulogy at Rodin's funeral, allegedly at the end kissing a rose and throwing it on the grave.

Each drawing has parted lips signalling the Romantic look of introspection. The spread of curls suggests the way Rodin frequently liked to see hair depicted in marble, by raked chisel

marks across the furrows. In view of her features, the head of Séverine is also called *Mulâtresse*.

1. *Rodin et les écrivains de son temps*, p. 129. The Musée Rodin drawing D2016 is close to this one in Budapest.
2. Athena Tacha Spear, *Rodin Sculpture in the Cleveland Museum of Art*, Cleveland, Ohio, 1967, pp.31–2.

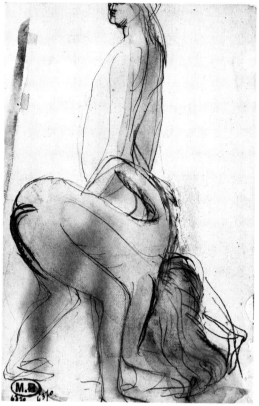

157

The moving model

160

Two nude studies of a woman lying on her back

Graphite and estompe on cream paper, 31.2 × 20.1 cm
Part of Album XVII

Musée Rodin (D842)

Rodin appears to have drawn and reworked this study because he was attracted to the balanced proportions of the pose. Traces of the guide-lines add rhythm to the drawing's harmony.

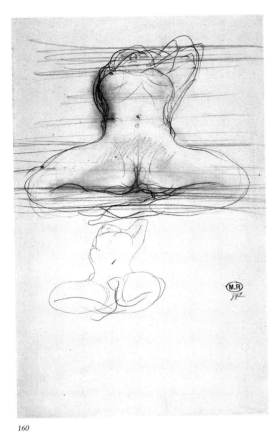

160

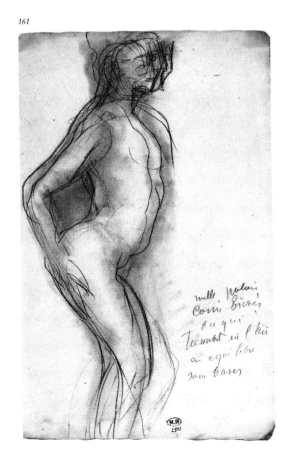

161

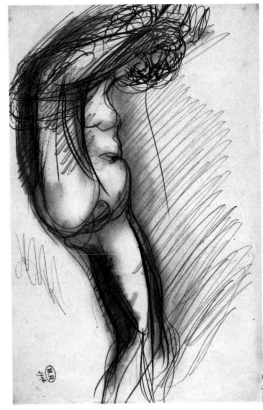

163

161

Woman in profile, hands on buttocks

Graphite and estompe on watermarked cream paper, 38.3 × 24.2 cm

Inscribed in graphite, lower right: 'Mille paliers coins brisés tiennent en l'air en équilibre sans bases'

Musée Rodin (D2893)

The drawing may represent the model Alda Moreno, a dancer at the Opéra Comique; Rodin executed a series of drawings of her in 1912. Letters addressed to the sculptor between 1910 and 1917 seem to confirm this suggestion.

In his late drawings, Rodin executes his nudes in pencil, and then reworks them quite heavily with estompe to bring out the myriad facets of the light playing on the bodies.

162 *pl. 275*

Cupid taking wing (*Départ de l'Amour*)

Graphite and watercolour on cream paper, 32.5 × 24.9 cm
Inscribed in graphite, right and centre: 'départ de l'Amour'; bottom: 'théâtre japonais'

Musée Rodin (D3970)

Rodin readily associated the word 'Japanese' with the image of blood, and therefore with Octave Mirbeau's *Le Jardin des Supplices*, but he makes the telling slip of confusing Japan with China.

The artist is also thinking of the myth of Cupid, and portrays him as he takes wing. It is possible to interpret one detail as a quiver.

163

Nude in profile with a leg raised

Graphite and estompe on cream paper, 31.3 × 20.2 cm

Musée Rodin (D2902)

Behind the moving figures, we can see a paler under-drawing in estompe heightened with heavy pencil to throw the silhouette into relief. The combination of different techniques results in a very powerful drawing.

164 *pl. 271*

Standing woman with arms and legs apart

Graphite on cream paper, 31 × 20 cm
Part of Album XXX

Musée Rodin (D1212)

165 *pl. 228*

Standing woman, hands behind back

Graphite on cream paper, torn at the right, 31 × 20.7 cm

Musée Rodin (D2377)

One senses here that the artist's hand was quick enough to capture by rapid lines the successive movements of the body in a great, spinning image.

166

Woman lifting a dress over her head

Graphite and estompe on cream paper, 31.1 × 20 cm
Stamped in violet, lower left

Musée Rodin (D2718)

Rodin was drawn on numerous occasions to the theme of a woman pulling her garments over her head or, more rarely, her feet and to the fleeting movements involved.

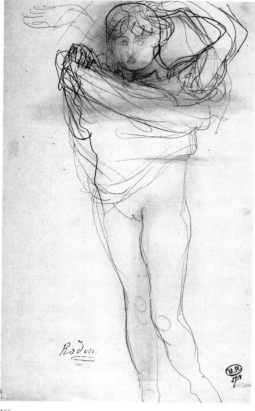

166

167 *pl. 270*

Male nude with arched back, hands and feet on ground

Graphite on cream paper, 36 × 24.2 cm
Inscribed in graphite, below left: 'bas'

Musée Rodin (D5392)

The inscription 'bas' (bottom) to the sides of the sheet does not really correspond to the trajectory of the model's pose. Rodin himself is proposing a different reading of the drawing. Certain works can in fact be interpreted in four different ways if they are viewed from different angles. Occasionally, Rodin adds at least two inscriptions to suggest different readings.

168 *pl. 251*

Kneeling woman from behind, head thrown back

Graphite on cream paper, with spots of watercolour, 31.3 × 20.6 cm
Inverted graphite inscription, top: 'bas'
Part of Album VI

Musée Rodin (D523)

When Rodin wanted to emphasize a particular pose, he sometimes repeated all or part of a drawing in a corner of the sheet.
 Cf. cat. no. 167.

169 *pl. 252*

Kneeling woman from the front, head thrown back

Graphite on cream paper, 31.3 × 19.9 cm
Part of Album X

Musée Rodin (D633)

A rather similar drawing, without the repeated motif, was published by the Manes company in an issue of the review *Volne Smery* devoted to Rodin, Prague, 1901.
 Cf. cat. no. 168.

170

Le Jardin des Supplices 1899

One of the 155 copies on vellum by Masure et Perigot

Trustees of the Victoria and Albert Museum

At Ambroise Vollard's instigation, Rodin agreed in February 1899 to illustrate an edition of his friend Octave Mirbeau's book. Twenty lithographic reproductions (eighteen in colour) of recent drawings were prepared by Eugène Clot and published in 1902. Each plate is protected by a tissue paper sheet with a line reproduction of the drawing, similar to the translations reproduced in *La Plume* in 1900.
 In the story, a young French deputy is sent to the Far East after a scandal and meets on board the ship Clara, an Englishwoman. Their affair leads them into a Chinese torture Garden. As Thorson has explained, the novel alludes to political satire and *fin-de-siècle* eroticism. In juxtaposition with Mirbeau's colourful phrases Rodin's quick drawings of female lovers and kneeling and reclining women swooning with passion acquire a more suggestive air. Consequently the Sapphic couples hint at masochism and the theme of unabashed self-gratification which was to become the focus of those private drawings Rodin made in quantity. Contour drawings with flat wash are mixed with those with pencil annotations and wash on the hair, thus securing fixed dates for the onset of the basic late-drawing modes.
 The cross-over between Rodin and Matisse through their respective collaborations with Clot in this period has been remarked upon, by Albert Elsen and Pierre Schneider among others.

1. Thorson, *Rodin Graphics*.

171

Eros: bas-relief

Graphite and watercolour on cream paper, 50.6 × 32.5 cm
Inscribed and signed in graphite, lower right: 'Eros: bas-relief: A. Rodin'

Musée Rodin (D5719)

This is a good example of how Rodin liked to combine figures, even in his drawings. The image of a young adolescent stretching out reappears in a lithograph illustrating the following passage from Octave Mirbeau's *Le Jardin des Supplices*: 'You will not say that this evening, when you are in my arms . . . and when I love you.' (1902, p. 29). In the lithograph, however, the pose adopted by the kneeling woman is very different. The same individual poses reappear in other drawings, and especially in the cut-outs. Rodin's desire to achieve a tangible feeling of relief in his cut-outs is underlined by the inscription: 'Eros: bas-relief.'

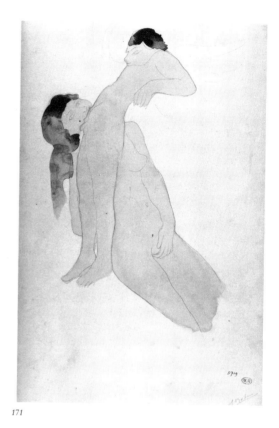

171

172 *pl. 261*

Sapphic couple

Graphite and watercolour on cream paper, 32.5 × 24.7 cm
Signed in graphite, upper left: 'A. Rodin'

Musée Rodin (D4649)

This mutal outburst of desire is not without an element of coquetry. Sapphic couples often appear in Rodin's drawings; he was steeped in the poetry of Baudelaire and Pierre Louys.
 It should be noted in passing, that the signatures on the drawings are later additions, and that often they are not in Rodin's own hand.

173 *pl. 278*

Sapphic couple in profile, one nude leaning on the shoulder of another

Graphite, estompe and water colour on cut cream paper, 31.3 × 15.6 cm

Musée Rodin (D5254)

This cut-out (cf. cat. no. 175) is reminiscent of a plate in the Germinal album published by La Maison Moderne in 1900. Rodin was represented, together with other artists, by a composition to which he seems to have been drawn on a number of occasions, by the arabesque of one body supporting another.

174 *pl. 265*

Crouching nude *c.*1900–5

Graphite and watercolour on paper, 22 × 32 cm

Stanford University Museum of Art. Gift of B. Gerald Cantor (69.155)

About 1900 Rodin favoured this downward view of a crouching woman with extended arm; variations include those with a wobbly line and a stylized contour around the hips, some with hair darkened by black wash as well as those with the deeper Sienna in-filling that flattened the shape and made the figure creature-like, as with the drawing reproduced in *Le Jardin des Supplices*. The model on all fours goes through the same permutations.

175 *pl. 264*

Woman in profile squatting on her heels, with one arm outstretched

Graphite, estompe and watercolour on cut cream paper, 19.5 × 30 cm

Musée Rodin (D5214)

At some point in the 1900s, Rodin cut out some one hundred drawings, and made collages of many. This reveals a great curiosity as to the possibilities opened by drawing. As early as 1880, if not sooner, Rodin had already shown a desire to free his drawings from the paper that imprisons them. It is well known that Matisse later put the same technique to great use.

176 *pl. 284*

The rising sun (*Quittant la terre*) *c.*1900–5

Graphite with watercolor, 48.3 × 31.8 cm

The Art Institute of Chicago. The Alfred Stieglitz Collection (1949.902 (R 9592))

This drawing, inscribed with its present title, was shown at the Photo-Secession Gallery in 1910, as one of two in the 'sun series', and was reproduced in *Camera Work*, April–July, 1911, p.57.
 It belongs to the group of drawings of long-legged, rubbery bodies which the wash flattens and makes more pattern-like (eg. D4775, D4776, D4719 'Egypte', D4681 and the bizarre examples with stump heads like D4672). The resemblance to illustrations in Mirbeau's *Le Jardin des Supplices*, commissioned in 1899 (for example, *Midi* (D4971)) may indicate a starting date for the practice.

177 *pl. 279*

Prehistoric

Graphite, estompe and water colour on cream paper, torn centre right and pasted to a second sheet of paper, 50.8 × 32.3 cm. Inscribed in graphite, upper right: 'préhistorique'. Signed, lower right: 'A. Rodin'

Musée Rodin (D4757)

There is something monumental and primitive about this rearing, horizontal body; the impression is heightened by the foreshortening and by the fact that the pose is difficult to read at first sight.
 This is not the only drawing in which Rodin overwhelms his model with aquatic colour.

178 *pl. 258*

The Embrace *c.*1900

Graphite pencil and watercolour on cream paper, 32 × 24cm

Private Collection, London

Rodin's consuming interest in female couples began in the 1880s, and by the period of this drawing, *c.*1900, the ample bodies of the embracing or playful models are often merged to form a single mass, amplified by the wash and punctuated by dark blobs for the coiffure. The relative proportions and faces of this couple resemble the couple with the same thin girl riding the shoulders of a fatter one (D5025).[1]
 Sometimes the juxtapositions were created by tracing women of different scales onto a common sheet. The nymphette with arched back (cat. no. 171) reappears, almost mechanically, numerous times (D5705, D5715, D4754).

1. Claudie Judrin in *Auguste Rodin. Drawings and Watercolours*, pl. 35.

179

The Good Fairy (*Le bon genie*) *c.*1900 (carved 1907)

Marble, 74 × 81 cm

Ny Carlsberg Glyptotek, Copenhagen (IN 1398). Bought from the artist in 1907

In order to increase the height of the upper torso of the kneeling girl, Rodin appears to have grafted on a second cast resulting in the torso having two pairs of breasts. The bizarre effect is apparent in the plaster but less obvious in marble where the smoothed contours with their lack of anatomical definition gives this figure an apparitional generality, reinforcing the confessional reference.
 The first title for this work, *Young Girl confiding her Secret to Ceres* (or Isis), was typical of an almost reactionary period in Rodin's art, when he indulged in mythological literary embellishments for the life studies; as Grappe explained: 'Il semble, à ce moment, que les thèmes plus ou moins empruntés a l'Hellade ne lui fournissent plus qu'une sorte d'*excitation* cerebrale, un motif melodique susceptible d'orchestration, un souvenir nostalgique `a renover, un beau nom.[1] In a similar sculpture, *The Bad Spirit*, of 1899, a maiden is practically suffocated by a figure who leans over her from behind, whispering evil enticements.

1. Georges Grappe, 'Ovide et Rodin', *L'Amour de l'Art*, Paris, 1936.

180 *pl. 254*

Seated girl on knees (drawing no. 6) before 1908

Graphite with watercolour, 32.5 × 25 cm

The Art Institute of Chicago. The Alfred Stieglitz Collection (1949.895 (R 9592))

This drawing belongs to a family of drawings with the same silhouette but widely various thereafter. The addition of wavy hair, the stressed lines of the hip, and more modelling makes the Musée Rodin girl (D3013) sit firmly on the ground, whereas this rendering with a pool of wash for the hair and another for the body is more pattern-like and floating. The Chicago drawing was among the 58 works in Rodin's exhibition at the Photo-Secession Gallery (291'), 2–21 January 1908, which was followed in April by Matisse's first exhibition in New York composed of works on paper. In 1908 Rodin and Matisse occupied spaces at the complex on the boulevard des Invalides which included the Hôtel Biron, but their personal contact was probably limited (Matisse left in September 1909 to move to Issy-les-Moulineaux). Both artists showed at the Galerie Bernheim-Jeune.
 The 1908 exhibition at '291' was a success with artists and most reviewers, although Rodin's informal style was criticized by a number of academics. It was the first of a major European artist and only the second of a fine artist in the gallery which previously had been devoted to photography.[1]

1. William Innes Homer, *Alfred Stieglitz and the American Avant-Garde*, London, 1977, pp.58–9, pl. 26.

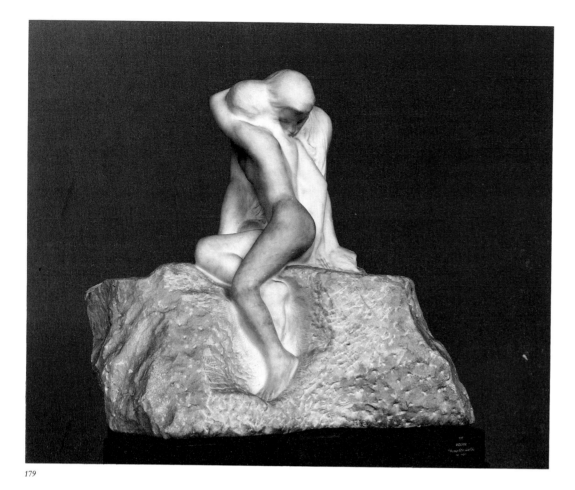

179

181

Woman sitting on her heels, supporting herself on her hands

Graphite and estompe on cream paper,
30.9 × 20.3 cm
Stamped in violet, lower right: 'Rodin'

Musée Rodin (D3013)

182 pl. 263

Crouching nude before 1900

Lead pencil and watercolour on paper,
23 × 31 cm

Herman Collection

The overhead view of the model's body and the pools of watercolour resemble closely the *Crouching nude* in the Philadelphia Museum of Art which was inscribed by Judith Cladel: 'cette acquarelle est l'original du dessin réproduit sur la couvature de mon livre, Auguste Rodin. L'Oeuvre et L'Homme. Paris Juillet 1925.'[1] Varnedoe calls this work a Type II drawing identified by simplified contours and interiors filled watercolour wash.

1. Varnedoe in *The Drawings of Rodin*, p.91, pl. 78.

181

183 pl. 225

Standing woman with hand in hair

Graphite, estompe and watercolour on cream paper, 32.8 × 24.8 cm
Part of Album XLI

Musée Rodin (D1545)

Here, Rodin uses his pencil as though he were adding colour to the real tints of the watercolour and the gouache. The clarity of the graphite combines with the mellowness of the estompe to add to the relief of the drawing.

184 pl. 289

Nude with serpent *c*.1900–5

Watercolour and pencil, 32 × 24.7 cm

Collection, The Museum of Modern Art, New York. Gift of Mr and Mrs Patrick Dinehart (217.63)

In spite of Rodin's claim to draw spontaneously from random poses of the model, there is hardly any drawing, late or early, that is unrelated to any other. This drawing, we discover, borrows the silhouette of the reclining girl seen from the front who was drawn twice on the sheet D1353 (cat. no. 185). In the transfer Rodin smoothed the contour and added the sunrays and serpent. The sexual references are reinforced by the underwater context of the lower half with the sponge-like, blue-green stains that contribute to an ambient eroticism that works in this drawing whereas in others it seems superfluous or merely awkward. John Elderfield wrote of *Nude with serpent*: 'Rodin, that is to say, by modifying the form of his technical as well as imagist expression, developed the initial theme of sensual innocence into one of sexual experience, while yet allowing their coexistence in this mysteriously ambiguous work as superimposed layers of opposing meaning.'[1]

1. John Elderfield, *The Modern Drawing*, The Museum of Modern Art, New York, 1983, pp.38–9.

185 pl. 290

Two nude studies of women lying on their backs, legs apart and tucked beneath them

Graphite on cream paper, 31 × 19.8 cm
Part of Album XXXIV

Musée Rodin (D1353)

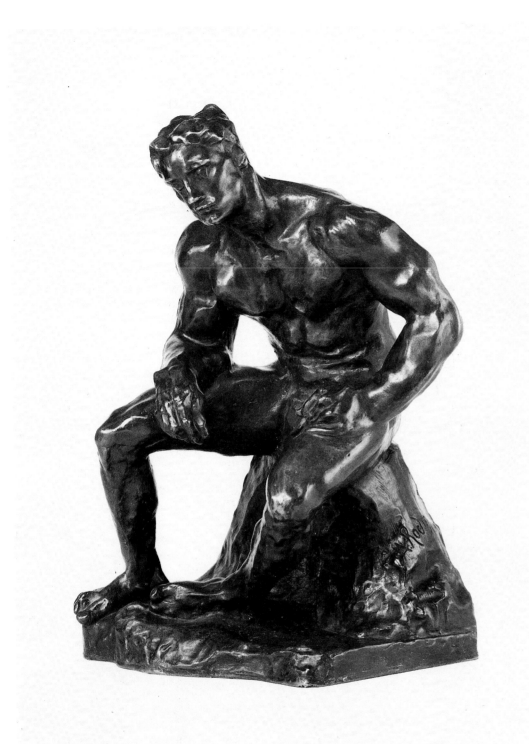

188

Woman removing her dress

Plaster, 45.5 × 18.4 × 16 cm

Musée Rodin (S683)

The definite analogy between this figure and *Woman pulling dress over head* suggests a similar date, *c*.1900.

188

Athlete 1901–4

Bronze, 42 cm
Founder: Alexis Rudier
Cast three

Axel Martens

The circumstances of this work were documented by the model, Samuel Stockton White, III from Germantown, Pennsylvania. While a student at Cambridge he had won a gold medal for physical development at Sandow's Academy in London. He wrote nearly fifty years later: 'I was spending some time in Paris and a friend of mine suggested that I take a pose of my own which I did,—seated—the pose being somewhat similar to "The Thinker".[1] Photographs of Mr White verify the sculptor's attention to his compact shoulder, torso and leg muscles and his serious, but untroubled, demeanour. Ironically, although the sculpture is a throwback to the early constricted men, it is also like the untroubled, healthy female specimens commonplace in drawings of seated and kneeling women of approximately the same date, for example D4846 and D3013. Another version of this sculpture, with head turned in profile, exists.[2]

1. Letter from White to Mrs Margery Mason, 25 May 1949, typescript in the Philadelphia Museum of Art.
2. Published in Tancock, p.321.

Interpretations

189

Ornament

Graphite and estompe on cream paper,
20.3 × 31 cm
Inscribed in graphite, upper right: 'Ornement'
verso, right: 'ornement oeuvre de l'Homme
61 ornement renaissance'

Musée Rodin (D5147)

The acrobatic movement is of interest because of the way Rodin makes it undergo a metamorphosis. It is not the mythological theme of a woman whose legs are being transformed into foliage that draws one's attention, but the decorative aspect of the ring formed by her legs and the way in which it is inscribed inside the triangle of her arms.

This drawing was exhibited in 1910 in Paris in the Salons du Gil Blas under the title, 'Ornement renaissance'.

186 *pl. 255*

Woman pulling dress over head
c.1899–1900

Terracotta, 40 × 13 × 16 cm

Musée Rodin (S525)
Formerly Fenaille Collection, purchased 1978.

This statue of a female nude leaning against a mound and taking off her chemise is a study for one of the four *Bathers* which decorated the swimming-pool in Maurice Fenaille's house in Neuilly-sur-Seine (now demolished). The great collector commissioned the *Bathers* in 1899–1900; the others are *Bather Combing her Hair*, *Bather Warming Herself* and *Bather in Coat*.

190

Ornament

Graphite, estompe and watercolour on cream paper, torn upper right, 25.1 × 32.5 cm
Inscribed in graphite, left: 'table'(?); lower right: 'ornement'

Musée Rodin (D4167)

The comments made on cat. no. 189 also apply here, but a curious reinterpretation of the figure as pedestal has been added.

191 *pl. 218*

Farewell 1892

Plaster, 38.8 × 45.2 × 30.6 cm

Musée Rodin (S1795)

This plaster is of particular interest in that it reveals how Rodin worked. It was cast from an assemblage consisting of a block of wood, a head of Camille Claudel and two hands. Originally, the elements were bound together by a piece of fabric. In the present state, the assemblage element disappears and drapery is used to bind the composition together. The Chrysler Museum in Norfolk owns a marble executed after the final study. The Musée Rodin owns a very similar composition known as *Convalescent* or *Melancholy* in which the head and hands scarcely emerge from the marble.

192 *pl. 220*

La France 1904

Founder: Alexis Rudier
Inscribed: 'A. Rodin'

Trustees of the Victoria and Albert Museum. Gift of the artist, 1914 (A. 39–1914)

Rodin began this tribute to his mistress, Camille Claudel (1856–1945), after they had separated, using an existing head shown as *St George* in the 1889 Monet/Rodin exhibition.[1] The work in this form was called *The Byzantine Princess* or *Bust of a Young Warrior* or *The Empress of the Low-Countries*. A postcard made from a photograph by Bulloz shows the adaptation in progress: a plaster soaked cloth forming the 'helmet', and the niche made from a cast plaster surface. Even without a title, the arrangement conveys Rodin's longing for the company of his mistress and work—companion before her decline into madness. With touching simplicity, Rodin offered the bust to the University of Glasgow, in 1906, as *St George*, and then as *La France*, in 1912, to a celebration to commemorate the 300th anniversary of the discovery of Lake Champaign: under the last title it went to the Victoria and Albert Museum in 1914 via the Grosvenor House exhibition.

1. *Rodin*, Martigny, 1984 p.130.

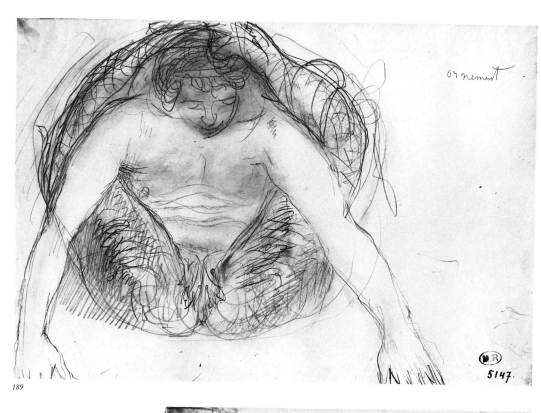

189

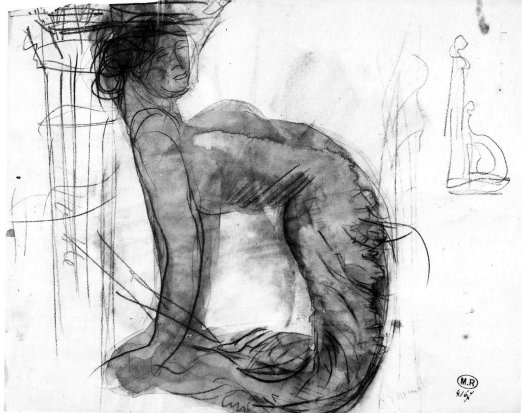

190

193 *pl. 277*

Study for an Obsession 1896

Plaster, 14 cm high

The Metropolitan Museum of Art, New York. Gift of the sculptor, 1912 (12.12.4)

This figure was probably the study for the small marble (55 cm high) which is dated by Grappe to 1896. The twisted limbs and featureless head have been read as a metaphor for a person in the grip of inner torment, limbs knotted. The shrouded surface is probably a result of dipping the maquette in a plaster bath and making a piece-mould and then a new positive. It is substantially less human than the first title, *Second Crouching Woman*, suggests.[1] It is akin to other works with a mute, occult look associated with Rodin's Symbolist tendencies and his marbles, for instance *L'Epervier et la Colombe* (a seated male figure turned to a wall).

When the Metropolitan Museum's gallery devoted to the work of Rodin opened on 2 May 1912 it contained more than forty works, ranging from landmark sculptures that had been purchased such as *Adam* and the Old Courtesan (or *She who was the Helmet-maker's Once-Beautiful Wife*), to recently commissioned marbles, to a group of terracotta and plaster studies, including this one, and a group of hands and legs which were Rodin's gift. The critic for the New York *Sun* recognized the honour of a gift which included work direct from the studio shelves.[2]

1. Grappe *Catalogue du Musée Rodin*, no. 219.
2. Clare Vincent, 'Rodin at the Metropolitan Museum of Art. A History of the Collection', *The Metropolitan Museum of Art, Bulletin*, New York, spring 1981, pp.9–11.

194 *pl. 300*

Assemblage of man and woman upside down

Plaster, 35.2 × 21.7 × 20.6 cm

Musée Rodin (S2122)

Rodin's *œuvre* includes numerous groups made up of figures executed for earlier works, but it is only recently that their multiplicity and importance has been recognized. When they are seen from a new perspective, the figures are not always immediately recognizable, and previously hidden features come to light. This example is particularly rich because of its complexity. The leaning woman is none other than one of the *Three Sirens* seen in the left-hand panel of the *Gates of Hell*. The Sirens also figure in a separate group, which is usually thought to date from 1888, and again in the second project for the Victor Hugo monument (1891–94). The woman sitting on the mound has been given a small *Polyphemus* head, which Rodin must have taken from his collection of casts. Many other casts can still be seen at Meudon.

Limbs

195 *pl. 297*

Assemblage of female torso and antique pot

Plaster and pottery, 15 × 12.6 × 20.9 cm

Musée Rodin (S343)

This assemblage, which has only recently been revealed to the public, is one of a series, many of which have never been exhibited. Rodin would select small female torsos, such as certain of the multiple casts made for the *Gates of Hell*, and, purely for his own amusement, he would place them in the many pieces of antique pottery in his collection, usually using damaged pieces. These provided a support for his creative phantasies. Some were studies for more developed sculptures like the *Small Water Fairy*, which originated with the figure of a woman emerging from an antique bowl and supported only by a fragment of plaster representing drapery. Most, however, were, like the present assemblage, purely gratuitous exercises, many of which defy the laws of equlibrium.

196

Hand of the pianist

Bronze, 18 × 25.5 cm
Founder: Georges Rudier
Cast ten

The Josefowitz Collection

Life-sized or enlarged, many of Rodin's hands acquire macabre, organic qualities which recall his continuation of the Romantic treatment of fragments as self-sufficient units. De Caso has pointed out that 'the fragment could also create a sense of mystery; like Symbolist poetry, it evokes without stating.' He also has made the point that the magical implications of detached parts appealed to nineteenth-century writers, citing Balzac, *The Elixir of life*, Gérard de Nerval, *The Enchanted Hand*, Gautier, *The Mummy's foot* and Maupassant, *The Hand*.[1]

1. De Caso and Sanders, pp.315–17.

197

Right Hand or **Hand No. 9**

Terracotta, 10.1 × 5 × 3.2 cm

Musée Rodin (S1261)

Most of the hands modelled by Rodin suggest tension or feverish activity. This example, in contrast, suggests an atmosphere of meditation and grace and, in that respect, it recalls the hands in *Cathedral*. The apparent simplicity tends to mask the subtle artistry of the articulation. Rodin was now beginning to master such features and enjoyed exploring similar aspects of Greco-Roman statuary by candle-light.

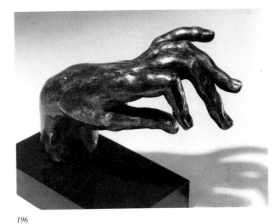

196

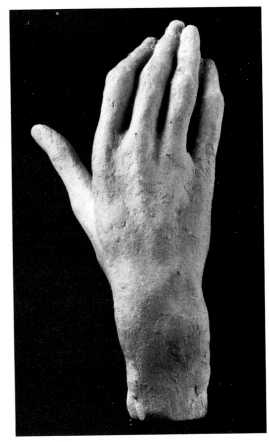

197

198

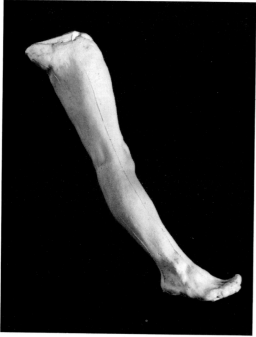

199

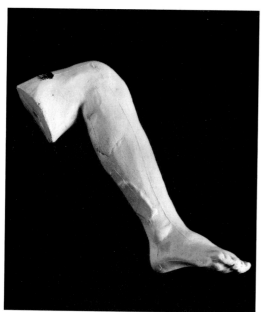

200

198

Right Hand or Hand No. 23

Terracotta, 8.5 × 6.8 × 4.5 cm

Musée Rodin (S1247)

Rodin was more interested in the expressive aspect of gestures than in their meaning. It is, for instance, possible that this hand is pointing somewhere, to some imaginary object, or even that it is miming something, but it is really the movement through space that is important. The fingers project in different directions, and the way in which they stretch

out indicates the artist's interest in spatial movement, an interest which also appears in *Dance movement F.*

199

Right Leg

Plaster, 27.6 × 6 × 7.1 cm

Musée Rodin (S710)

Unlike the preceding fragments, this leg and cat. no. 200 are characterized by their simplicity of form. The sculptor is interested in the pose itself rather than in what it expresses, in general contours rather than details. This suggests that these plaster casts were conceived not as finished works but as building blocks to be used in later assemblages.

200

Right leg

Plaster, 16.8 × 3.9 × 36.1 cm

Musée Rodin (S724)

Georges Grappe's inventory of the collections of the Musée Rodin lists more than two hundred legs in a wide variety of poses. Many of them seem to derive from earlier figures, especially from the characters portrayed in the *Gates of Hell*, where the intertwined limbs create truly spatial patterns.

201

201

Right Foot

Terracotta, 7.3 × 11.7 × 3.9 cm

Musée Rodin (S1242)

'In small things, the law is paramount; it wells forth and springs from their every feature.'

Rodin could have adopted Rilke's dictum as his own. He believed that one should learn to model by starting with hands and feet, as they are the areas where form is at its most concentrated. The curves and counter-curves of this terracotta and the prominent bone structure reveal both his genius as a modeller and his talent for observation. Moreover, the artist combines analysis with expressivity in this image of a bruised, sinewy foot which has been trampled upon by life.

Dancers

202 *pl. 267*

Nude Dancer

Graphite on cream paper, 31 × 19.5 cm

Musée Rodin (D1141)

The Japanese actress Ota Hisa or 'Hanako' signed a contract with Loïe Fuller's troop. It was while she was appearing in *La Vengeance de la geisha* in Marseilles, during the 1906 Exposition Coloniale, that she met Rodin, who had travelled south to draw the Cambodian dancers, for the first time. Between 1907 and 1911, Rodin sculpted some fifty busts, heads and masks of Hanako. An album of drawings appears to have been devoted to her. It is entitled 'Sada Hanako', presumably because Hanako has been confused with Sada Yacco, who would not agree to pose nude for any artist—even Rodin—and comprises some twenty drawings. Rodin describes the dancer's body to Paul Gsell in his *L'Art*: 'She has no fat on her at all. Her bulging muscles stand out like those of the little dogs they call fox terriers, and her tendons are so strong that the joints to which they are attached are as big as her limbs. She is so strong that she can stand on one leg for as long as she likes, with the other leg raised at right-angles to her body. In that pose, she seems to have taken root in the earth, like a tree. Her anatomy is therefore very different to that of European women, but she is still very beautiful because of her unusual strength.'[1]

1. *L'Art: Entretiens réunis par Paul Gsell*, Paris, 1911, p.152.

203 *pl. 268*

Head of Hanako *c.*1909

Bronze, 17.5 × 12.5 × 13.5 cm
Founder: Alexis Rudier

Private Collection

In comparison with most of the terracotta and plaster heads and masks of Hanako, this bronze is faithful to her Oriental hairstyle, arranged in masses with a flower to one side. Numerous casts exist, including the twelve issued by the Musée Rodin between 1956 and 1965. Several of the other most striking versions are masks with frighteningly vivid apertures for the eyes, nose and mouth suggesting her Kabuki-inspired training. Twenty-six different sculpted heads are reproduced in the catalogue published by the Musée Rodin in 1979, *Rodin et l'Extrême-Orient*.

203a

203a

Hanako, mask, type E

Plaster, 23.1 × 13 × 13.8 cm

Private Collection, Paris

This head is close to no. 18 in the catalogue *Rodin et l'Extrême Orient*. It's expression of serene introspection contrasts with those demonstrating anger and pain such as the ones photographed by Steichen in 1908. Bronze versions of a similar mask exist (one copy entered the Musée du Luxembourg in 1911).

204 *pl. 282*

Cambodian Dancer

Graphite, pen and brown ink with watercolour and gouache on cream paper, 30.6 × 24.5 cm
Inscribed in graphite, right and centre: 'sampot/sim'

Musée Rodin (D4504)

On 10 July 1906, King Sisowath of Cambodia, who had come to visit the Exposition Coloniale in Marseilles at the invitation of the French government, had his own dance troupe give an open-air performance at the Pre-Catalan in the Bois de Boulogne. Rodin was present, and describes his amazement as follows: 'I watched them in ecstasy . . . They left me feeling so empty! When they left, everything went cold and dark. I thought that they had taken the beauty of the world away with them . . . I followed them to Marseilles, and I could have followed them to Cairo!'[1] He visited the town house in which they were staying in order to capture a few poses, but as they were in Paris for only a short time, he took the train with them and went on drawing them until they set sail from Marseilles. He discovered movements he had never seen before, and even inscribed the drawing with the word 'sampot', the name of the silk garment worn by Cambodian women. 'Their costumes could not be more beautiful; they reveal every line . . . They seem complicated, but they are not, and they reveal the line of the naked body beneath.'[2]

1. Louis Vauxcelles in *Exposition des dessins chez Devambez*, Paris, 19 October–5 November 1908.
2. Georges Bois, 'Le Sculpteur Rodin et les danseuses cambodgiennes', *L'Illustration*, 28 July 1906.

205 *pl. 280*

Dance movement *c.*1911

Graphite and estompe on cream paper, 31.2 × 20 cm
Stamped in violet, below right: 'Rodin'

Musée Rodin (D2838)

This pose often appears in the drawings, and this example can be related to the sculpture *Dance movement 'A'* (cat. no. 206), which dates from 1911. Rodin preferred freely moving, acrobatic figures to classical dancers.

206 *pl. 285*

Dance movement 'A' *c.*1911

Bronze, 71 × 22 × 33.5 cm
Cast before 1952

Galerie Beyeler

207 *pl. 286*

Dance movement 'H' *c.*1910

Bronze, 28 × 17 × 22 cm
Cast before 1952

The Josefowitz Collection

208 *pl. 287*

Pas de deux 'B' *c.*1910–13

Bronze, 33 × 19 × 13 cm

Private Collection

209 *pl. 288*

The Crouching Dancer *c.*1910–11

Bronze, 9 × 18 × 11 cm

Founder: Georges Rudier
Cast twelve

The Josefowitz Collection.

210 *pl. 298*

Seated figure raising left leg

Plaster, 13.1 × 17.5 × 11 cm

Musée Rodin (S914)

This sketch, which was first seen in the 1962 *Rodin Inconnu* exhibition, has all the force of something modelled from life, and may be a movement study of a dancer.

211 *pl. 274*

Nijinsky 1912

Bronze, 17 × 9 × 5 cm
Cast by the Musée Rodin in 1958

Private Collection

Rodin's enthusiasm for modern dance forms dated from the 1890s, and ranged from the can-can and Oriental dances to the spectacular stage effects and swirling draperies of Loïe Fuller and the light, spontaneous gestures of Isadora Duncan with her references to Hellenistic poses and costumes.[1] It was not the stage performances which intrigued Rodin, although he was curious to see certain ones, but the opportunity to bring the dancers to his own studio so that he could feed off their exhibitionism and raw energy. In the nineties Rodin's drawing reflected his desire to 'savour' the moving human form, to create by letting his eyes follow the movement as a phenomenon in itself and take it as directly as possible to the page. After years of working with swift pencil line, and forms filled by Sienna-coloured wash, Rodin moved to using logs of fresh clay, finding a similar extruded look which paid tribute not only to the pliable movements of dancers but also to the ability of the human to analogize nature unselfconsciously. He told Paul Gsell:

> You have certainly read in Ovid how Daphne is transformed into a laurel and

Procne into a swallow. The charming writer shows the body of the one being covered with bark and leaves, and the limbs of the other being clothed with feathers, so that in each case one still sees the woman that will soon cease to be and the sapling or bird that she will become. It is basically a metamorphosis of this kind that the painter or sculptor executes in making his personnage move. He makes visible the passage of one pose into the other; he indicates how imperceptibly the first glides into the second.[2]

On the morning of 29 May 1912, following the début of Nijinsky in *L'Apres-midi d'un faune*, a letter with ecstatic praise for the performance appeared under Rodin's signature in *Le Matin*. It was composed by Roger Marx and contained the Rodinesque comparison: 'You would think Nijinsky were a statue when he lies full length on the rock, with one leg bent and the flute at his lips.' The letter caused a furious rejoinder from the critic Calmette and Rodin, afraid of a scandal and influenced by the Duchess of Choiseul, denied its authorship.[3] Nijinsky came to Meudon on more than one occasion to pose. According to legend Diaghilev discovered the two men asleep on the couch (after lunch) and concluding, ludicrously, that the 72-year-old sculptor had seduced his protégé, terminated the collaboration.[4] The identification of the 'Nijinsky' sculpture with the dancer has been contested by Serge Lifar on the grounds of its greater resemblance to a character in another ballet in which Nijinsky did not dance.[5]

The repetition of forms in *Pas de deux 'B'* (two duplicates of the figure entitled *Dance Movement 'G'*) recalls the technique used in the *Three Shades*, as well as in early drawings.

The lack of detail in these Dance Movements and the especially unconventional liberties with structure foreshadow the spirit of contemporary artists who use a restrained touch that leaves intact the quality of the medium before it becomes 'art'. The recent sculpture of Barry Flanagan shares this approach, also an interest in the collaboration between artist and performer (see his *Three hares—candelabra* (1982) and the statue of Lisa Lyons (1985)).

1. Rodin's interest in dancers is well documented, including in Isadora Duncan, *My Life*, New York, 1927, and *Rodin Inconnu*.
2. Gsell, *Auguste Rodin. Art*, p.28.
3. Cladel, *Rodin. Sa vie*, pp. 281–4. The denial, which was shameful in view of Marx's long support for Rodin and Rodin's genuine enthusiasm for Nijinsky, is partly explained by his sensitivity to charges of immorality when the issue of the future Musée Rodin (in a building that was formerly a convent) was at stake.
4. The legendary incident was cited by Romola Nijinsky (see Mario Amaya, 'Rodin's dancers', *Dance and Dancers*, March 1963, pp.24–6 and Anita Leslie, *Rodin: Immortal Peasant*, London, 1939, pp.241–5).
5. *Rodin*, Martigny, 1984, p.140.

212 *pl. 301*

The Juggler (also called *The Acrobat*) *c.*1892–5

Bronze, 30.5 cm high

Private Collection

Grappe described the sculpture as a clown supporting a person and dated it to the period of Rodin's major fascination with the circus, mentioning his friendship with the lion-tamer Bidel.[1] The upper figure with its smooth contours and dome-like head is like the honed-down torsoes filled with Sienna-coloured wash that acquired the same primitive, fetishistic look, for example *Prehistoric* (cat. no. 177). The lower figure has the nervous line of drawings made with eyes on the model which in clay resulted in a pinched look common to the sculpture of *Polyphemus and Acis* as well as *Nijinsky*.

1. Grappe, *Catalogue du Musée Rodin*, no. 389.

The female nude

213 *pl. 293*

The Abandoned (*L'Abandonée*) *c.*1910

Graphite pencil, stumped, 19.4 × 30.4 cm

The Metropolitan Museum of Art, New York.
Purchased through the Rogers Fund, 1910 (10.45.20)

The model for this delicate drawing may have been Fenella Lowell, a singer, who corresponded with Rodin between 1908–1911.[1] Certainly the exact pose and face are familiar through closely related works including the *Clothed woman lying on her side* (D5657) (the cover of *Auguste Rodin. Drawings and Watercolours*, Munster, 1984.) and that annotated 'chanson de geste pour tous les dessins' (D5660). J.A. Schmoll gen. Eisenwerth related the drawing D5657 to the portrait D2361 with a similar emphatic bone structure.[2]

Roger Fry, who met Rodin in 1906, advised the Metropolitan to purchase this drawing, their first, in 1910 (it is catalogued as 'Turner through Fry').

1. The models, Musée Rodin Archives.
2. In *Auguste Rodin. Drawings and Watercolours*, p.336.
3. Archives, Metropolitan Museum, and Clare Vincent, 'Rodin at the Metropolitan Museum of Art. A History of the Collection', *Metropolitan Museum of Art Bulletin*, XXVIII, spring, 1981.

214

Seated female nude leaning to left 1908

Graphite pencil on paper, 31.2 × 20 cm
Inscribed: 'dessin fait cette matinée 7 juillet 1908 et dédié a mon ami John Woodruff Simpson Aug. Rodin'

National Gallery of Art, Washington, D.C. Gift of Mrs John W. Simpson

The placing of the subject on the page so that her head is in one corner and her trunk runs along the diagonal, with thighs at cross-angles, is as typical of the bias towards zig-zag structures in Rodin's work on paper as it is in his sculpture. A similar drawing, also given to the Simpsons and in the National Gallery, Washington, allows the model to sit upright, her perplexed facial expression lending a comical air.[1]

1. *The Drawings of Rodin*, pl. 85. The Simpsons bought the majority of the Rodin sculptures now in the National Gallery in Washington (Ruth Butler has recently lectured on the Simpsons as collectors: 'La sculpture française et les Américains au XIXᵉ siècle', at the Recontres de l'ecole du Louvre, *La sculpture du XIXᵉ siècle une memoire retrouvée*, Paris, April 1986.

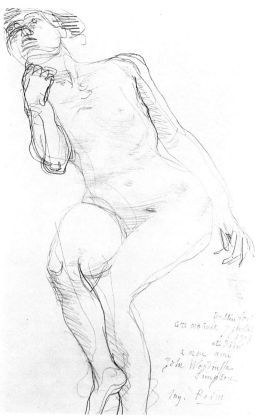

214

215

Reclining figure by 1907

Lead pencil on paper, 60 × 40 cm
Inscribed: 'en hommage à Madame &
Monsieur Symons'

Trustees of the British Museum (1937–2–13–
7). Bequeathed by Mrs Arthur Symons

Noticeable among Rodin's late drawings are
families of images. Many come from tracings
and others are slight variations, as this one is
of the drawing with yellow watercolour called
Sleeping girl seen obliquely from below which is
now in the Kunsthalle, Bremen. Sometimes
the tracings were probably not by Rodin's
hand as Varnedoe has pointed out, but by
magazines making line drawings or by un-
authorized copyists.[2] There are long chains of
variations such as that of the dancer in the 'A'
pose and the chromolithographic process in
the mid-1880s.[3] The similarity is sometimes
uncanny when it is not the pose but the
physiques and mood which are so constant, as
if frames of a film of models moving about in
private, oblivious to the artist. This sensation
occurs in the drawing of a Lesbian couple,
D5960 and D4889, one with bony hips and
one plump.

Arthur Symons (1865–1945), the poet,
translator and critic, wrote for the *Athenaeum*,
Saturday and the *Fortnightly Review*, publish-
ing his principle book, *Symbolist Movement in
Literature*, in 1899 and *From Toulouse-Lautrec to
Rodin, with some personal reminiscences* in 1929.
He became a personal friend of Rodin's and
visited him in Paris and Meudon, probably
receiving this drawing and others as gifts.

1. *Auguste Rodin. The Drawings and Watercolours*, no. 126.
2. J. Kirk T. Varnedoe, doctoral thesis, Stanford Univer-
 sity, 1971.
3. See '*Poet, take up your lute*' (cat. no. 69).

216

Nude woman with arched back
*c.*1900–10

Pencil on paper, 20 × 13 cm
Inscribed, in pencil: 'en hommage à Madame
Daisy Turner'

Lent by the Visitors of the Ashmolean
Museum, Oxford

The emphatic repeated line and the physique
with prominent hipbones are evident in draw-
ings of the same model (such as cat. no. 218,
or that reproduced in *L'Art Vivant* (D4889).[1].

This drawing was reproduced, before being
annotated, under the description 'dessin inédit
par A. Rodin' in Paul Gsell's interviews with
Rodin.[2] The drawing was beqeathed to the
Ashmolean by Mrs H.H. Turner in 1959.
Daisy Turner was a friend of Camille Spooner
who knew Rodin. Rodin stayed with William
Archibald Spooner, warden of New College,
Oxford, when he received his honorary
degree in 1907.

1. Rainer Maria Rilke, Rodin, *L'Art Vivant*, 1 August
 1928, p.281.
2. *L'Art*, p.125.

217

Reclining nude lying on her stomach

Graphite and estompe on cream paper, torn
on the right, 31.3 × 20.7 cm
Stamped in violet, below right: 'Rodin'

Musée Rodin (D2776)

218 *pl. 259*

Sapphic Couple

Graphite and estompe on cream paper, torn
on the left, 30.9 × 22.8 cm

Musée Rodin (D5960)

Cf. cat. no. 236.

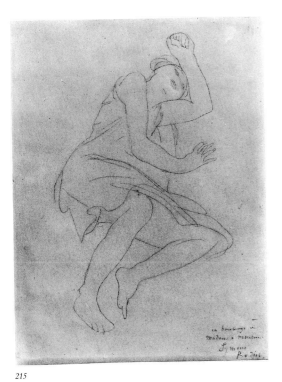

215

216

217

219 pl. 235

Seated nude with hand on forehead

Graphite and estompe on cream paper,
30.9 × 20.4 cm
Signed in graphite, lower right: 'Aug. Rodin'

Musée Rodin (D4886)

220 pl. 292

Standing figure 1900–9

Graphite and estompe on paper,
31.2 × 20.6 cm

The Art Institute of Chicago. The Alfred
Stieglitz Collection (1949.896 R 9592)

This work was included in Rodin's second
exhibition at the Photo-Secession Gallery
(1910). The muting of the silhouette is related
to the soft treatment of the marble surface
Rodin preferred after 1900, and the stillness,
lack of detail and suppressed focus on the
pubic area are equally eloquent in the draw-
ings of details of the body from close-up.

1. Reproduced in *Camera Work*, no. 34/35, April–July
 1911, pl. IX.

221 pl. 253

Woman on all fours, in profile

Graphite and estompe on cream paper,
20.3 × 31.1 cm
Signed in graphite, above, left and side: 'Aug.
Rodin'

Musée Rodin (D5163)

222

Reclining nude, legs apart

Graphite on cream paper, 21.4 × 30.9 cm

Musée Rodin (D5387)

223

Boreas and Aquilon

Graphite, estompe and watercolour on cream
paper, 25.1 × 32.3 cm
Inscribed in graphite, lower left: 'borée et
aquillon'
Stamped in violet, lower left: 'Rodin'

Musée Rodin (D4080)

The figures represent winds and they are
usually portrayed as men, but here Rodin
draws them as women. Both names, one
Greek and the other Latin, refer to the North
Wind.

224

Nude with cloven feet lying on her back

Graphite and estompe on foxed beige paper,
torn at the bottom of the sheet, 31 × 20 cm
Stamped in violet, below left: Rodin

Musée Rodin (D3096)

Male and female fauns were subjects dear to
both the sculptor and the draughtsman. They
allowed him to portray somewhat lascivious
poses.

225

As in Egypt (*Comme l'Egypte*)

Graphite and estompe on cream paper,
20 × 30.9 cm
Inscribed in graphite, upper right: 'dessin à
faire dans la pierre comme l'Egypte': upper
left: 'bas'

Musée Rodin (D5148)

Here, Rodin takes his inspiration from the
geometric pose adopted by his model. He was
often sensitive to the antique or hieratic impli-
cations of a pose, and thought of executing
this drawing in stone, but the project appears
to have come to nothing. There is rarely any
direct correspondence between the drawings
and the sculptures. The convincing allusion to
Egypt is a reminder that Rodin owned several
hundred Egyptian objects.

226 pl. 296

Psyche

Graphite and estompe on cream paper, torn
below, 20.9 × 31.3 cm
Inscribed in graphite, upper right: 'Psyché;
left: 'bas'

Musée Rodin (D5411)

Rodin associates this pose of a woman leaning
backwards, leg raised, which is similar to that
in cat. no. 227, with the legend of Psyche. If
Paul Gsell is to be believed, Rodin once asked
Anatole France what he thought of Psyche, as
he wanted to devote a series of watercolours
to her legend. Wanting to please the sculptor,
and knowing his tastes, France replied that she
was simply a little woman who was only too
happy to show 'you know what'. Rodin
agreed, and gave the name 'Psyche' to figures
which have nothing in common with
Apuleius's dreamy heroine.[1]

1. Paul Gsell, *Douze Aquarelles d'Auguste Rodin*, Paris,
 1920, p.21.

227 pl. 295

Diana or Hecate

Graphite, estompe and watercolour on cream
paper, 32.7 × 24.9 cm
Inscribed in graphite, lower right: 'Diane—
Hécate'; above left: 'la lune' (inverted).

Musée Rodin (D5718)

Here, Rodin combines his liking for acrobatic
poses with his interest in mythology. Both
Diana and Hecate are moon goddesses, and
the woman's body is perfectly inscribed
within a crescent moon.
The annotations on this drawing and cat. no.
226 indicate the way Rodin changed his mind
about his preferred orientation of drawings.

222

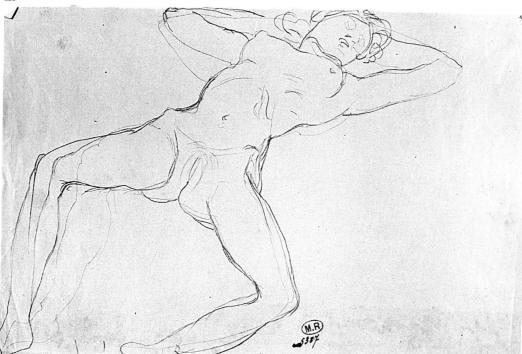

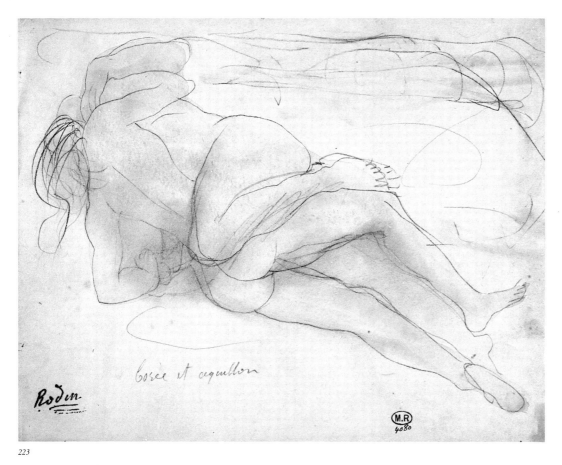

223

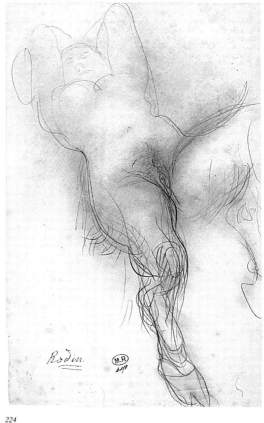

224

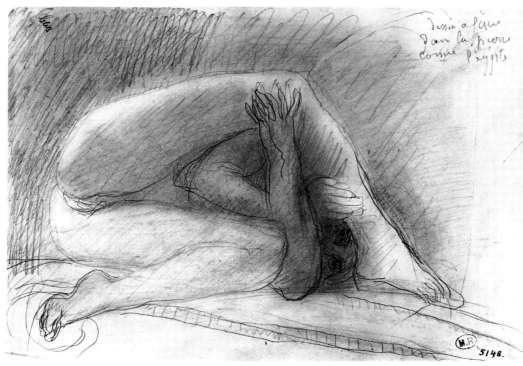

225

228

'Keep away' (*'N'Approchez pas'*)

Graphite and estompe on watermarked cream paper, 23.4 × 38 cm
Inscribed in graphite, above right: 'retient tout—comme un voile(?)'; below:
'n'approchez pas—le docteur—sur le lit'
Verso: 'banquet(?)' (in graphite)

Musée Rodin (D1773)

It is possible that the model for this nude lying on her back, legs doubled up, was Alda Moreno, a dancer at the Opéra Comique. She corresponded with Rodin between 1910 and 1917, and appears to have sat for some drawings in 1912. Rodin devoted a series of works in rubbed estompe on quality paper to her. This drawing is in his late 'enveloppé' manner.

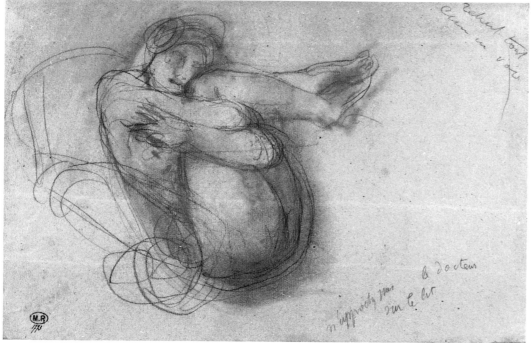

228

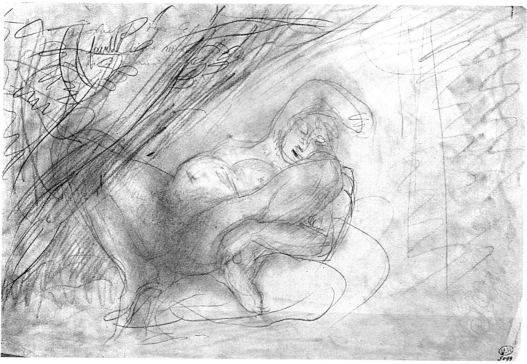

230

229 *pl. 269*

Reclining nude with legs apart, seen from the front

Graphite, estompe and watercolour on cream paper, 25.4 × 32.5 cm
Diagonal graphite inscription on left: 'bas'

Musée Rodin (D4796)

Rodin had an obvious preference for watercolours with soft, subtle tints. The line is usually traced lightly, and it is rare for the entire sheet to be coloured.

230

Female nude on her back, legs apart and folded

Graphite, estompe on watermarked cream paper, 30.8 × 46.6 cm
Inscribed in graphite, above, left: 'feuille . . .'

Musée Rodin (D5094)

Rodin's inscriptions are often difficult to decipher, especially when, as here, one inscription is superimposed upon another. Our understanding of the drawing obviously suffers as a result. It is tempting to see the model as a pregnant woman.

231 *pl. 236*

Setting sun (*Le Soleil couchant*)

Graphite and watercolour on watermarked cream paper, 25.2 × 32.5 cm
Inscribed and signed in graphite, lower right: 'le soleil couchant. Rodin'

Musée Rodin (D4848)

This is one of Rodin's favourite poses: a woman lying on her side, with her garments bunched up around her hips. He often gives such drawings symbolic or even cosmic titles.

232

Woman lying on her back with legs apart, seen from the front

Graphite and estompe on cream paper, 30.9 × 20.2 cm

Musée Rodin (D5959)

Cf. cat. no. 236.

233 *pl. 276*

Woman lying on her back, with arms and legs apart, seen from the front

Graphite and estompe on cream paper, 31 × 20.7 cm

Musée Rodin (D5981)

Cf. cat. no. 236.

232

234

235

234

Seated woman with chin on foot

Graphite and estompe on beige paper,
31.2 × 20.4 cm
Stamped in violet, below right: 'Rodin'

Musée Rodin (D3109)

235

Satan

Graphite and estompe on cream paper, with
spots of watercolour below, 32.7 × 25.7 cm
Inverted inscription in graphite, above:
'Satan—Milton'

Musée Rodin (D5973)

Did Rodin in fact read Milton's *Paradise Lost?*
One suspects that he had not, but here it
provides a pretext for an erotic drawing, and
Rodin does not hesitate about giving his
model a devil's tail. One senses a demonic
energy in the blackness of the line.
Cf. cat. no. 236.

236 *pl. 304*

Salammbô

Graphite and estompe on cream paper,
20.4 × 31 cm
Inscribed in graphite, lower left: 'Salambô;
and right: 'St Antoine'

Musée Rodin (D6012)

In his *La Vie Artistique*, Gustave Geffroy
speaks of Rodin's lasting affection for Dante,
Baudelaire and Flaubert. He must have been
especially drawn to Flaubert's *Salammbô* and
La Tentation de Saint Antoine. In 1889, he
executed a plaster cast based on *La Tentation*:
the movement of the arms in the drawing is
slightly reminiscent of those of the woman
who tempts the hermit, but her posture is
more audacious.
 In about 1927 the museum curators, in
eloquent testimony to the prudery of the era,
catalogued this drawing and a number of
others shown in London (cat. nos. 218, 232,
233, 235, 237) as belonging to the 'secret
museum' or the 'private collection'.

1. Geffroy, *La Vie Artistique*, Paris, 1893, vol. II, p. 62.

237 *pl. 294*

Nude fragment, hand on genitals

Graphite and estompe on cream paper,
20 × 31 cm
Inscribed in graphite, upper right: 'bas'

Musée Rodin (D5996)

Cf. cat. no. 236.

238

Study of a nude female figure *c.*1910

Pencil and colour on smooth wove paper,
24.8 × 32.1 cm

The Metropolitan Museum of Art, New
York. Gift of Georgia O'Keeffe, 1965
(65.261.2)

The drawing was given to Alfred Stieglitz
(who showed Rodin's drawings in New York
at his '291' gallery). Stieglitz wrote: 'I had
spent a Sunday morning in 1911 at Rodin's
Meudon studio with Steichen and Clara
[Westhoff] and Rodin told Steichen to let me
see anything I wanted to. I saw hundreds of
amazing drawings amongst other things and
this one I fell in love with—never thinking it
could become "mine".'[1]
 The handling of the stomp and faint pink on
the thigh and body adds to the mirage-like
immediacy. Like many of Rodin's late draw-
ings of female anatomy the sexual pivot and
circular bias speak metaphorically of the
'origin' of life. This happens in studies like
Naïade (D5130), as well as in *Cinquième acte*
(D4026) which is closely related, although the
model's feet remain human.

1. Archives, Metropolitan Museum of Art, New York.

239 *pl. 237*

Reclining female nude with legs apart, seen from front

Graphite, estompe and watercolour on watermarked cream paper, 32.7 × 25 cm

Musée Rodin (D4798)

240 *pl. 299*

Fat torso

Terracotta, 25.6 × 12.4 × 16 cm

Musée Rodin (S326)

241

The Creator before 1889

Bronze, 41 cm wide
Founder: Coubertin, 1983

Bruton Gallery, Somerset

This relief appears on the inside of the base of the *Gates of Hell* opposite a curled naked woman, identified by Elsen as probably Eve reaching for the apple. Elsen and the scholars Albert Alhadeff and J.A. Schmoll have suggested that the bearded man is Rodin's self-portrait. The figure of a muse hovering above and the hand touching the forehead follow his pattern for representing the moment of creation. What is slightly unconvincing is the male figure's lower half. In the catalogue of the B. Gerald Cantor Collections, (Metropolitan Museum, New York, 1986) it is dated *c*.1900.

1. Elsen, '*The Gates of Hell*', p. 221.

241

238

Rodin and photography

Hélène Pinet

Figurative artists have always passed on to one another the names of models endowed with specific physical characteristics, and the painters and sculptors of the nineteenth century were no exception to the rule. This meant that, should they require a tall man or a plump woman for a work in progress, they could be sure of finding them in a colleague's studio. They would make a note of a Christian name, which was usually enough to identify any given model, and of the physical features that were likely to be of use to them: good shoulders, shapely legs, thick hands . . . It would, however, be impossible to reconstruct a whole body by putting together features of the different models seen by only one artist, as his eye could take in only certain aspects of their physiognomy.

Both painters and sculptors restricted the process of fragmentation to making lists of attributes, rapidly noting them on scraps of paper or listing them in a diary. The trick was then to amalgamate or harmonize the limbs of different models into original compositions in accordance with the aesthetic canon of the day.

Of all the artists working in the latter part of the century, only Rodin pursued the experiment beyond this stage and integrated his visual research into his working methods. As Italo Calvino rightly points out, it is not because his sculptures correspond in any systematic way to some ideal of anatomical perfection that they appear so complete: 'The trunks may have no heads and no limbs, but they still have all the splendour of life, and they still seem to breathe deeply.' He adds that this proves that 'A great creator scorns superfluities and reveals only essentials.'[1]

The way in which Rodin deliberately breaks down bodies and isolates details somehow reminds one of the way in which a photographer chooses a subject, and then isolates and frames it in his lens. By choosing to photograph a specific figure, building or landscape, he enriches it with a beauty or an aura it might never have acquired otherwise.

The parallel between Rodin and the photographer is not confined to the use of a selective viewpoint or to the reduction of a whole to its parts. The sculptor constantly displayed a truly photographic concern for lighting and presentation. He always gave precise instructions to ensure that his works were seen at their best, both in exhibitions and in private collections. According to Carl Burckhardt, all Rodin's work stems from the same obsessions. He claims that the artist intended all his sculptures to be seen from a specific angle and in a specific light. We might almost say that they were meant to be photographed, even though the liveliness of the modelling disappears as a result. The Swiss critic also argues that the creation of *St John the Baptist* marks Rodin's first step on 'the narrow path leading to the purely pictorial problem of how to animate surfaces.'[2]

Whilst this argument goes against the theory of profiles that meant so much to Rodin, and thus may seem somewhat narrow, it has to be admitted that the artist's description of his ideal light sources—'in a dark room, the light should come from a narrow window set high in the wall; In a light room, it should come from a zenithal room'—applies to the many photographs taken under his supervision.

Rodin was very particular about how two-dimensional reproductions of his works were made, and never gave the many photographers who worked in his studio a free rein. We know from his letters that he alone decided upon the angle of the shot, the lighting and the background. Every print was submitted to him for approval before being published, and if he did not like it the glass plate was destroyed.

Although Rodin was interested in photography throughout his career, the history of his involvement can be divided into two phases. The turning point came in 1896, when photographic reproductions of his sculptures were exhibited for the first time. As a result of this exhibition, the creative artist realised that the new technique had immense potential in both educational and publicity terms. Until then, he had been primarily concerned with the creative side of his work; he now saw that it could be reproduced for world-wide distribution.

Yet even in the 1880s, which had been a period of major State commissions, the camera had its place in the studio alongside the other tools for reproduction in three dimensions. Both Rodin and the technicians who worked for him used all these aids with equal fervour and ingenuity. For Rodin, photographs were not simply models; he used them as sketch-pads, as canvases, and even as supports for new ideas.

A photograph is the perfect intermediary between a sculpture and its two-dimensional image. The engraver or the draughtsman can use it as a model when he has to supply illustrations for the press. The artist can work from photographs when his model is resting between sessions; photographs of someone who has passed on can be used to produce a commissioned statue.

But Rodin thought it inconceivable that a statue could be based upon images alone, or that photographs could ever really replace models. Photographs were simply part of the mass of documentation he collected before beginning a sculpture; for example, for the *Monument to Balzac* he acquired a photograph of a postman from the Angers region who resembled the author.

Rodin's use of photographs as supports for his ideas and for research is at once more curious and more interesting. Like Zola, he believed that 'You cannot claim to have really seen anything until you have seen a photograph of it.' Reproductions allowed him to stand back from his works and to look at them more critically. If necessary, he could then correct a movement, adjust a fold in the drapery or modify the plinth.

Not all the changes were corrections. New ideas were drawn on to the photograph; in this way, Rodin could discover an image, which became a new work, a hybrid, and a unique record of the many ideas which he had neither time nor inclination to execute, but which he could use as a starting-point for other sculptures. When they took on this role, the photographs were no longer single images of in-the-round sculptures in their final state, but starting-points for countless possible interpretations which evolved as the sculptor drew on them.

The new interest which Rodin took in photography from 1896 onwards may have stemmed from his need to teach the viewer how to look at his sculptures, but it also reflected his desire to make multiple images of them at very little cost. From this point onwards, Rodin's relations with the photographers who worked for him were inevitably stormy. Although the artist retained strict control over everything, and although he made no allowance for the element of chance inherent in photography, the prints produced at this time are all marked by the personal vision of the photographer. As though aware of this, Rodin placed more and more emphasis on their aesthetic character.

In 1896, he began to collaborate with Eugène Druet, who was by trade a bistro owner. The photographs taken at this time are the result of an unhappy compromise between the demands of the sculptor and the amateur techniques of the photographer, and it is this which gives them their special quality. The black-and-white prints are, for example, blurred because of the enlargement process used. The mistiness, which is at first sight so disconcerting, gives them a very personal look and, because it highlights the modelling rather than the details, it reveals the strange and sometimes morbid side to Rodin's sculpture. The diffuse lighting and the use of unconventional backgrounds add further to that impression.

When Eugène Druet opened an art gallery, Rodin had to look for a new collaborator, and finally chose the publisher and photographer J. E. Bulloz with whom he signed an exclusive contract in 1903. Bulloz produced a priceless set of documents which show how the artist himself visualized the presentation of his works, and publicized Rodin in a very

sophisticated series of photographs which provide the collector with a guide, an anthology of the sculptor's œuvre.

The only person to suspect why Rodin found Druet's prints so attractive was the journalist André Fontainais, who saw in them 'Something misty and delicate which almost reminds one of the harmonious but profound art of Eugène Carrière.'[3] The sculptor subsequently provided confirmation of this insight by working for two years (1903–4) with the English photographers Stephen Haweis and Henry Coles. Their use of gum bichromate and their retouching techniques allowed them to produce photographs which were so similar to Carrière's paintings, for which Rodin had a particular fondness, that they could not fail to delight the sculptor.

The techniques used by Haweis and Cole meant that the sculptor had no—or very little—direct involvement in producing the prints, as he had had when he worked with Druet and Bulloz. As a result, roles were reversed. The photographic reproductions became originals. They were outside the sculptor's control, and he therefore came to regard them as true works of art.

1. A. Savinio, 'Isadora Duncan', in *Hommes, racontez-vouz*, Paris, 1978.
2. Carl Burckhardt, *Rodin und das plastische problem*, Basel, 1921.
3. *La Mercure de France*, July 1901.

242

Monument to Whistler without drapes

Limet(?), c.1906
Photograph, 16.6 × 11.5 cm

Musée Rodin (Ph1550)

243

Tragic muse

Limet(?), from 1901
Photograph, 23.5 × 17 cm

Musée Rodin (Ph1307)

244 pl. 256

Model with Meditation

E. Druet, from 1911
Photograph, 27.1 × 23.4 cm

Musée Rodin (Ph1554)

245 pl. 30

Torso of Ugolino, back view

E. Freuler, from 1877
Photograph, 14.5 × 9.9 cm

Musée Rodin (Ph1555)

246 pl. 29

Torso of Ugolino, in profile

E. Freuler, from 1877
Photograph, 14.5 × 10 cm

Musée Rodin (Ph2071)

247 pl. 146

Despair, three-quarters view

C. Bodmer, c.1893
Photograph, 13.6 × 10 cm

Musée Rodin (Ph1559)

248 pl. 145

Despair

E. Druet, 1896
Photograph, 39.7 × 29.8 cm

Musée Rodin (Ph1560)

249 pl. 147

Despair

Haweis et Coles, 1903–1904
Photograph, 22.2 × 16.1 cm

Musée Rodin (Ph1556)

250 pl. 142

L'Emprise, in profile

E. Druet, from 1896
Photograph, 39.7 × 29.9 cm

Musée Rodin (Ph1557)

251

Young woman kissed by a phantom

E. Druet, from 1896
Photograph, 20 × 26 cm

Musée Rodin (Ph347)

252

The Dream

E. Druet, from 1896
Photograph, 29 × 40.1 cm

Musée Rodin (Ph1558)

253

Fatigue

Photographer unknown, from 1887
Photograph 14 × 23 cm

Musée Rodin (Ph655)

254

The Metamorphosis of Ovid

Photographer unknown, from 1886
Photograph, 14.5 × 10.2 cm

Musée Rodin (Ph669)

255

Model with veils

Photographer unknown
Photograph, 15 × 10.5 cm

Musée Rodin (Ph1561)

256 pl. 217

Monument to Puvis de Chavannes

Photographer unknown, from 1901
Photograph, 23.7 × 17.5 cm

Musée Rodin (Ph384)

257 pl. 138

Ugolino and his children

C. Bodmer(?), 1880–81
Photograph, 11 × 15.5 cm

Musée Rodin (Ph294)

258

Avarice and Lust

E. Druet, from 1896
Photograph, 29.8 × 39.6 cm

Musée Rodin (Ph1547)

259 pl. 88

Avarice and Lust

E. Druet, after 1896
Photograph, 39.7 × 29.9 cm

Musée Rodin (Ph1548)

260 pl. 211

Headless, naked figure study for Balzac, in the Clos Payen

E. Druet, c.1896–97
Photograph, 16.8 × 11.9 cm

Musée Rodin (Ph1549)

261

Heroic Head of Victor Hugo at Meudon

Limet(?), from 1901
Photograph, 23.4 × 17.8 cm

Musée Rodin (Ph1306)

262 pl. 180

Rodin with the Bust of Victor Hugo

Photographer unknown, c1883
Photograph, 13.5 × 10.5 cm

Musée Rodin (Ph353)

263

Je suis belle

C. Bodmer, c.1893
Photograph, 25 × 19.3 cm

Musée Rodin (Ph1551)

264 *pl. 200*

Monument to Victor Hugo at the Palais Royal

F. Bianchi, 1909
Photograph, 17.5 × 23.5 cm

Musée Rodin (Ph1553)

265

Victor Hugo and the muses

Haweis et Coles, 1903–4
Photograph, 23.3 × 16.8 cm

Musée Rodin (Ph259)

266 *pl. 223*

Monument to Whistler with drapes

J.E. Bulloz, *c*.1906
Photograph, 36.5 × 26.5 cm

Musée Rodin (Ph385)

267 *pl. 201*

Monument to Victor Hugo

Manzi-Joyant, *c*.1897
Photograph, 17.2 × 23 cm

Musée Rodin (Ph1552)

268

Group of photographs belonging to Jessie
Lipscomb, *c*.1887

Collection of her grandson

269 *pl. 202*

Photogravure of Eduard Steichen's *Le
Penseur-Rodin* published in the supplement to
Camera Work, April 1906, plate X (*Steichen
Supplement*)

15.3 × 18.7 cm, size of entire issue:
22.9 × 32.5 cm

The Royal Photographic Society

270

Group of photographs from the collection of
Henriette and Jeanne Bardey

Harry Spiro